IMAGES
of America

YORKTOWN

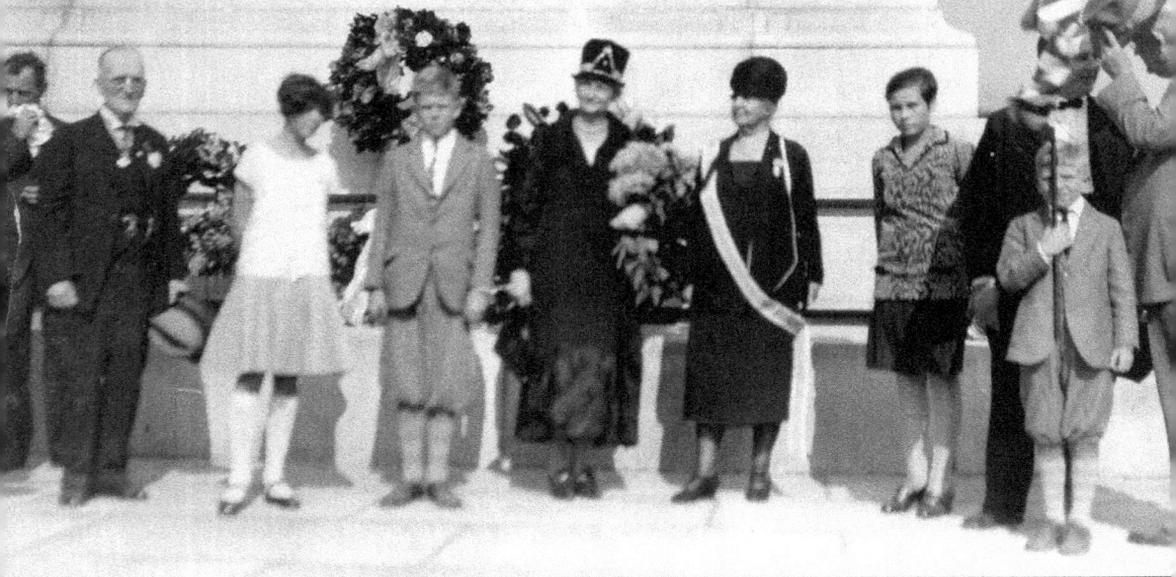

The picture reads "To Jimmie with love from Mr. and Mrs. Chenoweth." Jimmie O'Hara (holding the flag) is pictured with other dignitaries of the Daughters of the American Revolution (DAR); notice the patriotic gesture of the man tipping his hat to the flag. (Courtesy of O'Hara Collection.)

IMAGES
of America

YORKTOWN

Kathleen Manley

ARCADIA
PUBLISHING

Published by Arcadia Publishing
Charleston, South Carolina

Library of Congress Catalog Card Number: 2004103210

For all general information contact Arcadia Publishing at:
Telephone 843-853-2070
Fax 843-853-0044
E-mail sales@arcadiapublishing.com
For customer service and orders:
Toll-Free 1-888-313-2665

Visit us on the Internet at www.arcadiapublishing.com

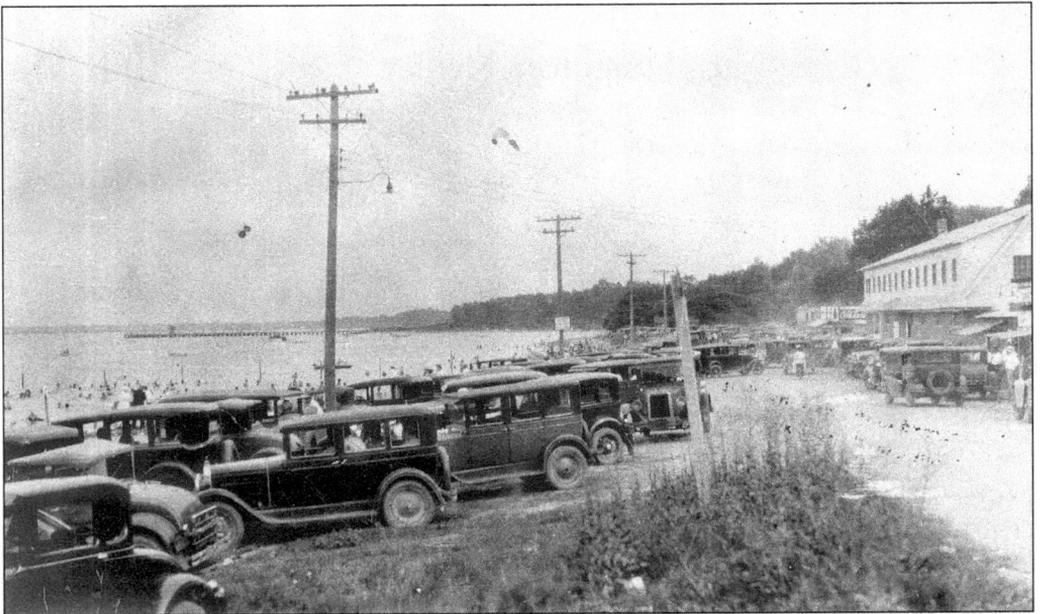

It was crowded at the beach c. 1920. (Courtesy of National Park Service, Colonial National Historical Park Yorktown Collection.)

CONTENTS

This happy boy, Hunter Fletcher, is seen behind a book, *c.* 1925; he has a long lifetime of memories in Yorktown. (Courtesy of Fletcher collection.)

ACKNOWLEDGMENTS

My initial interest was just to pass on the accounts of the locals who lived down in the Yorktown village about this wonderful time period. As in any literary pursuit there became more to write than just a few stories. The journey of retracing the steps of the two generations before me in my hometown has been my most comfortable private place.

My most grateful thanks to Margaret Penzold, Nancy Spaniol, and Kathleen Endebrock, who took the time to sit for hours and tell me their stories. So many thanks go out to Robbie English and Jane Sundberg at the Colonial National Historical Park. To Tom and Lola Landvogt, Mr. and Mrs. James O'Hara, and some of my dearest friends who helped me in various ways in assembling this book, thank you. My editor, Susan Beck, has been my greatest advocate in this endeavor. And thanks go to the late Mary Hester, who gave so much of her life to make ours better.

But thanks goes most of all to my father's dearest friend in Yorktown, Hunter Fletcher, for taking large blocks of time to tell me so many things. Everyone agrees, Hunter remembers everything! There is no more credible source living today about so many details that can not be researched in any book written. My humblest and most heartfelt thanks to Hunter for his time.

Also, there are so many details that can be seen in documents available to the general public, but too tedious to use in a book of this size. I enjoyed—and in some cases felt overwhelming joy mixed with tears of sadness—researching the aspects of Yorktown during this age. I hope my passion was revealed to you.

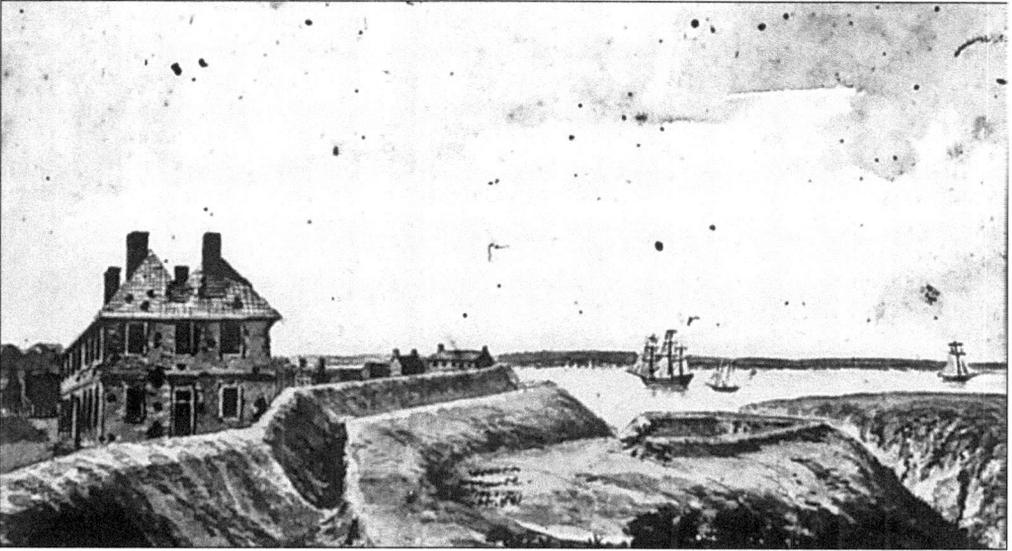

Pictured above is a sketch from Latrobe of the Nelson house, 1789–1799. (Courtesy of National Park Service, Colonial National Historical Park Yorktown Collection.)

INTRODUCTION

The town had begun in 1691 with a land grant and architectural plans setting the properties in grids, for tax purposes. Life began to flourish until the Revolutionary War when the people of the village fled as a result of the ferocity of the battles. The homes were shot through with such force that the chaplain of the French troops wrote, "I have been through the unfortunate little town of York since the siege, and saw many elegant houses shot through and through in a thousand places, and ready to crumble to pieces; rich household furniture crushed under their ruins, or broken by the brutal English soldier; carcases of men and horses half covered with dirt, books piled in heaps, and scattered among the ruins of the buildings."

Thomas Nelson was governor of Virginia and commander of the state militia and owned one of the largest homes on Main Street. During the siege in Yorktown, Nelson was quoted as saying, "point the cannon toward that house . . . there you will be almost certain to find Lord Cornwallis and the British Headquarters. Fire upon it, my dear marquis, and never spare a particle of my property so long as it affords a comfort or a shelter to the enemies of my country."

Grace Episcopal Church stood from the beginning in 1697, when the third church of York parish was built of marl (sand and shell) at the present-day site. It was nearly demolished by the Revolutionary War; during the Confederate and Union occupations during the Civil War the interior was damaged, with evidence of the soldier's winter quarters in the churchyard during the Union occupation. Finally, in 1927 the church closed for nine months for a major renovation under the direction of The Rev. Dr. W.A. R. Goodwin, who had charge over Grace at this time.

The early part of the century brought a new beginning to Yorktown as it did with much of the country. Because the Atlantic Fleet came to the York River as safe haven before departing to the beginning of World War I, Yorktown began to come alive with merchants and service industry to support the military.

7

By the 1920s summer homes were being built in the Temple Farms area, near the Moore House, and development was also associated with the Naval Refueling Depot, currently the Coast Guard Base. The stories are still being told of the simple days of ice skating on Roosevelt Pond, sledding down Read Street, roller skating around the Victory Monument, and playing on the foundations of the Swan Tavern, before it was restored. But, most of all, residents recall watching the Baltimore Steamer come in daily. The DAR were in stages of restoring the Customs House and together with the Association for the Preservation of Virginia Antiquities, Yorktown Day was becoming a yearly event. There was a passionate movement growing to save this lovely historical hamlet and Congress was listening. The Yorktown Manor Hotel and Country Club built a golf course on the battlefield. A 300-room Manor House Hotel was planned, which failed in only a few years.

By the 1930s the Sesquicentennial Celebration that brought hundreds of thousands of people, paved streets, electricity, and telephone service changed everything. The hurricane of 1933 brought desperate times for many, but with the build-up of the military at the Naval Mine Depot and Fort Eustis, the population was growing. The waterfront was bustling with commercial trade, more than it has since that time.

If the hotel had succeeded the town would have taken a very different path. Would there be more development into the future but away from our history? Is it that we long to be in the vast expanse of the fields of rich brown earth that spreads wide from the bluffs of the river? The answer lies deep in the hearts of those who have known Yorktown, for the experience lingers forever on the souls who have come before and those who reside now in this graceful place.

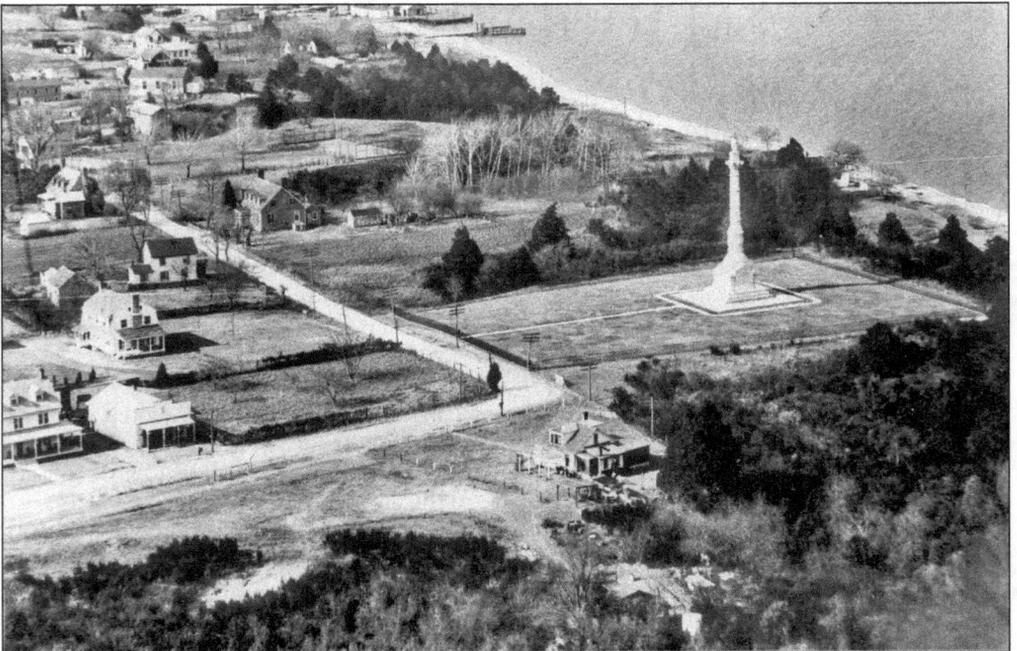

This is Yorktown in the early days before the Monument Lodge was built on the corner of Monument Road and Main Street. The white country store on Monument Road (with a commercial front) was one of the three grocery/general stores in town. The O'Hara, West, and Sheild houses and Grace Church, along with the beginning of the waterfront, can be easily seen in this aerial photograph. (Courtesy of National Park Service, Colonial National Historical Park Yorktown Collection.)

One

THE GLORY OF YORKTOWN

The fame was won because of both of the wars fought in Yorktown, but with the loss of the tobacco trade and the relocation of the capital, Yorktown was left with only its pride of ownership. The roads were dusty and rutted from the wheel of the horse and buggy. The walkways were paths worn by the pedestrian in simpler times. Fences needed tending and houses needed repair. Fields were lost to the weeds, with only wild flowers to color the locale. Yorktown was bountiful in its climate, water, and rolling terrain. Those who stayed when everything was lost found a pleasant exchange of good manners and the gentility that is so prevalent in the South.

The residents who believed in Yorktown created and supported the things that have stayed. Mrs. Emma Chenoweth, Regent of Comte DeGrasse Chapter of the DAR, wrote, "the members [of the chapter] give service freely without thought of self, solely for the glory of Yorktown and reverence for the romance of history of this revered locality."

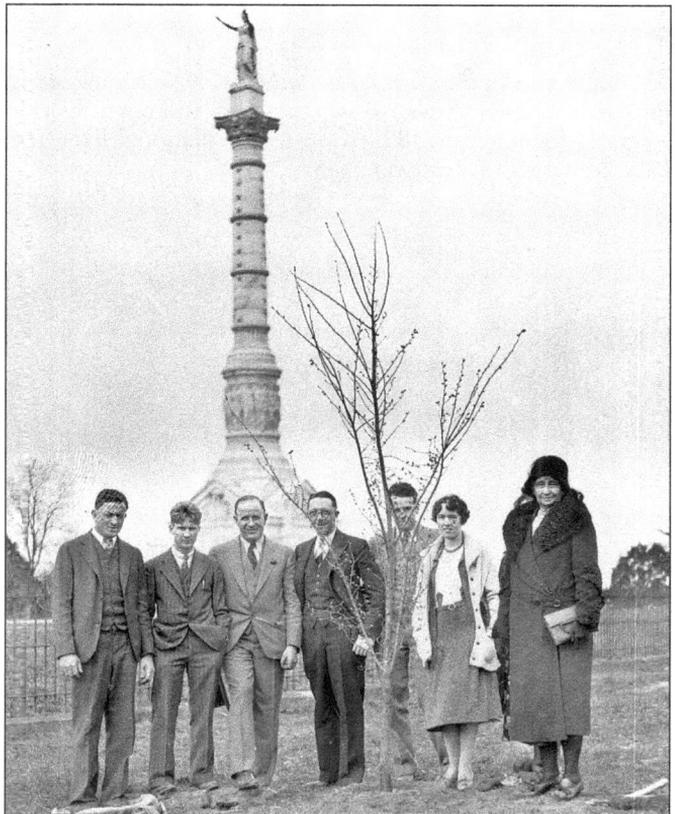

On April 20, 1931, Emma Chenoweth, longtime regent of the DAR, and friends planted a commemorative elm tree. (Courtesy of National Park Service, Colonial National Historical Park Yorktown Collection.)

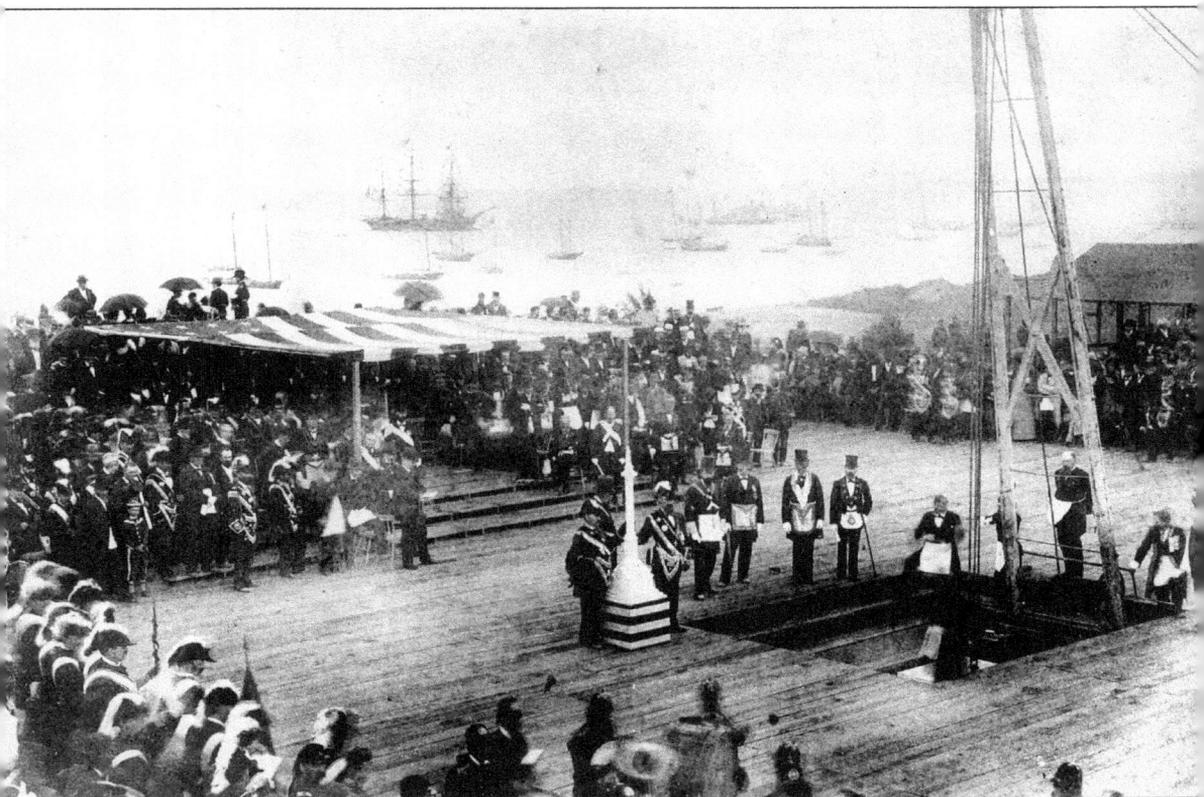

President Chester Arthur was present in Yorktown for the laying of the cornerstone to the Victory Monument in 1881. (Courtesy of National Park Service, Colonial National Historical Park Yorktown Collection.)

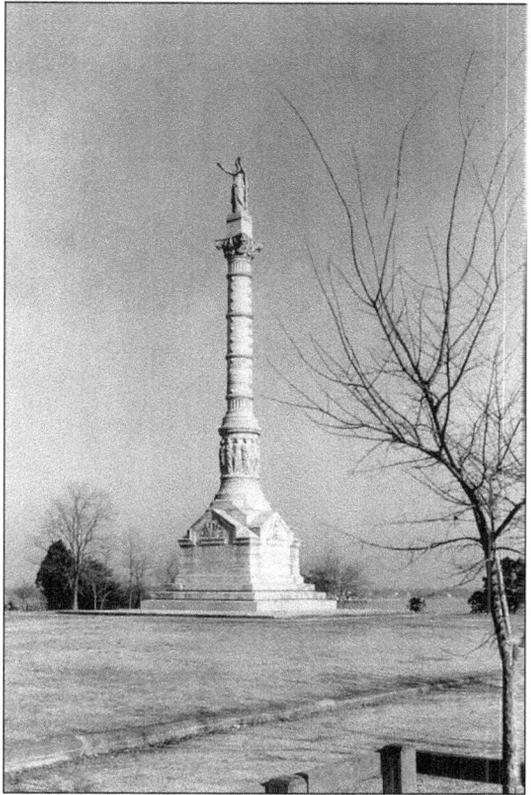

The Lady Liberty, first styled with
dramatic outstretched arms, welcomed the
soldier as well as the visitor to our home.
(Courtesy O'Hara Collection.)

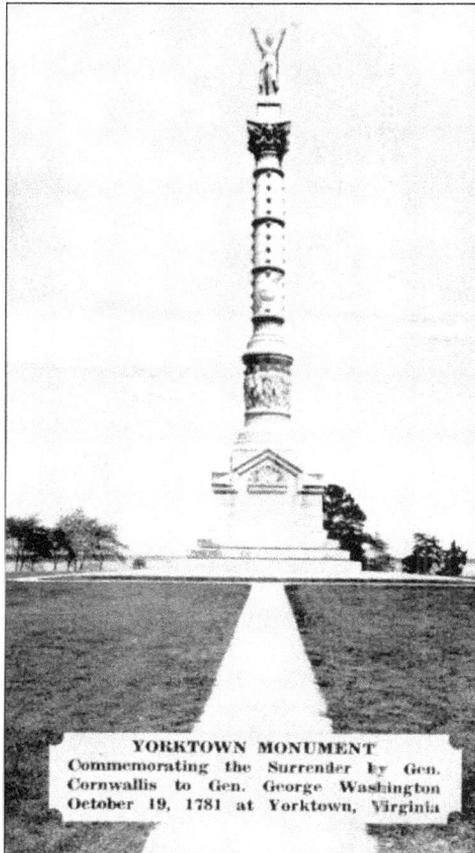

YORKTOWN MONUMENT
Commemorating the Surrender by Gen.
Cornwallis to Gen. George Washington
October 19, 1781 at Yorktown, Virginia

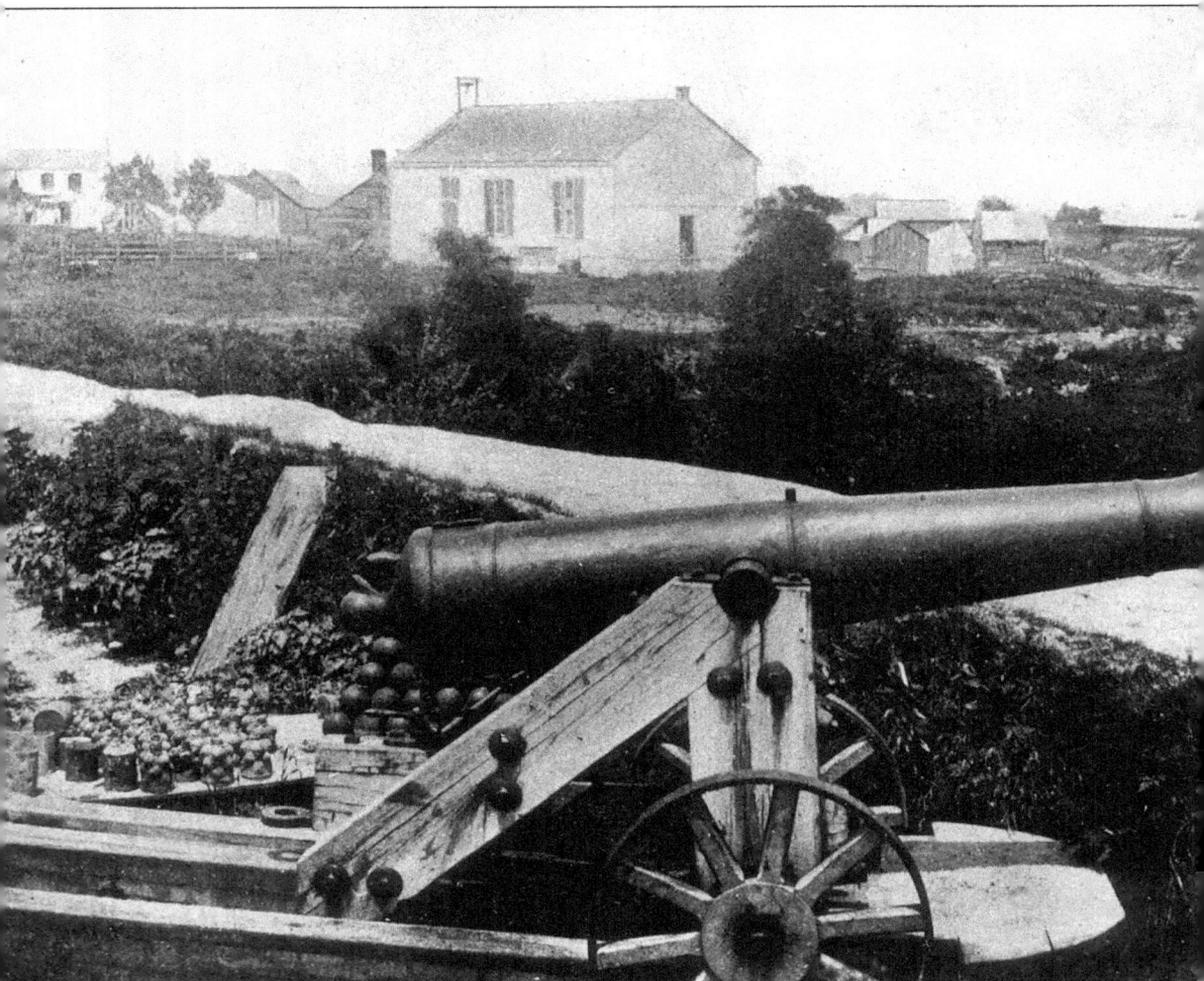

A Civil War cannon in Yorktown is depicted here, with Grace Church in the background. (Courtesy of National Park Service, Colonial National Historical Park Yorktown Collection.)

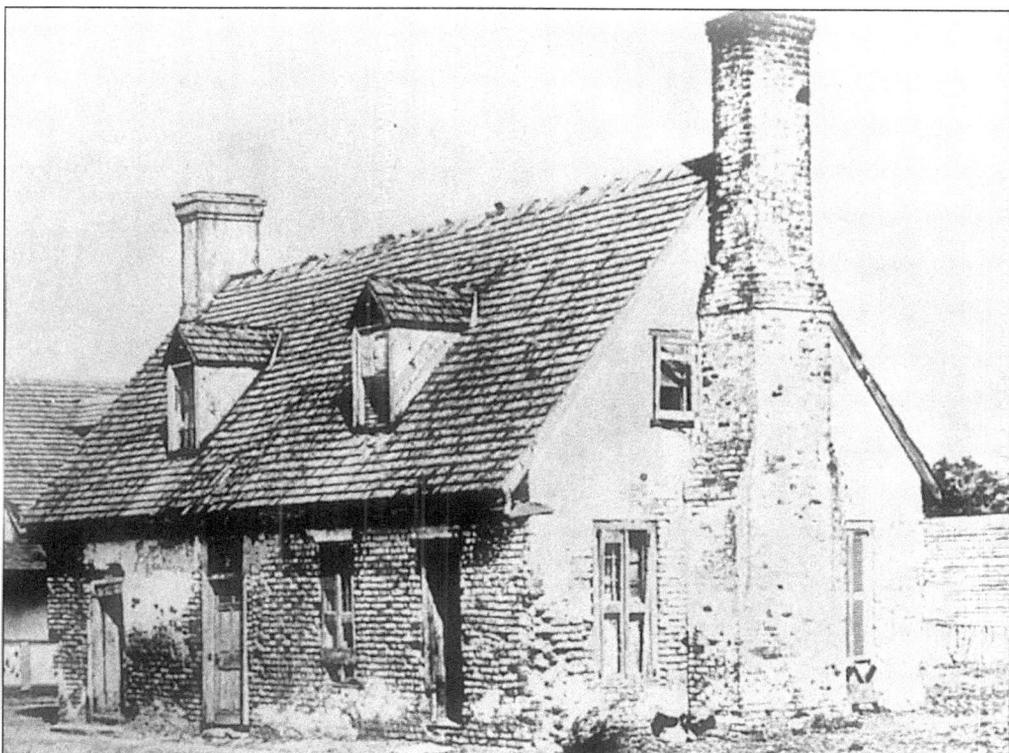

The now demolished Cox house stood next to the Pate house, now called the Cole Digges house, on Main Street (before the Read Street extension to the river). (Courtesy of National Park Service, Colonial National Historical Park Yorktown Collection.)

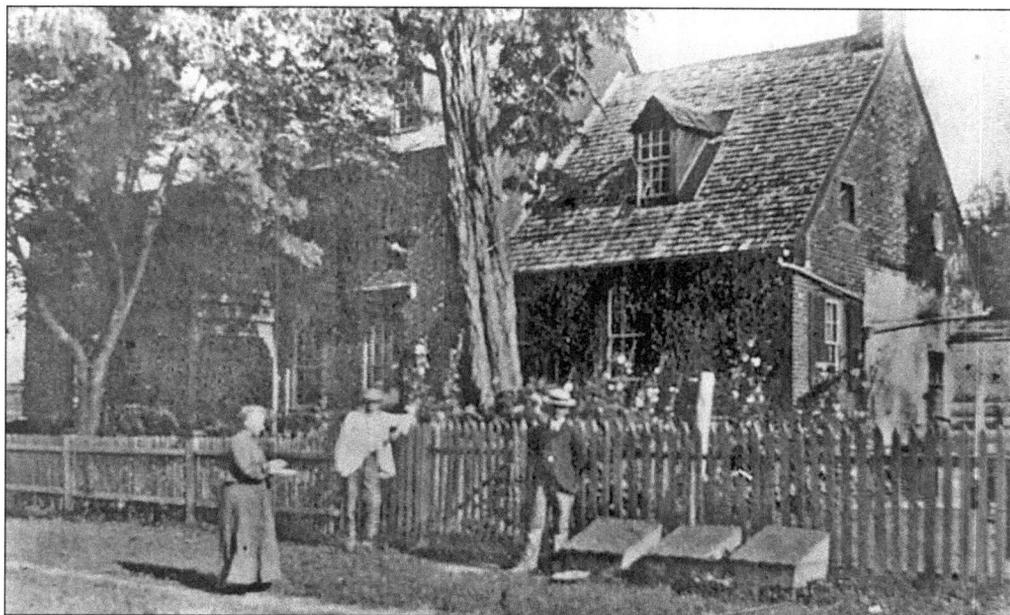

Ringfield Plantation house, now demolished, stood outside of town. (Courtesy of National Park Service, Colonial National Historical Park Yorktown Collection.)

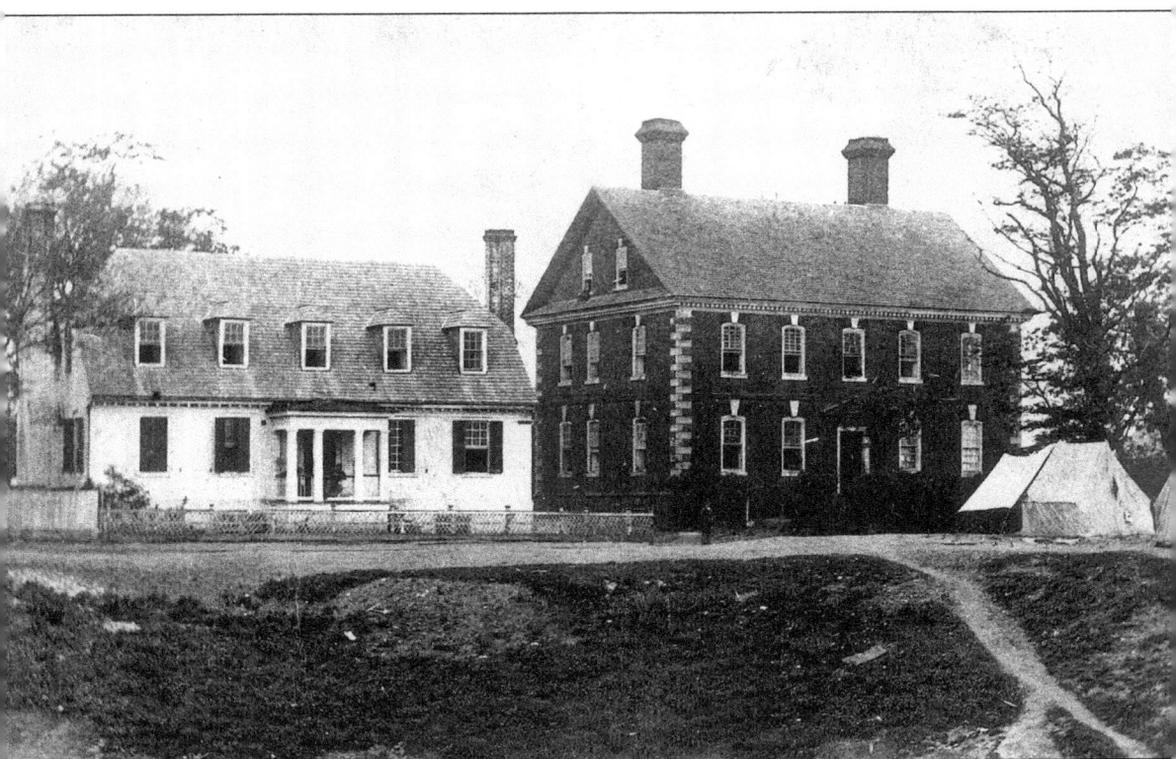

This image shows the Thomas Sessions house/Nelson house during the Civil War. (Courtesy of National Park Service, Colonial National Historical Park Yorktown Collection.)

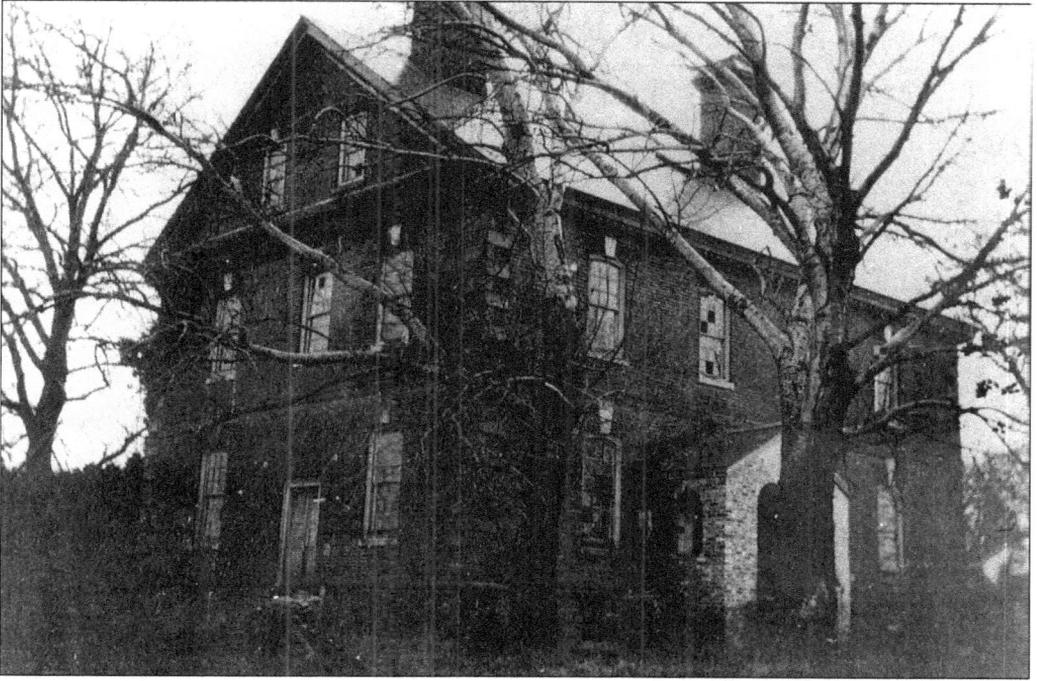

Shown here is the Nelson house early in the century before restoration. (Courtesy of National Park Service, Colonial National Historical Park Yorktown Collection.)

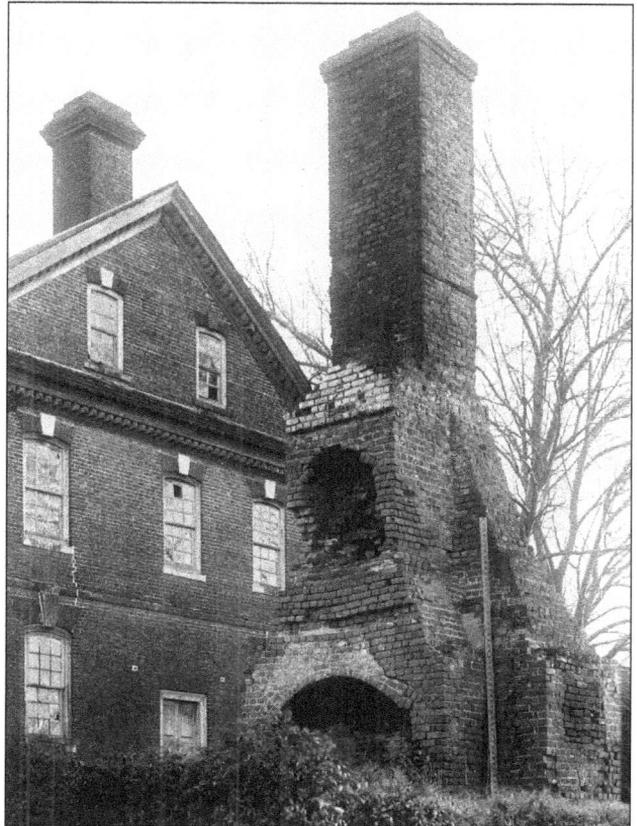

Ruins of a chimney—perhaps of the kitchen building—stand next to the Nelson house. (Courtesy of National Park Service, Colonial National Historical Park Yorktown Collection.)

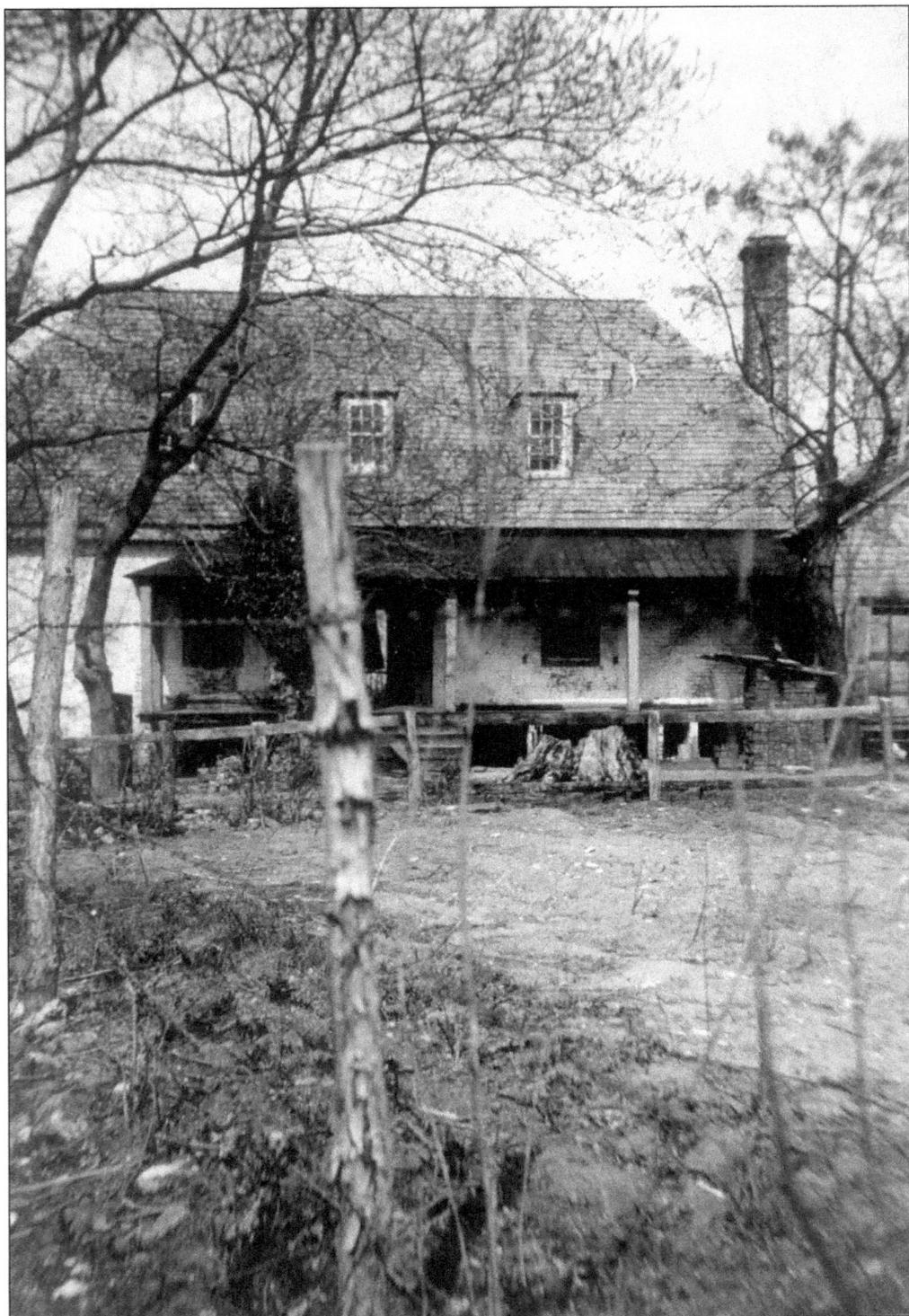

This image illuminates the backside of the Sessions house post–Civil War. (Sheild family archives.)

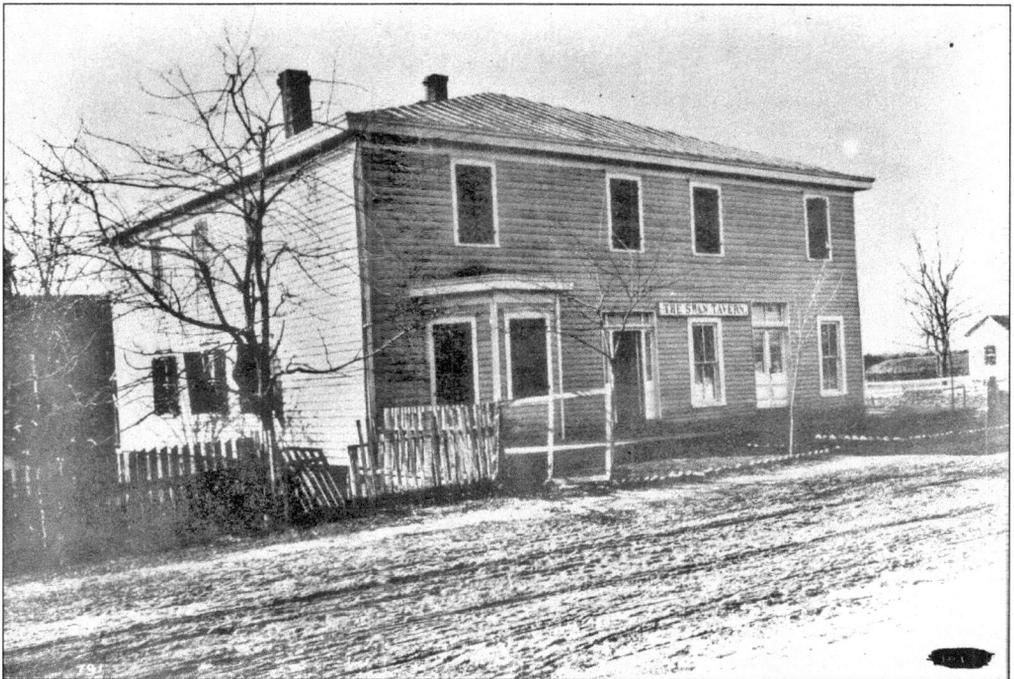

The early Swan Tavern replaced the original destroyed in 1863 during the Civil War. (Courtesy of National Park Service, Colonial National Historical Park Yorktown Collection.)

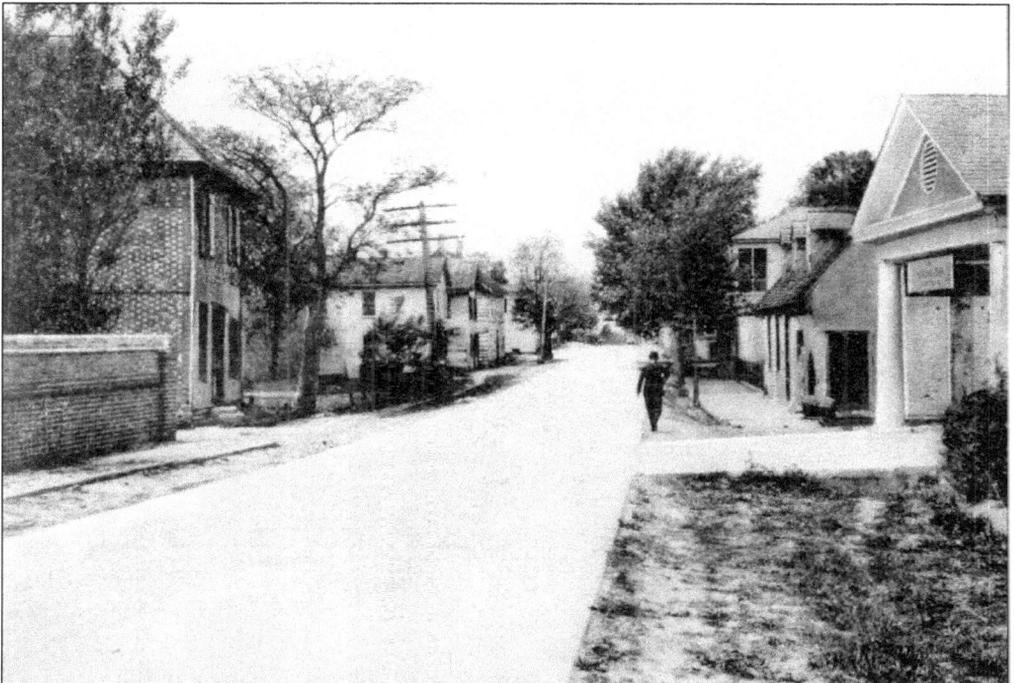

This image of Main Street, which was taken after 1912, shows the Cox and Pate house and De Neufville's Store beyond. (Courtesy of National Park Service, Colonial National Historical Park Yorktown Collection.)

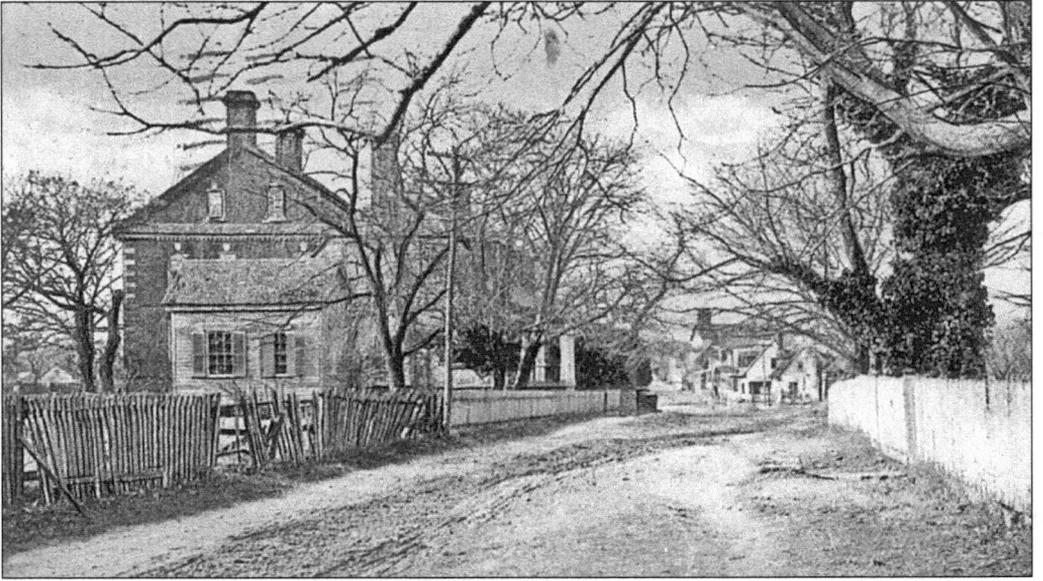

This postcard illustrates Main Street looking west, with the Sessions House shuttered windows behind the tattered picket fence and the Nelson House behind. (Courtesy of John A. Lawson III, Williamsburg, Virginia.)

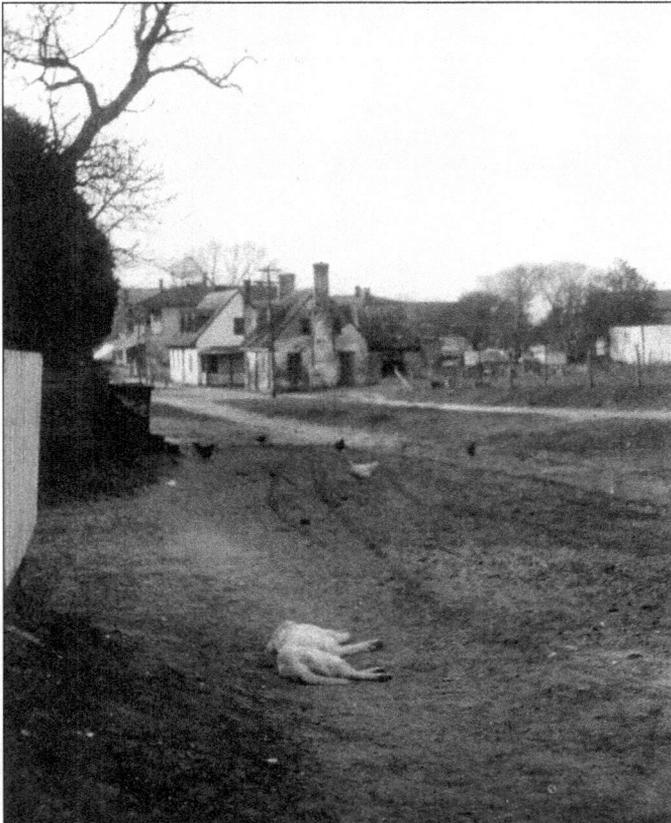

Main Street in the early 1900s is the resting spot for a sleeping dog. (Courtesy of Sheild Family Archives.)

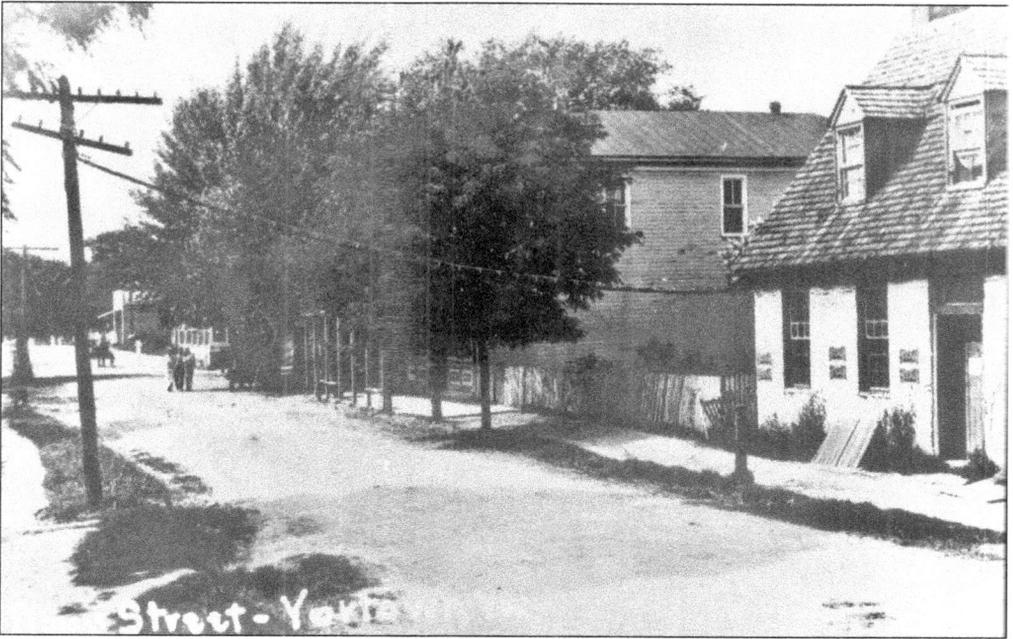

In this photo a telegraph utility pole is seen on Main Street looking west, *c.* 1920. (Courtesy of National Park Service, Colonial National Historical Park Yorktown Collection.)

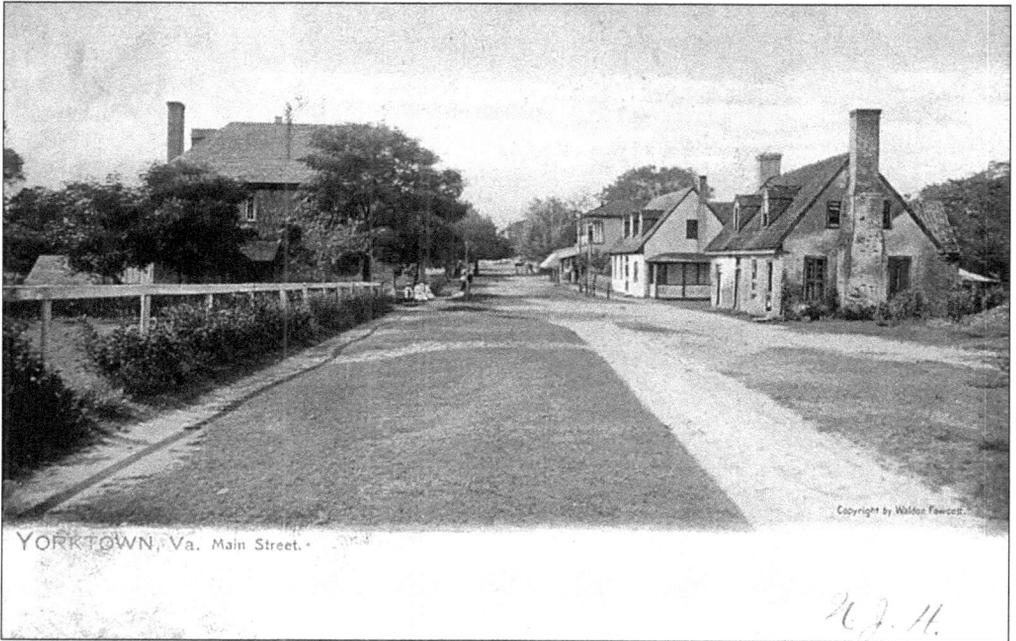

A postcard portrays Main Street looking west. The Cox and Pate houses are on the right and the Customs House adorns the left. (Courtesy of Sheild family archives.)

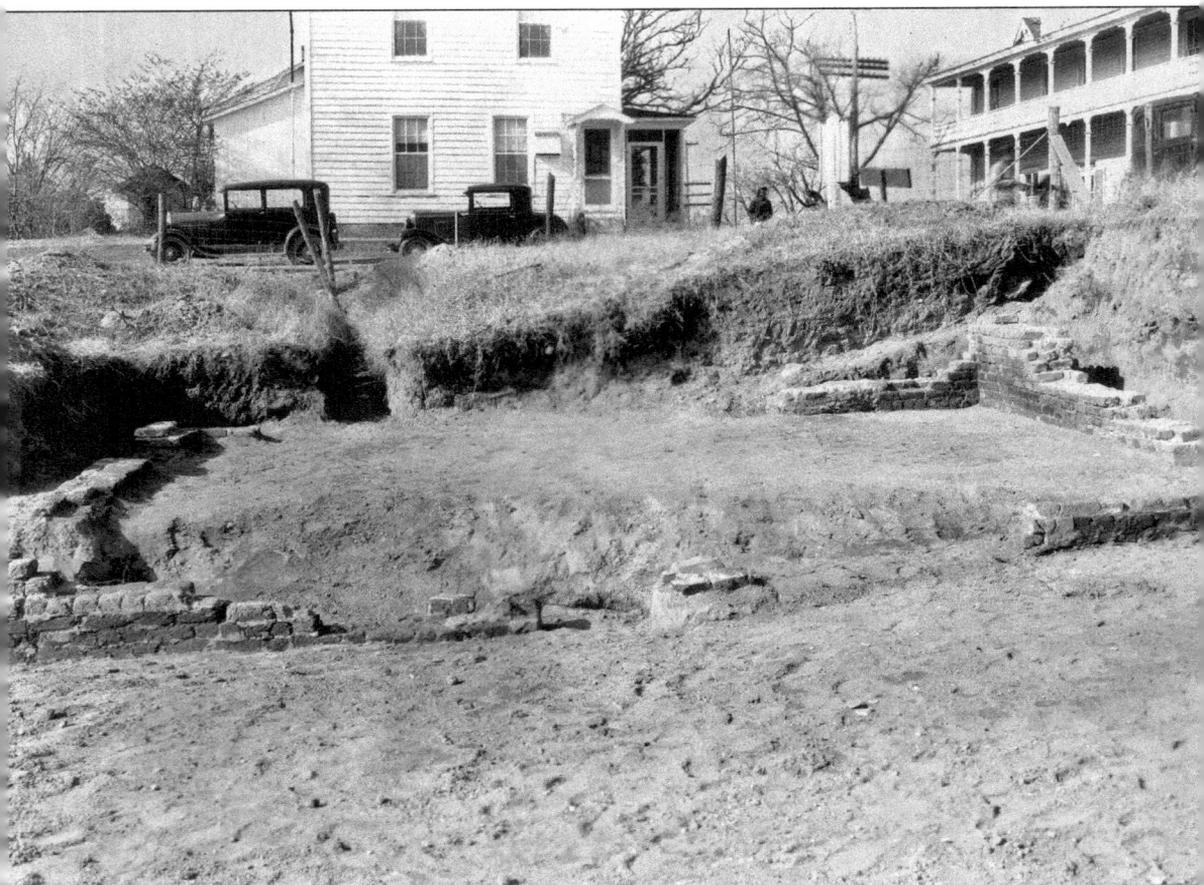

The archaeological study of the Swan Tavern at Main and Ballard Street is pictured c. 1930; the Yorktown Inn is in the background. (Courtesy of National Park Service, Colonial National Historical Park Yorktown Collection.)

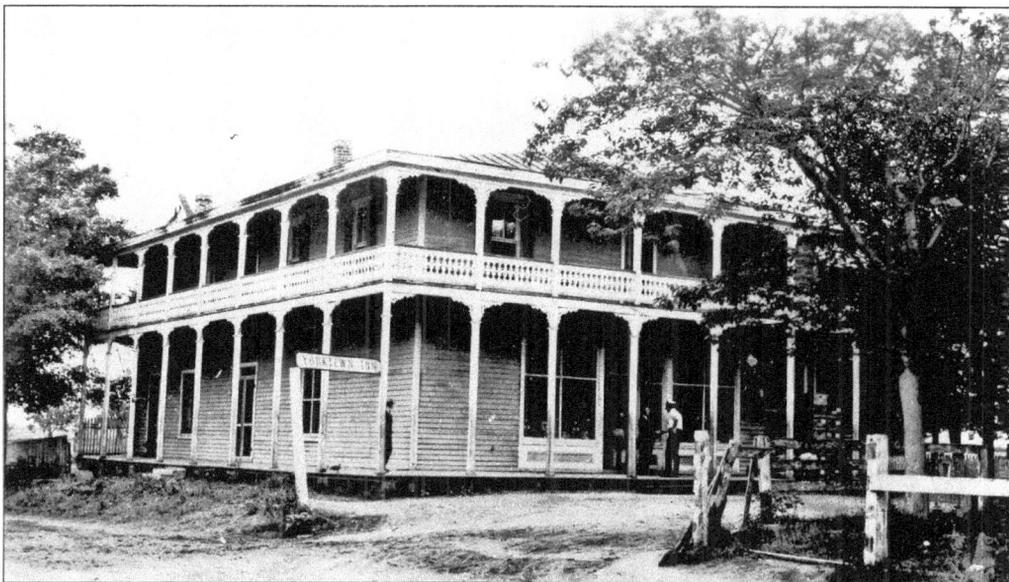

Yorktown Inn stood at the corner of Main and Ballard. (Courtesy of National Park Service, Colonial National Historical Park Yorktown Collection.)

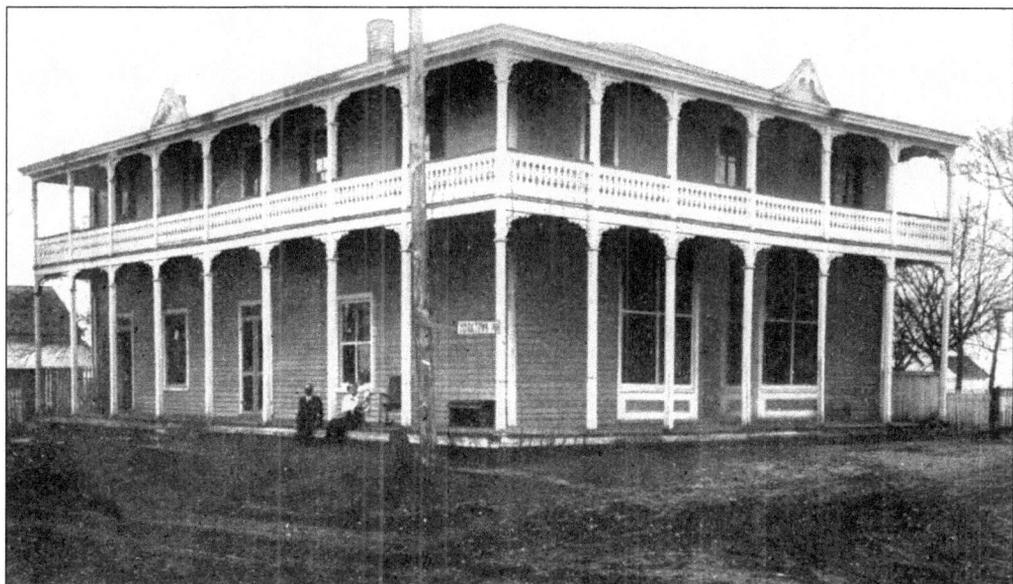

In this earlier photograph, the Yorktown Inn was owned by the Curtis Family and operated by Walter Cooke. (Courtesy of Cooke-Krams Collection.)

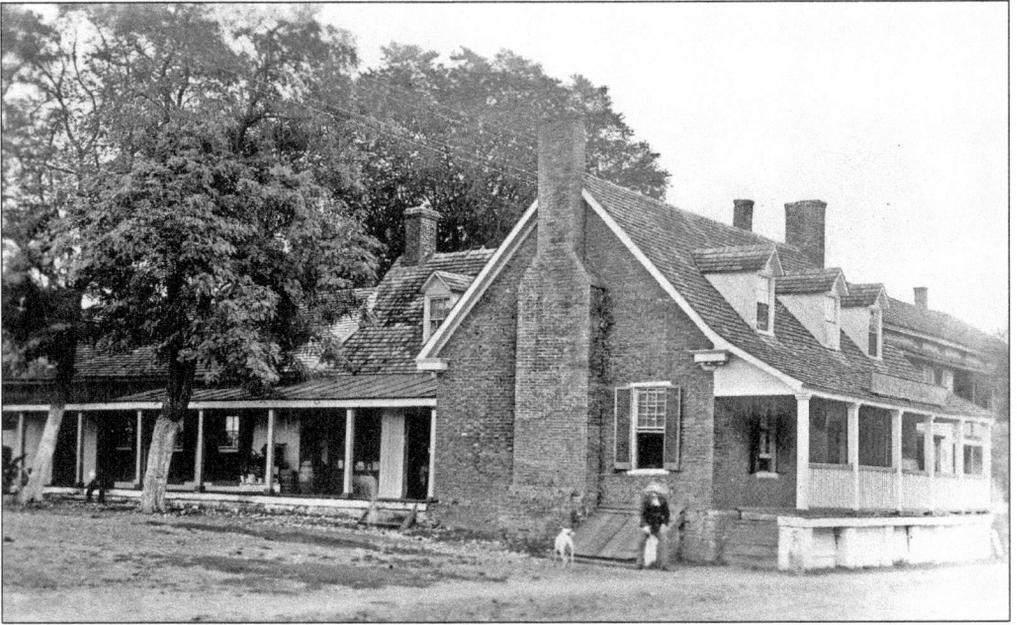

This is how the Lightfoot/Somerwell/Yorktown Hotel appeared in the 1920s—before its restoration. (Courtesy of National Park Service, Colonial National Historical Park Yorktown Collection.)

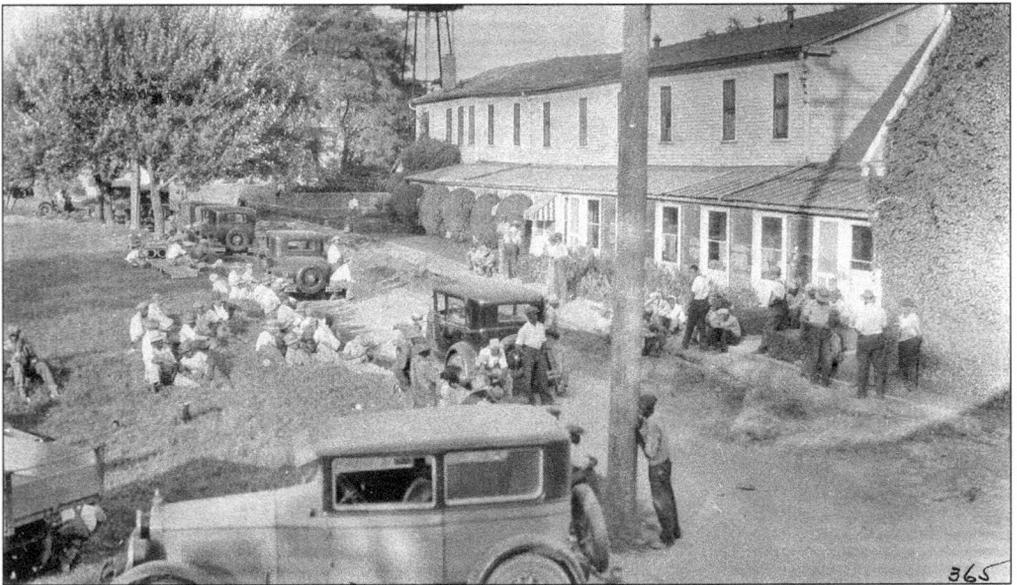

Working men are pictured beside the Yorktown Hotel, c. 1920, with the Church Street water tower in the background. (Courtesy of National Park Service, Colonial National Historical Park Yorktown Collection.)

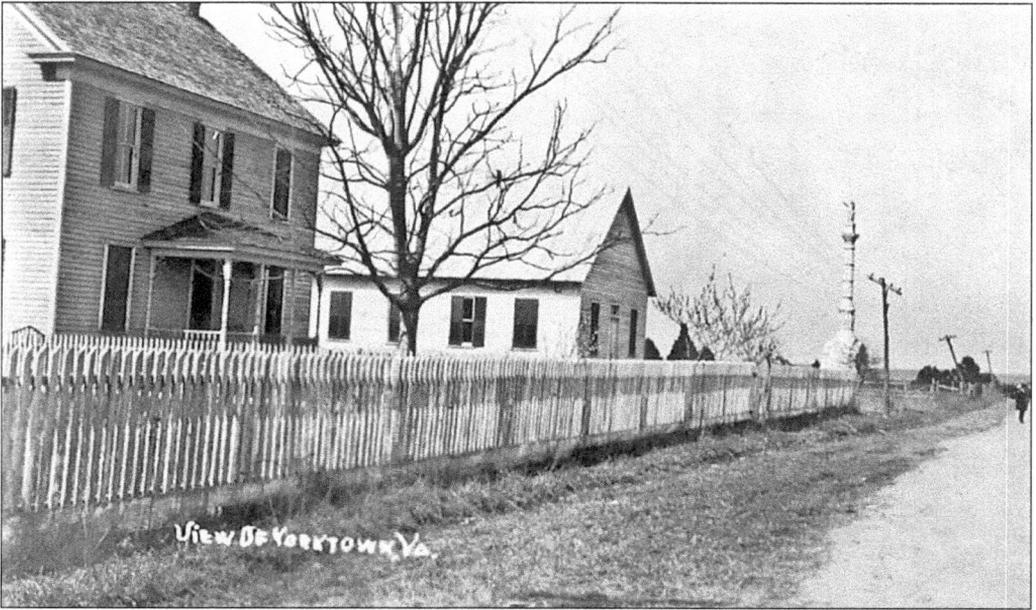

In this postcard the Victory Monument is seen looking up from Monument Road, c. 1900. (Collection of John Lawson III, Williamsburg, Virginia.)

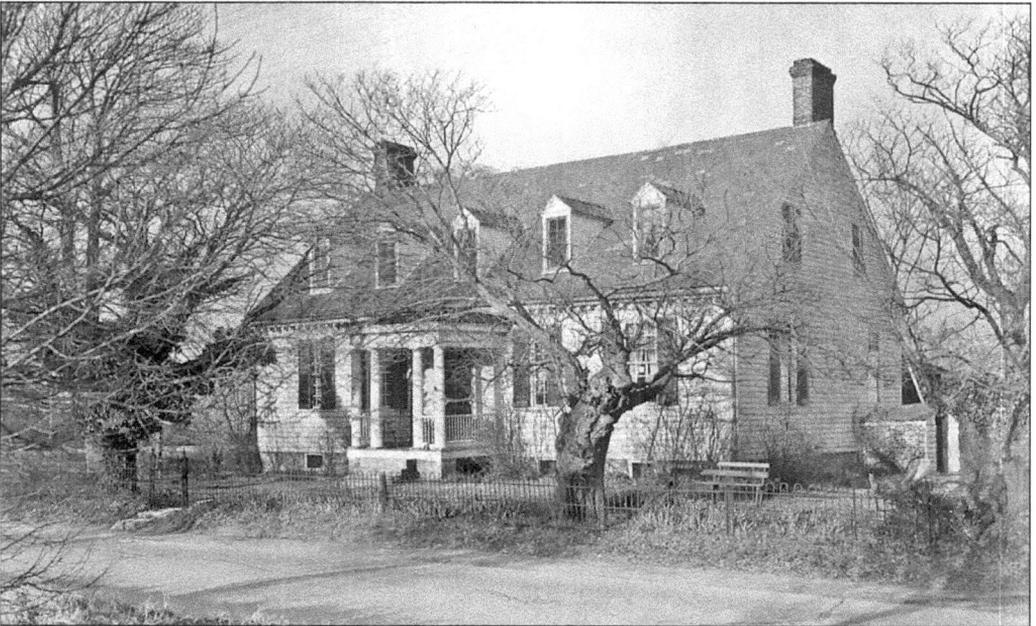

The West House, known now as the Dudley Diggs House, on Main Street is shown here on December 15, 1936, before restoration. (Courtesy of National Park Service, Colonial National Historical Park Yorktown Collection.)

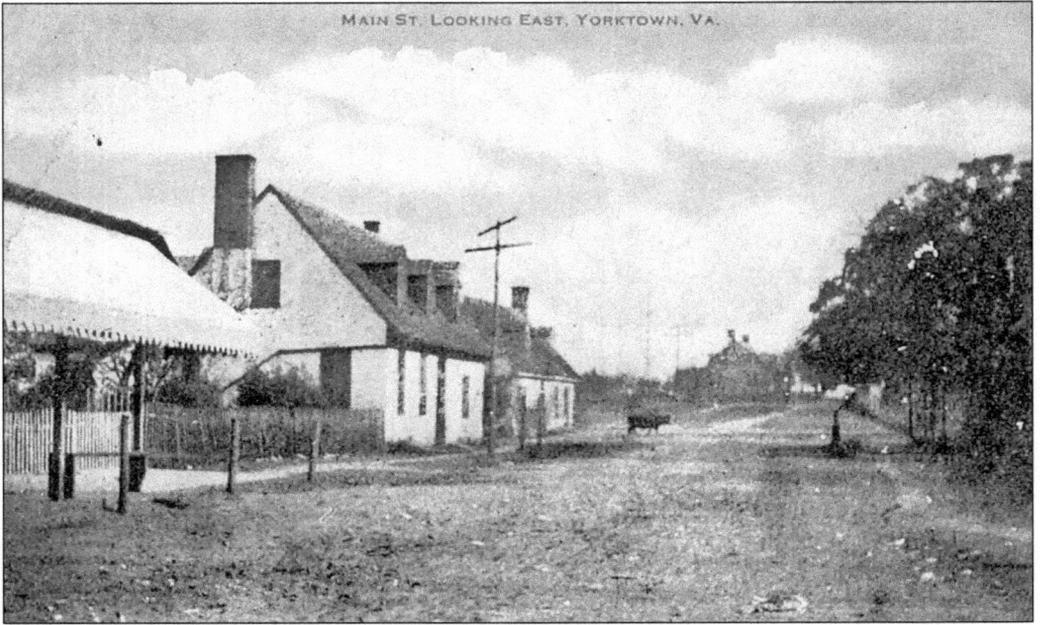

MAIN ST. LOOKING EAST, YORKTOWN, VA.

A postcard paints a picture of Main Street that includes the awning of De Neufville's Store. (Courtesy of John A. Lawson III, Williamsburg, Virginia.)

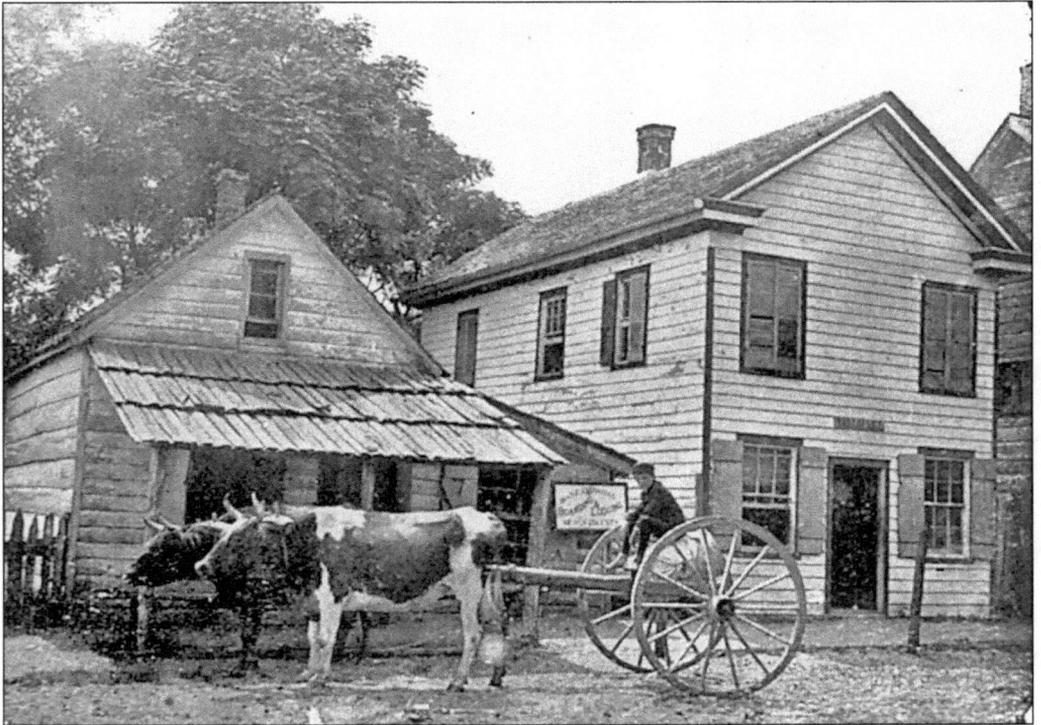

Seen here on Main Street is an old ox cart of the early days. (Courtesy of John A. Lawson III, Williamsburg, Virginia.)

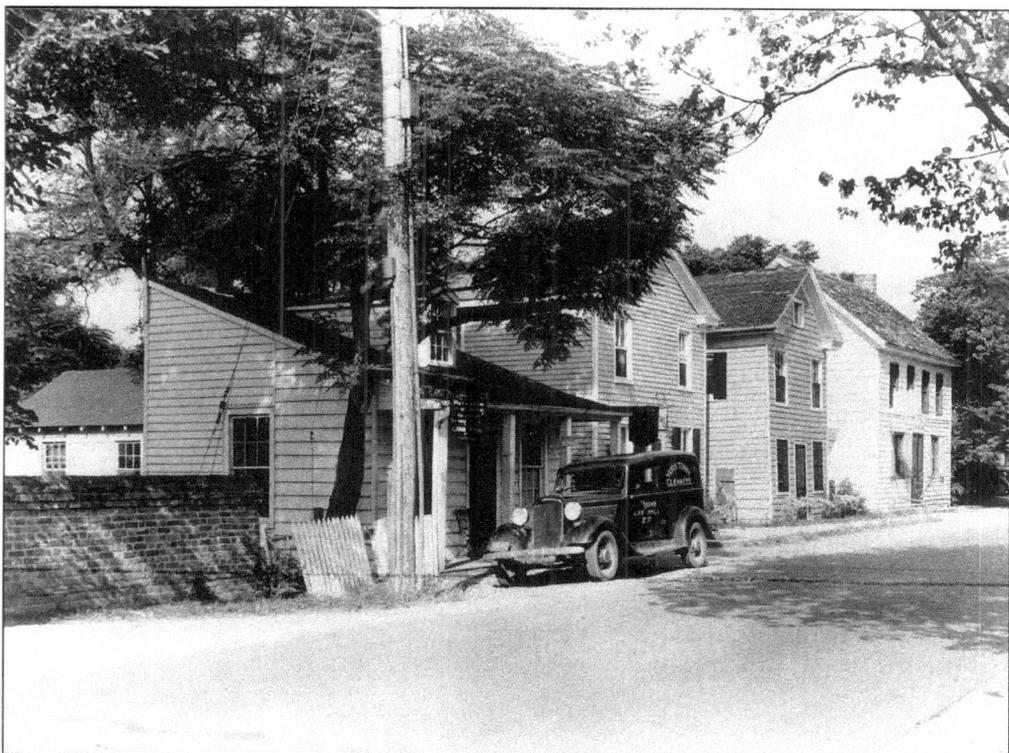

The Burcher Cottage and shops grace Main Street in the late 1920s. (Courtesy of National Park Service, Colonial National Historical Park Yorktown Collection.)

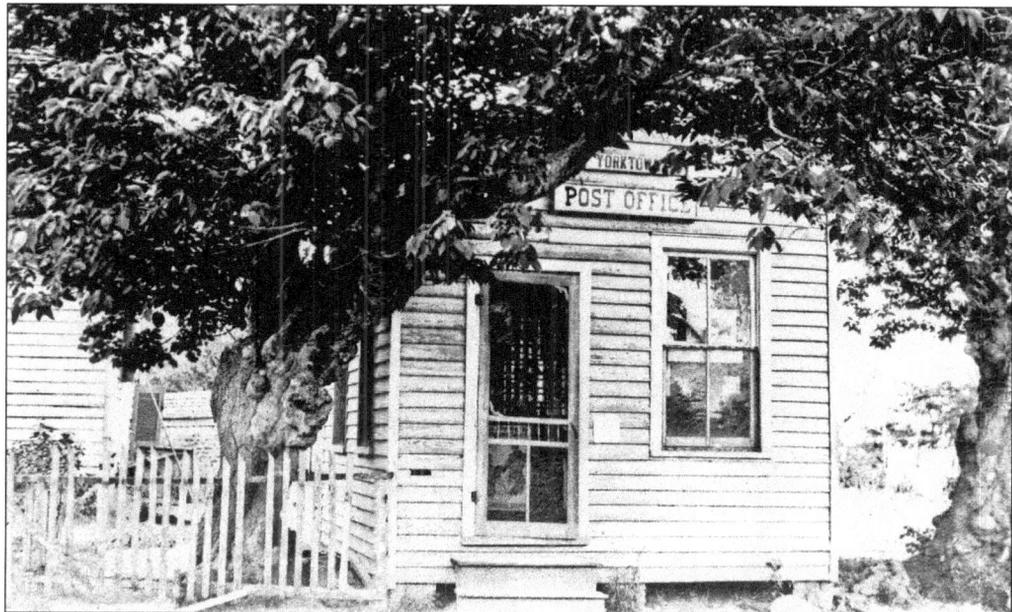

Here is the doorway to the postmaster's office in the Slaight house; this was taken before Eugene Slaight built his house on Ballard Street, on the south side of Church and Main Streets. (Courtesy of National Park Service, Colonial National Historical Park Yorktown Collection.)

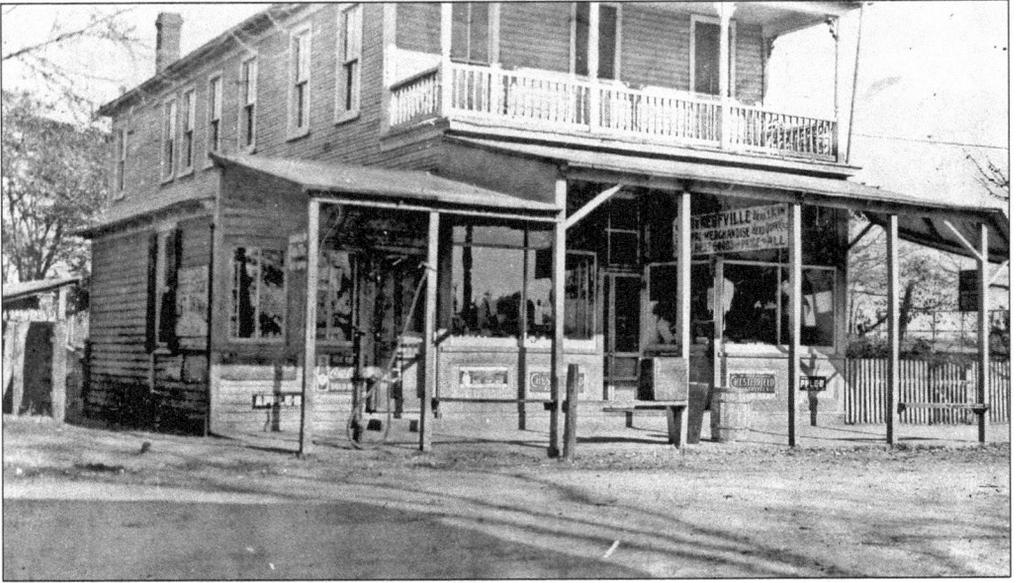

De Neufville's General Store, between the Pate and Somerwell houses in 1917, provided many a happy memory to the children with penny candy. (Courtesy of National Park Service, Colonial National Historical Park Yorktown Collection.)

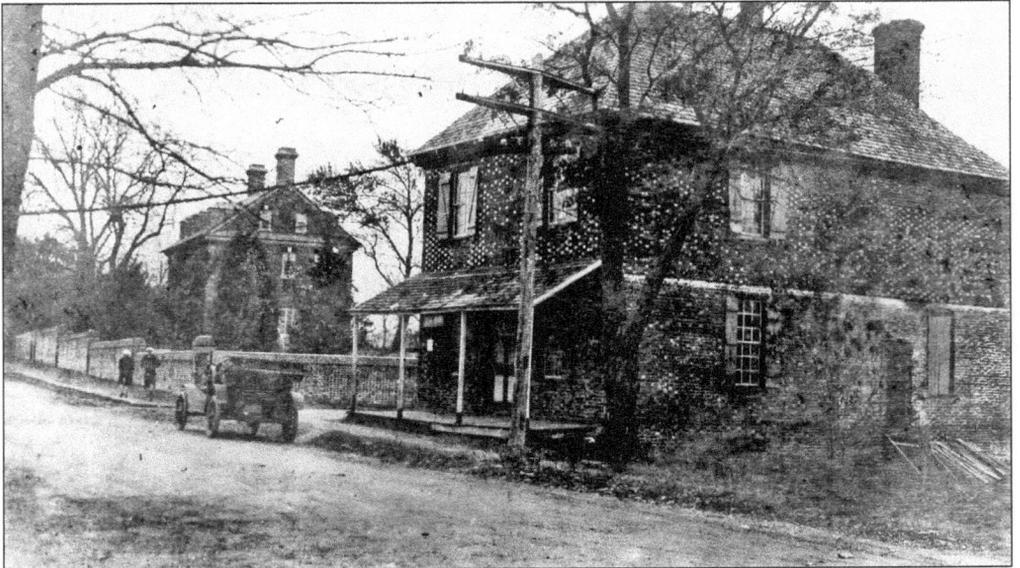

The Customs House, with the newly installed wall around the Nelson House in the background, is pictured c. 1917. (Courtesy of National Park Service, Colonial National Historical Park Yorktown Collection.)

Grace Church's interior is shown here, c. 1890, with Rev. William Byrd Lee. (Courtesy of the Sheild family archives.)

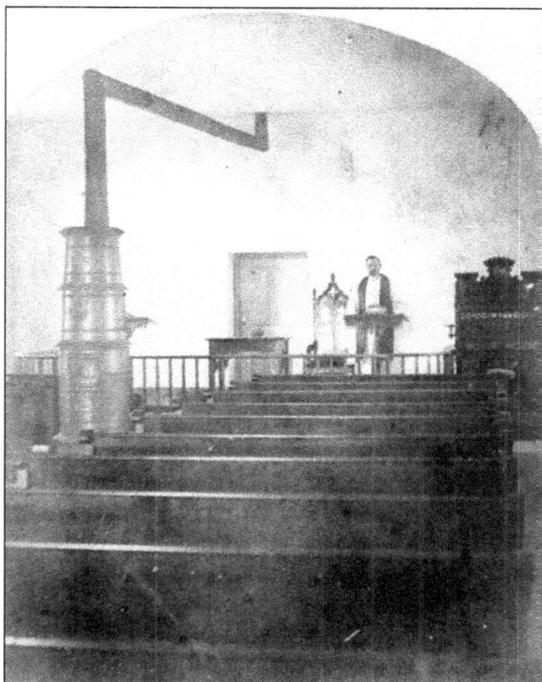

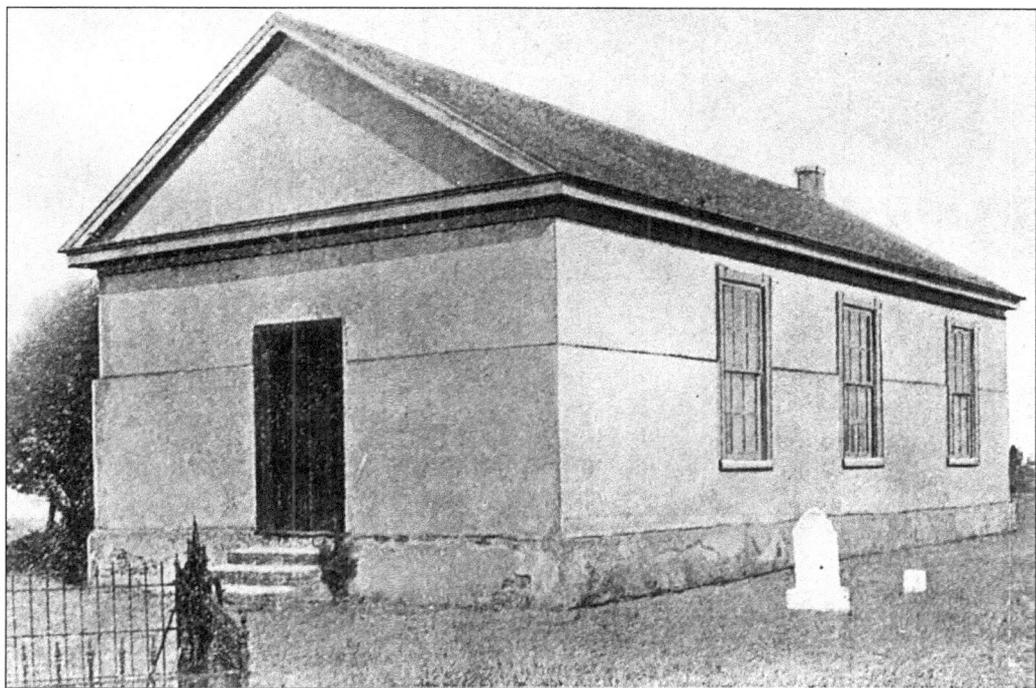

Despite the windows and pews being destroyed by fire in 1814 along with the ravages of the Revolutionary and Civil Wars, Grace Church has continued its worship services in this building—with only a few interruptions—since 1713. The church is pictured here c. 1885. (Sheild Family archives.).

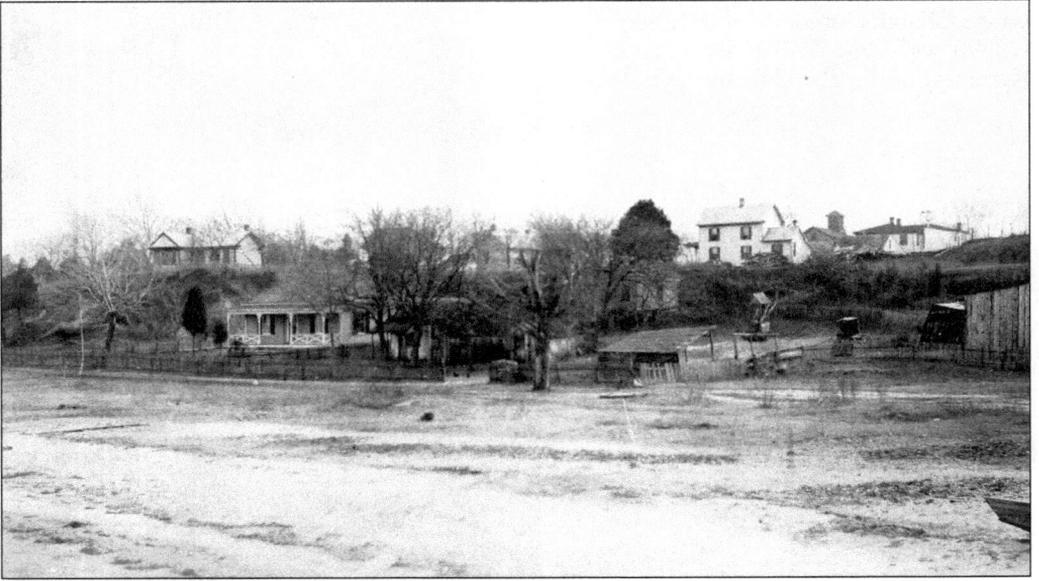

This is a scene from the beach, with the fourth courthouse on the hill, in the 1880s. (Courtesy of Cooke-Krams Collection.)

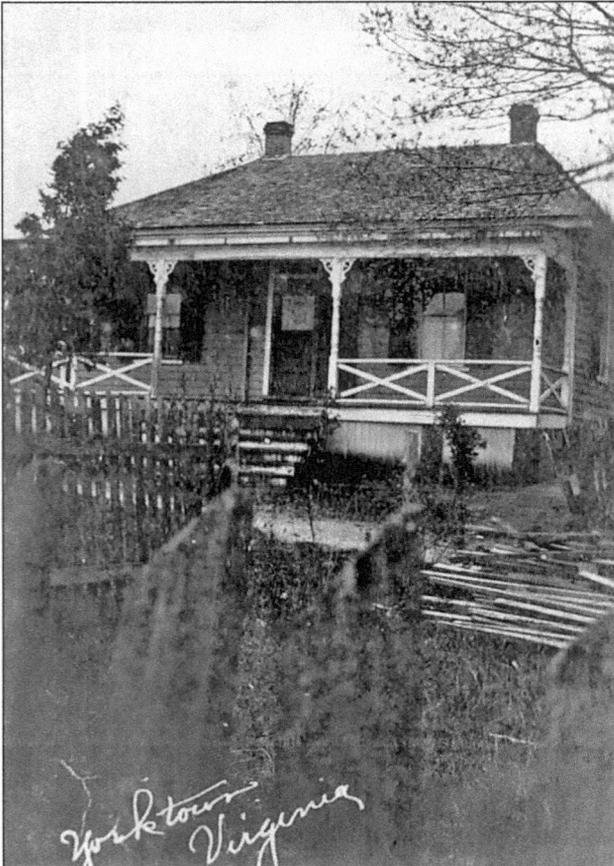

A serene beach setting before Ballard Street was built just before World War I; this postcard shows a close-up of the Henry Charles cottage. (Collection of John A. Lawson III, Williamsburg, Virginia.)

John Gary (left) and Hunter Fletcher are pictured on the Yorktown Beach. (Courtesy of Fletcher Collection.)

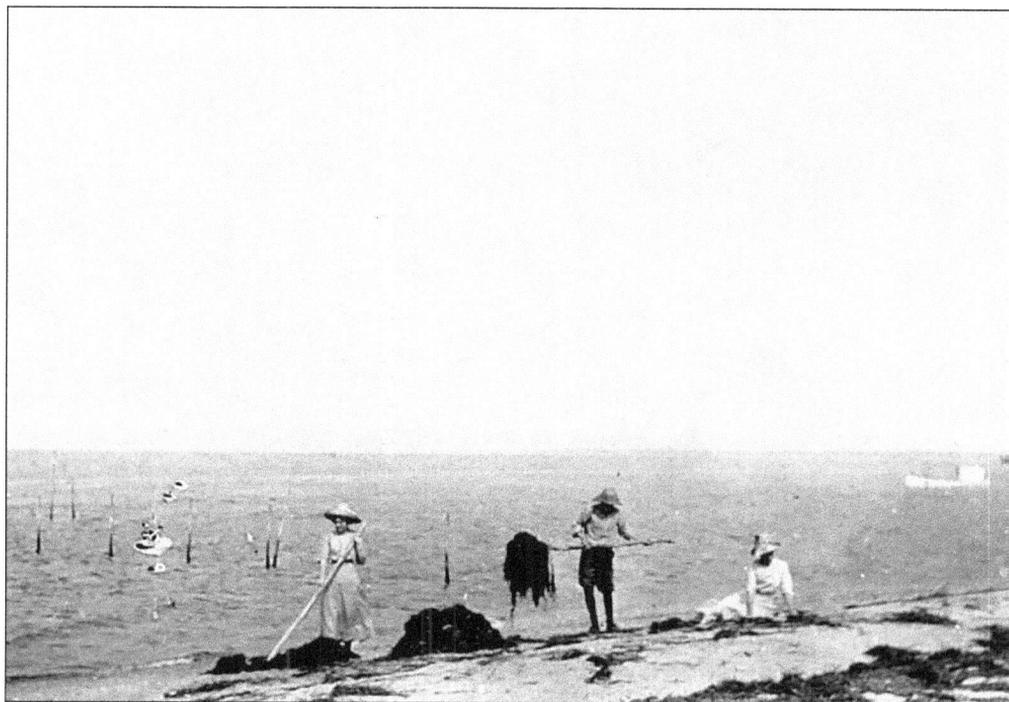

Children rake in the seaweed on the shoreline. (Courtesy of Cooke-Krams Collection.)

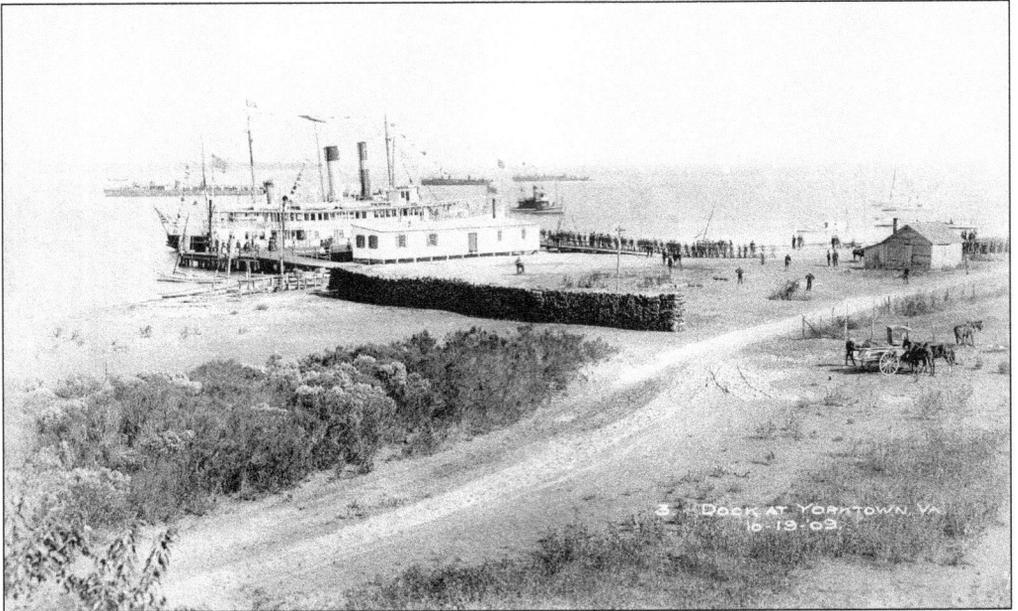

As early as 1909 the Yorktown area was serviced by steamer ships that came in from the Northeast. People would gather daily to watch them bring people and goods from many Northern destinations. There are many stories of people taking the steamer on their wedding honeymoon to Washington, Baltimore, and New York City. (Courtesy of O'Hara Collection.)

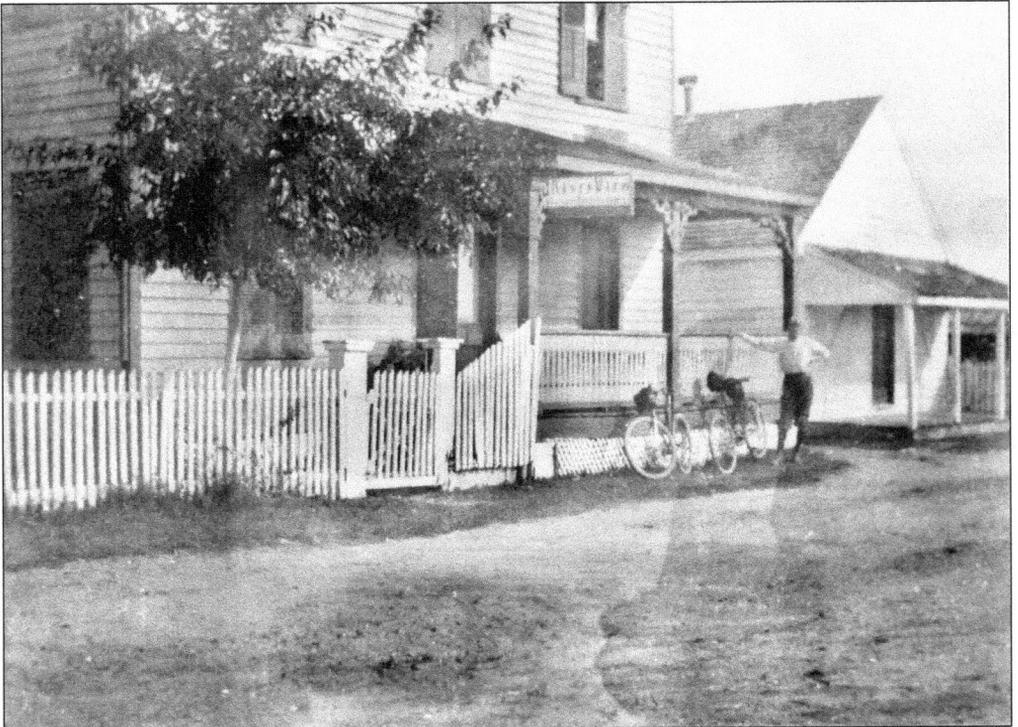

A man poses with two bikes in front of the RiverView. (Courtesy of National Park Service, Colonial National Historical Park Yorktown Collection.)

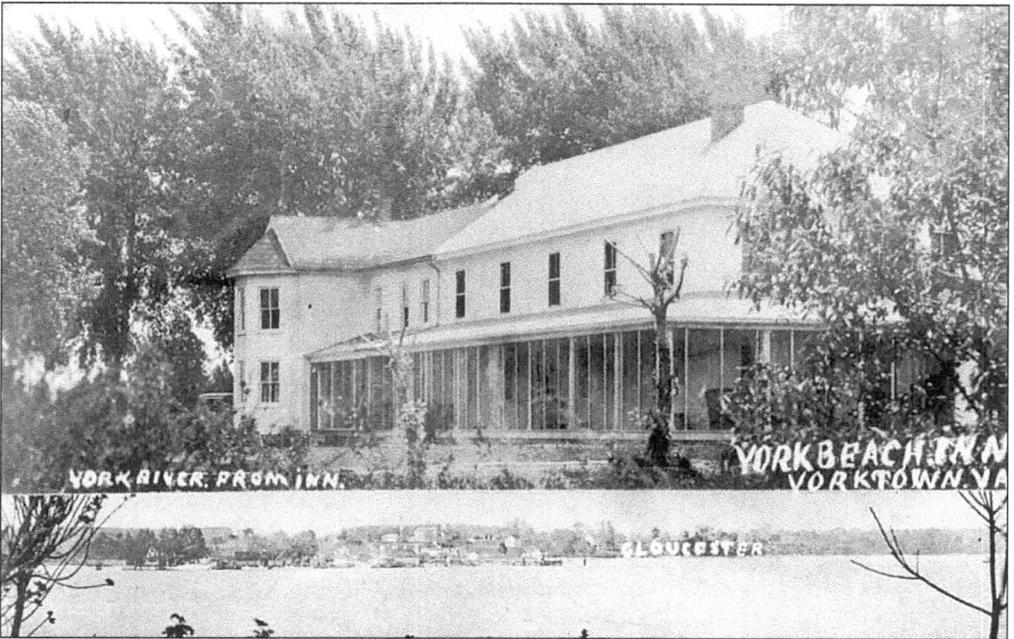

This undated postcard is of the York Beach Inn belonging to T.W. Crockett; it stood on the hill where the Duke of York is today. (Collection of John A. Lawson III, Williamsburg, Virginia).

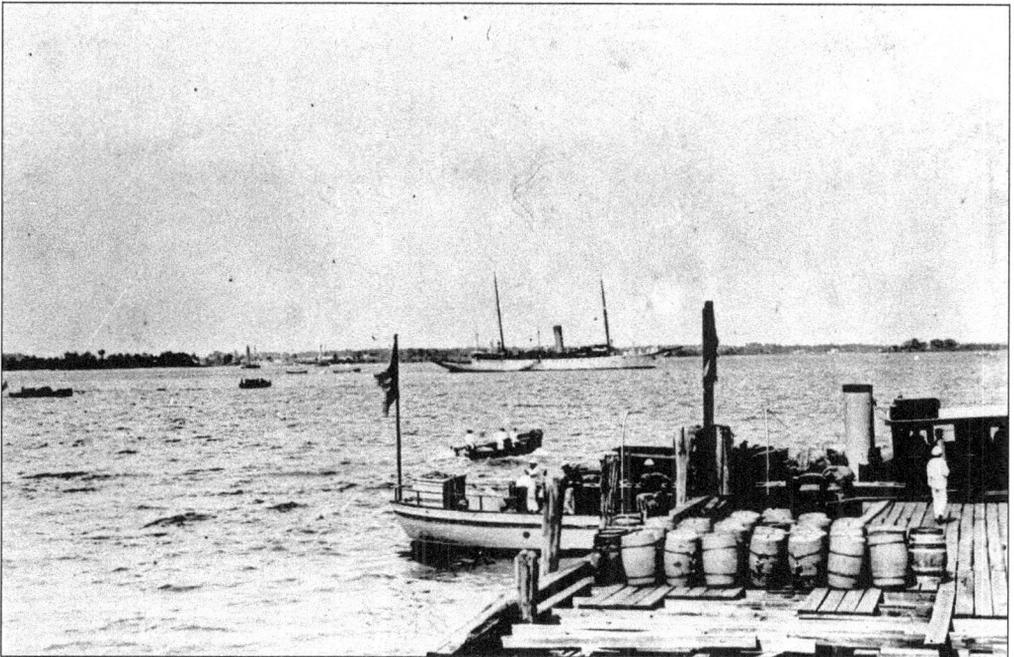

A 1917 photograph displays the Yorktown Wharf and the boats that frequented it. (Courtesy of National Park Service, Colonial National Historical Park Yorktown Collection.)

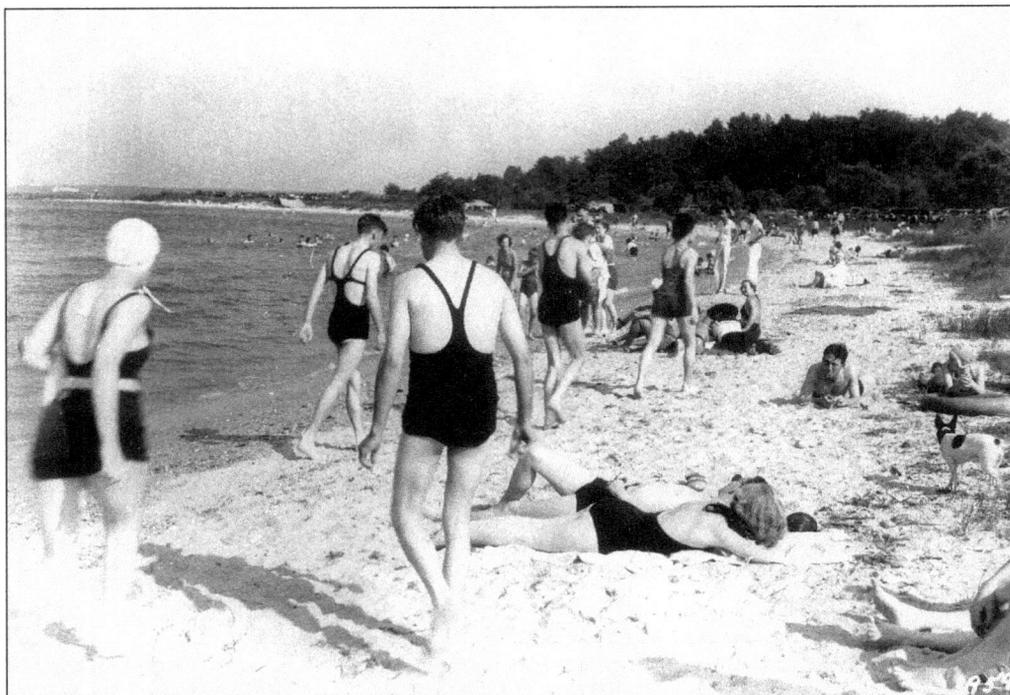

Swimmers enjoy a day at the beach in 1936. (Courtesy of National Park Service, Colonial National Historical Park Yorktown Collection.)

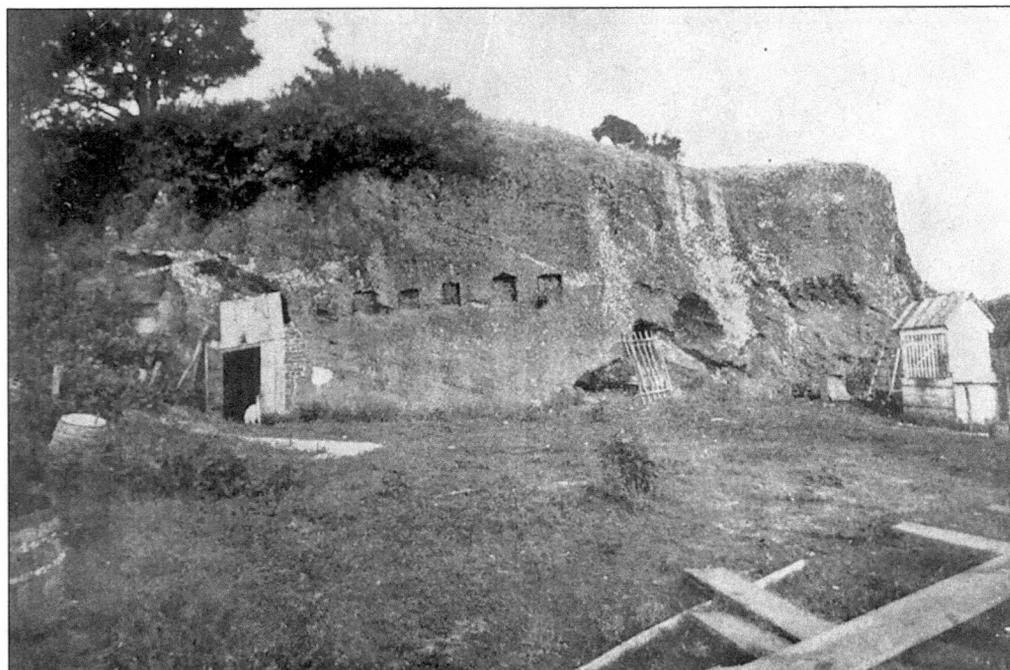

Cornwallis Cave is pictured on the waterfront, unlike today with a woodless cliff above. (Courtesy of National Park Service, Colonial National Historical Park Yorktown Collection.)

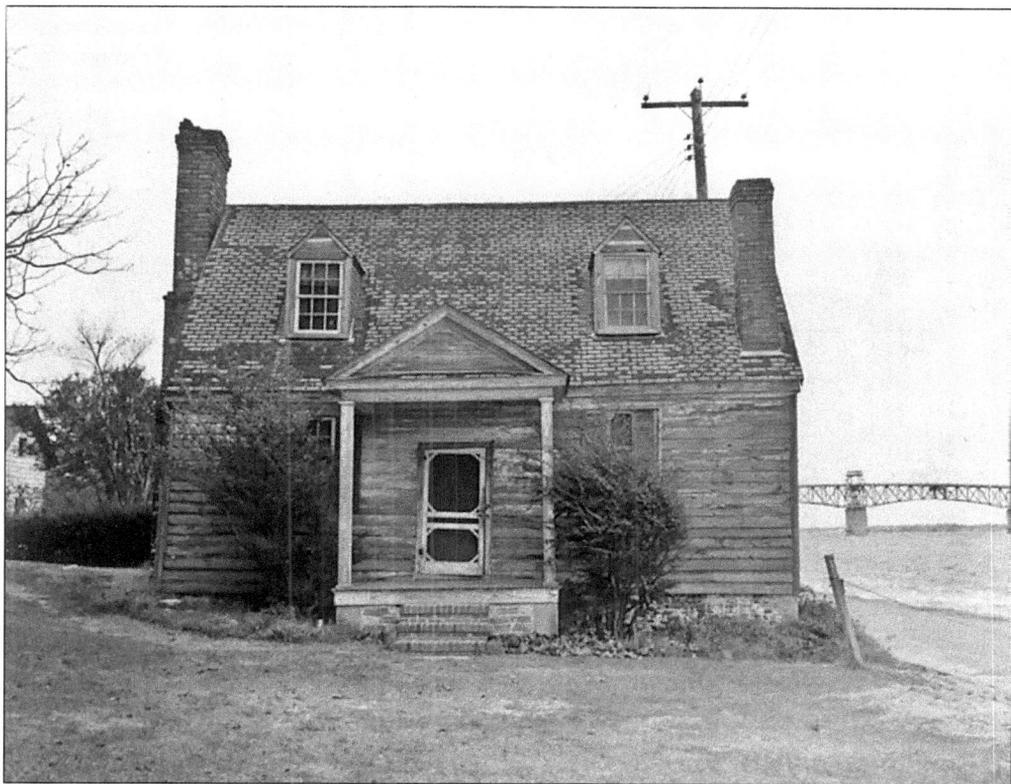

The Archer Cottage on Water Street closely resembles many types of structures occupying the waterfront in the 18th century. It was acquired and restored by the Park Service after this photograph in 1957. (Courtesy of National Park Service, Colonial National Historical Park Yorktown Collection.)

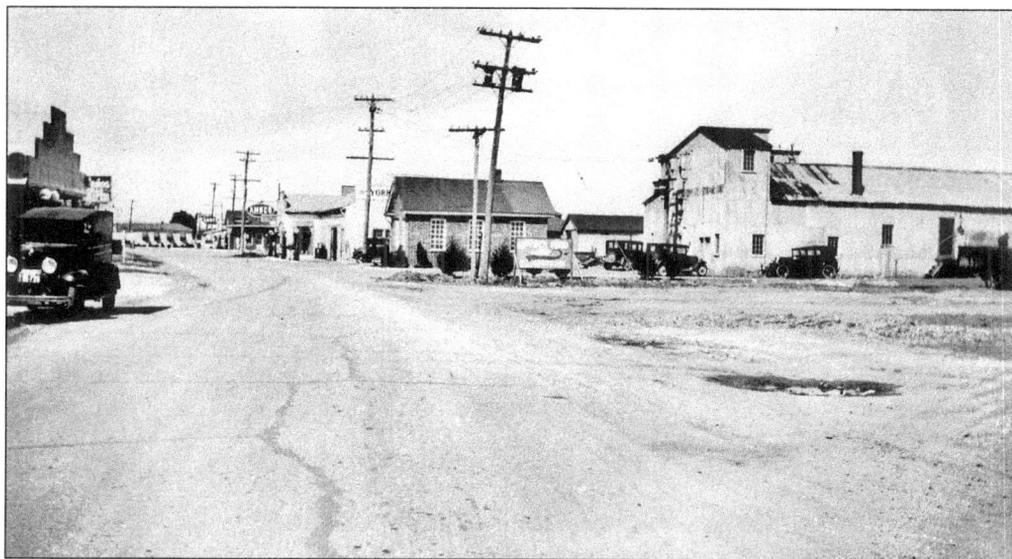

Water Street is seen during the 1920s. (Courtesy of National Park Service, Colonial National Historical Park Yorktown Collection.)

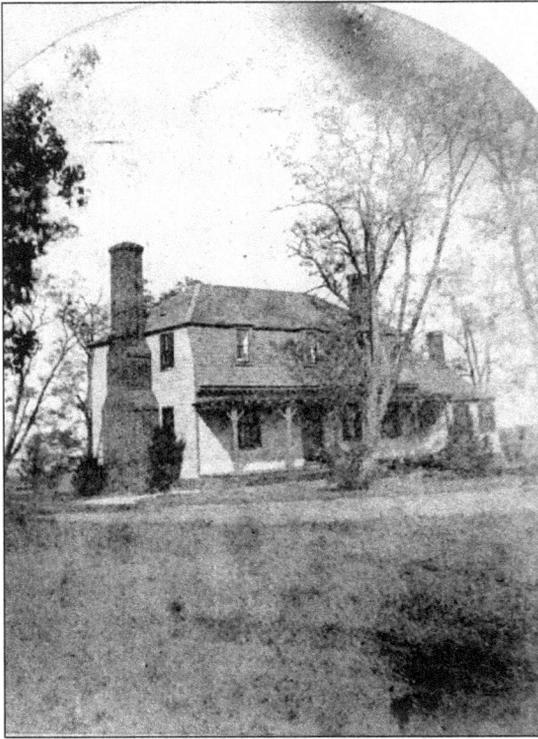

This image captures the Moore house in the 1920s, before its final restoration. (Courtesy of National Park Service, Colonial National Historical Park Yorktown Collection.)

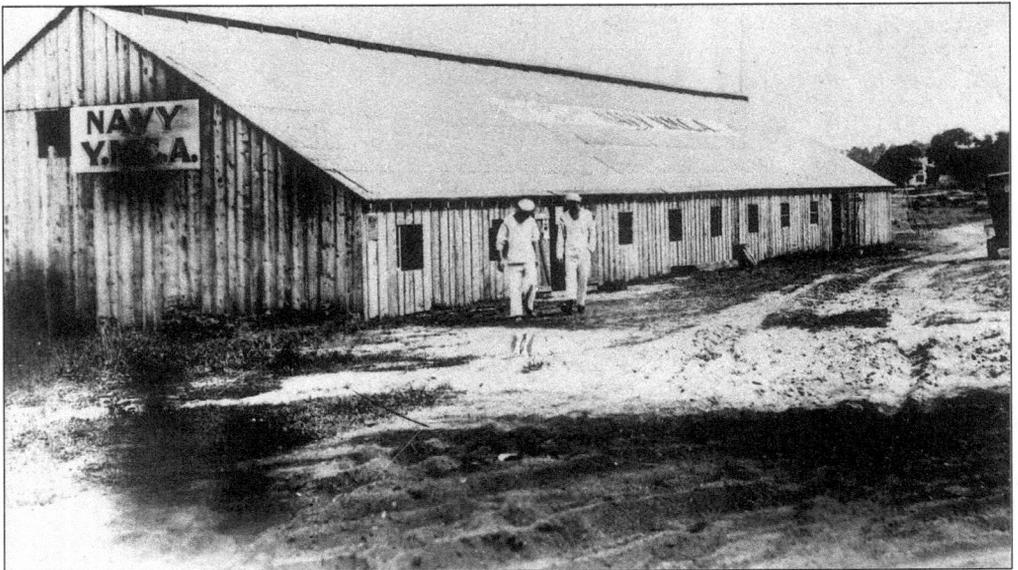

The YMCA near the Moore house was located close to the Naval Refueling Depot, currently the Coast Guard station, and was rumored to have a bowling alley inside. (Courtesy of National Park Service, Colonial National Historical Park Yorktown Collection.)

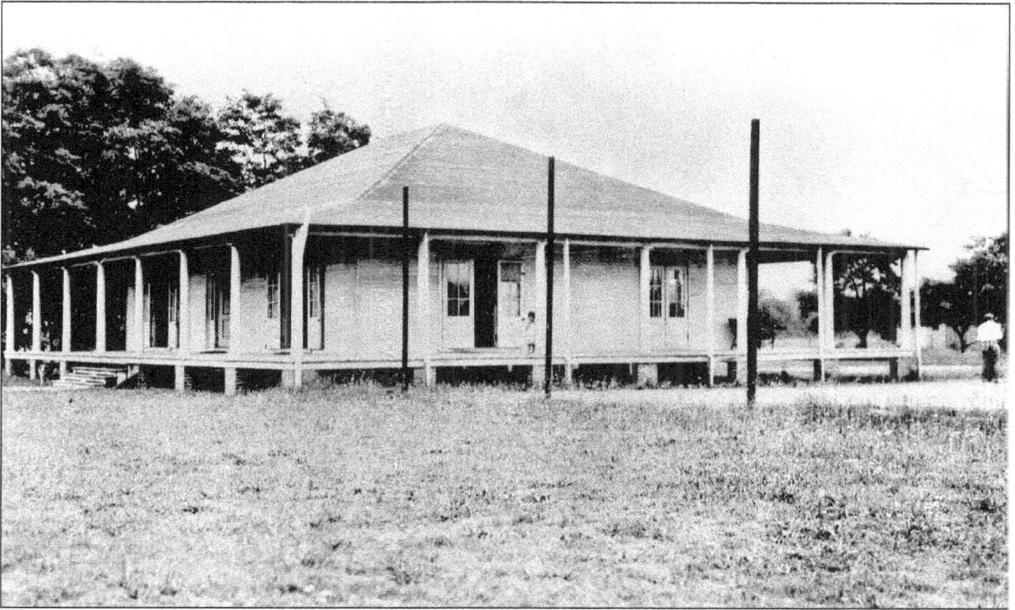

The Officers Club is shown here, near the Moore house, c. 1900. (Courtesy of National Park Service, Colonial National Historical Park Yorktown Collection.)

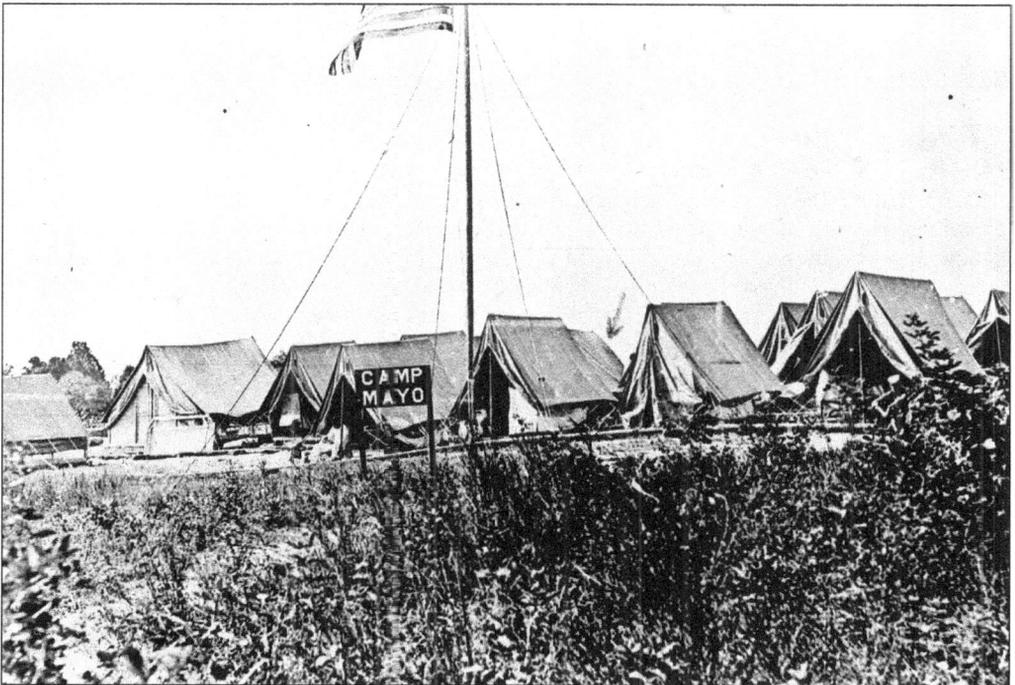

Camp Mayo was an army encampment on the current site of the visitors center. (Courtesy of National Park Service, Colonial National Historical Park Yorktown Collection.)

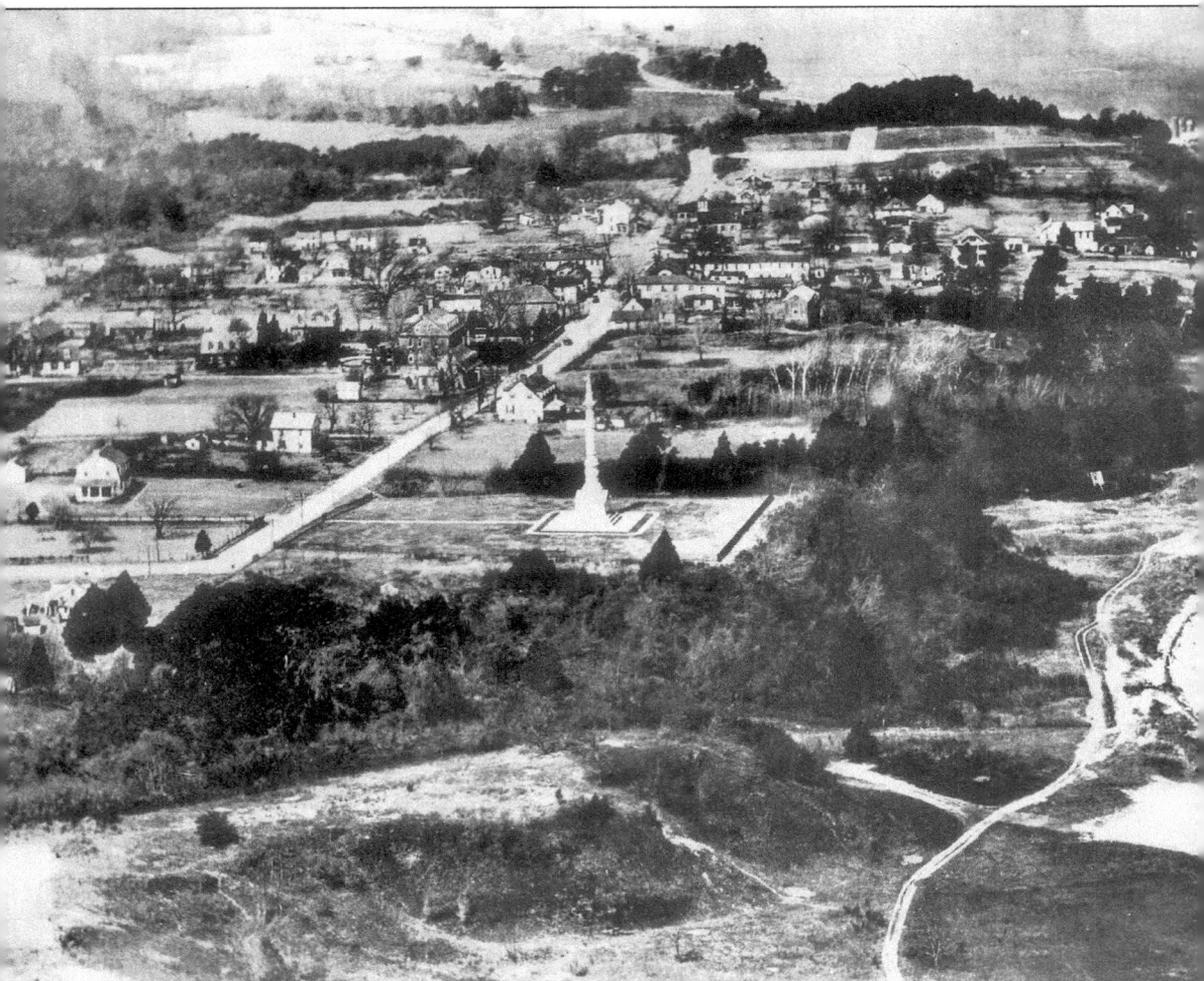

This aerial view shows all of Yorktown to nearly the waterfront, looking west; it is a fine example of how many businesses and homes used to be in the village. Also, notice no Comte DeGrasse Street beside the monument. The streets are not paved, and only telegraph poles can be seen on Main Street, as electricity and telephone service had not yet come to Yorktown. (Courtesy of National Park Service, Colonial National Historical Park Yorktown Collection.)

Two

THE NEW AGE

In 1922, the new age of Yorktown had already begun with a dusting of a depression that settled gently on the town. The few colonial homes that had survived a steady decline with time were cloaked in anachronistic architecture. There were no street numbers in any address, nor were there phones, indoor plumbing, or electricity. George Hunter Fletcher, a boy of four in 1922, came to Yorktown when his father was hired to manage the First National Bank at Main and Read Streets. In the mornings, he remembers the ladies washing the smut off their lampshades from the oil burning of the previous evening.

Growing up on Water Street, Kathleen Jeanette White—one of eight children—lived in a large home behind the Seafood Pavilion (later, Nick's Seafood Pavilion). Her father ran a general store on the hillside. Margaret Childrey's family came to Yorktown in 1926, where her father was the caretaker of the Blow estate (Nelson House) as the Blow family was not always in residence. Margaret, Hunter, and Kathleen all attended a two-room schoolhouse—with first through fourth grades in one room taught by Mrs. Gray. Nancy Coleman Slaight's first memory was of sitting in her mother's lap at the the Sesquicentennial Celebration in 1931. In a formal ceremony, Lola Mae, Nancy's mother, met the honored Gen. John J. Pershing, and he said to her, "I'm glad to meet you, I'm sure."

With the excitement of the forthcoming country club and the invention of the automobile, life was beginning to change. In 1918 the Naval Mine Depot was established and businesses were taking shape in town. By 1925 summer cottages were being built in the Temple Farms area on Moore House Road. For Yorktown, and America, life began to zoom.

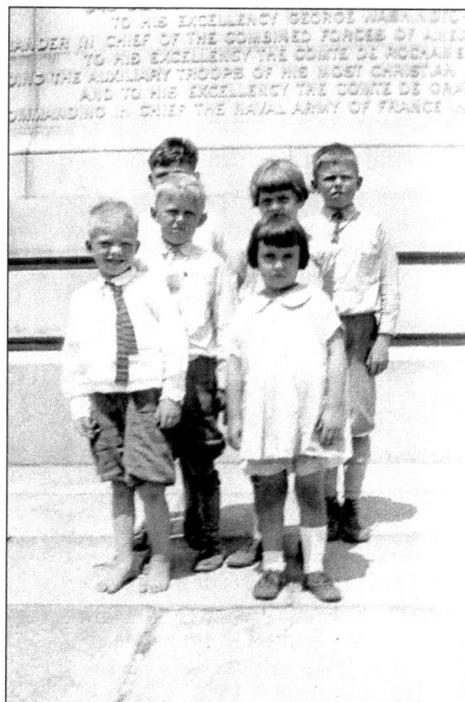

This image of a group of school-age buddies reveals the innocence of the time. In ties, long sleeves, dresses, and tall socks—yet shoeless—are, from left to right, (front row) Jimmie O'Hara and unidentified; (middle row) Hunter Fletcher and Kathleen O'Hara; (back row) Leslie O'Hara and Jack Fletcher. (Courtesy O'Hara Collection.)

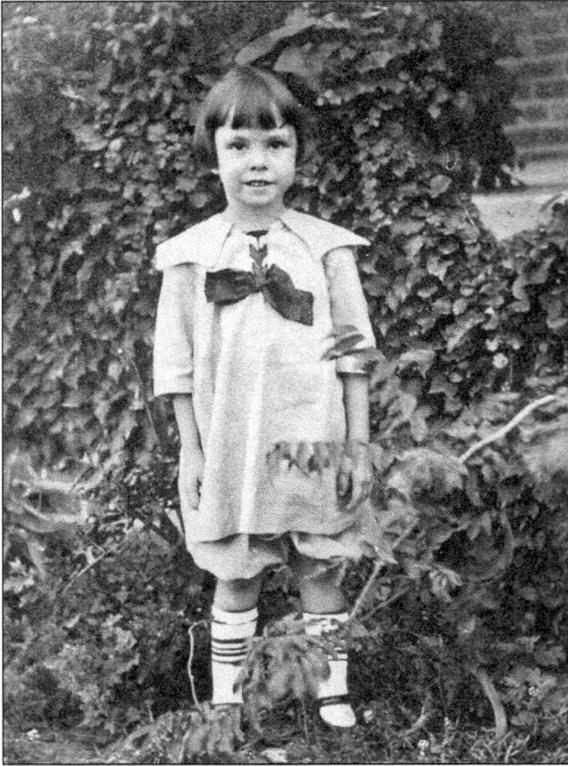

Margaret Childrey, at an elementary school age, lived with her family in the caretaker's house on the Nelson property. Later, going to school at Morrison High on Warwick Boulevard, she and the kids of Yorktown all rode together in the "Pie Wagon" with her seat right beside the driver, Ray, who was Kathleen White's brother. (Courtesy of Margaret Penzold.)

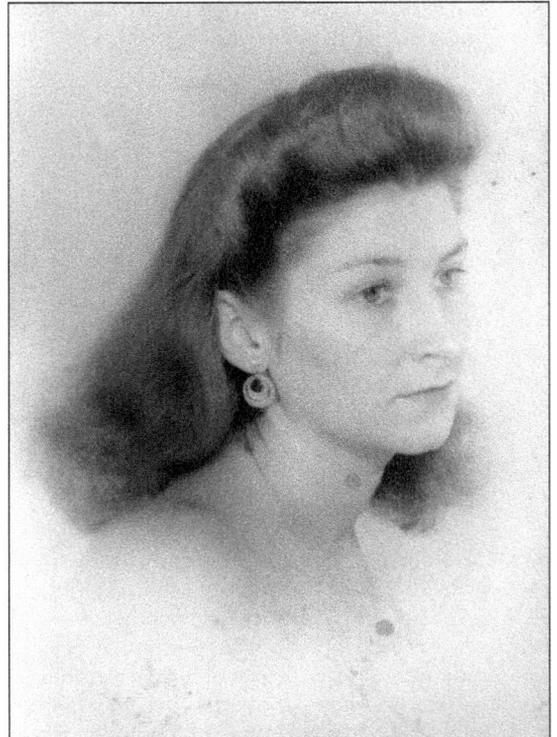

Kathleen White grew up in the house behind the Seaside Pavilion on Water Street. Her life and escapades on the river resulted in many warm hometown memories. (Courtesy of Kathleen Endebrock.)

Nancy Slaight grew up on Ballard Street with five sisters and one brother. Life as a prominent citizen, with riches beyond her family money, was a fairy tale come true. (Courtesy of Nancy Spaniol.)

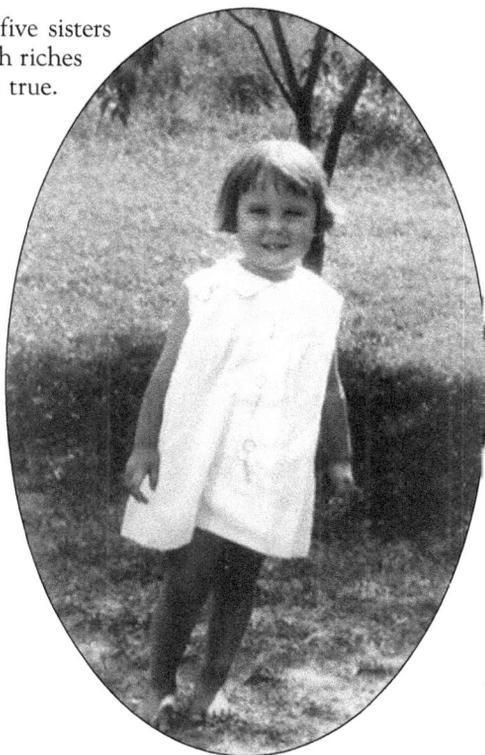

Hunter Fletcher spent his entire youth in Yorktown and after returning from World War II, which he served in England he married and started a career in insurance and land development. Forever known for his wit and jovial nature, Hunter's memory exceeds an educated historian's about this time period in Yorktown. (Courtesy of Fletcher collection.)

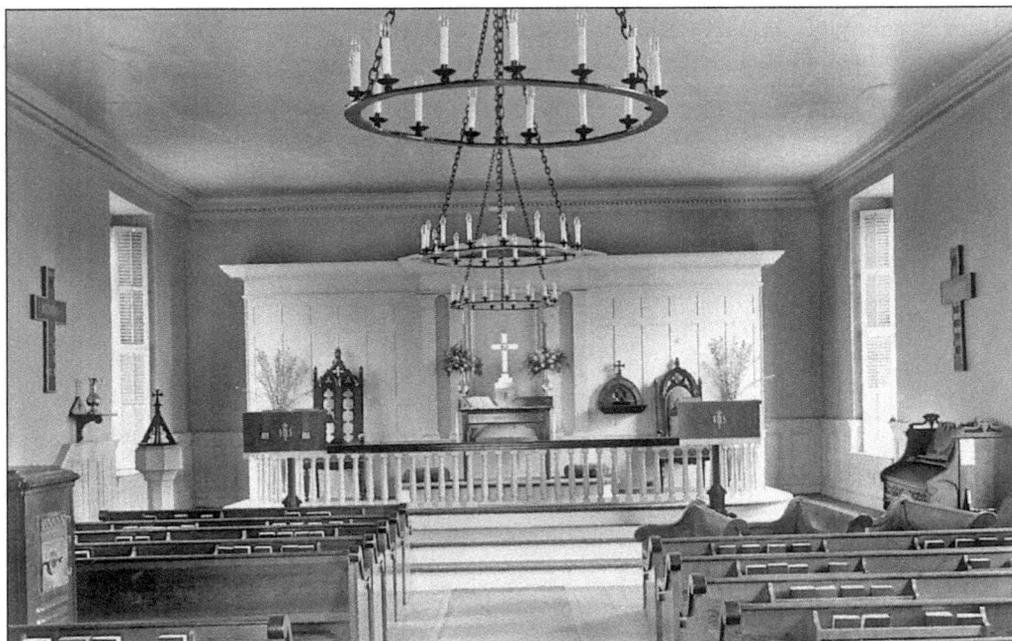

The interior of Grace Church is shown here on March 23, 1936, after the 1927 renovation. The famed Rev. W.A.R. Goodwin, known for getting the Rockefellers involved in the Williamsburg restoration, had charge over Grace Church at this time and much of the interior remains today, minus the stove on the left and the smaller organ on the right. (Courtesy of National Park Service, Colonial National Historical Park Yorktown Collection.)

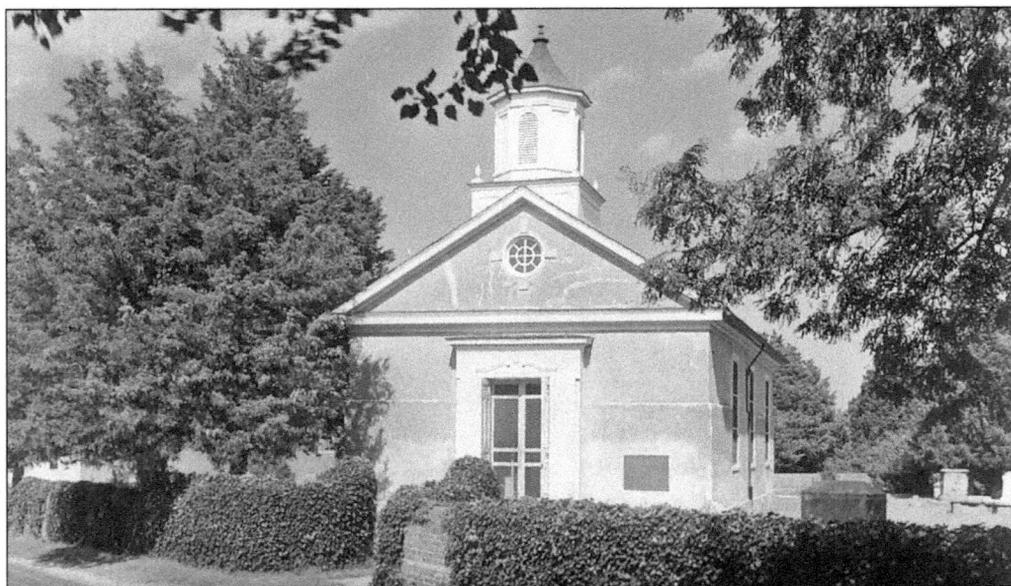

Grace Church, pictured on October 12, 1938, is a constant reminder of the strength in the people who persist in Yorktown. This is the third church of York-Hampton Parish, built of marl (sand and shell), on this current site. The first two churches (1642 and 1667) were built on Wormley Creek where the first settlement of York began. (Courtesy of National Park Service, Colonial National Historical Park Yorktown Collection.)

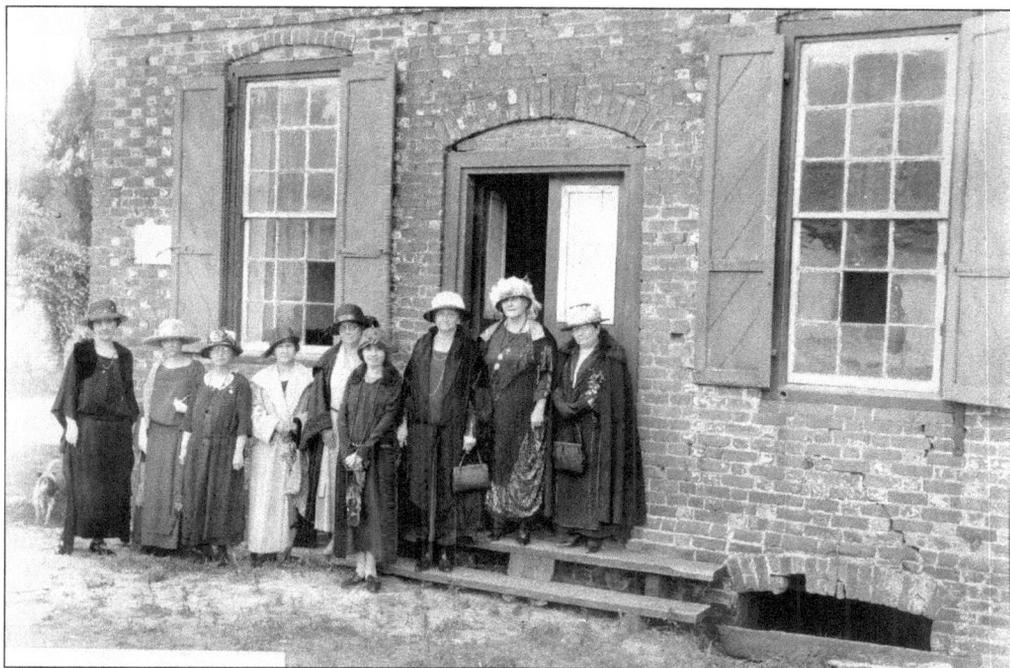

The ladies of the Comte DeGrasse Chapter of DAR gather outside their newly acquired Customs House on Main Street, c. 1926. The generous donation of Kay Blow and funding of the restoration by Mrs. Evans made this purchase from the famed Dr. McNorton a good investment. (Courtesy of O'Hara Collection.)

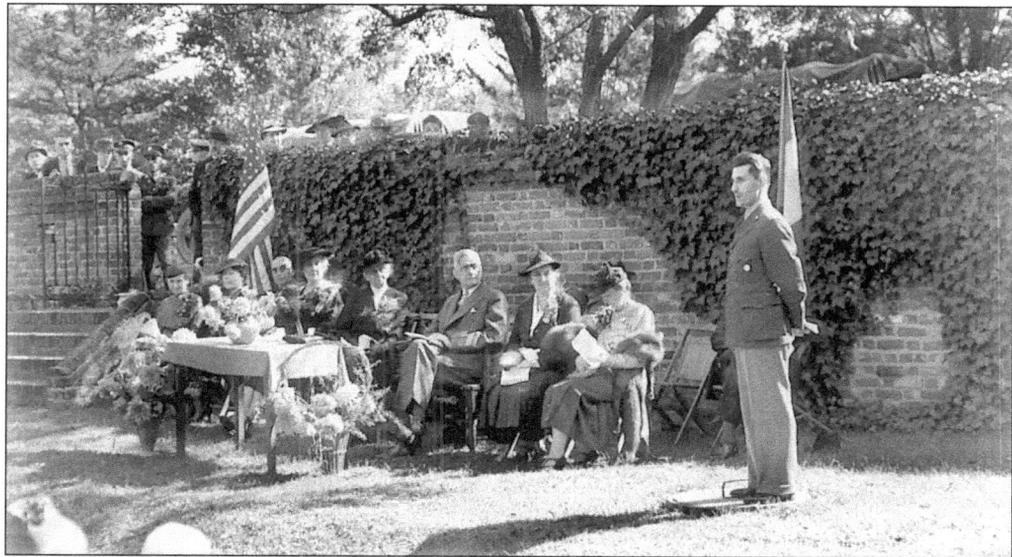

A dedication ceremony is pictured on the back lawn of the Customs House on Main Street, c. 1930. Seated fifth from the left is Emma Chenoweth, longtime regent and a strong leader in getting the Customs House purchased and renovated. Standing is B. Floyd Flickinger, superintendent of the Colonial National Monument at that time. Notice the onlookers peeping over the wall. (Courtesy of National Park Service, Colonial National Historical Park Yorktown Collection.)

This tiny elementary school was attended by most of the local children during the 1920s. It was located on Ballard Street, on the hill behind the courthouse. Later, a new elementary school was completed on the extension of Ballard Street. The new school was converted for county use and still stands adjacent to the new courthouse on Ballard Street extension. (Courtesy of Cooke-Krams Collection.)

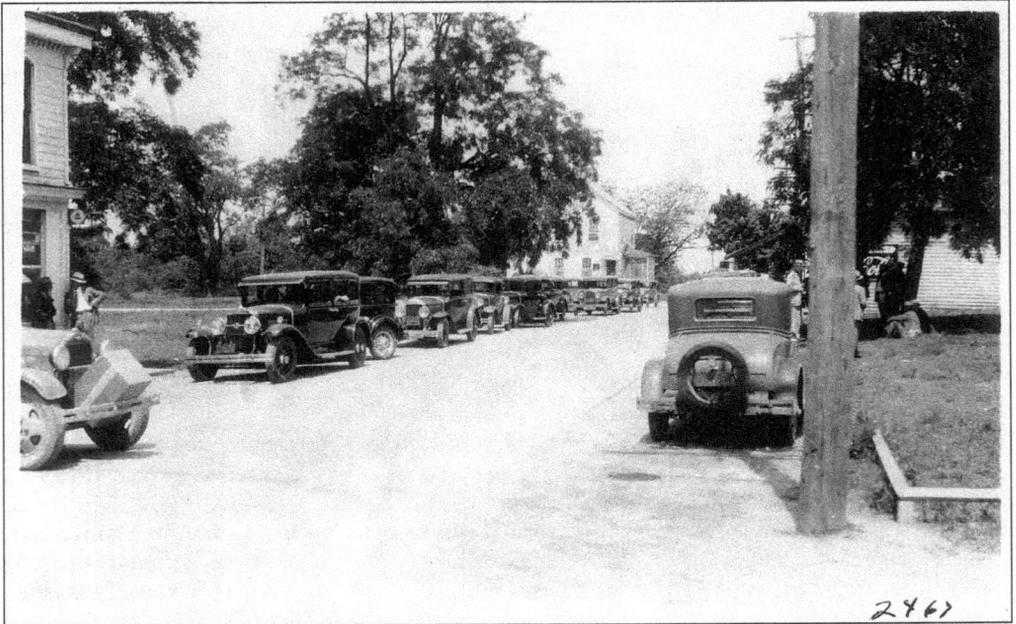

Life was beginning to bustle in Yorktown with cars lining both sides of Main Street, c. 1920. (Courtesy of National Park Service, Colonial National Historical Park Yorktown Collection.)

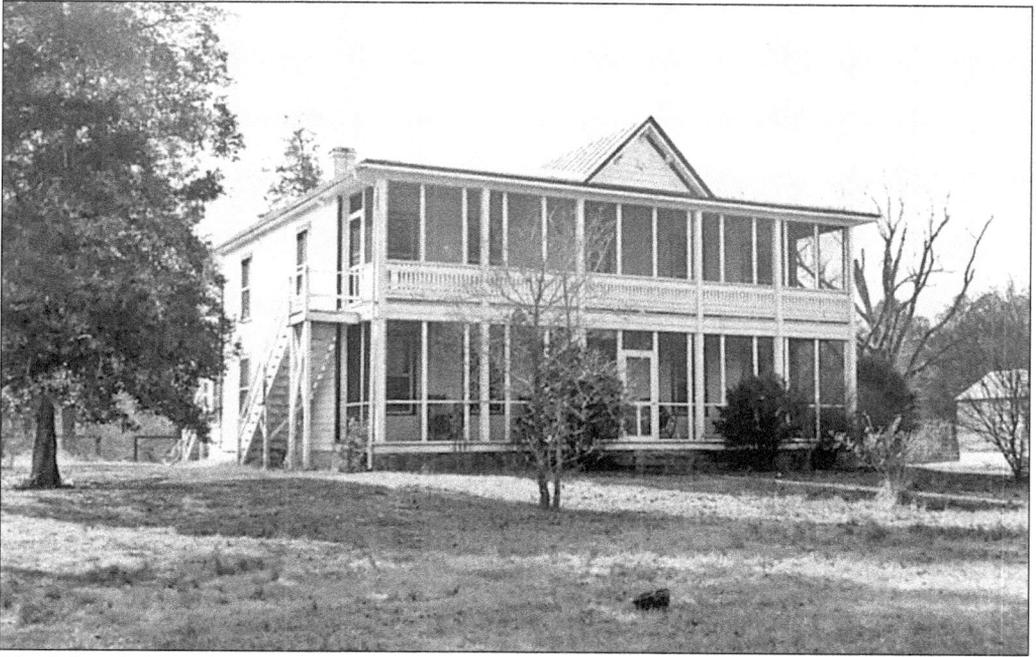

The John C. Beer farmhouse was built after 1882 and purchased by the National Park Service in 1931. It is located on Route 17 around the Park maintenance area. It has been altered to serve as staff housing. (Courtesy of National Park Service, Colonial National Historical Park Yorktown Collection.)

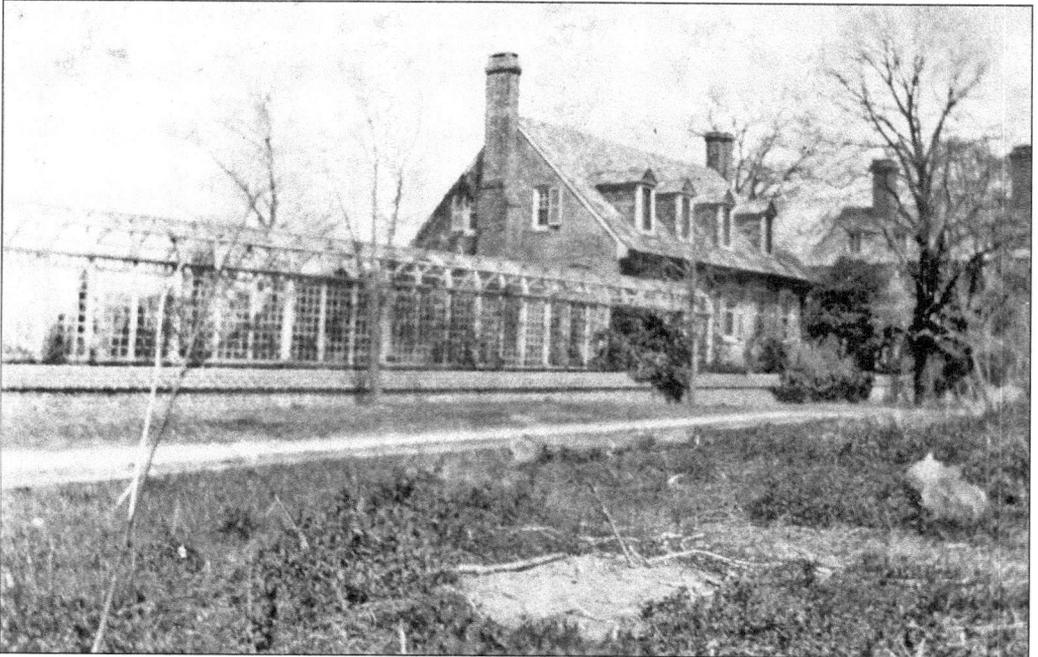

The Edmund Smith house was first built in 1751, with the Nelson house in the background. True to the anachronistic style of that period, there is an arbor along the side of the house. (Courtesy of Fletcher collection.)

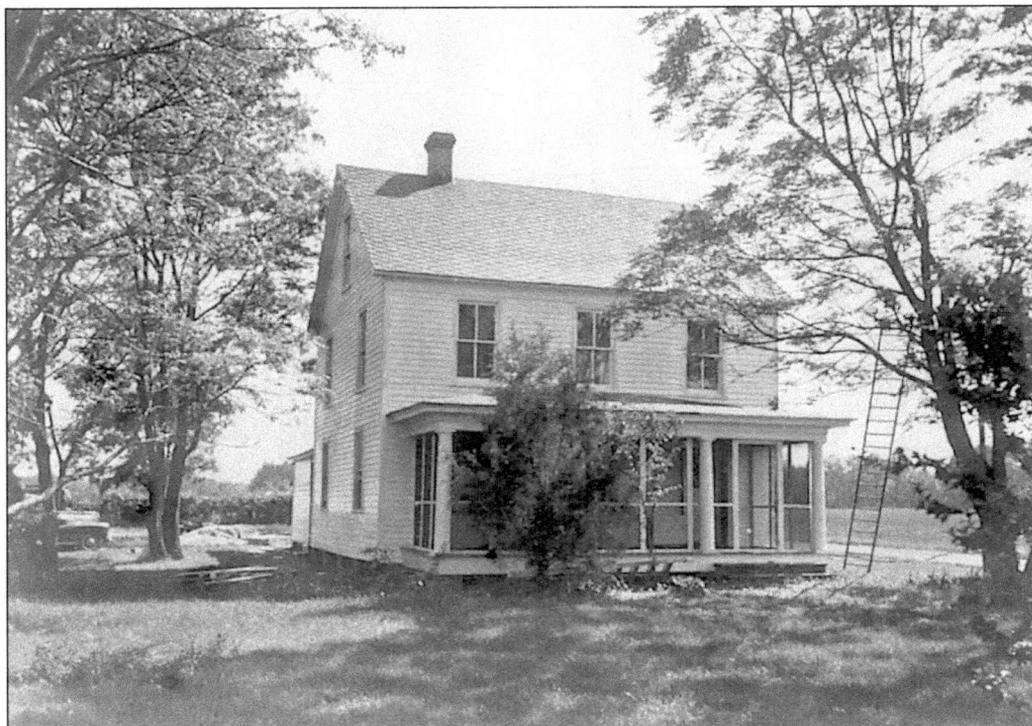

The Edgehill farmhouse (along Surrender Road), purchased by the National Park Service and used at one point for staff housing, has been demolished. (Courtesy of National Park Service, Colonial National Historical Park Yorktown Collection.)

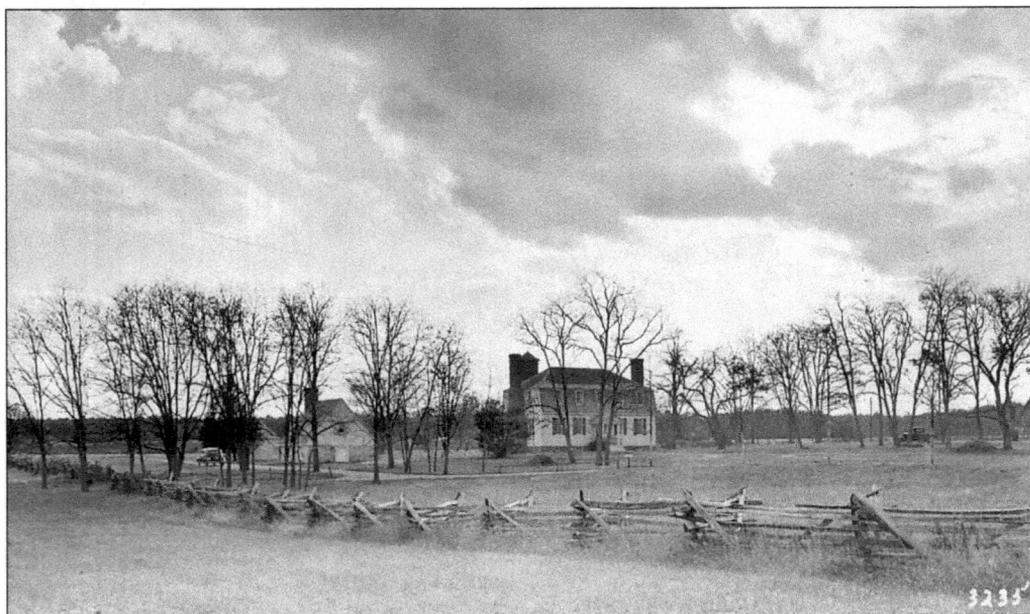

The Moore house stands in its final restoration, looking like the epitome of colonial hearth and home. (Courtesy of National Park Service, Colonial National Historical Park Yorktown Collection.)

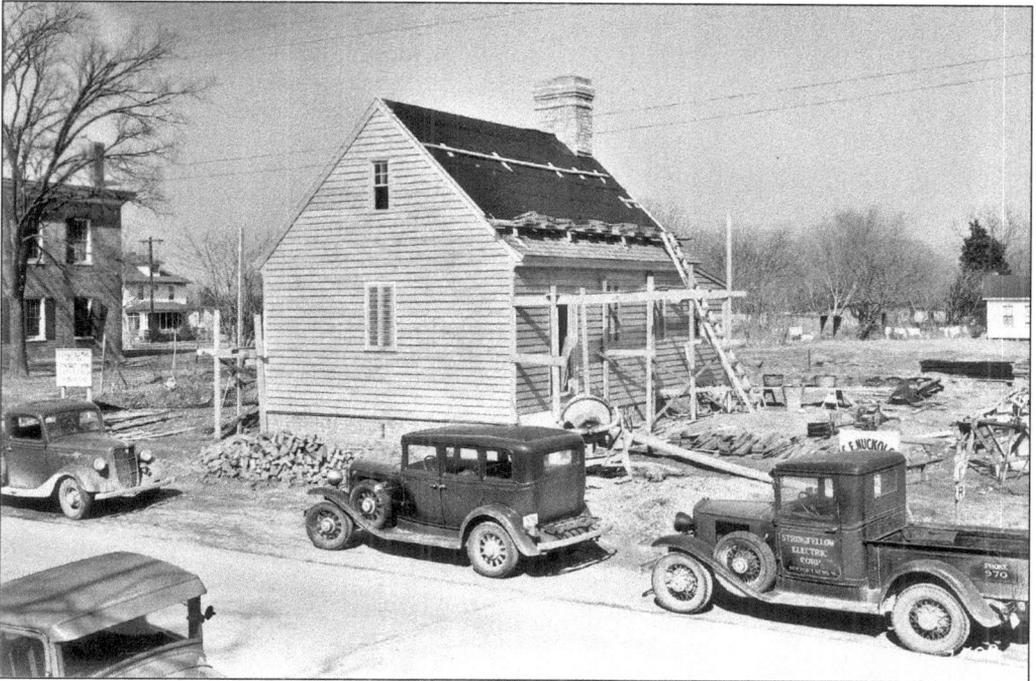

A 1930 photograph shows the reconstruction of the Medical Shop in Yorktown. (Courtesy of National Park Service, Colonial National Historical Park Yorktown Collection.)

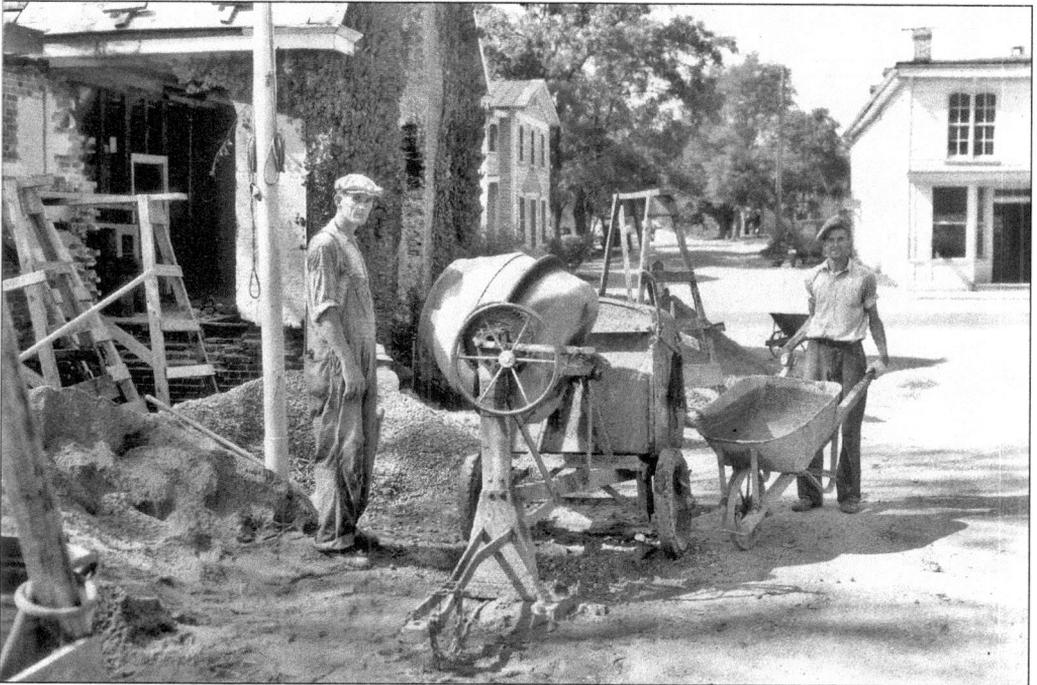

Reconstruction of the Somerwell House at Church and Main took place during the 1930s, with the Chandler Building in the background. (Courtesy of National Park Service, Colonial National Historical Park Yorktown Collection.)

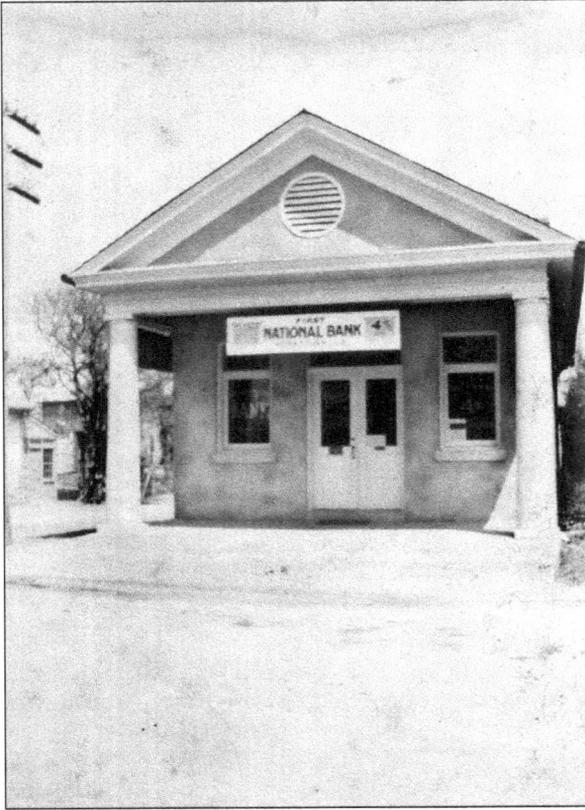

The First National Bank—now demolished—at Main and Read Streets sits diagonally across from the Customs House, managed first by Cecil B. Fletcher. (Courtesy of National Park Service, Colonial National Historical Park Yorktown Collection.)

This Yorktown Day parade in the 1930s is noteworthy because of the Hornsby house construction going on in the background. (O'Hara Collection.)

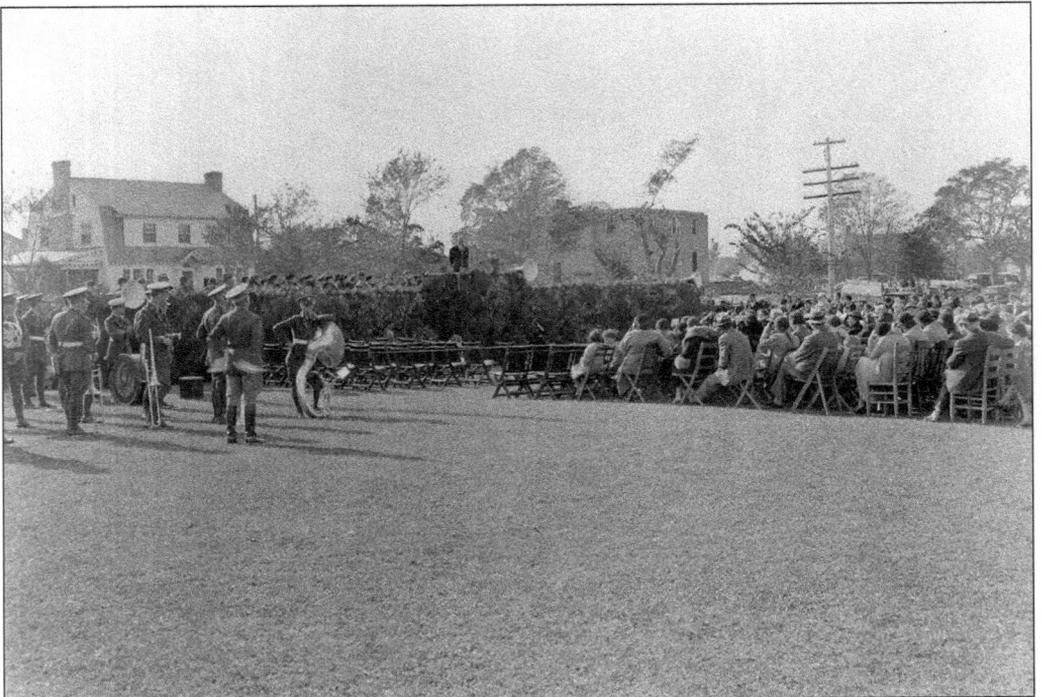

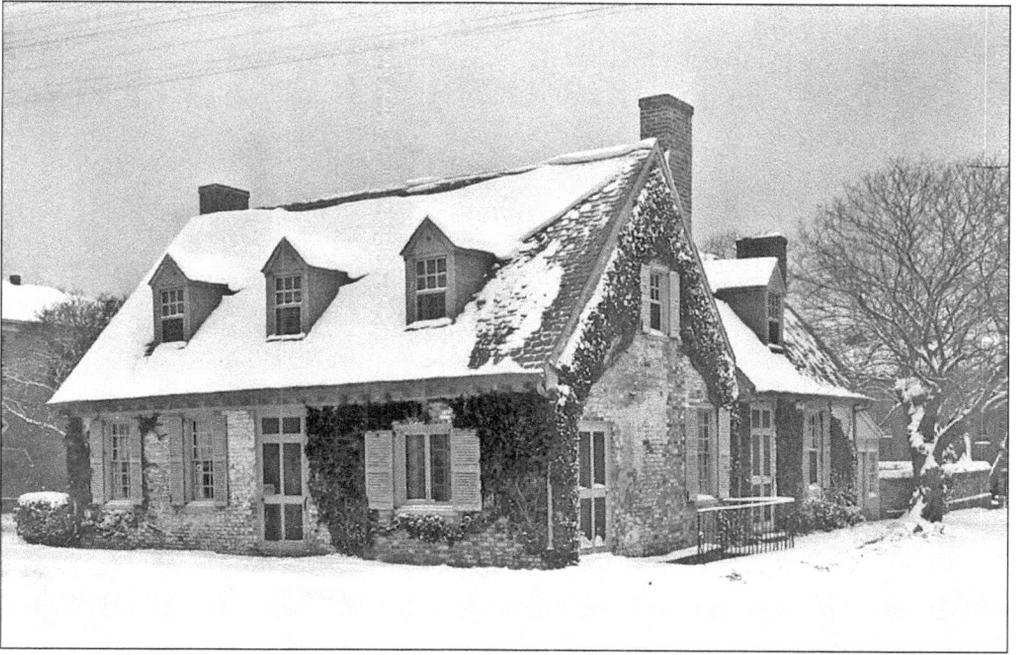

The Cole Digges house, seen here on December 23, 1935, was built in 1720. For many years, Emma Chenoweth and her husband lived in the house across from the Customs House at Read and Main Streets. (Courtesy of National Park Service, Colonial National Historical Park Yorktown Collection.)

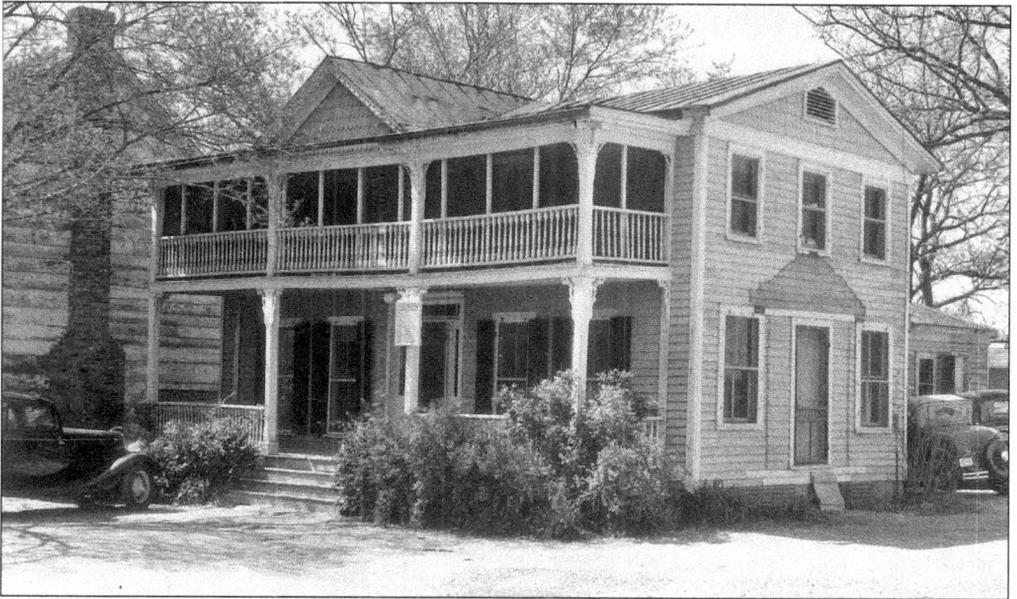

A bright sunny day in 1925 graces the residence of the Slaight Family before they moved to their newly constructed home on Ballard Street. Lola Mae Slaight served as postmaster inside their house at the corner of Main and Church Streets across from the Somerwell house/Yorktown Hotel. (Courtesy of National Park Service, Colonial National Historical Park Yorktown Collection.)

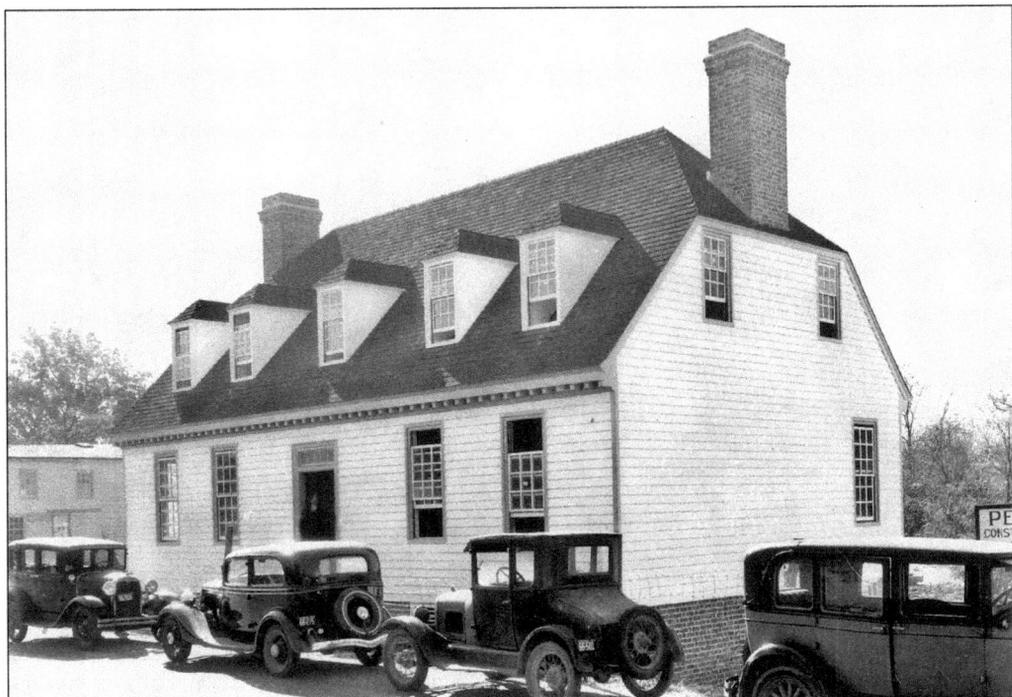

Swan Tavern is being restored, c. 1938, on Main Street across from the courthouse. (Courtesy of National Park Service, Colonial National Historical Park Yorktown Collection.)

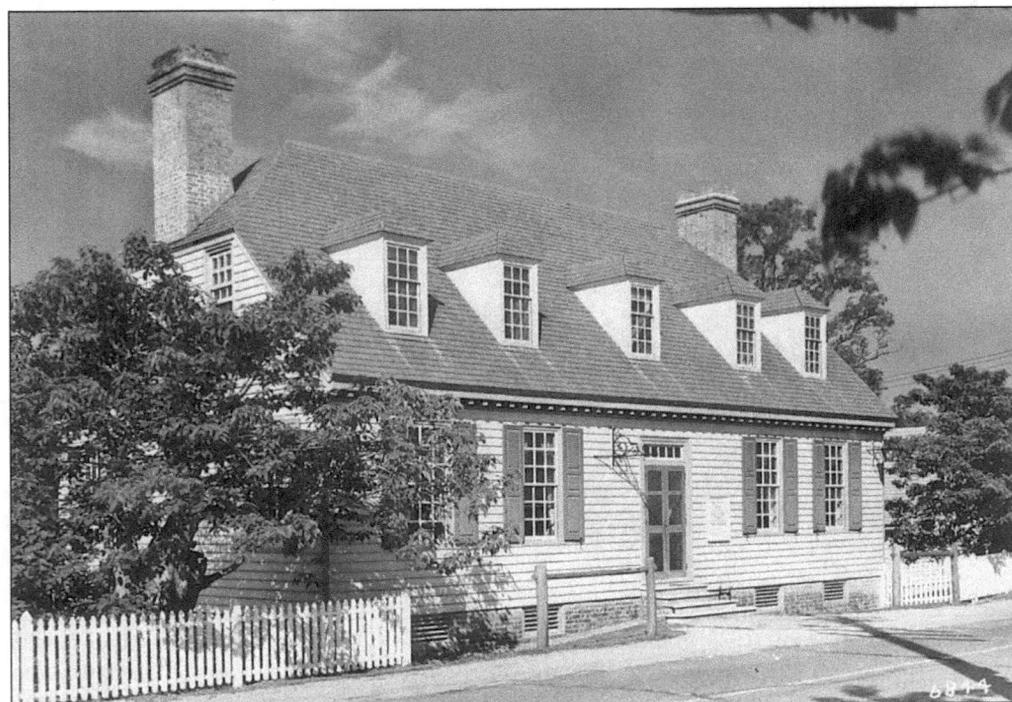

This image depicts the completed restoration of Swan Tavern on July 2, 1938. (Courtesy of National Park Service, Colonial National Historical Park Yorktown Collection.)

The completed restoration of the Lightfoot/Somerwell House/Yorktown Hotel on Main and Church Street is shown here, with the De Neufville Store in the shadows next door, on May 5, 1937. (Courtesy of National Park Service, Colonial National Historical Park Yorktown Collection.)

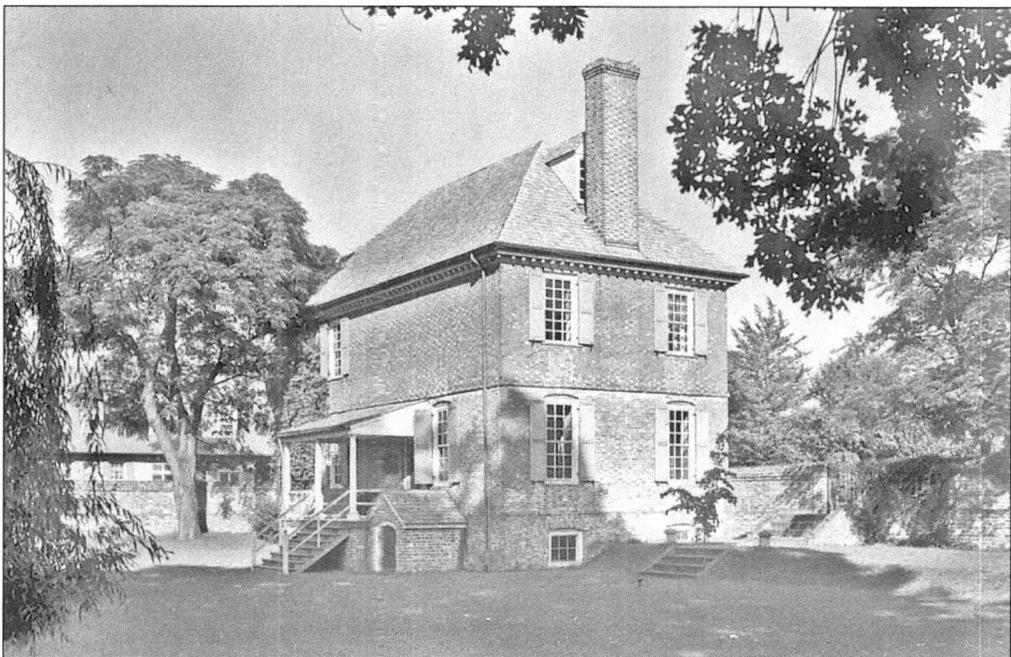

Purchased and renovated by the Comte DeGrasse Chapter of the DAR (seen from the back), this is what the Customs Houses looked like on September 16, 1936. (Courtesy of National Park Service, Colonial National Historical Park Yorktown Collection.)

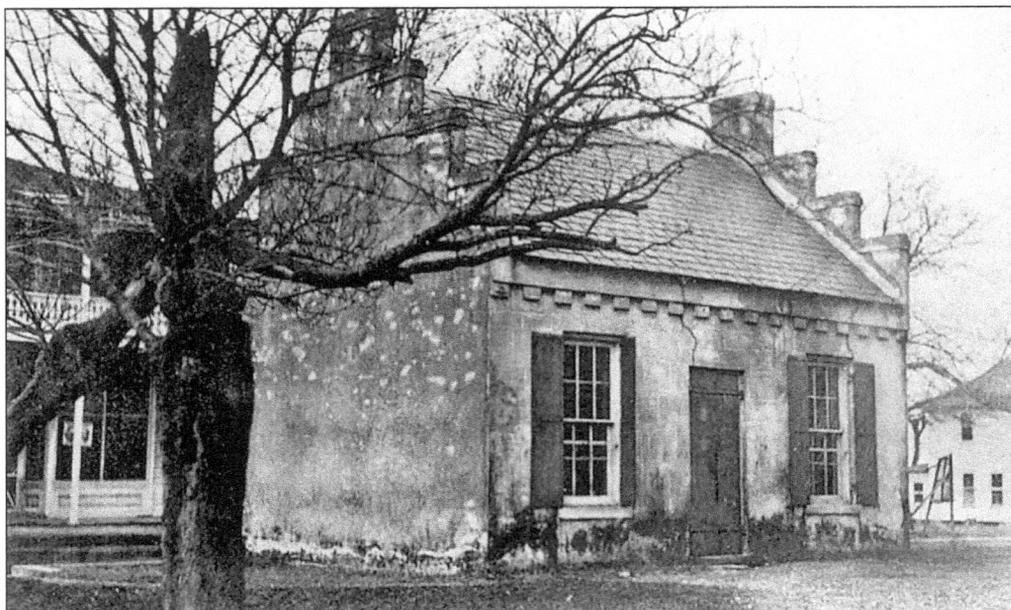

An undated shot features the clerk's office beside the courthouse on Main Street. (Courtesy of John A. Lawson III, Williamsburg, Virginia.)

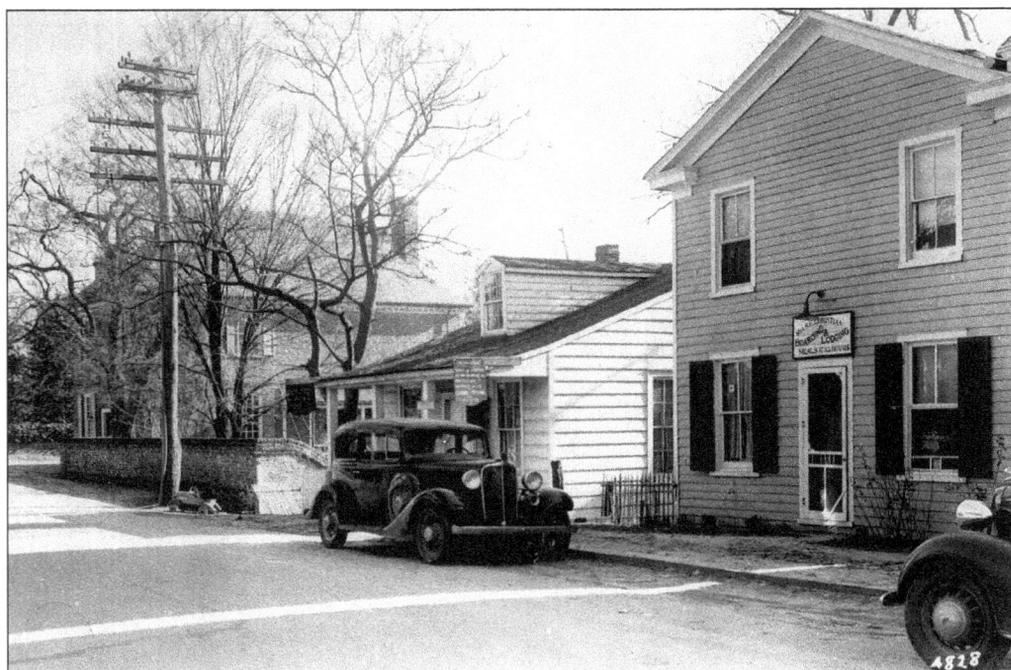

A Main Street view of Mrs. Christian's boarding house, c. 1930, also shows the Customs House in the background. (Courtesy of National Park Service, Colonial National Historical Park Yorktown Collection.)

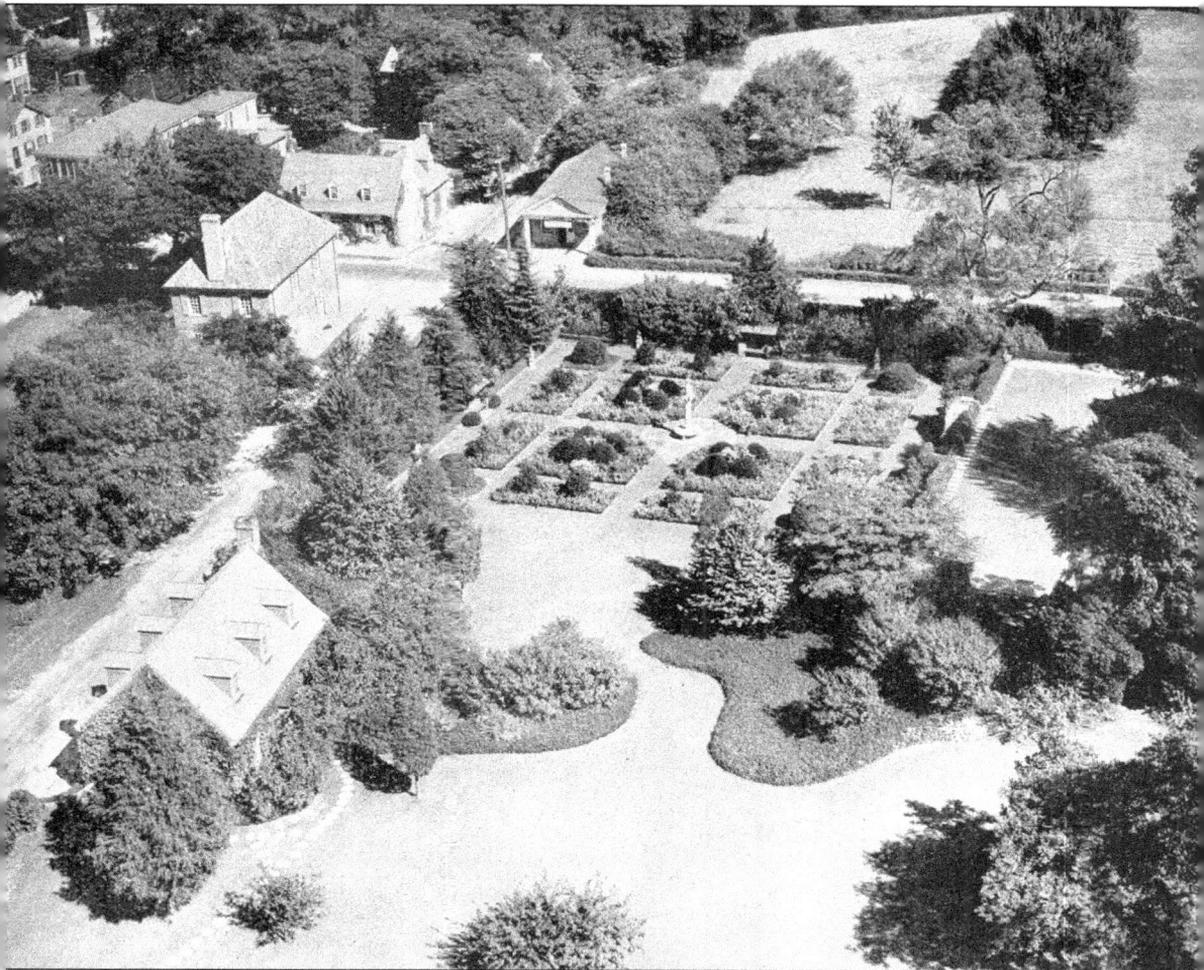

The Nelson house is indeed famous because the original owner, Gen. Thomas Nelson. First built in 1711, this house is the subject of many pictures and articles with regard to the Revolutionary War. It was restored by Capt. George Preston Blow of LaSalle, Illinois, after he acquired it around 1907. It was then acquired by the National Park Service in 1968. Gardens of the Nelson house are on display in a 1931 image above. Also in view are the Customs and Pate houses and First National Bank out on Main Street. The beauty of the grounds and house contributed greatly to the renovation process in Yorktown during those years. (Courtesy of O'Hara Collection.)

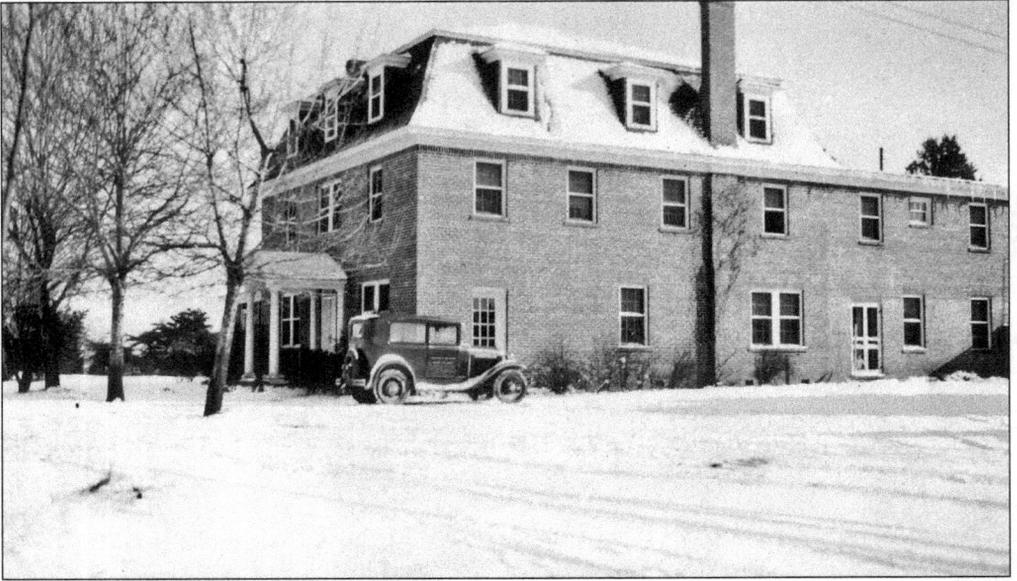

The Monument Lodge is pictured in the snow, c. 1925. It was built on the corner of Monument Road and Main Street.

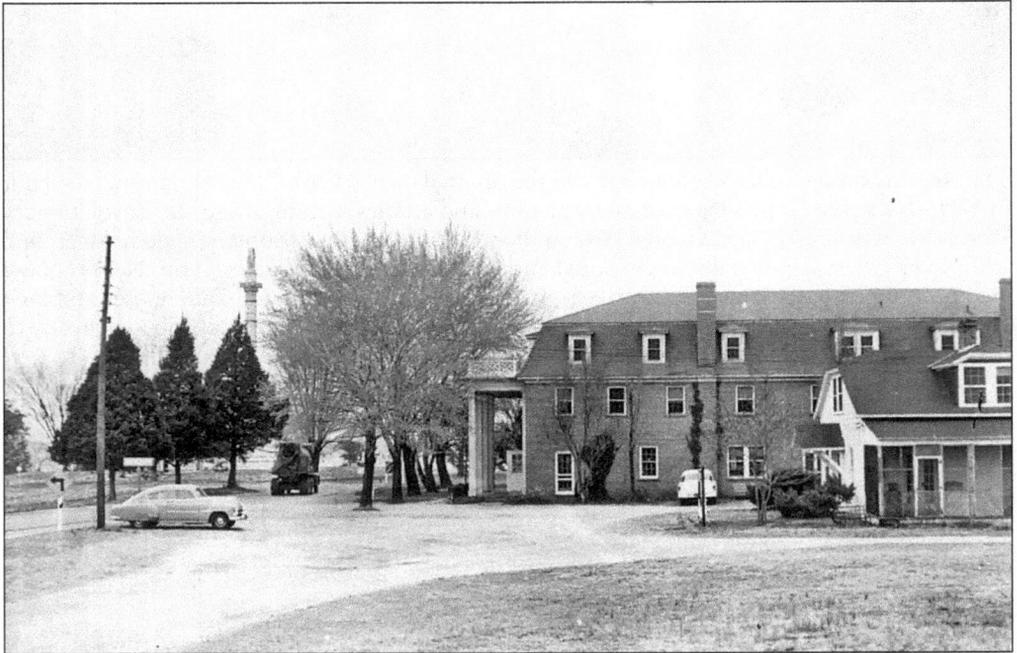

This postcard of the Monument Lodge, c. 1950, is looking toward the river. (Courtesy of National Park Service, Colonial National Historical Park Yorktown Collection.)

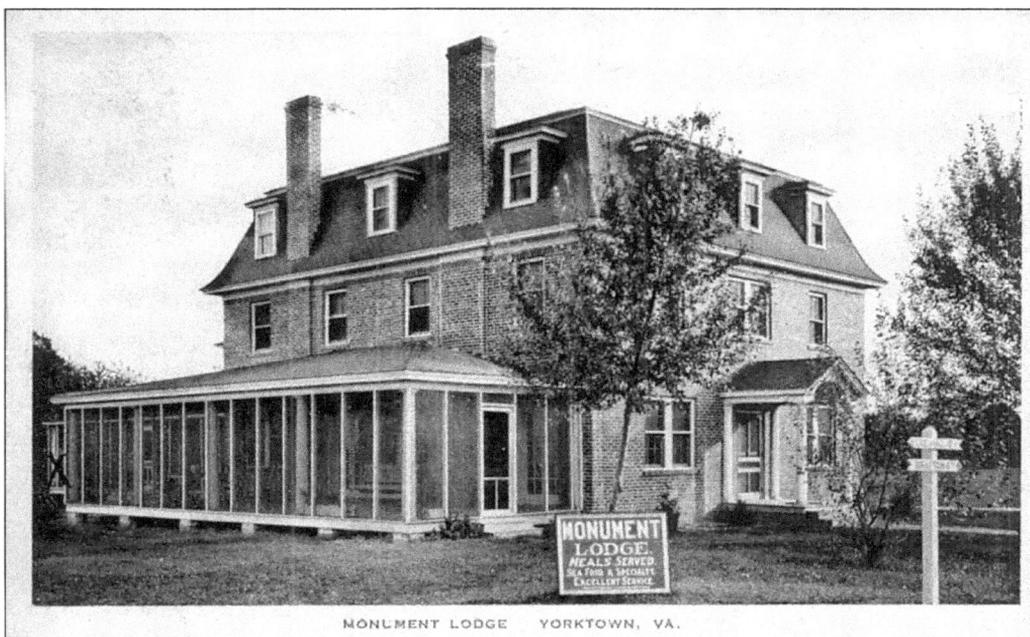

The backside of the Monument Lodge, c. 1925, sits on the grounds of the Victory Monument. (Courtesy of National Park Service Colonial National Historical Park Yorktown Collection.)

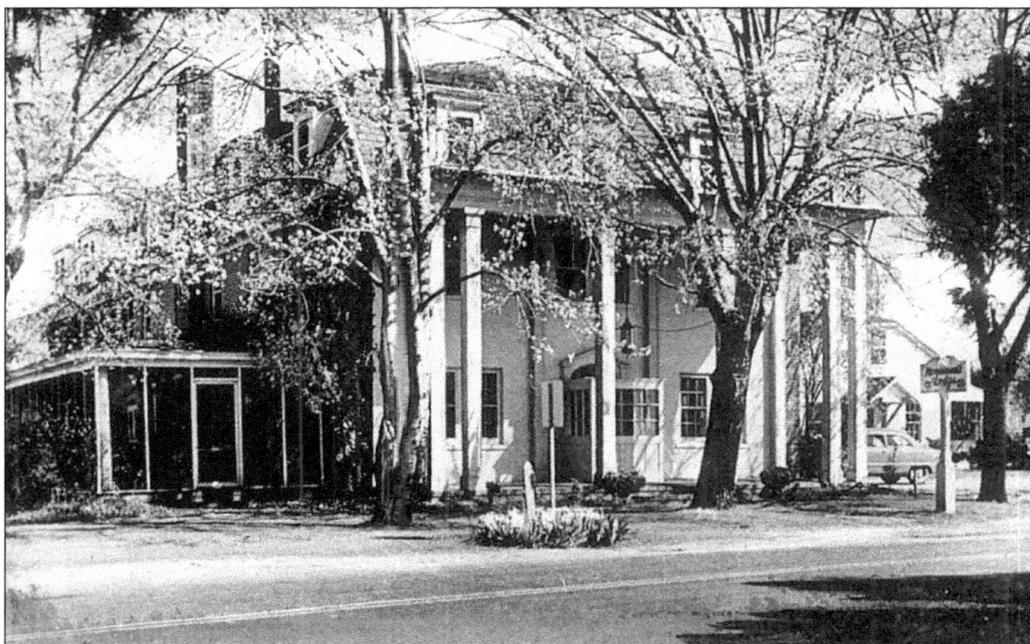

The Monument Lodge, c. 1950, is seen with all remodeling complete. (Courtesy of National Park Service, Colonial National Historical Park Yorktown Collection.)

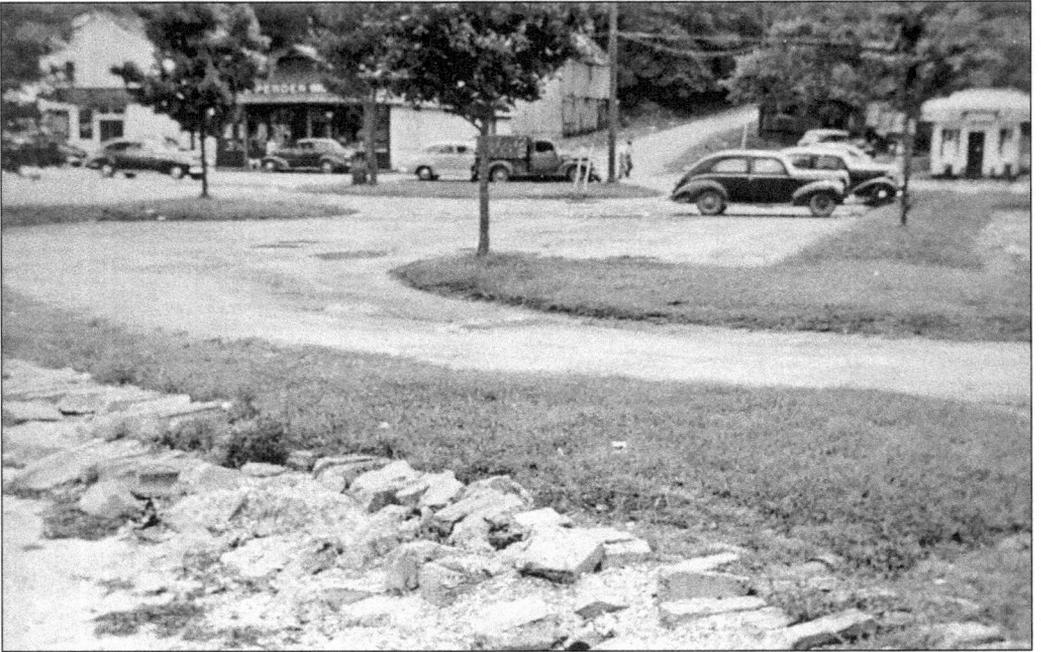

The retail stores were photographed on February 21, 1946, from the wharf parking lot, with Buckner Street in the center background. (Courtesy of National Park Service, Colonial National Historical Park Yorktown Collection.)

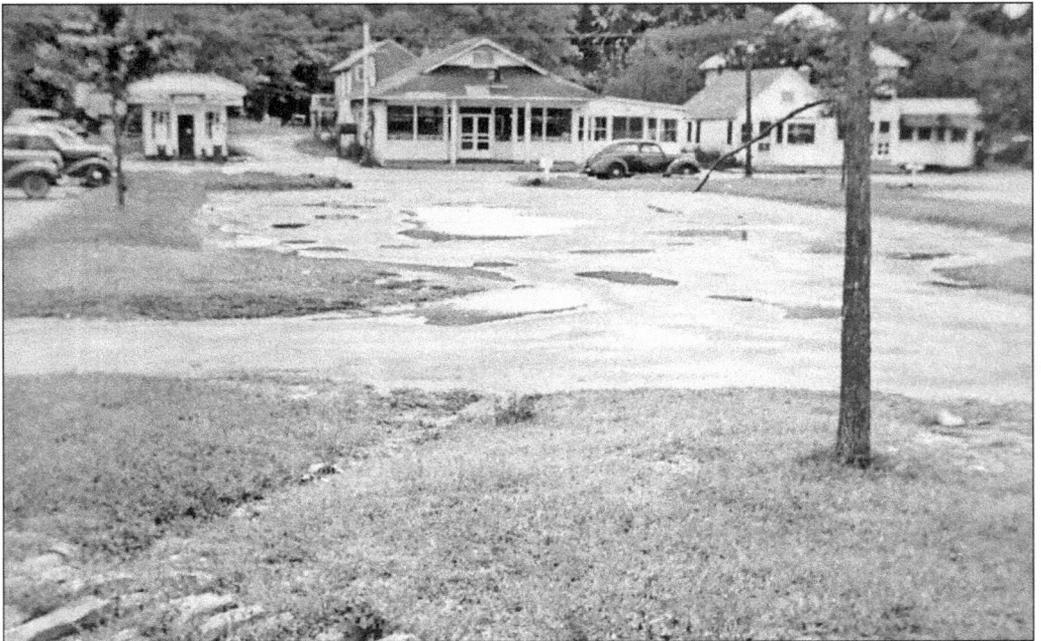

Here is a filling station and restaurant from September 21, 1946, on the west side of Water Street looking from the river. (Courtesy of National Park Service, Colonial National Historical Park Yorktown Collection.)

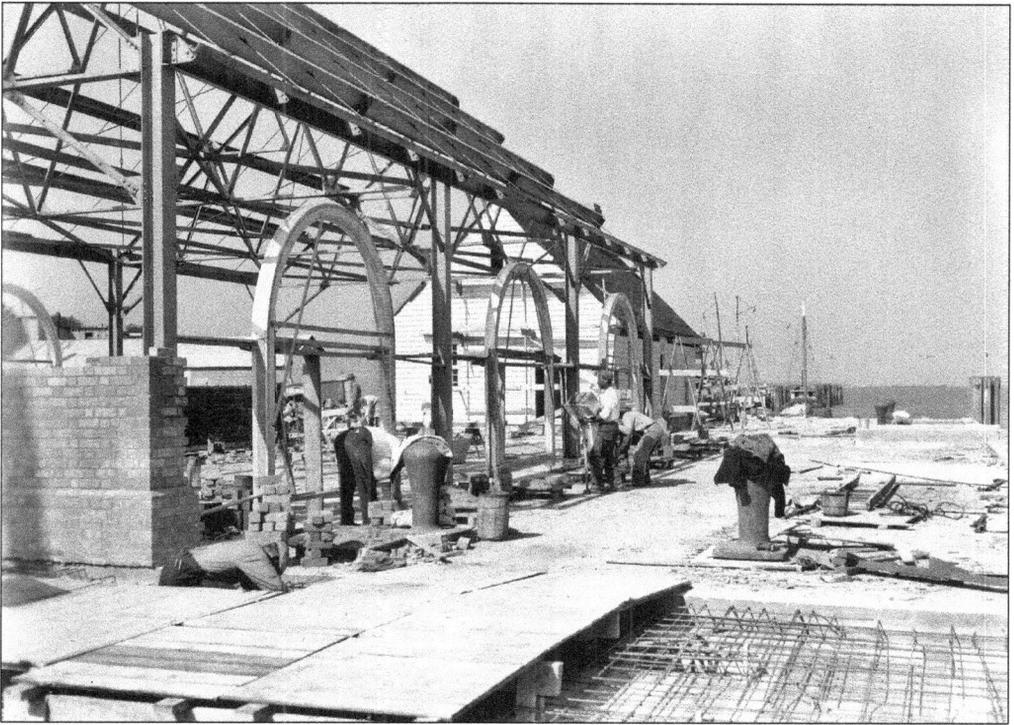

This photograph is of the building of a freight shed; it would later house the post office for many years. (Courtesy of National Park Service, Colonial National Historical Park Yorktown Collection.)

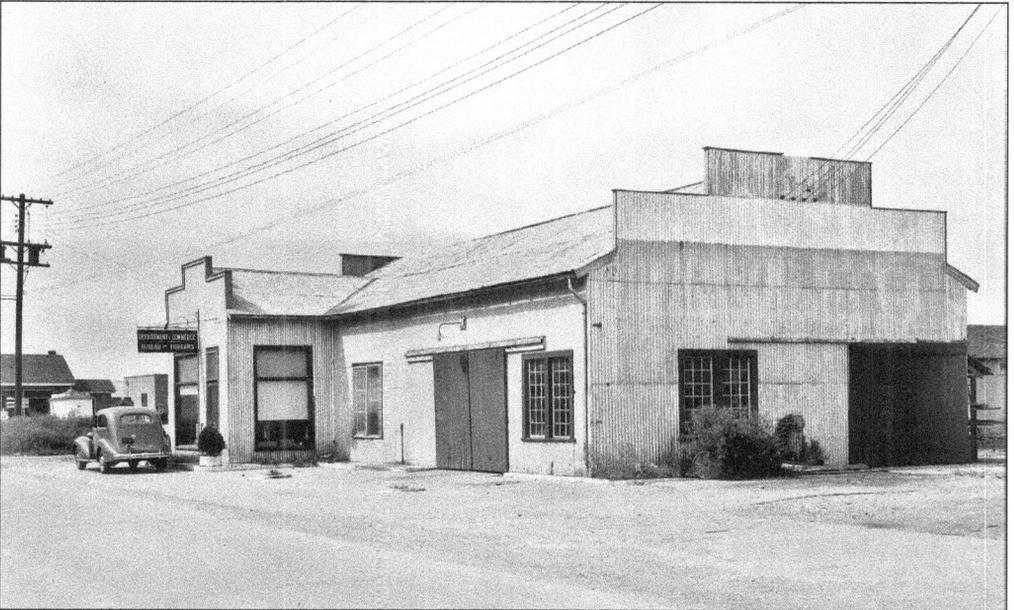

The Bureau of Fisheries office of Mr. Leslie O'Hara and storage to the ice warehouse for the fishing boats is seen *c.* 1945. (Courtesy of National Park Service, Colonial National Historical Park Yorktown Collection.)

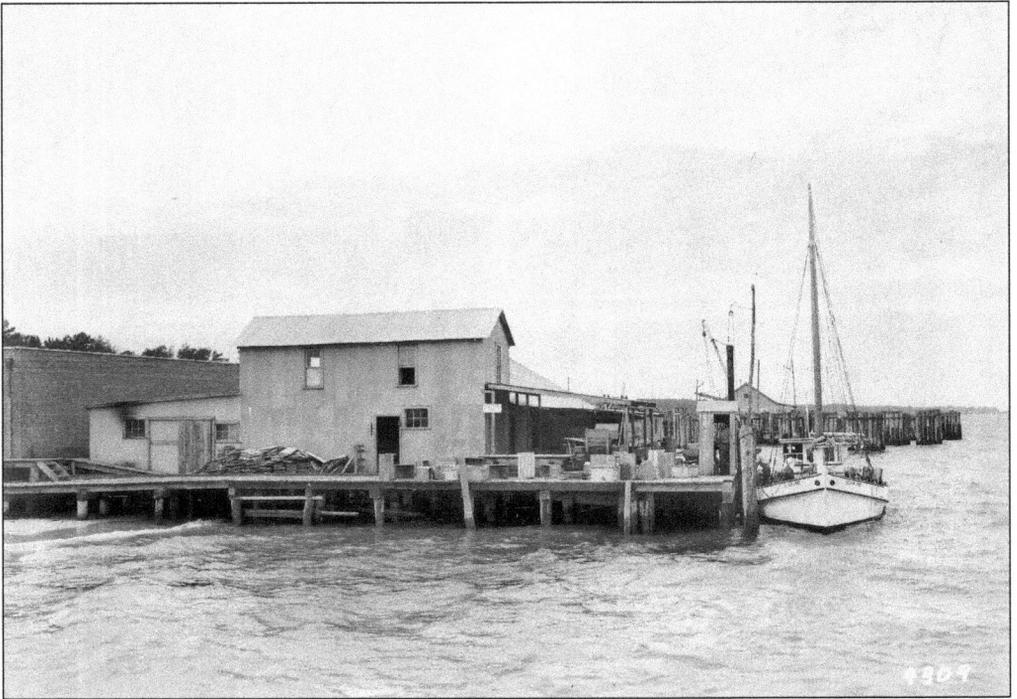

A commercial vessel waits at the end of a fishing wharf that is attached to the Fisheries Bureau. (Courtesy of National Park Service, Colonial National Historical Park Yorktown Collection.)

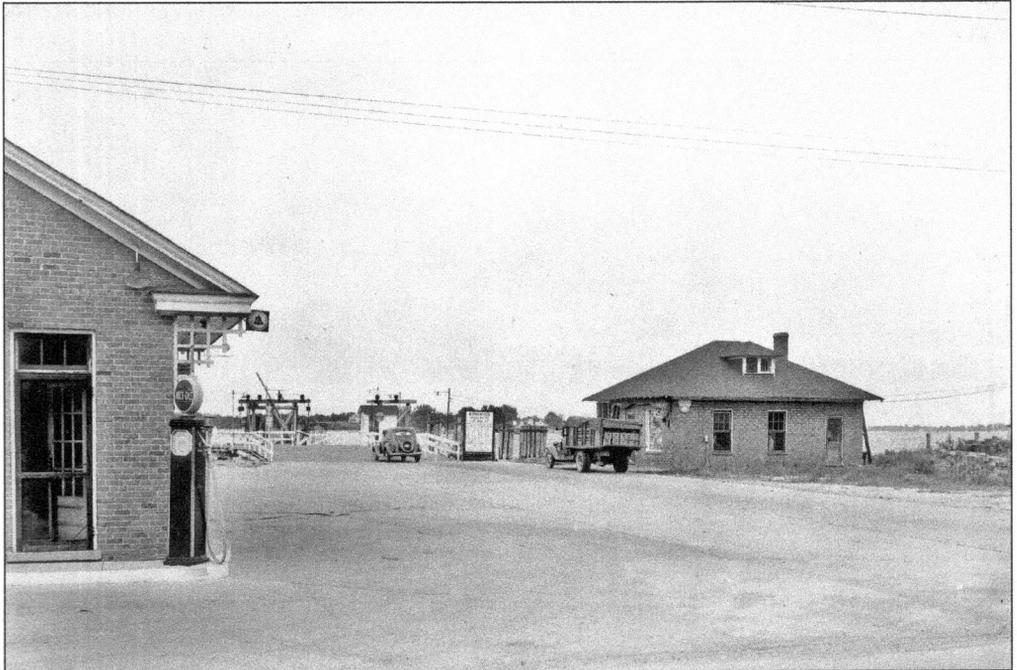

This is one of the few pictures of the Ferry lunchroom, along with the ferry dock, west of Ballard, c. 1930. (Courtesy of National Park Service, Colonial National Historical Park Yorktown Collection.)

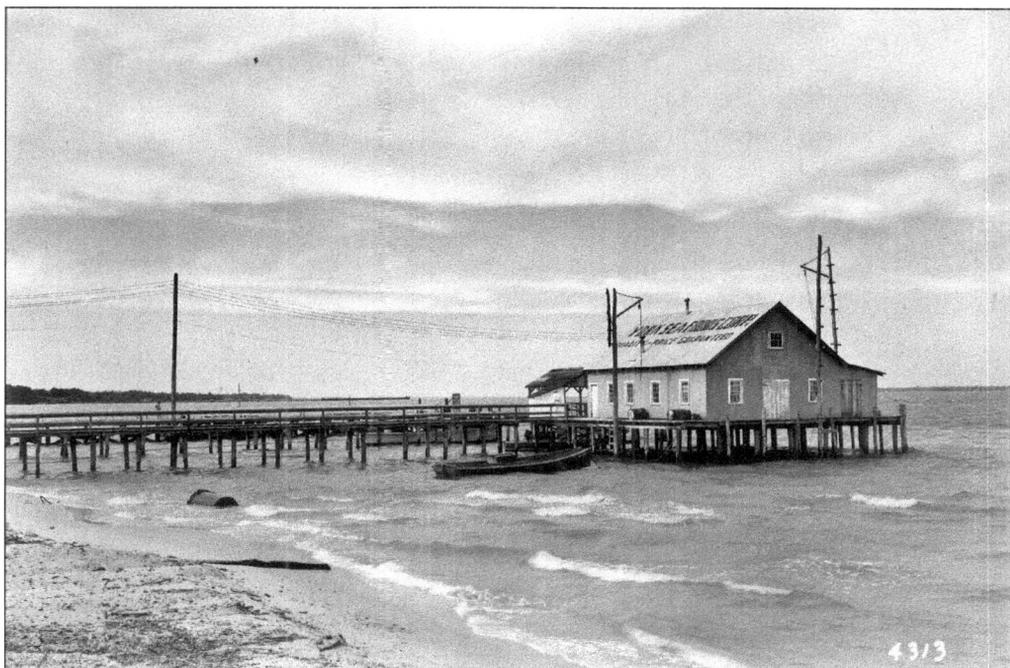

The York Seafood Company pier and fisheries warehouse, next to the Fisheries Bureau and owned by Eugene E. Slaight, provides a backdrop to rolling whitecaps. Mr. Slaight shipped seafood all over the East Coast, and at the time of this 1925 photograph he was considered one of the wealthiest men in Yorktown. (Courtesy of National Park Service, Colonial National Historical Park Yorktown Collection.)

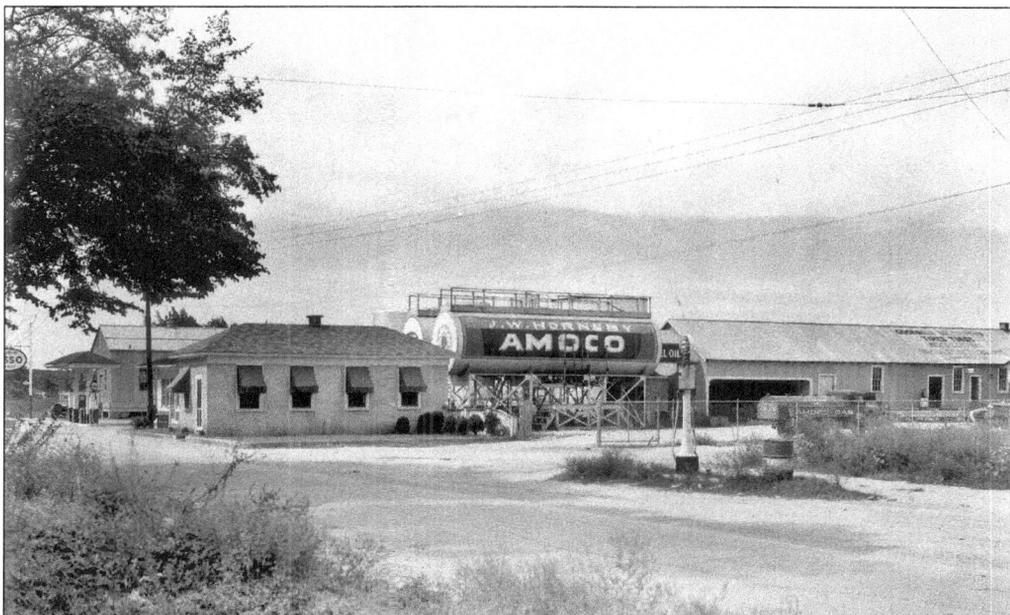

This undated image documents the presence of the J.W.Hornsby Amoco Oil Tanks on Water Street, next to the York Seafood Company pier. (Courtesy of National Park Service, Colonial National Historical Park Yorktown Collection.)

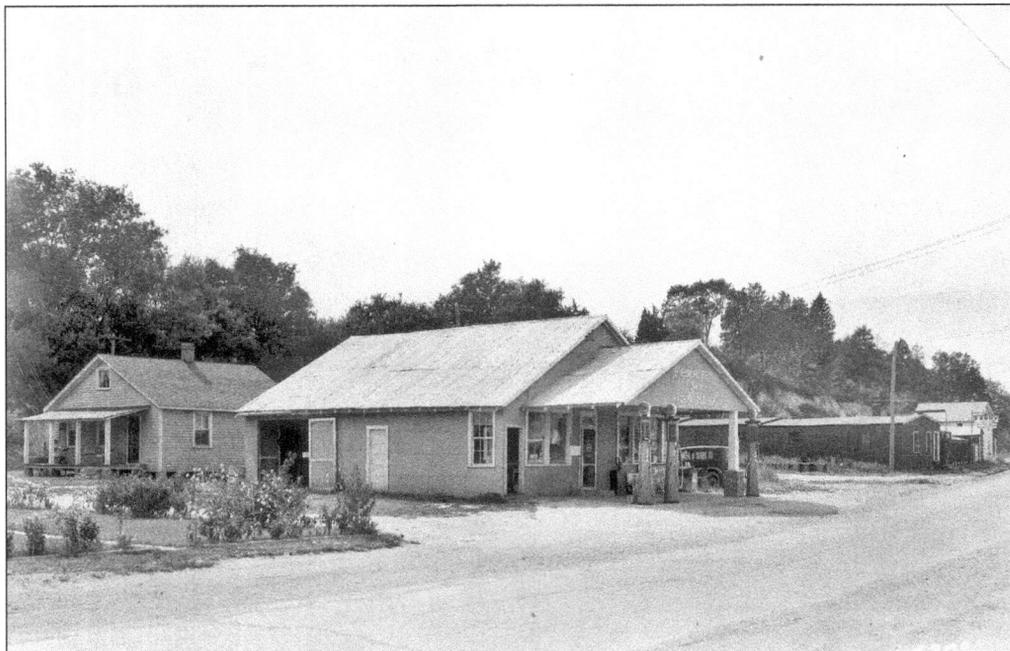

Robert Elmer White's general store on the north side of Water Street is seen in 1925. Mr. White sold items everyone needed, but his primary clientele was the the fishing industry. (Courtesy of National Park Service, Colonial National Historical Park Yorktown Collection.)

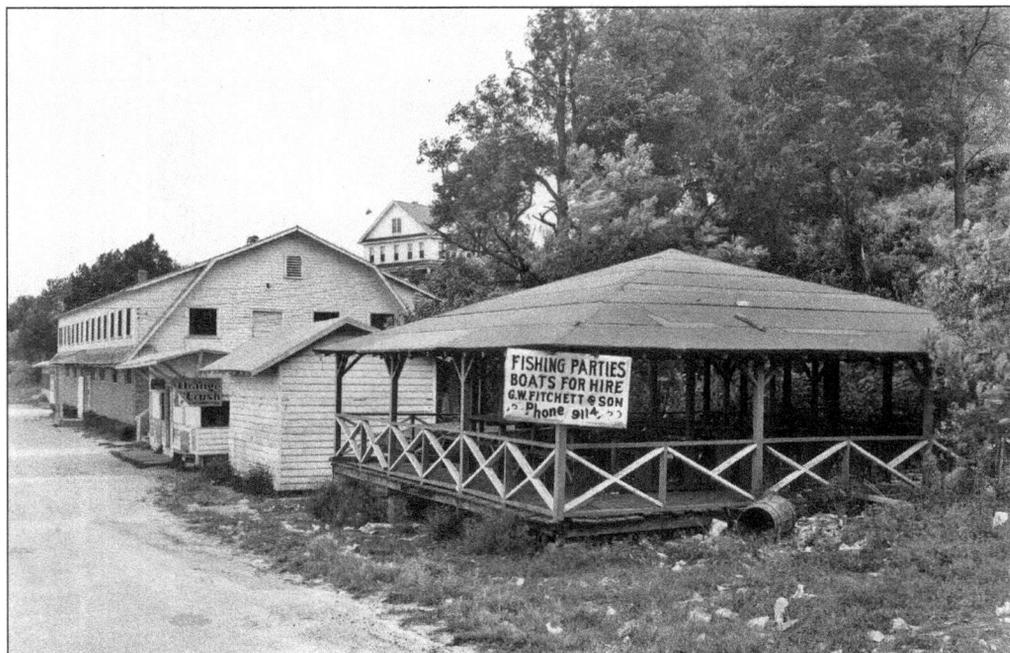

Looking east on Water Street there are small buildings and the Bathhouse, owned by the Crockett Family; the Cooke house is in the background. Note how the telephone number on the sign has no prefix. (Courtesy of National Park Service, Colonial National Historical Park Yorktown Collection.)

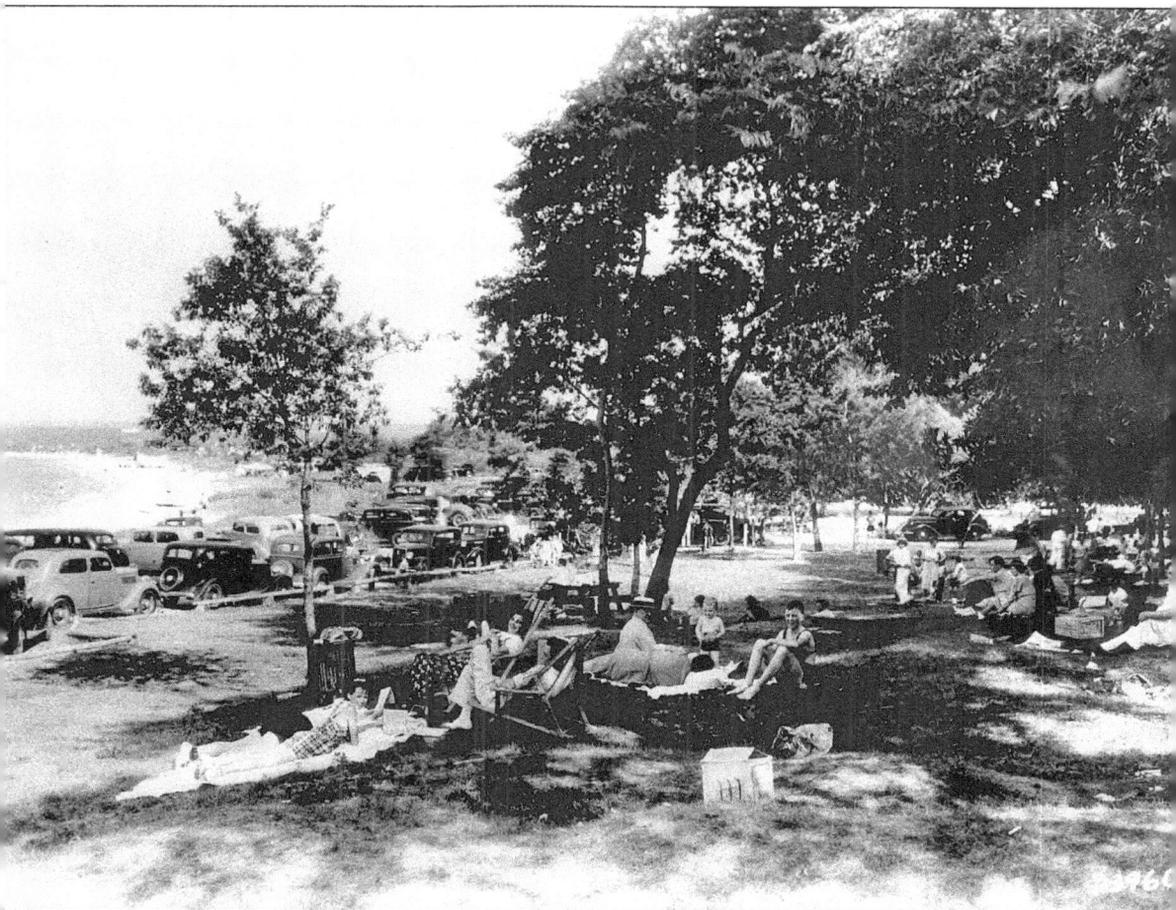

It is a perfect day c. 1930 for a picnic at the beach down from the Victory Monument for the throngs of people looking to enjoy the afternoon. (Courtesy of National Park Service, Colonial National Historical Park Yorktown Collection.)

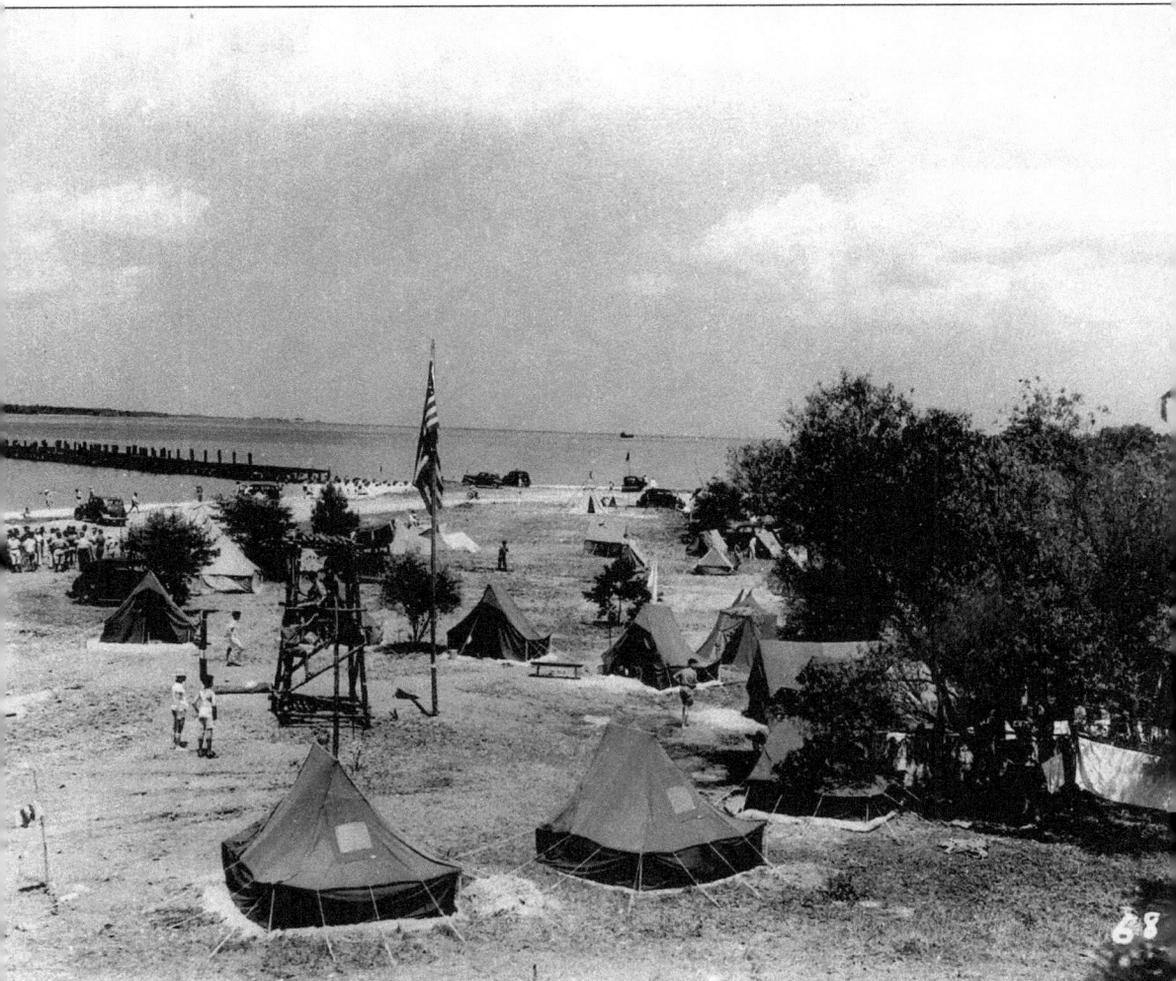

Boy Scout Camp is pictured with the hurricane damaged Manor Hotel wharf in the background, June 18, 1938. (Courtesy of National Park Service, Colonial National Historical Park Yorktown Collection.)

There is a noticeable narrow crossing at Beaver Dam Creek Bridge, September 26, 1936. (Courtesy of National Park Service, Colonial National Historical Park Yorktown Collection.)

A shop and residence is seen c. 1946 at south end of Church Street. (Courtesy of National Park Service, Colonial National Historical Park Yorktown Collection.)

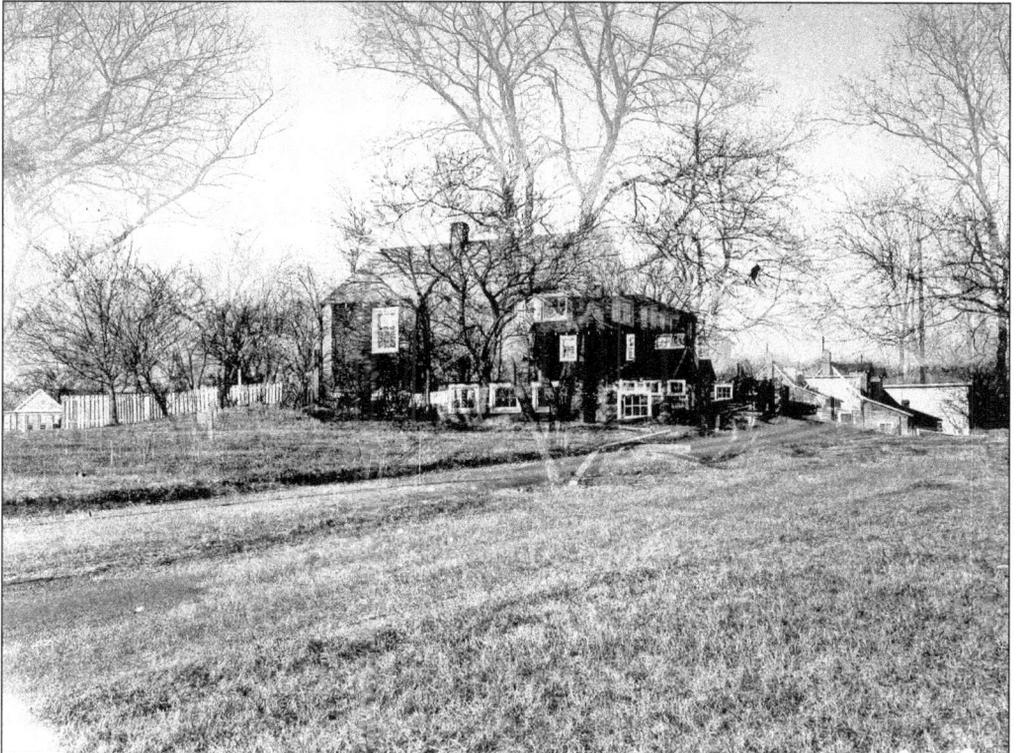

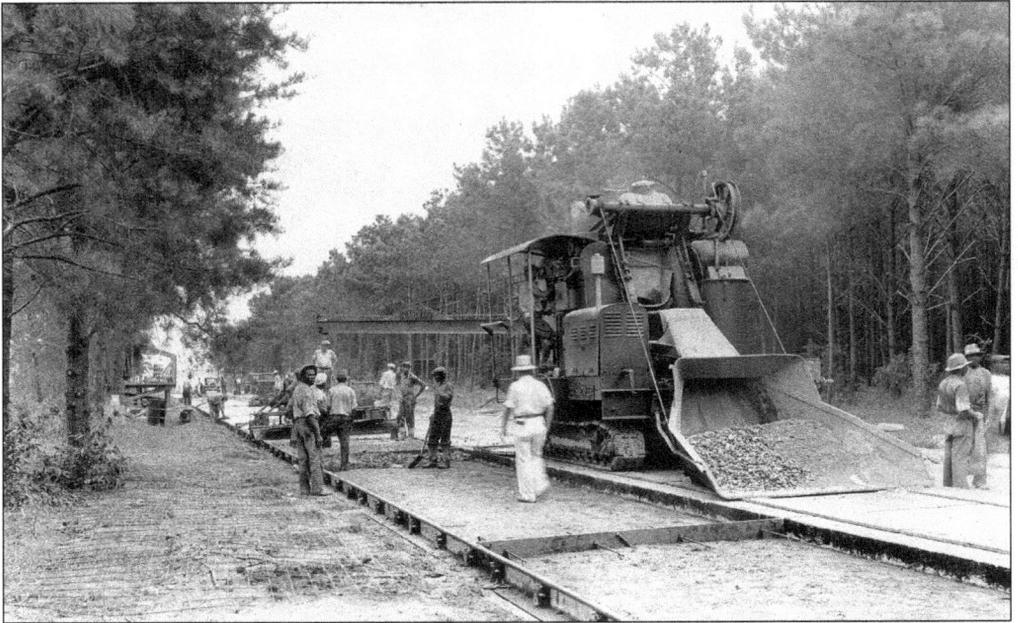

Construction of the Colonial Parkway was underway in this 1931 image. It was a roadway to connect the "historic trinity"—Yorktown, Williamsburg, and Jamestown. This section between Yorktown and Williamsburg was opened in 1938, with the final section to Jamestown dedicated on April 1, 1957. (Courtesy of National Park Service, Colonial National Historical Park Yorktown Collection.)

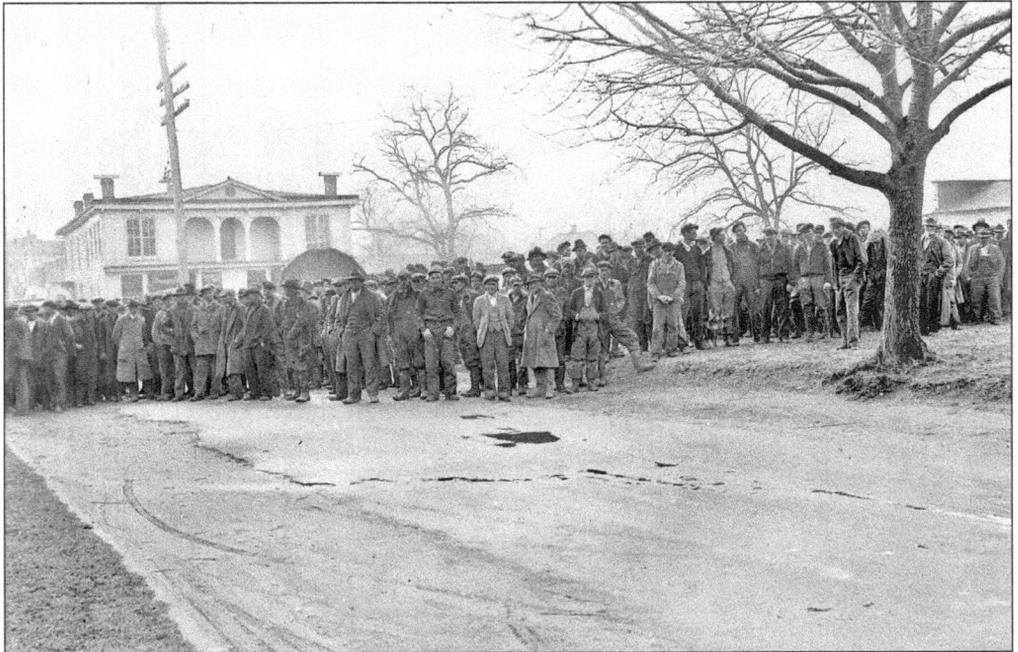

Men gather on December 15, 1933, on Church Street for payday at the Civil Works Administration; the Chandler building is in the background. (Courtesy of National Park Service, Colonial National Historical Park Yorktown Collection.)

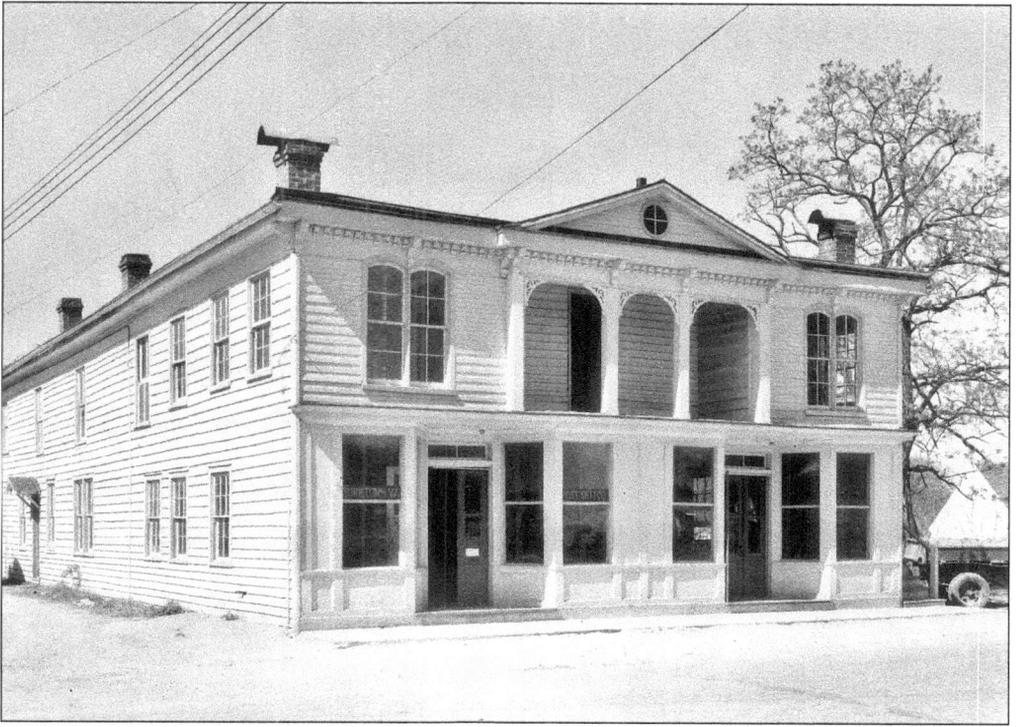

The Chandler Building (facing) on Main and Church, c. 1930, was a commercial building housing many businesses over the years that served Yorktown before it was demolished. (Courtesy of National Park Service, Colonial National Historical Park Yorktown Collection.)

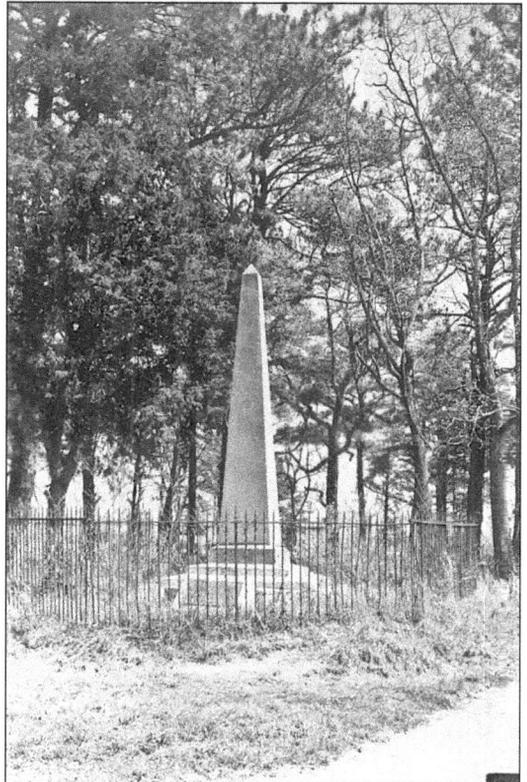

An April 15, 1934 photo shows the Exact Spot Monument, near the National Cemetery, that was erected to show what was considered to be the "exact spot" of surrender of the Revolutionary War. (Courtesy of National Park Service, Colonial National Historical Park Yorktown Collection.)

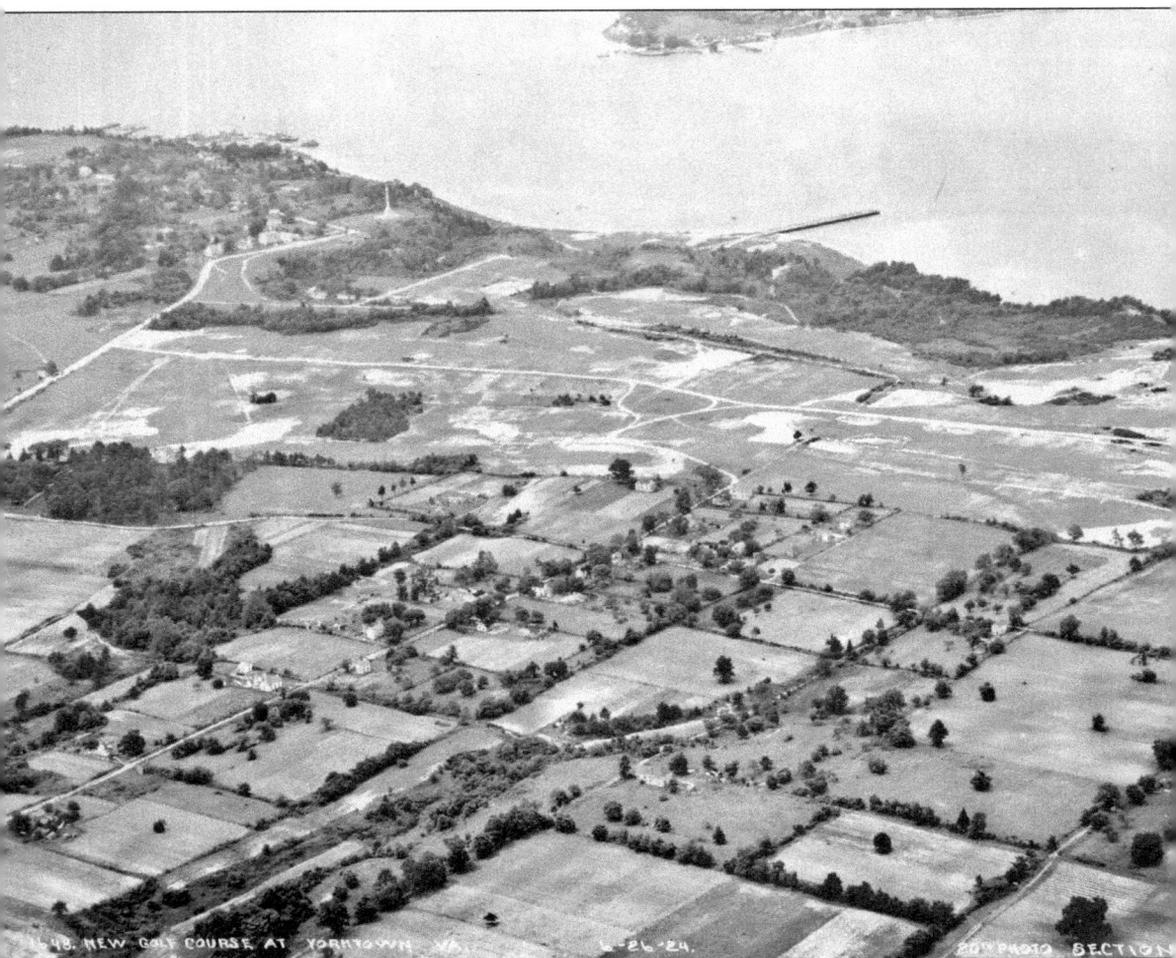

An aerial view captures the golf course on July 26, 1924; this image clearly shows the clusters of trees and houses that make up Uniontown/Slabtown and the central roadway down its center. (Courtesy of National Park Service, Colonial National Historical Park Yorktown Collection.)

Three

Uniontown/Slabtown
and the CCC

Gen. Isaac Jones Wistar, general of the Union forces during the Civil War, described Yorktown as "the Augean stables of the District of Eastern Virginia." (Augean being exceedingly filthy from long neglect). To start, a fortified place needed to be cleared out to house and keep the "contrabands, or refugees"(freed and refugee slaves). In 1863, a large area of abandoned fields was surveyed and laid in two and four-acre lots. The soldiers dubbed this place "Slabtown" because of the slabs of wood that presumably had been put there by previous sawmills in the area. The population was speculated to be a force of 3,000 men besides the 400 black slaves that were on the Post Quartermaster's payroll. A part of Slabtown's beginning was Shiloh Church, named after a church in Philadelphia, Pennsylvania. The original church was closer to the Moore House. In 1974, each family of Uniontown was given notice by the United States Department of the Interior, National Park Service, Mid Atlantic Region, that their homes were subject to inspection for the land acquisition. This procedure, mandated by Congress, authorized the purchase of privately owned lands within the park boundaries. The families were relocated to various neighborhoods in the area. The Civilian Conservation Corps, under President Franklin D. Roosevelt, brought black camps to the area. These men were highly praised and worked on various projects. Along with work there was education in many fields. Much of the clean-up and the area's largest projects were thanks to the work of the CCC.

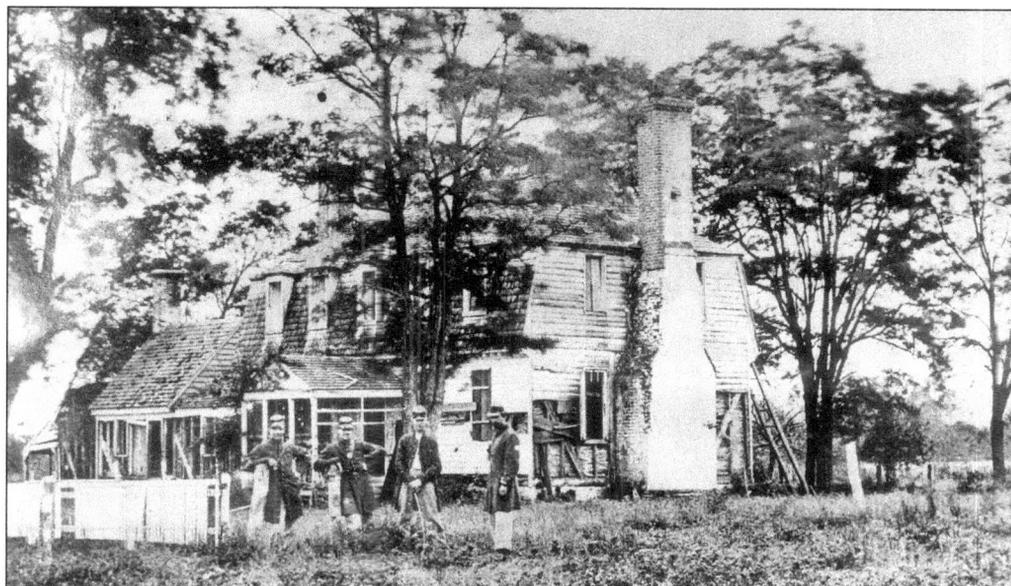

Union soldiers pose in front of the Moore house with the building looking desecrated by Civil War fighting.

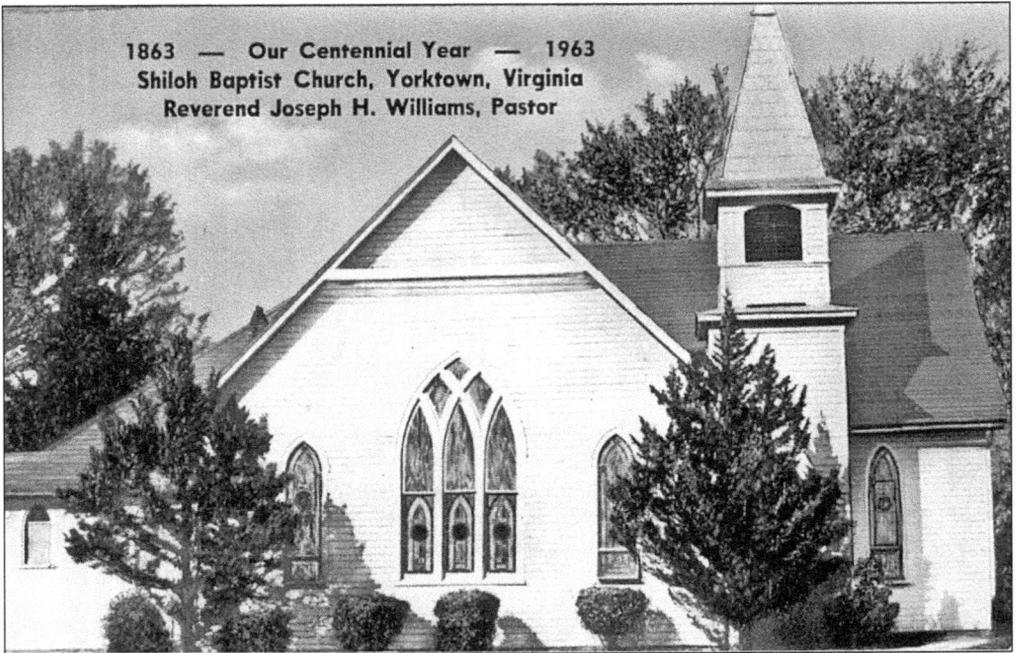

1863 — Our Centennial Year — 1963
Shiloh Baptist Church, Yorktown, Virginia
Reverend Joseph H. Williams, Pastor

Shiloh Baptist Church (now demolished) on Cook and Goosley Road is shown here. (Courtesy of Lillian Lewis, Shiloh Baptist Church.)

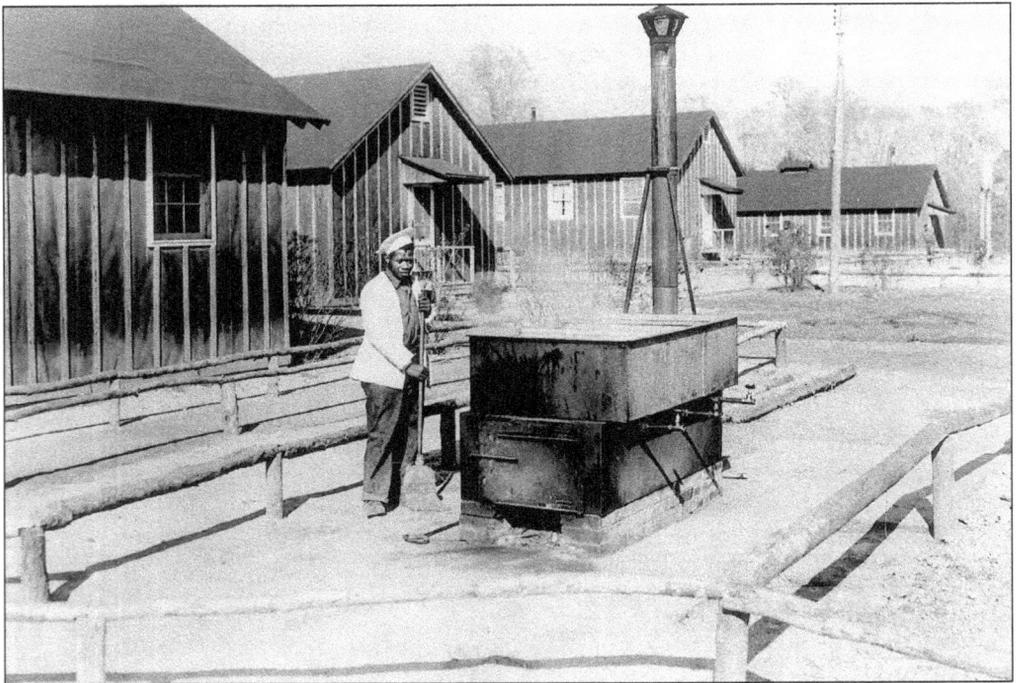

A proud culinary member is at work at the barracks of camp 352. Selection for the CCC consisted of candidates 18 to 25 years of age, unmarried, unemployed, and fit to serve at least six months and in agreement to allot $25 to $30 to their dependents. (Courtesy of National Park Service, Colonial National Historical Park Yorktown Collection.)

A view from the redoubt nine (a reinforced earthworks) of Uniontown was taken on May 24, 1954. (Courtesy of National Park Service. Colonial National Historical Park Yorktown Collection.)

This intersection in Slabtown is pictured c. 1980, after the neighborhood was abandoned. (Courtesy of National Park Service, Colonial National Historical Park Yorktown Collection.)

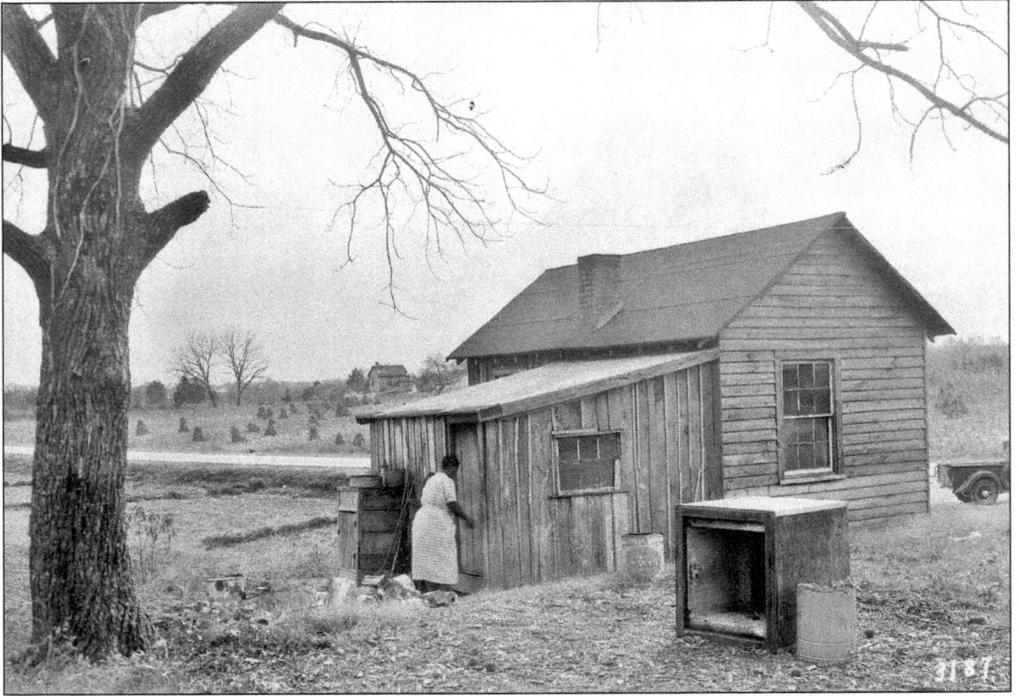

This October 29, 1935 photograph shows a cottage along Old Route 17. (Courtesy of National Park Service, Colonial National Historical Park Yorktown Collection.)

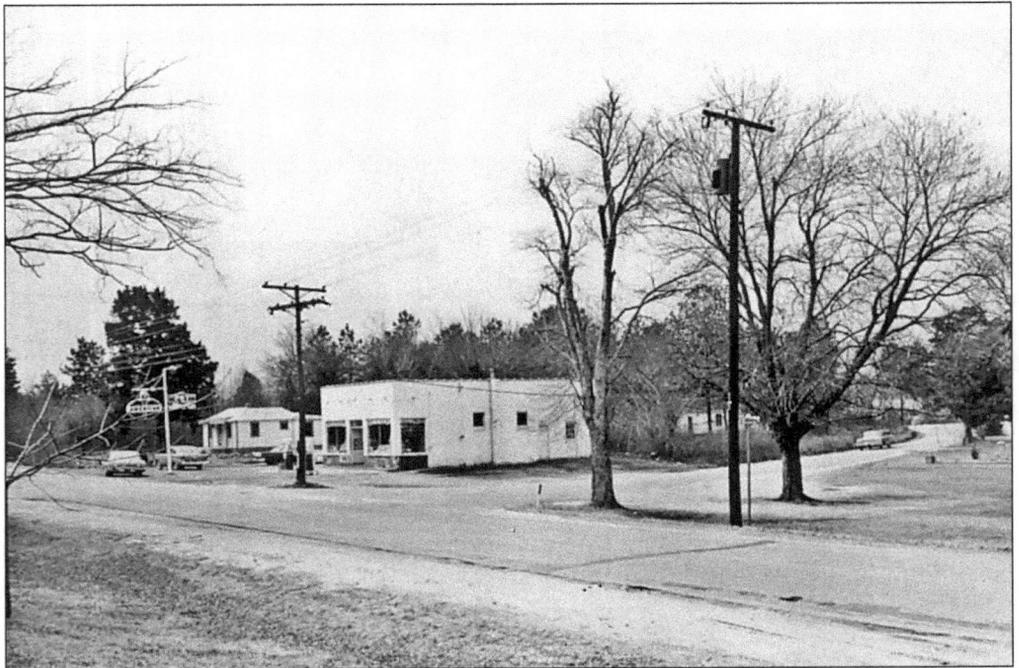

Many people remember the Vadie Hopson property at intersection of Goosley Road and Old Route 17 across from the National Cemetery. (Courtesy of National Park Service, Colonial National Historical Park Yorktown Collection.)

Cooks pose outside their kitchen at the CCC camp. With the formation of the work programs at the start of the Roosevelt administration, black camps were formed and accomplished—with praised results—much of the clearing and clean-up around the Yorktown area. (Courtesy of National Park Service, Colonial National Historical Park Yorktown Collection.)

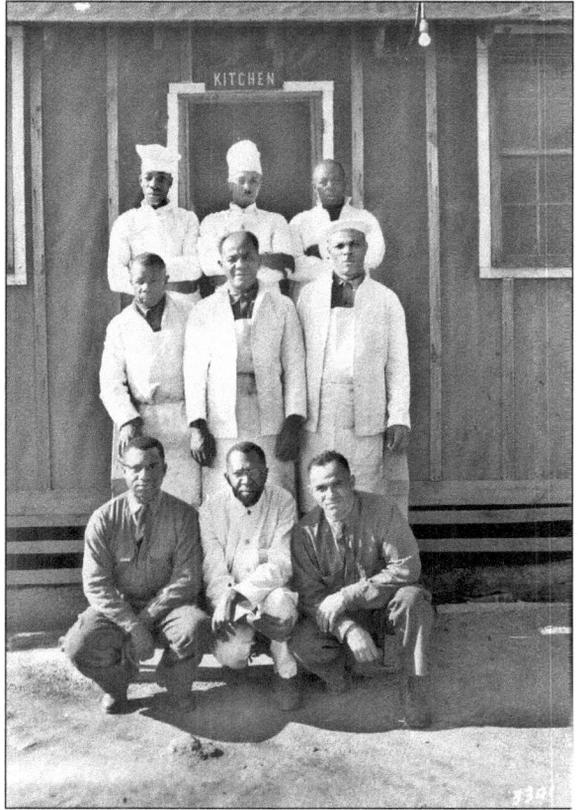

The Camp of 323 Company of the CCC was just off of Surrender Road in 1933. These men were credited with work at the Naval Mine Depot, clearing property at Ringfield plantation, Jones Pond, and effected erosion control on the Historical Parkway. (Courtesy of National Park Service, Colonial National Historical Park Yorktown Collection.)

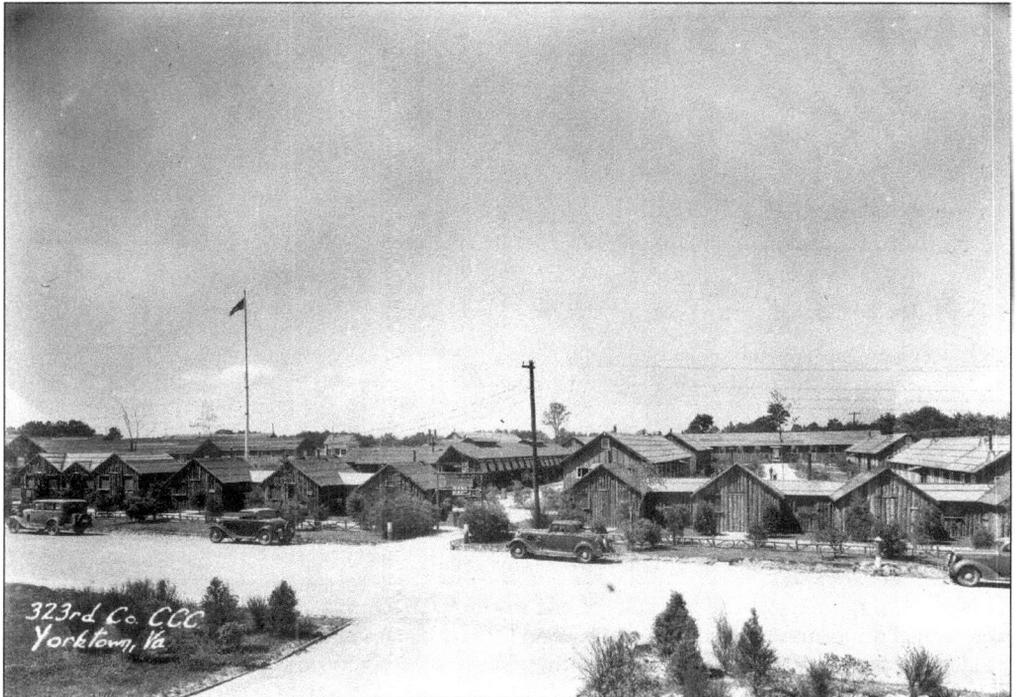

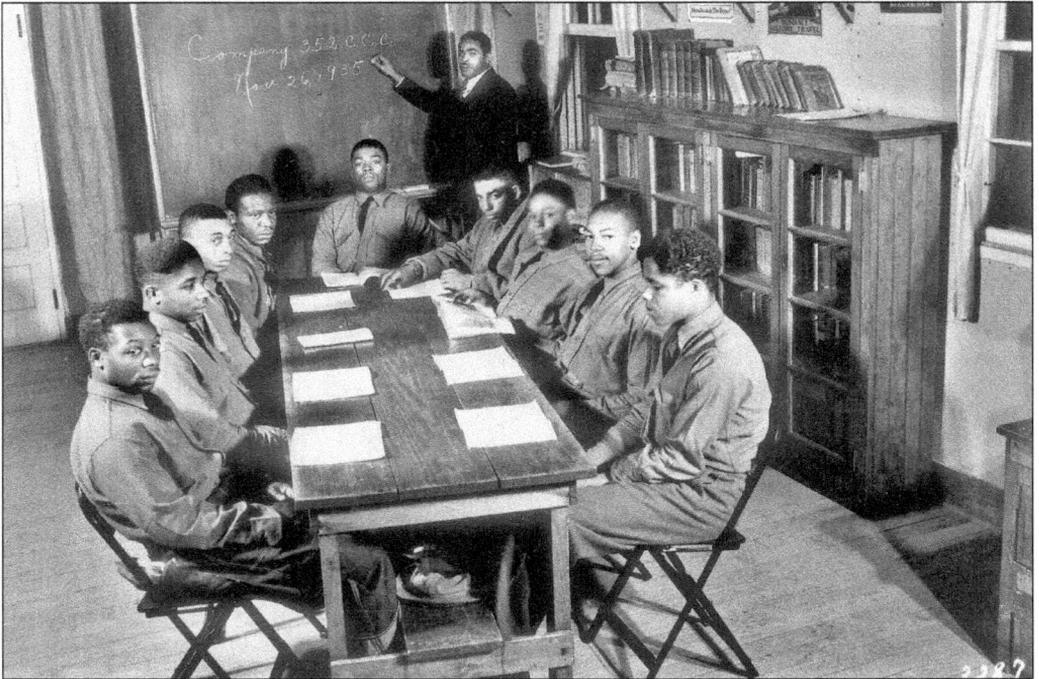

A diligent group of students sit in a classroom of Company 352 of the CCC on November 26, 1935. This company of men was formed in May of 1933 and were credited with cleaning up the newly acquired Park property, excavating the Swan Tavern, running a tool repair outfit, and dispensing gas and oil. (Courtesy of National Park Service, Colonial National Historical Park Yorktown Collection.)

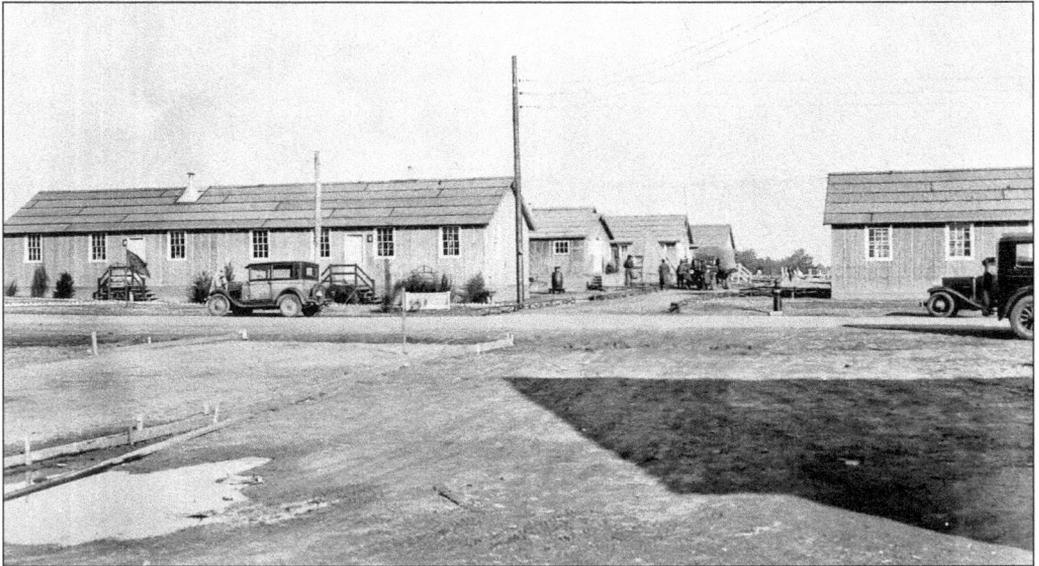

This photograph depicts the barracks of one of the CCC camps in 1933. Upon entry the men were issued uniforms and went to training and literary classes mandated for all the CCC camps. Studies, to list a few, were in cabinet making, mechanics, safety, and pipe fitting. (Courtesy of National Park Service, Colonial National Historical Park Yorktown Collection.)

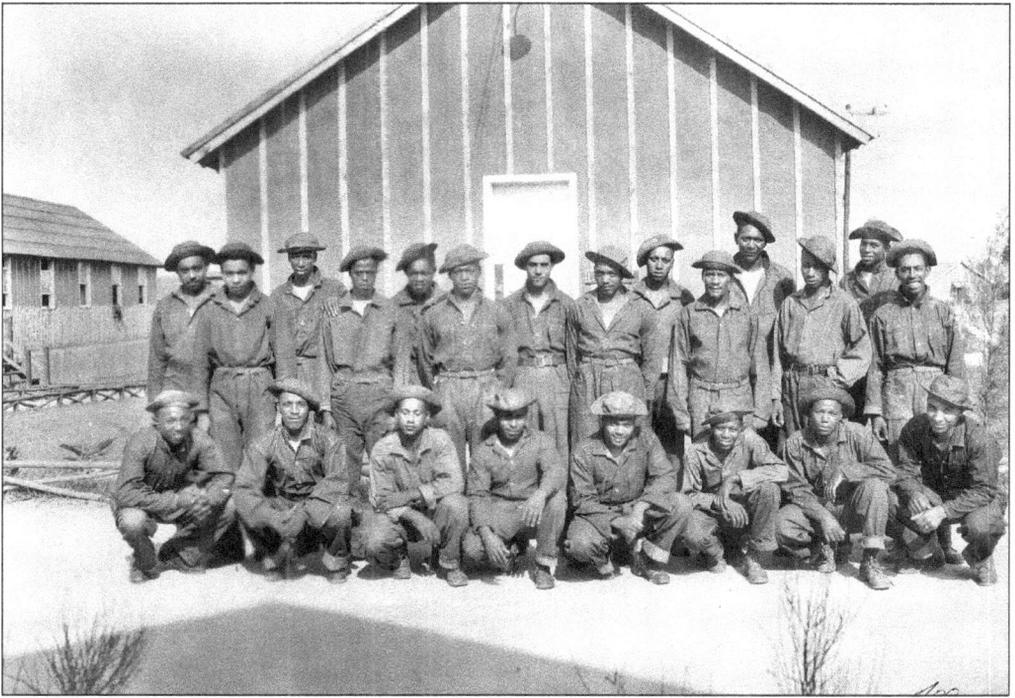

CCC members posed for this picture upon receiving their honorable discharge on June 28, 1934. (Courtesy of National Park Service, Colonial National Historical Park Yorktown Collection.)

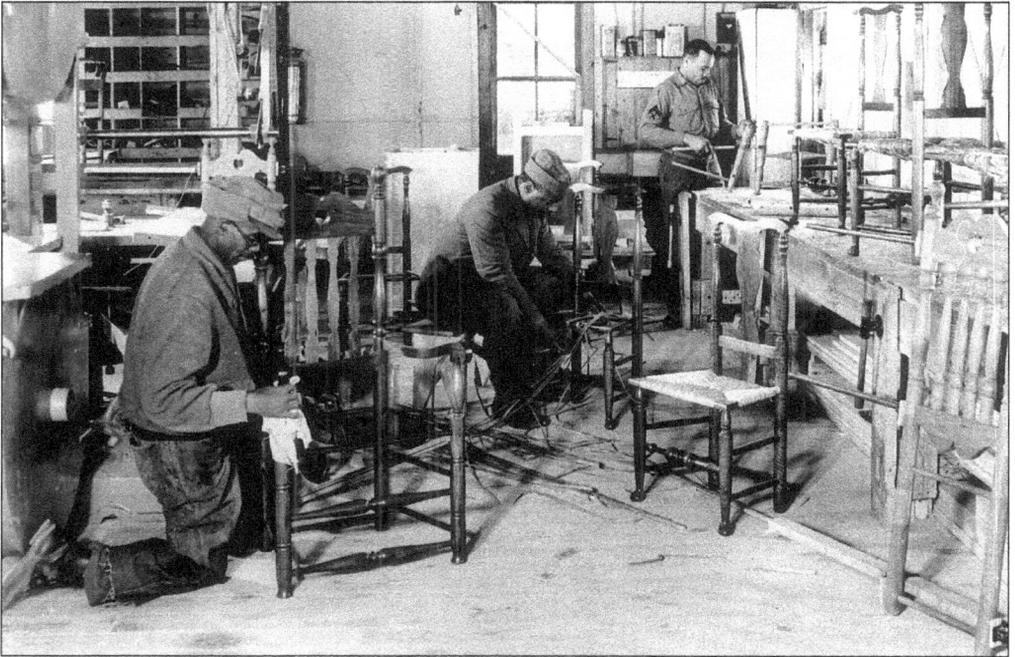

Craftsmen create chairs at the CCC camp. (Courtesy of National Park Service, Colonial National Historical Park Yorktown Collection.)

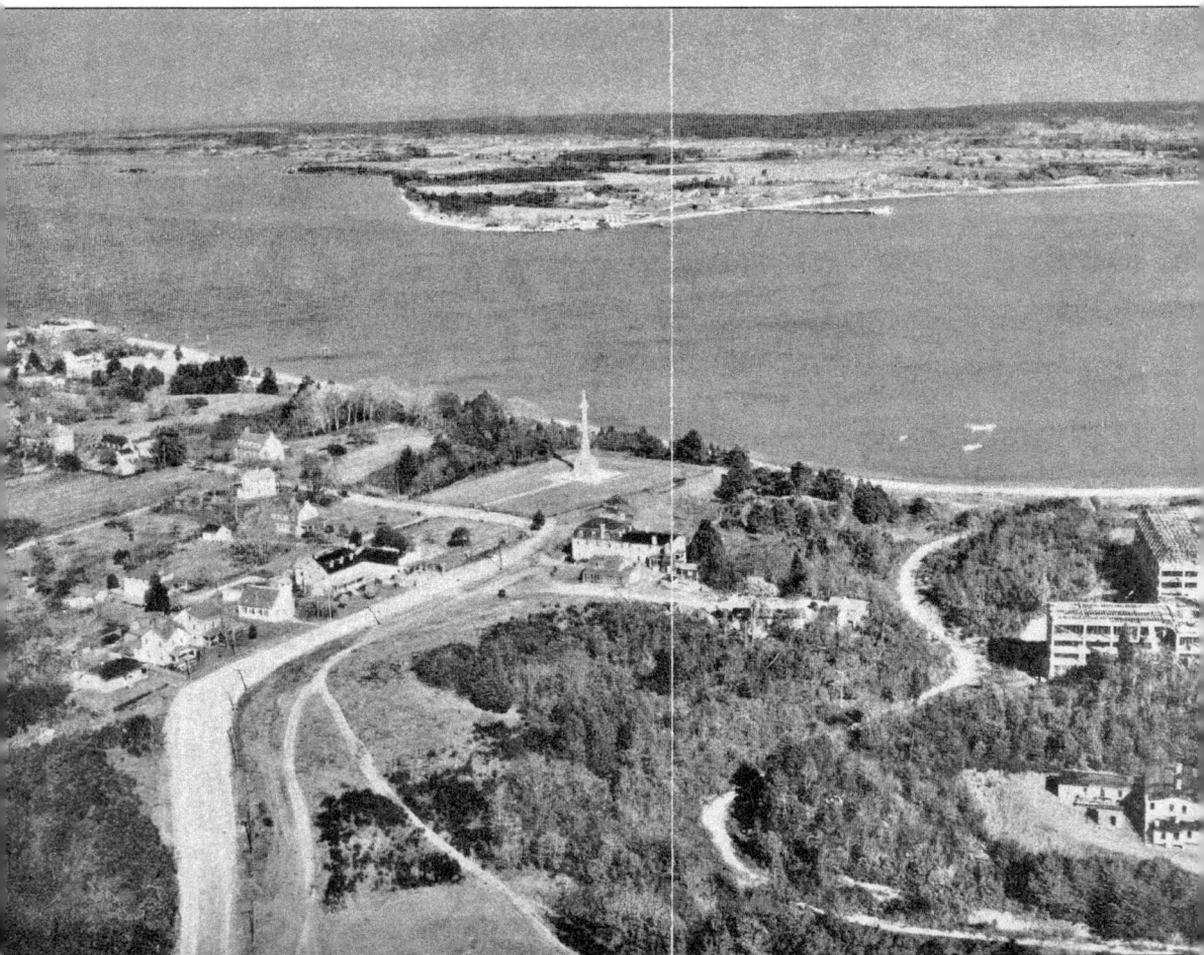

This aerial shot reflects the markings of a resort town's beginning, c. 1925, as it is clear that things are beginning to change. Monument Road more directly moves toward the monument as before, but now the Monument Lodge is seen clearly and the structure of the Yorktown Manor Hotel is in the building stages. Also note the Methodist Church on Monument Road as well as a view of Glouscester Point without Coleman Bridge. (Courtesy of National Park Service, Colonial National Historical Park Yorktown Collection.)

Four

THE YORKTOWN
MANOR HOTEL

In an article in the Richmond Times Dispatch on May 20, 1925, Dr. John Braun of Philadelphia, president of the Yorktown Country Club and Philadelphia Art Alliance, regretted that the government had not taken over the historic battlefields. The plans for the hotel offered the most modern facility for the visitors comfort. It was going to be fully fireproof, with a ballroom in one wing and both dining rooms in the other. Of the 300 rooms, 52 were to have private baths. In the southwestern wing there were to be 50 rooms for dormitories, with baths for single men. "All the corridors would reach exterior walls, insuring free currents of fresh air." Luxury was planned with rooms that would have slatted doors and 40 rooms to have fireplaces. The manor house was to follow the colonial Georgian style. The Riverview 18-hole golf course on the battlefield opened on July 4, 1924. Two golf courses were planned but the existing course was on the side nearest the river, with a golf shack.

The place and timing was everything. Two years later, the owners were bankrupt. The worst of times were ahead for the everyone in America and yet, the Sesquicentennial Celebration was in rumor stages. There was hope!

Mrs. George Durbin Chenoweth (left), Regent of the local DAR for 25 years and Mrs Arthur Evans, financier of the restoration of the Customs House, were enduring friends and well respected for their tireless work to preserve history in Yorktown. (Courtesy of O'Hara Collection.)

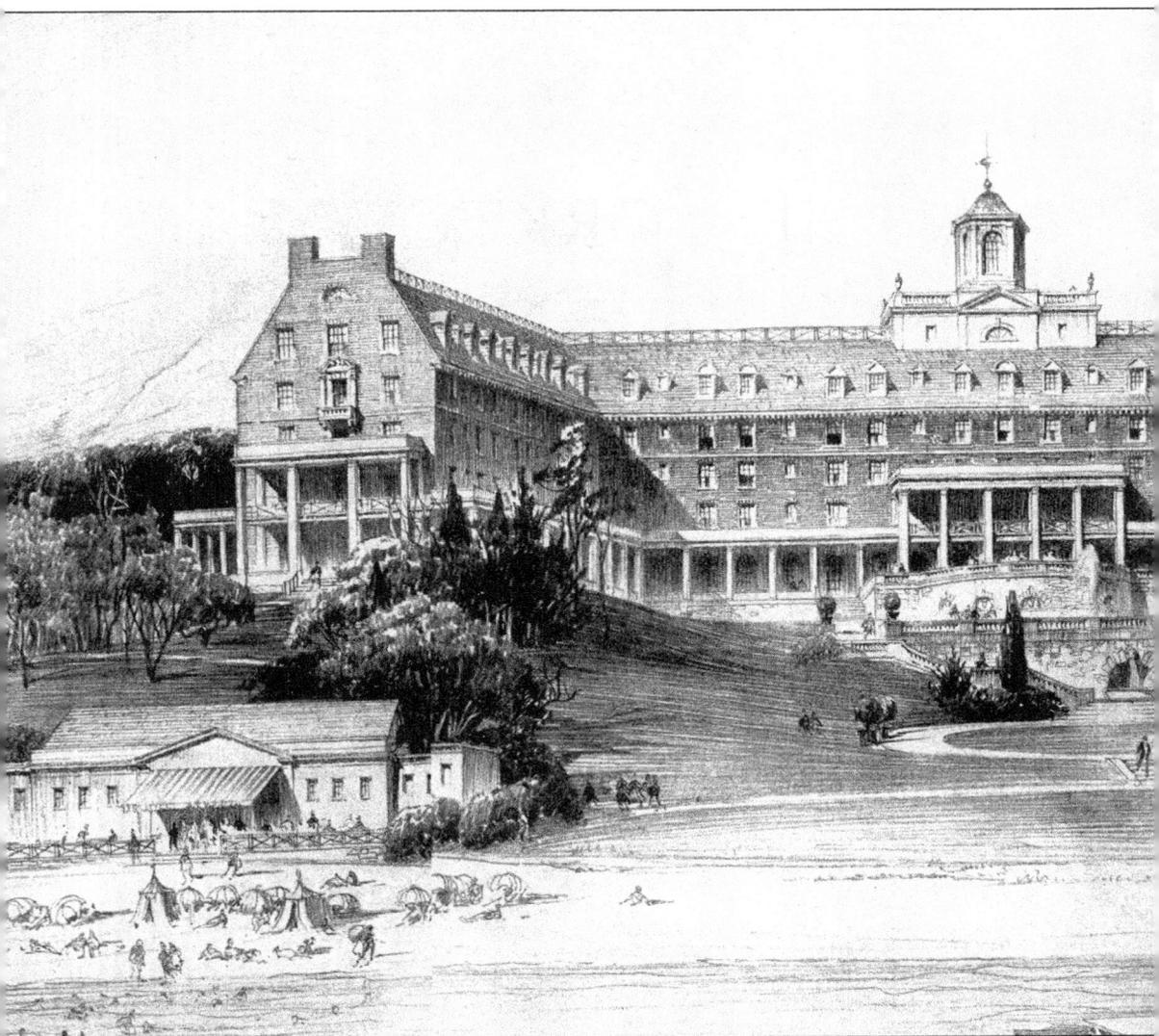

This architect's rendering was publicized to be a hotel set on "principal forts, ramparts and entrenchments seated high on a picturesque plateau overlooking the York River." Three hundred rooms were planned where the main building would house a huge amphitheater with the sides terracing down to the beach seventy feet below. A casino was to be included and there

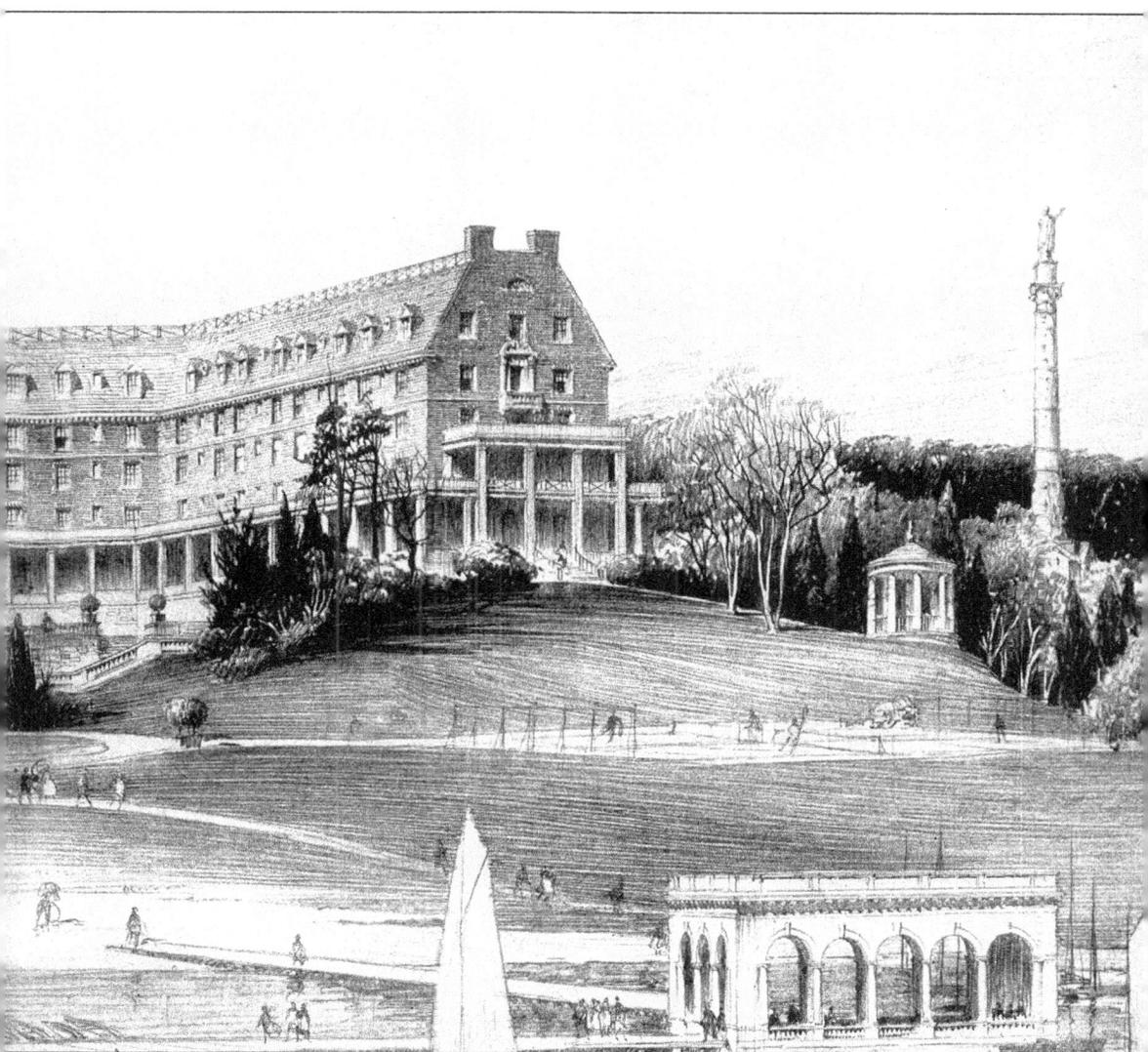

was to be ample space for "dancing fetes, and entertainments." Dining rooms large and small were planned and would have open verandas for outdoor teas and dinners. (Courtesy of the O'Hara Collection.)

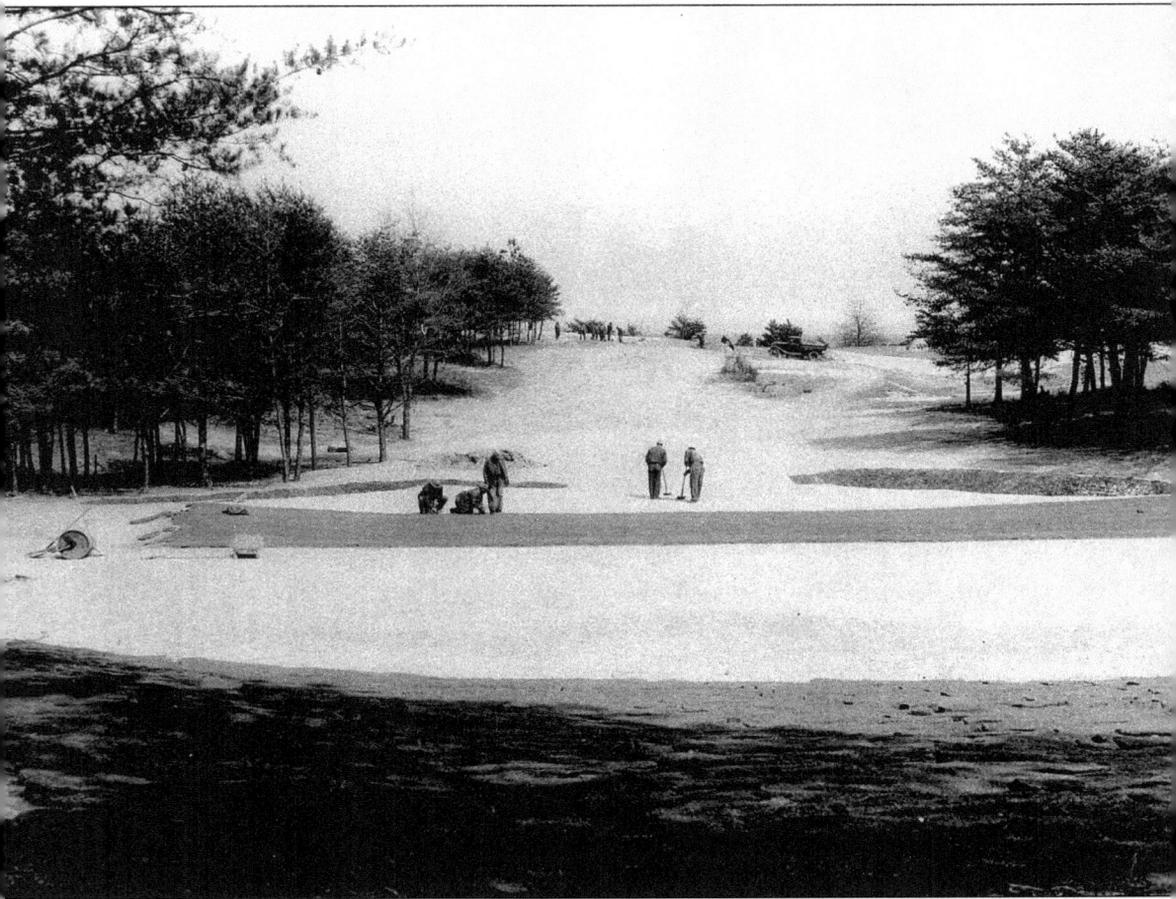

An 18-hole golf course was built and opened on July 4, 1924. This photograph clearly shows some maintenance on one of the holes. The topography of the battlefield lent itself naturally to being recognized as one of America's finest. With the golf course open and operating, the owners were negotiating a large tract of land nearby for fishing and a shooting preserve. It was "a veritable paradise to the sportsman with a rod and a gun." (Courtesy of National Park Service, Colonial National Historical Park Yorktown Collection.)

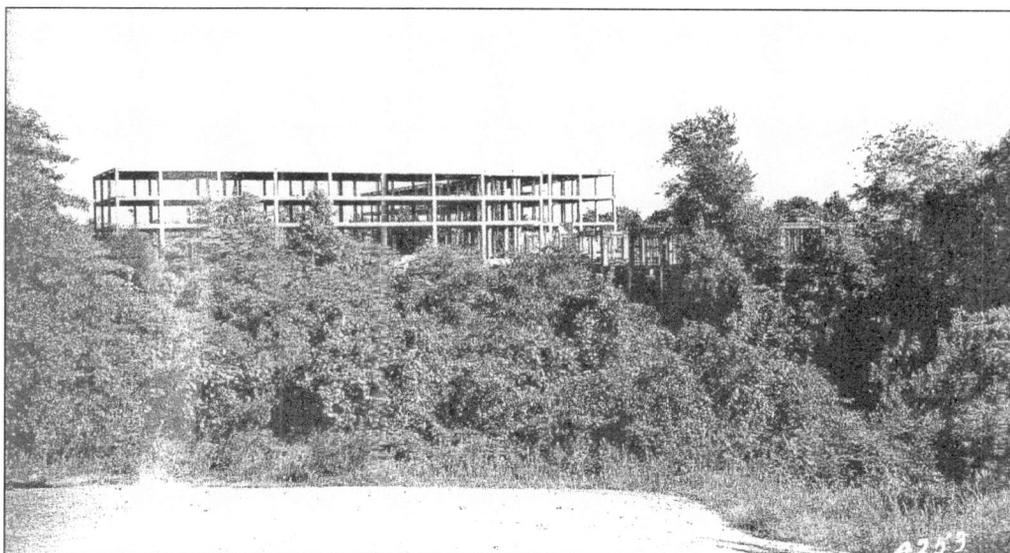

The structure of the hotel could be clearly seen here on September 11, 1936, 10 years after the project had failed. (Courtesy of National Park Service, Colonial National Historical Park Yorktown Collection.)

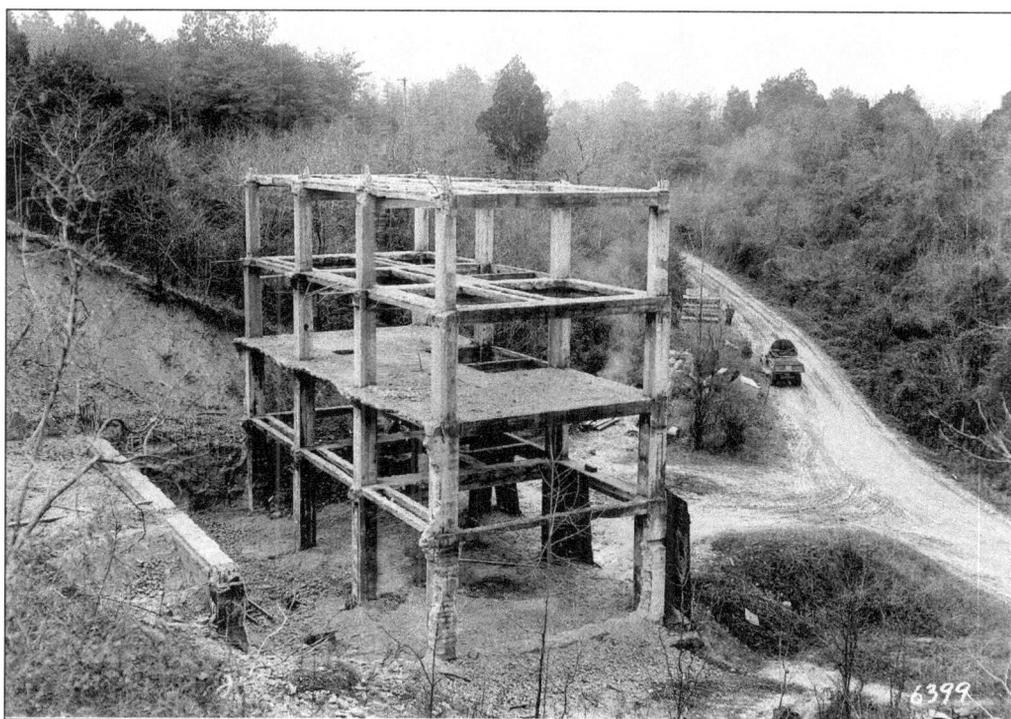

This close-up shot shows one of the hotel's structures during demolition, with Tobacco Road running in the background. (Courtesy of National Park Service, Colonial National Historical Park Yorktown Collection.)

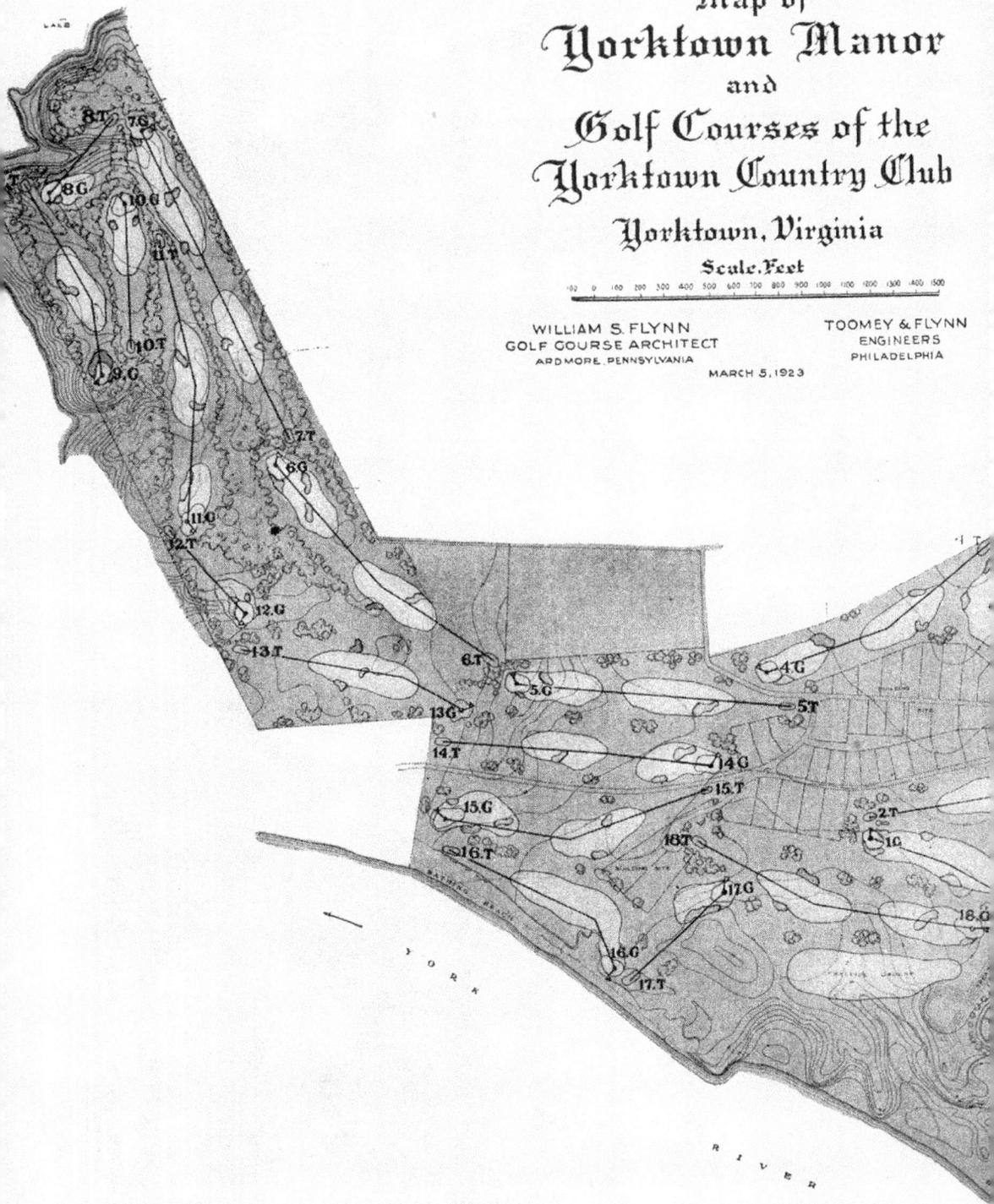

Map of
Yorktown Manor
and
Golf Courses of the
Yorktown Country Club
Yorktown, Virginia
Scale.Feet

WILLIAM S. FLYNN
GOLF COURSE ARCHITECT
ARDMORE, PENNSYLVANIA

TOOMEY & FLYNN
ENGINEERS
PHILADELPHIA

MARCH 5, 1923

This map of the golf course displays the design and layout. For those who always wondered, this is the first visual of the dream course that operated for many years on the battlefield.

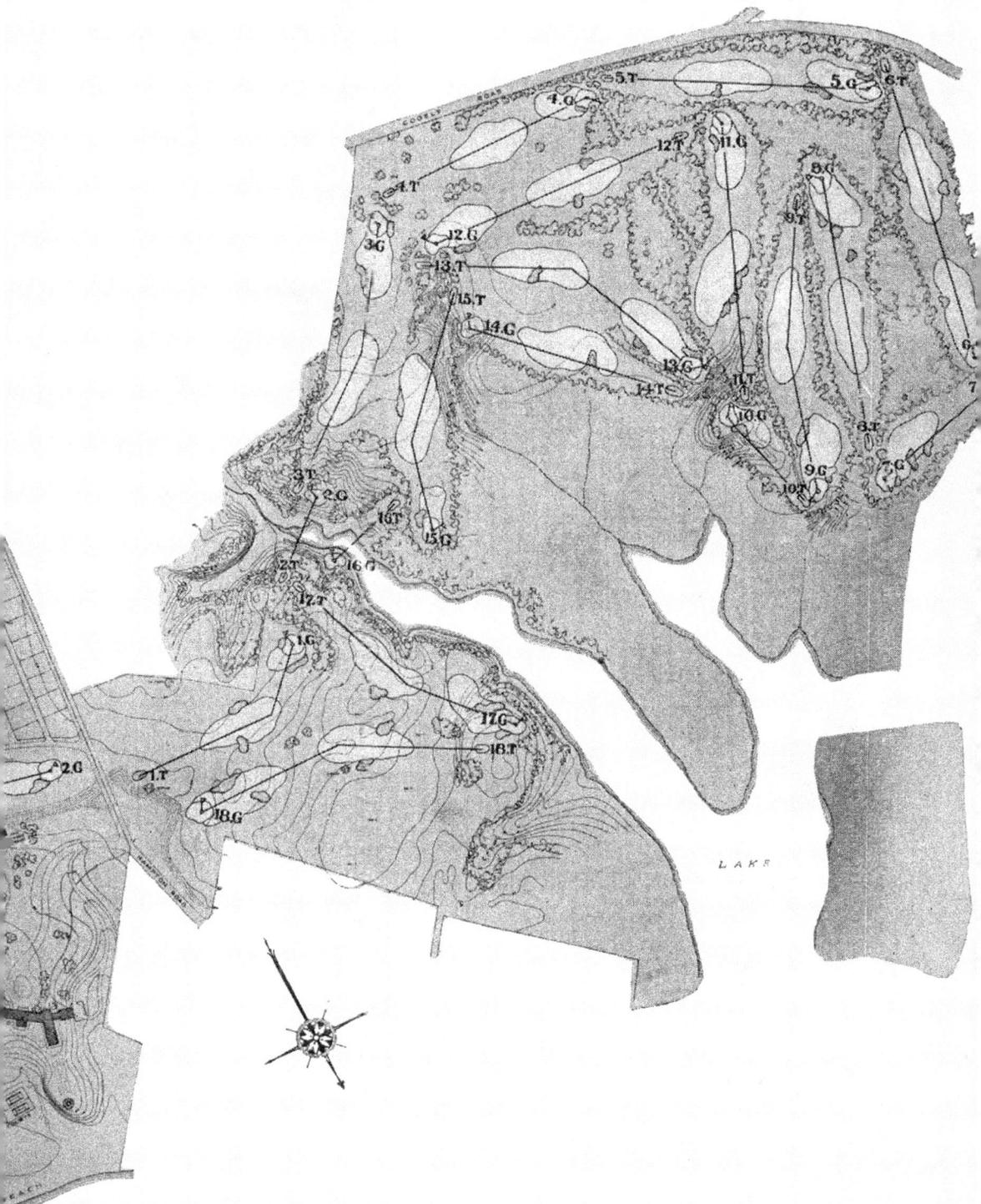

(Courtesy of O'Hara Collection.)

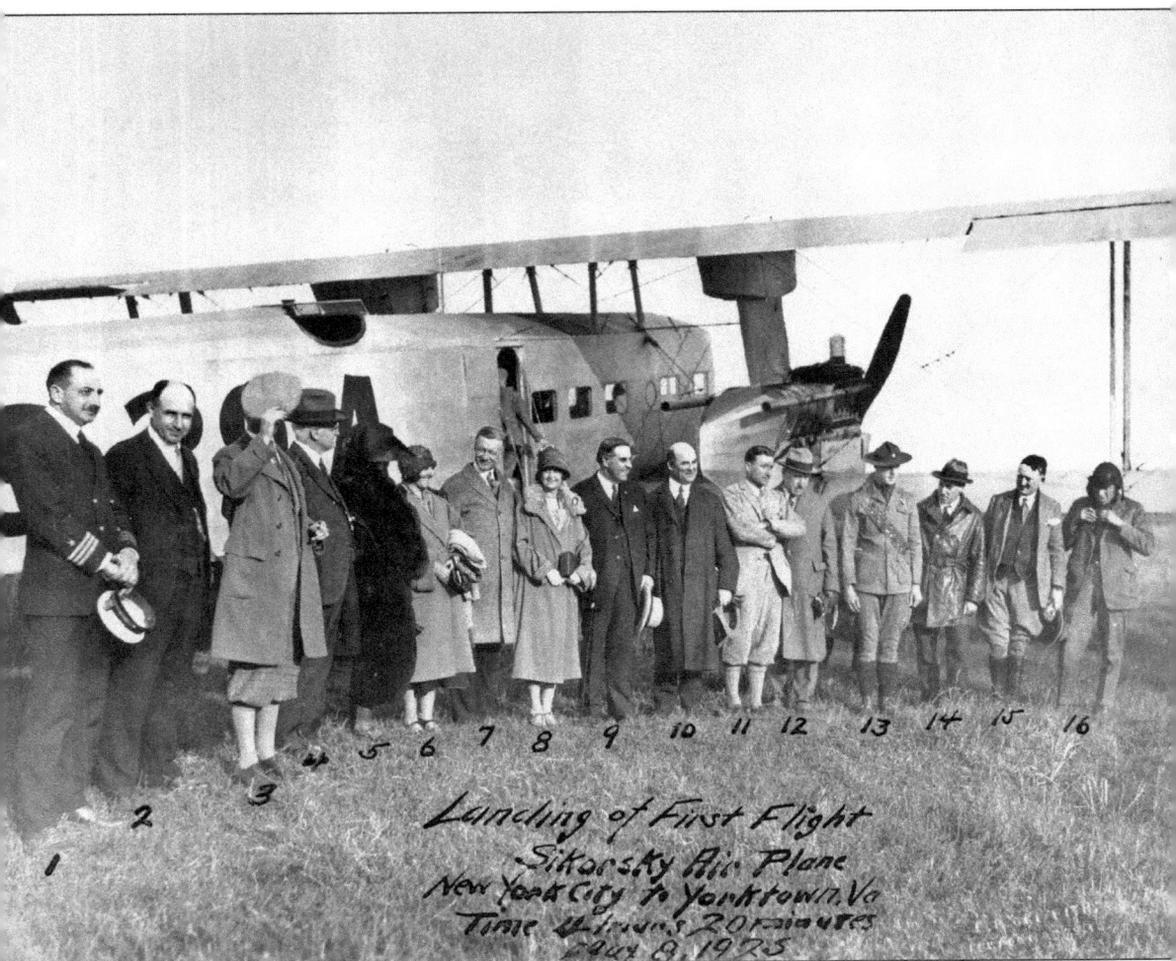

Handwritten on photograph:

4 5 6 7 8 9 10 11 12 13 14 15 16

3

2

1

Landing of First Flight
Sikorsky Air Plane
New York City to Yorktown, Va
Time 4 hours 20 minutes
May 8, 1925

On the morning of May 8, 1925, from Mineola, Long Island, 12 passengers christened the Sikorsky Air Plane, General Airways S-29-A, piloted by its inventor, and flew the route that Washington had marched in 1781. Flying at an altitude of 3,500 feet at 110 mph, a broadcast of their trip could be heard on the radio throughout their flight. They arrived at 5:15 p.m. near the Naval Mine Depot. A memorial stone was laid to commemorate the first passenger flight on a regular route in the country. (Courtesy of National Park Service, Colonial National Historical Park Yorktown Collection.)

WORLD FORUM OF FREEDOM

AT YORKTOWN IN VIRGINIA

Agreed at 3500' altitude

CLARENCE J. OWENS
Director General

Executive Offices

New York, 350 Madison Avenue

May 8, 1925.

Initial Flight From New York To Yorktown In Sikorsky's Air Plane - S-29-A

--

Signatures Of Those Making The Flight

--

Name	Address
[signature]	N. club New York
Clarence J. Owens	Washington, D.S.
[signature]	New York City.
Millard Bloom	Am. Airways Corp. N.Y. (4000' up)
Geo. a. Galliver	Orange N.J.
Jimmy Washington	Virginia
Don S. Duncan	Cal.
Jose Evans	Yorktown. Va
Charles B. Collyer	(Navigator) Va.
Alex. Krapish	Westbury L.I.
Andrew N. Beliaeff.	Mitchel Field L. I. N.Y
I. Sikorsky	Westbury L.I.
Harold F. Hartney	Washington, D.C. (joined flight at Washington D.C.)

With handwriting that looked like calligraphy, the signatures of the flight members were signed on the "World Forum of Freedom" stationary. The World Forum was to be a place for world assembly to discuss political problems that consisted of the historical society, established to disperse facts of history, and the country club, which offered accommodations to guests arriving from all over the world. (Courtesy of National Park Service, Colonial National Historical Park Yorktown Collection.)

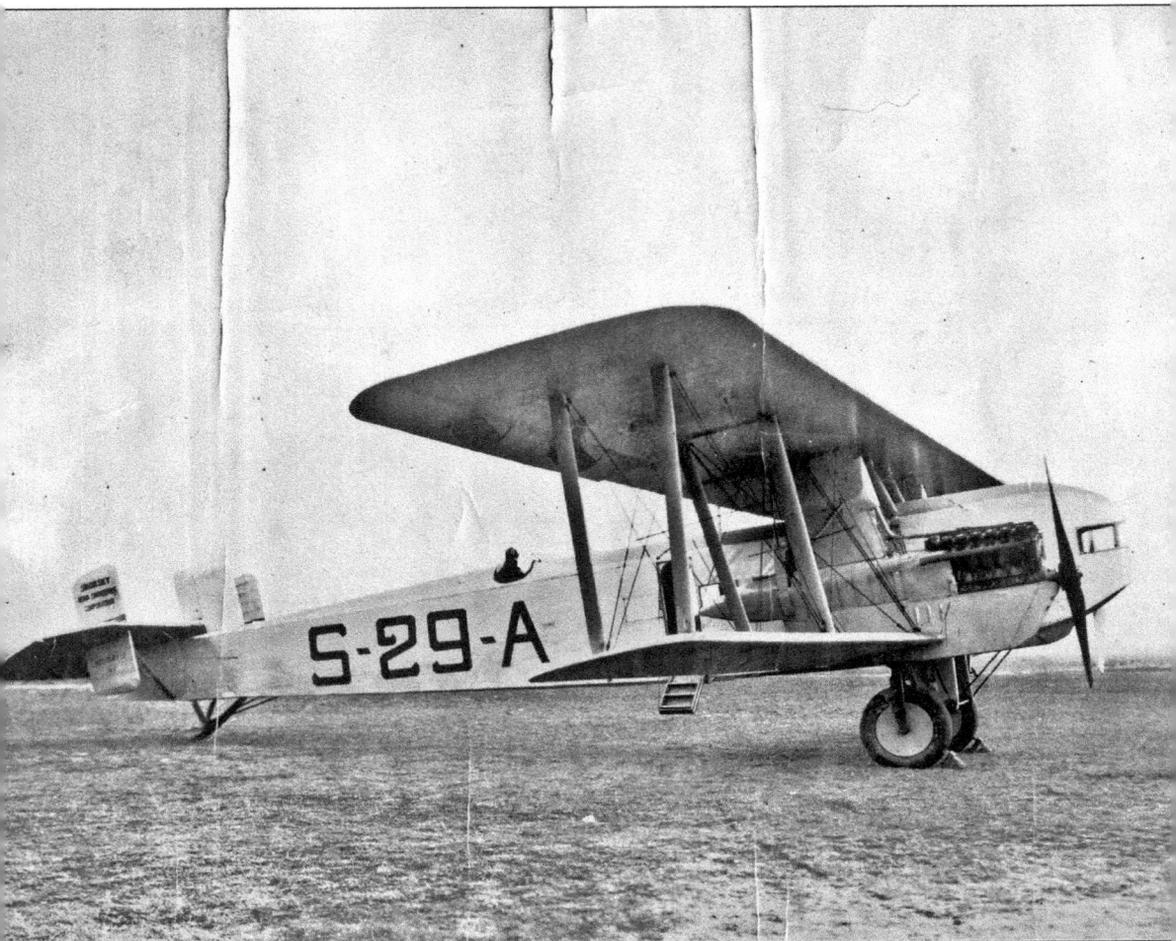

This S-29-A Sikorsky Air Plane carried the passengers of the publicity flight for the country club in Yorktown. Among the passengers was Fannie Washington, General Washington's great-great grandniece. Their route of flight was to have a ceremonial stop in Washington, D.C.; however a water leak in the engine caused a forced landing at Logan Field in Baltimore, Maryland. With minor repairs made, they continued on and landed safely that day in Yorktown. The first commercial flight was made, and a continuing service of departures from New York City was planned on Fridays, with a return on Sundays, at a cost of $60 per round trip. (Courtesy of National Park Service, Colonial National Historical Park Yorktown Collection.)

Western Union delivered the good news that the flight had made the journey safely and in good time. Surely there were people anxiously awaiting the news. (Courtesy of National Park Service, Colonial National Historical Park Yorktown Collection.)

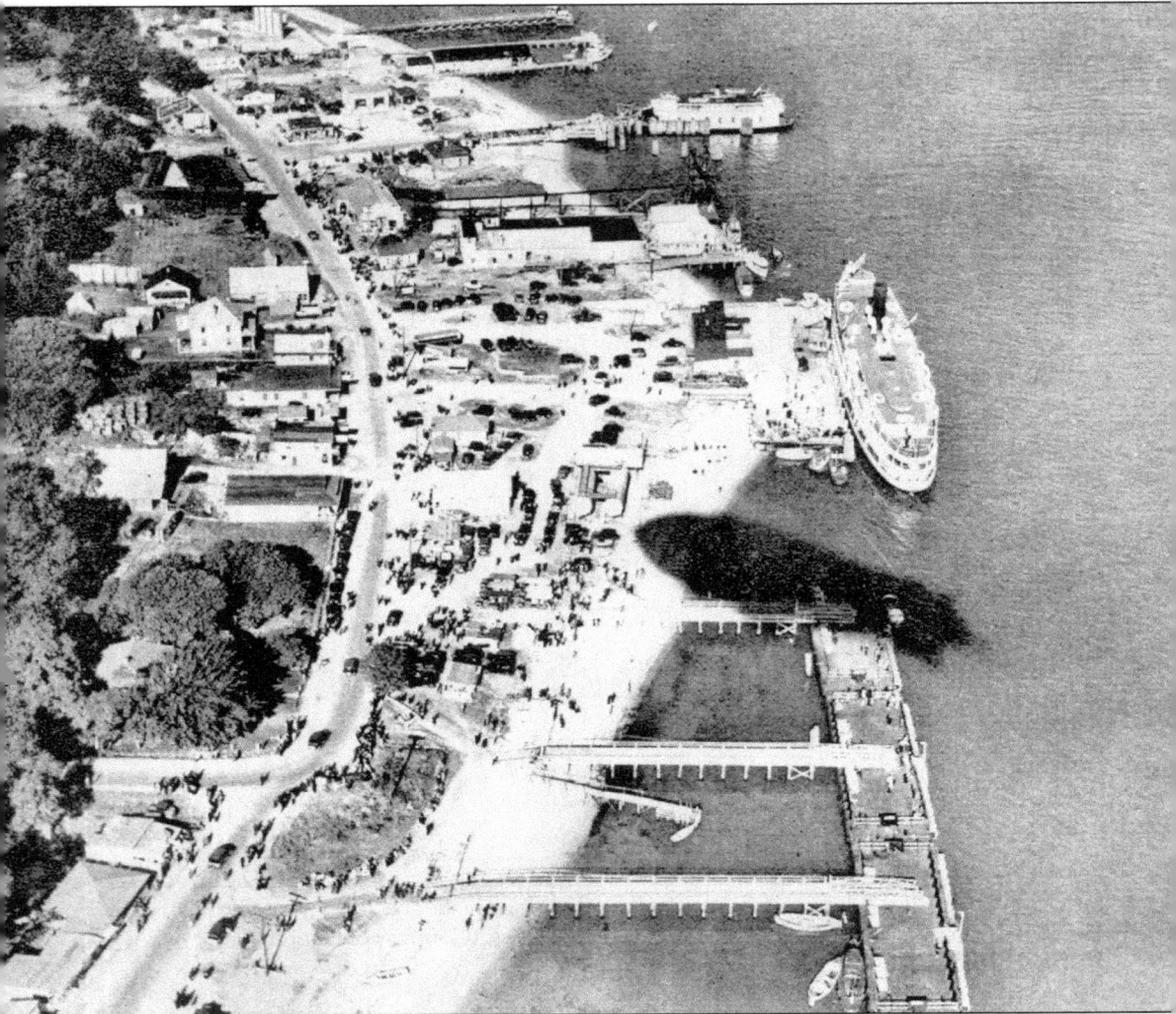

This picture is the most conclusive aerial view of what Yorktown was becoming as it captures Water Street in 1931 amid the shadow of the dirigible *Los Angeles*. The three piers beneath the shadow were temporary wharves built by the Navy for the celebration. A good look at the *Baltimore* steamer, docked at the post office wharf, is there as well as the ferry dock. Above the ferry are the wharves of O'Hara, Slaight, and Hornsby. The businesses on the Yorktown riverside, starting at the top of the picture, are as follows: the Standard Oil Company, with their warehouse; the J.W. Hornsby oil business, a two-bay garage; the ferry-filling station; the Tidewater lunchroom, beside the ferry on the ramp; the Yorktown garage; and the office of L.R. O'Hara, with his ice business. Fronting the street are the Fisheries Buildings; further down are the Topping oil tanks and Bristow's Drug Store nearest the temporary naval wharves. Across the street (from the top) are Weaver Brothers lumber yard and storage shed; Elmer White's store, with tenant houses behind; the chandler shop; the Yorktown restaurant, operated by Slaight, Wornom, and Megas; Bob Smith's restaurant and barbershop; Penders grocery store, crossing Ballard Street; a pop shop; a bingo shop; and Crockett's bathhouse. (Courtesy of the Endebrock Collection.)

Five

THE SESQUICENTENNIAL
CELEBRATION OF 1931

According to notes from a speech by Leslie R. O'Hara of Yorktown, the Rev. A.J. Renforth, minister of the Grafton Christian Church, started discussions in early 1930 of Yorktown's upcoming birthday. He approached O'Hara and suggested that they should go talk to the governor, Harry F. Byrd Sr., and although that meeting did not ignite the process, it was a beginning. It was the first time O'Hara had met the governor and he was impressed with his unassuming way. As they stood to leave, "he reached in his desk and pulled out a packet of gum and said, 'have a piece.'" So the three men stood at the end of their meeting chewing gum.

While the United States commission was planning for the celebration, the Park Service was in negotiations to acquire 1,961.78 acres of land from John F. Braun that included the Old Yorktown Hotel (the Somerwell house), the Moore house, and practically all of the battlefield of Yorktown. From October 1, 1931, the merchants, caterers, and support staff for the celebration started to arrive. The river was festooned with the force that the town had not seen since the deployment of the Navy before World War I. The 41 ships included the USS Constitution and the dirigible Los Angeles.

The monumental task was given to the park service of doing the physical preparations of the celebration until September 1, 1930, when "the work became so heavy that the combined assistance of the Army, Navy, and the Coast Guard was required." That year the Ballard Street bypass and Comte De Grasse Street beside the Victory Monument were built.

With all the heavens and good graces of the loyal and committed participants, the celebration was a profound success. "Gratitude was felt to the good God who gave the cloudless skies and undimmed stars," wrote William A.R. Goodwin, president of the Yorktown Sesquicentennial Association Inc.

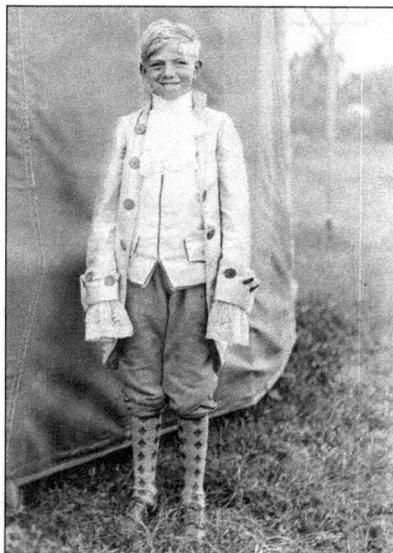

With all the innocence of youth, this happy boy, Jimmie O'Hara, is dressed in his colonial best for the celebration. (Courtesy of O'Hara Collection.)

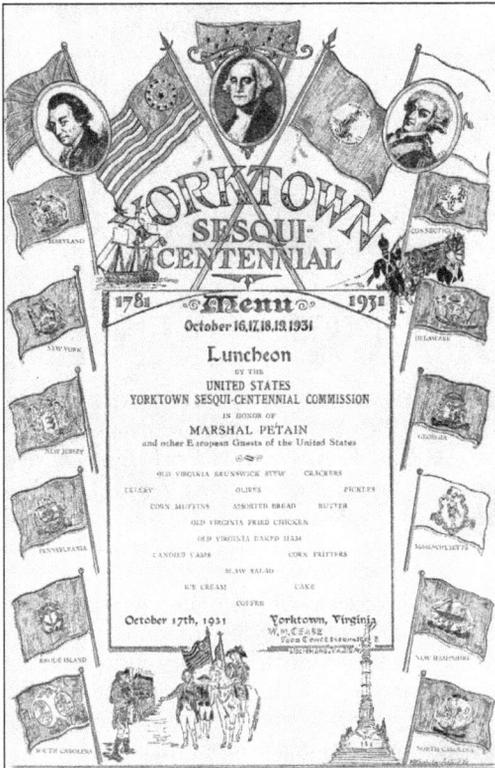

This charming and simple luncheon menu details what was served in honor of Marshal Petain, the French visiting dignitary. (Courtesy of O'Hara Collection.)

This image gives a closer view of the camp. (Courtesy of O'Hara Collection.)

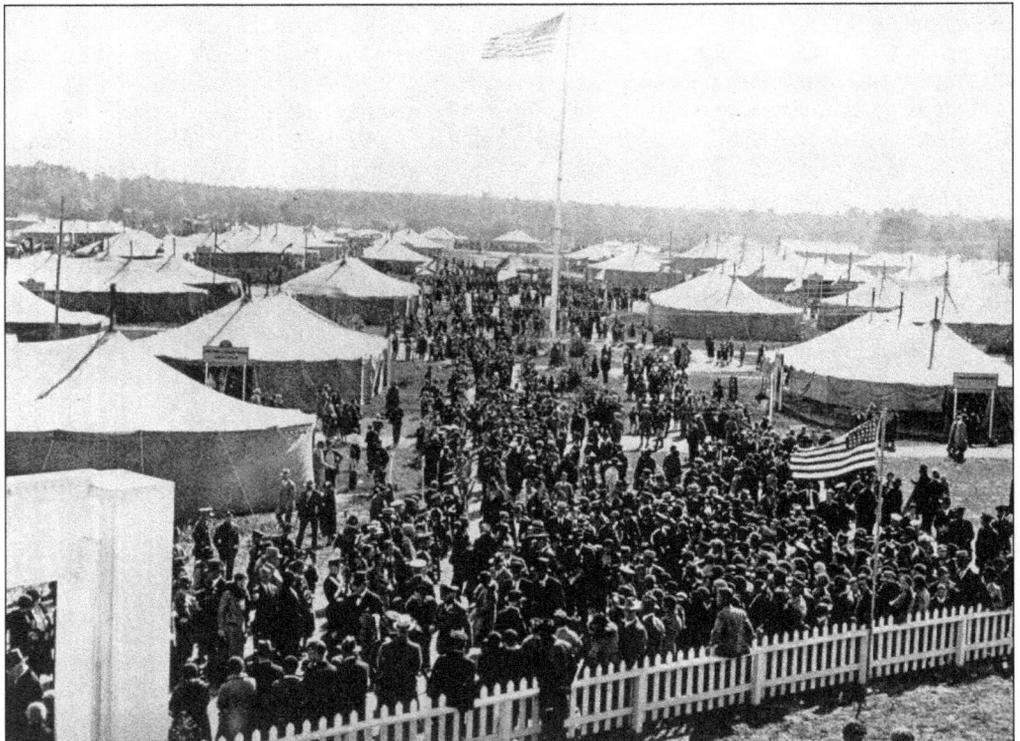

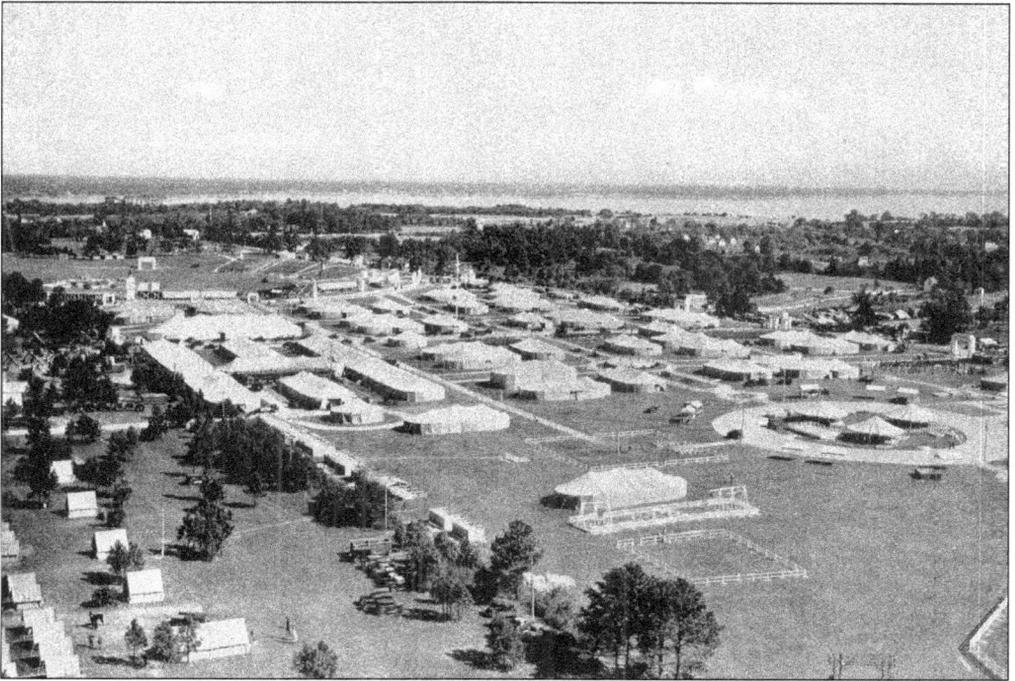

A view from above the celebration grounds near Surrender Field shows the stadium in the background, looking towards the river. (Courtesy of O'Hara Collection.)

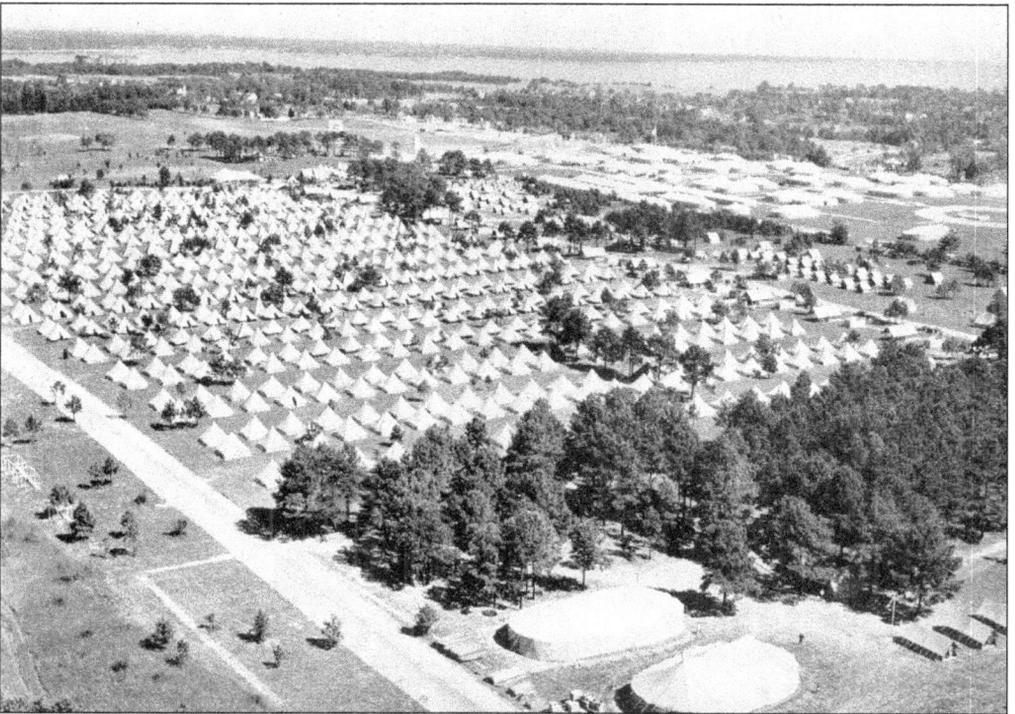

A tent city was erected for the soldiers and military participants. The grounds were cleared and not heavily wooded at the time. (Courtesy of the O'Hara Collection.)

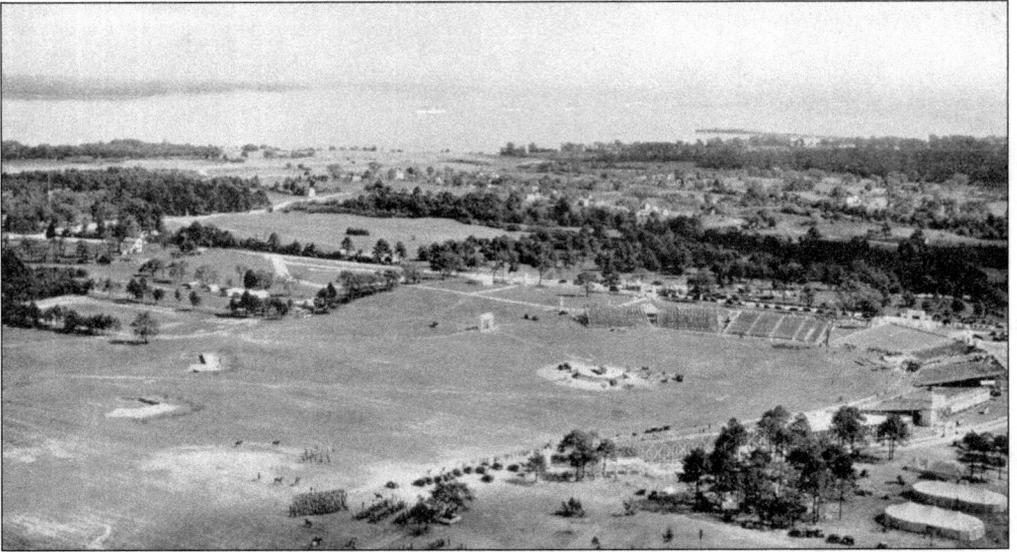

This photograph shows the stadium with a stage in the center. The National Committee learned of some bleachers that had been used for a celebration in New York State, near the Hudson River. The bleachers had been dismantled and stored. With the cooperation of Gov. F.D. Roosevelt, and his wife Eleanor, the bleachers were loaded onto barges and brought to Yorktown and reassembled at the celebration site. A parade drill gathers at the bottom of the picture. (Courtesy of the O'Hara Collection.)

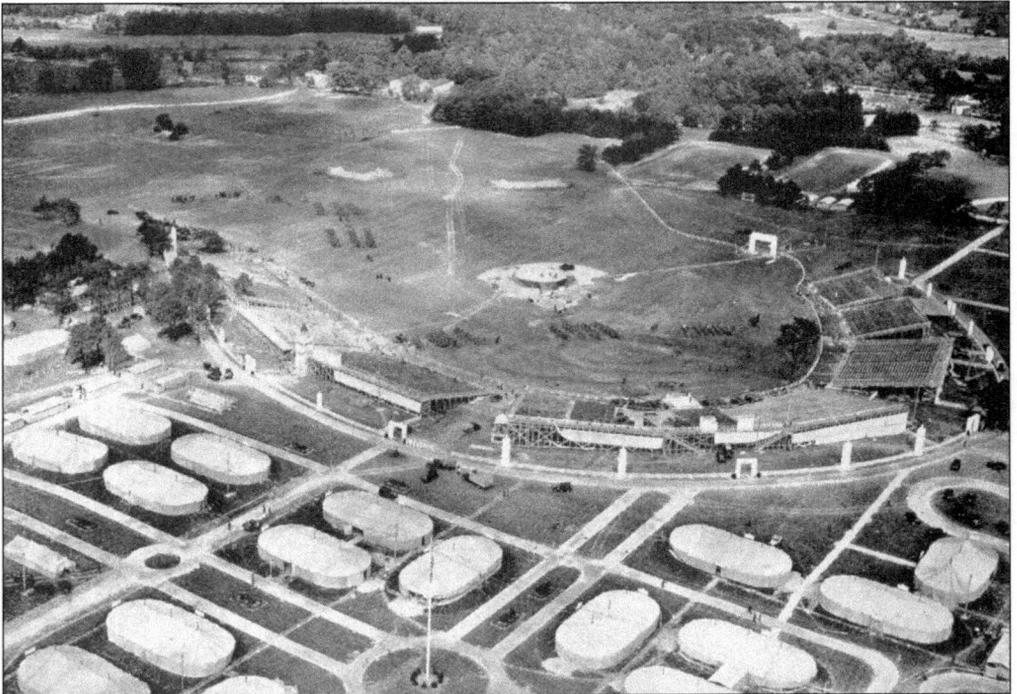

The stadium is seen from the back with a clear view of the stage in the center. This modern stage was seven feet high, simple in design, with steps and an electric elevator to bring up the participants and changes in scenery. (Courtesy of O'Hara Collection.)

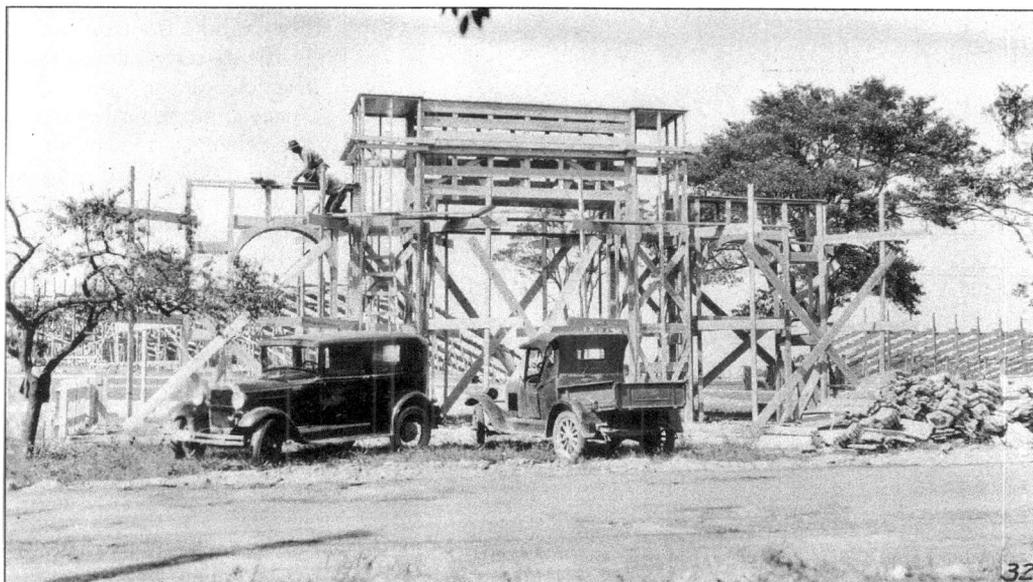

Eighteen arches and thirteen pylons were built in large part from funds donated by various states and patriotic societies. (Courtesy of National Park Service, Colonial National Historical Park Yorktown Collection.)

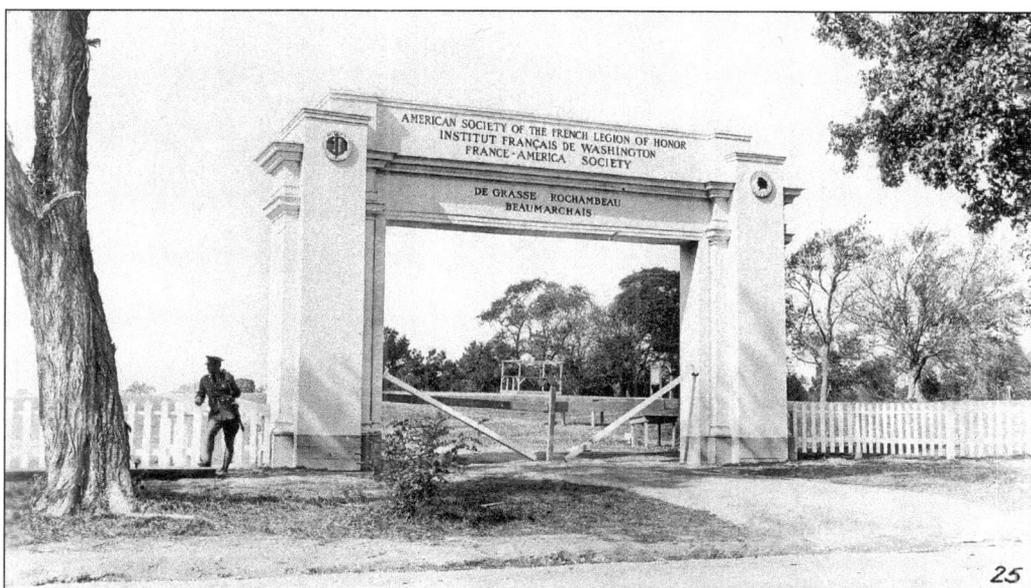

This completed arch reads, "The American Society for the French Legion of Honor Institut Francais De Washington - America Society." (Courtesy of National Park Service, Colonial National Historical Park Yorktown Collection.)

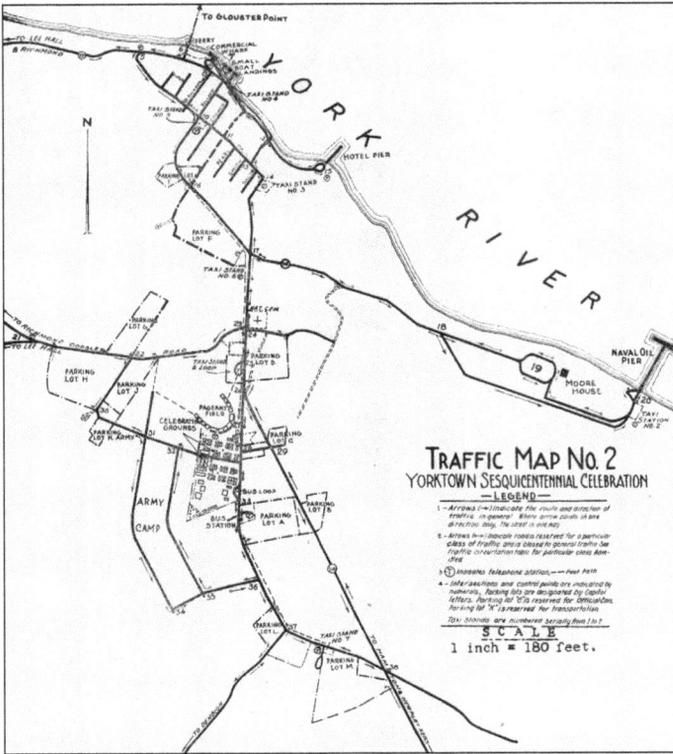

Shown here is a map of the traffic patterns planned for the celebration. Notice the Army camp roads behind the celebration location and the now closed roadways and the number of taxi stands. (Courtesy of O'hara Collection.)

The crowds ranged from 60,000 to 150,000 on the last day. The figures were approximate and based on Army reports of cars parked, but did not include visitors who came by boat, bus, ferry, or those who parked in private places. (Courtesy of the O'Hara Collection.)

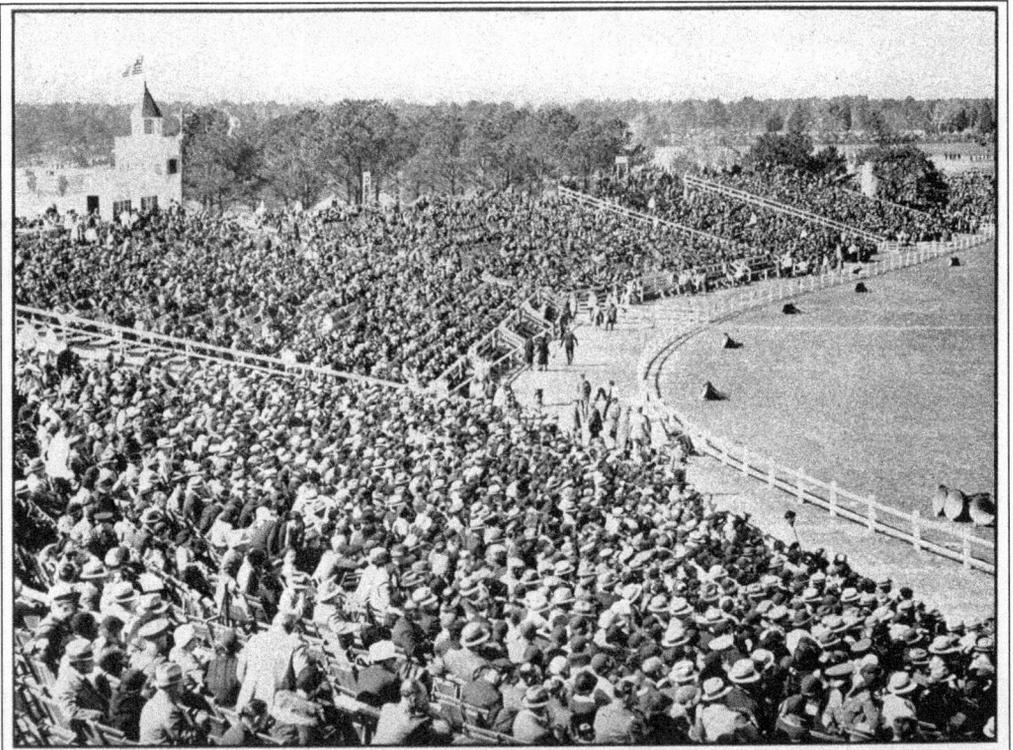

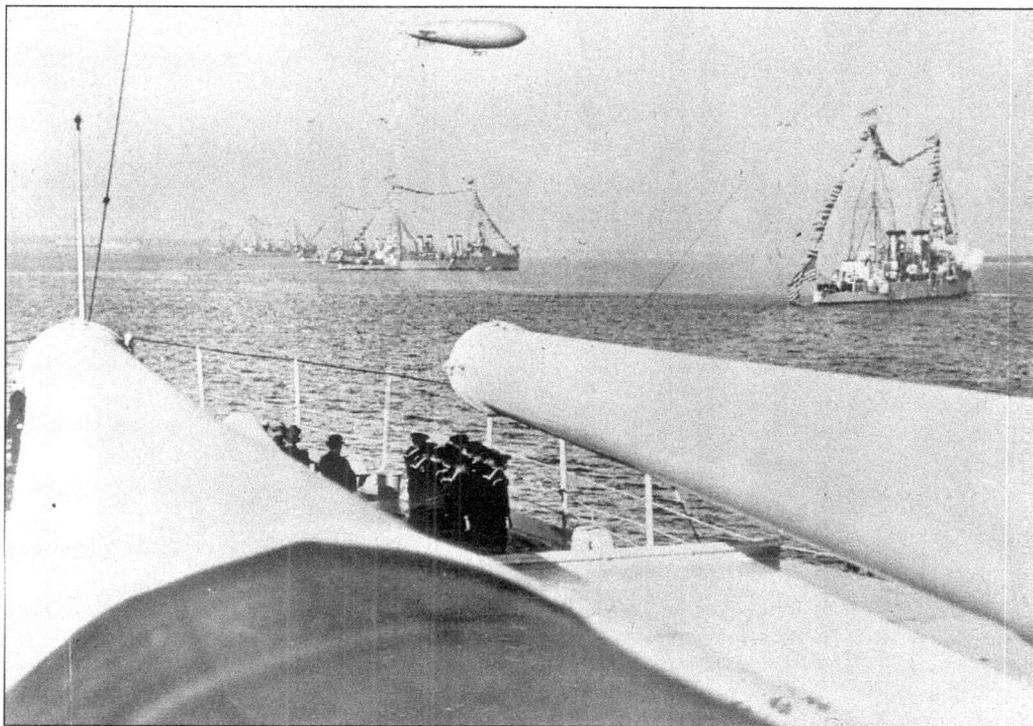

Forty-two ships, including the USS *Constitution*, were anchored in the York River for the celebration. Shown here are some of the festooned naval ships, with the dirigible *Los Angeles* above. (Courtesy of National Park Service, Colonial National Historical Park Yorktown Collection.)

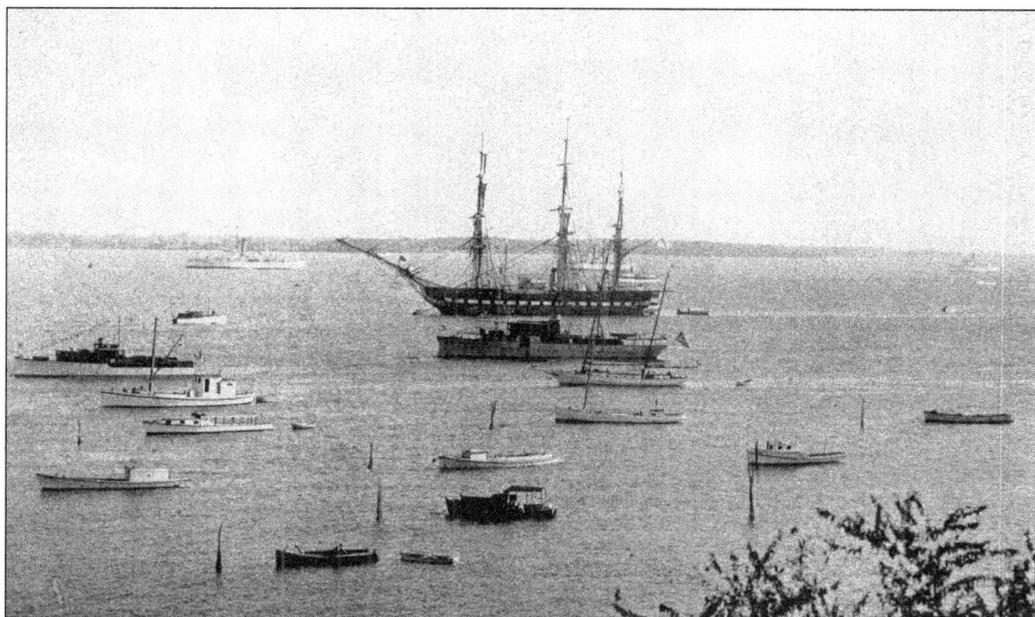

The number of naval vessels in the river did not include the private vessels shown here surrounding the USS *Constitution* (Courtesy of O'Hara Collection.)

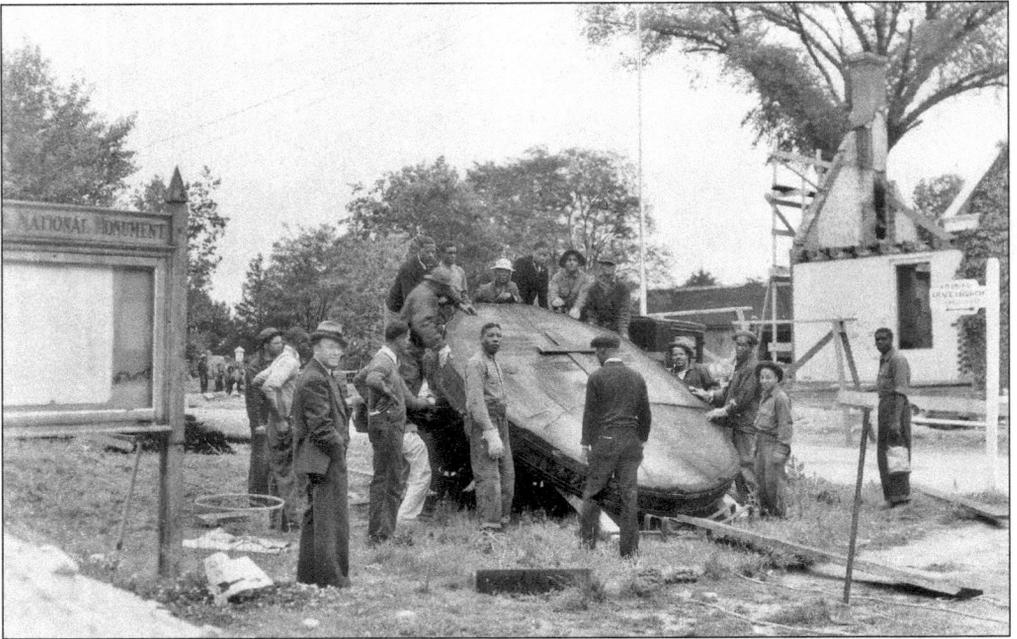

Received from the Sequoia National Park, this is a section of a Sequoia Giganta tree that was more than 10 feet in diameter and weighed over 2 tons. Brought thru the Panama Canal to the wharf in Yorktown, this tree was thought to have been a seedling in 78 B.C. and did not fall until 1917. Construction of this display was on the corner of Church and Main Streets. (Courtesy of National Park Service, Colonial National Historical Park Yorktown Collection.)

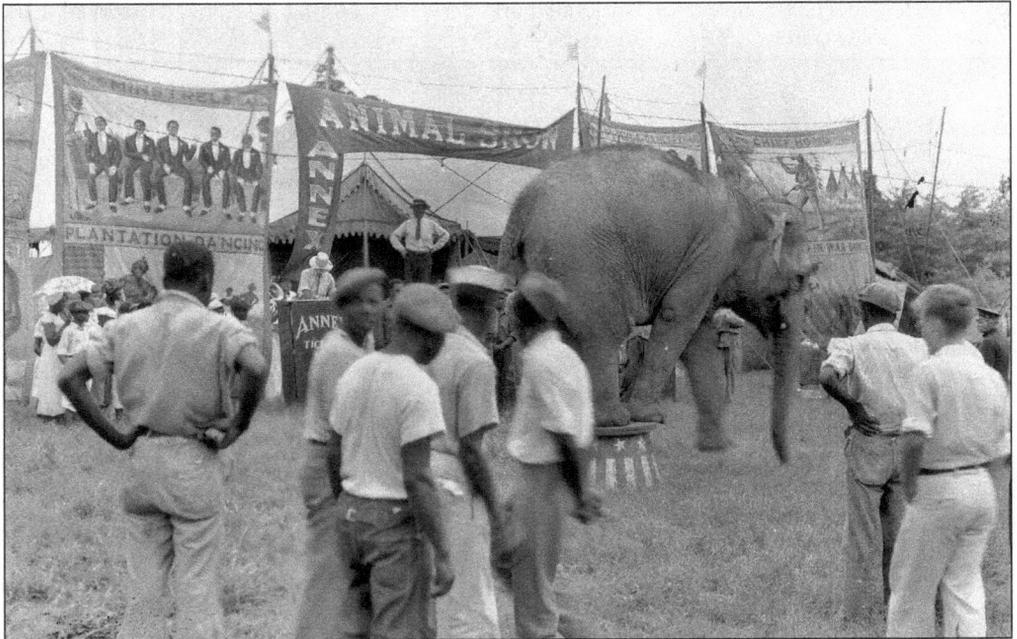

There were various shows and demonstrations during the celebration. Among them was this animal show on the grounds of what is today the new courthouse. (Courtesy of National Park Service, Colonial National Historical Park Yorktown Collection.)

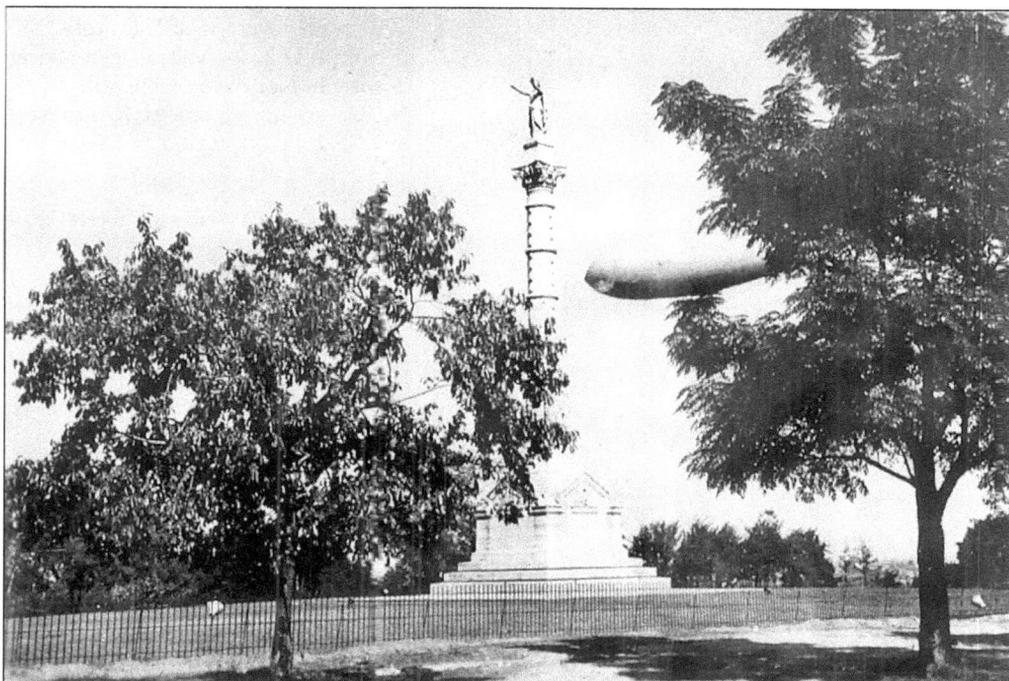

This is a once-in-a-lifetime view of the dirigible flying with a clear scope of the first statue atop the Victory Monument. (Courtesy of National Park Service, Colonial National Historical Park Yorktown Collection.)

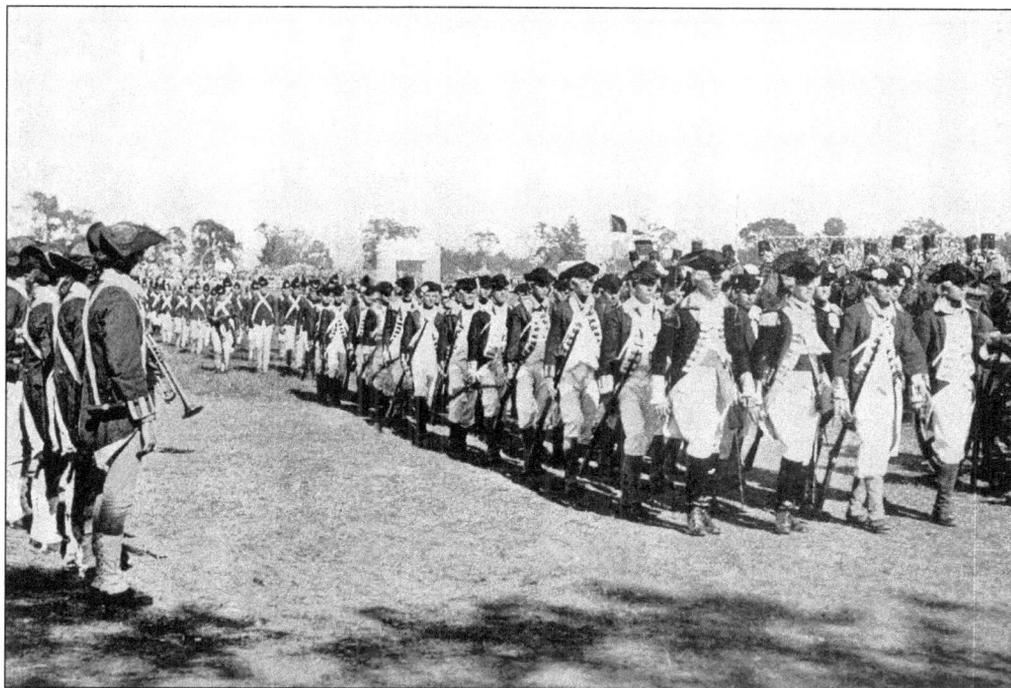

Here is one of the many impressive pictures of the costumed (Washington's Continentals) armies that participated in the Surrender Pageant. (Courtesy of O'Hara Collection.)

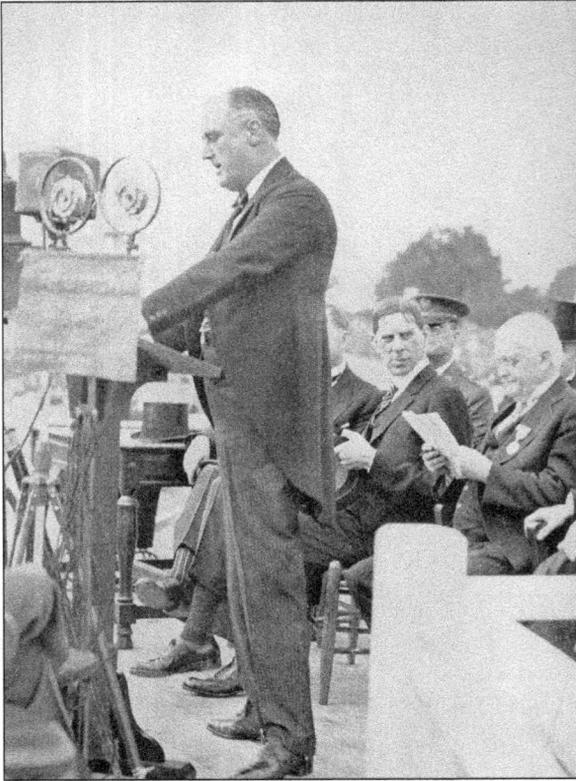

The then governor of New York, Franklin D. Roosevelt, is seen giving a speech. Not obvious but still visible are his leg braces. (Courtesy of O'Hara Collection.)

In this photograph, from left to right, are Marshal Petain, President Hoover, Mrs. Hoover, and General Pershing. They are reviewing the pageant with an impressive crowd behind them. (Courtesy of O'Hara Collection.)

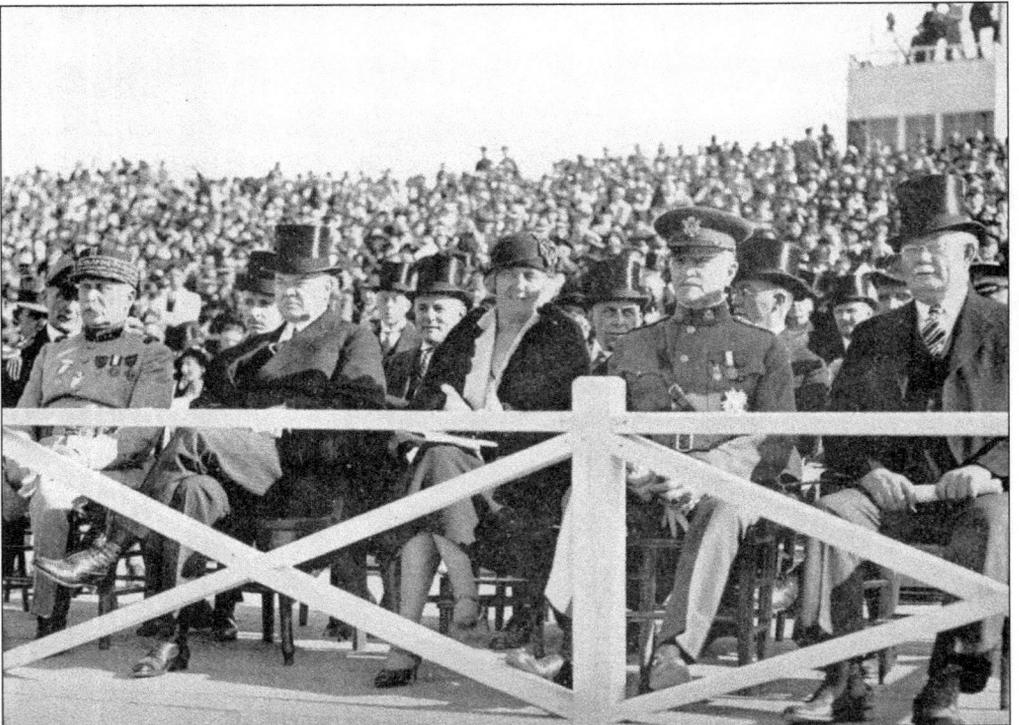

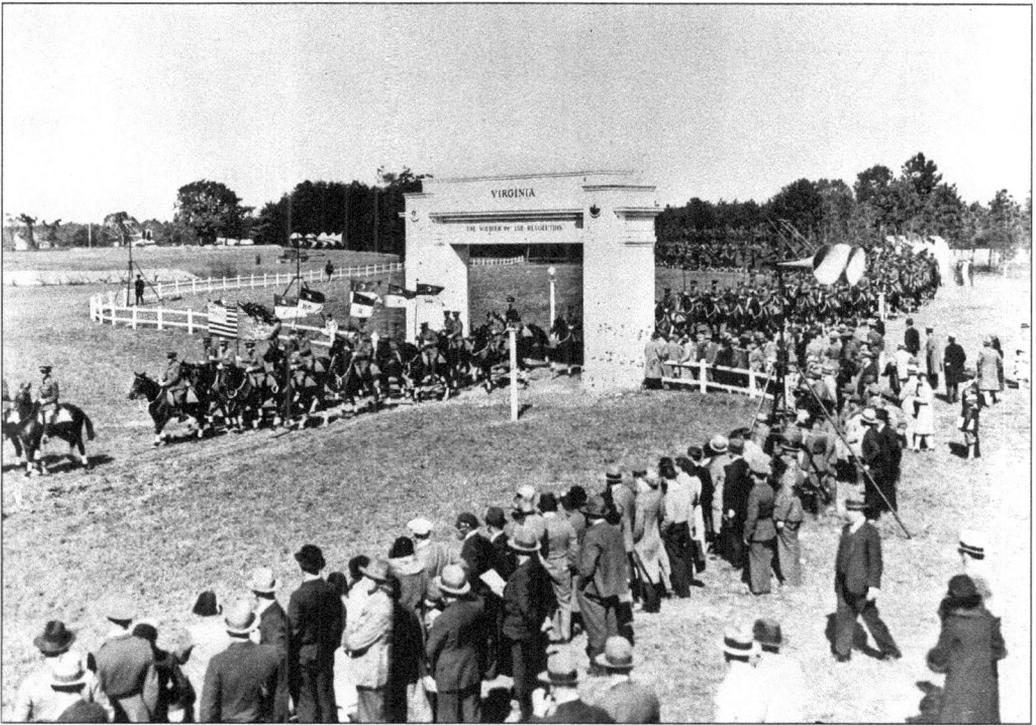

The 3rd U.S. Cavalry escorts a distinguished guest thru the Virginia arch. (Courtesy of National Park Service, Colonial National Historical Park Yorktown Collection.)

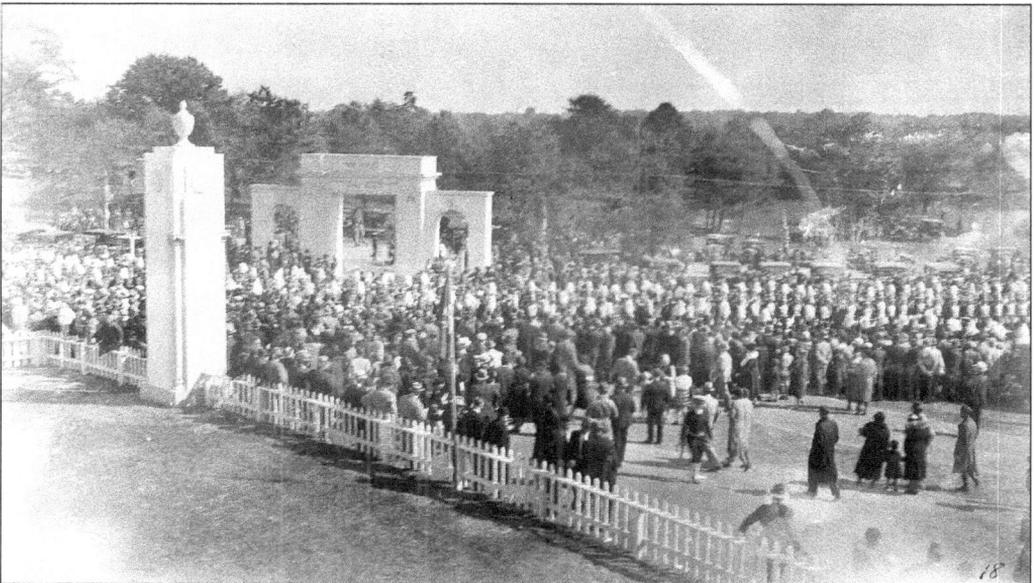

A clear image documents the crowds and one of the 13 pylons constructed in two sizes, 14 and 21 feet, with each kind standing upon a 4- or 5-foot base. Placed on top of each pylon was a round composition urn about four feet high. (Courtesy of National Park Service, Colonial National Historical Park Yorktown Collection.)

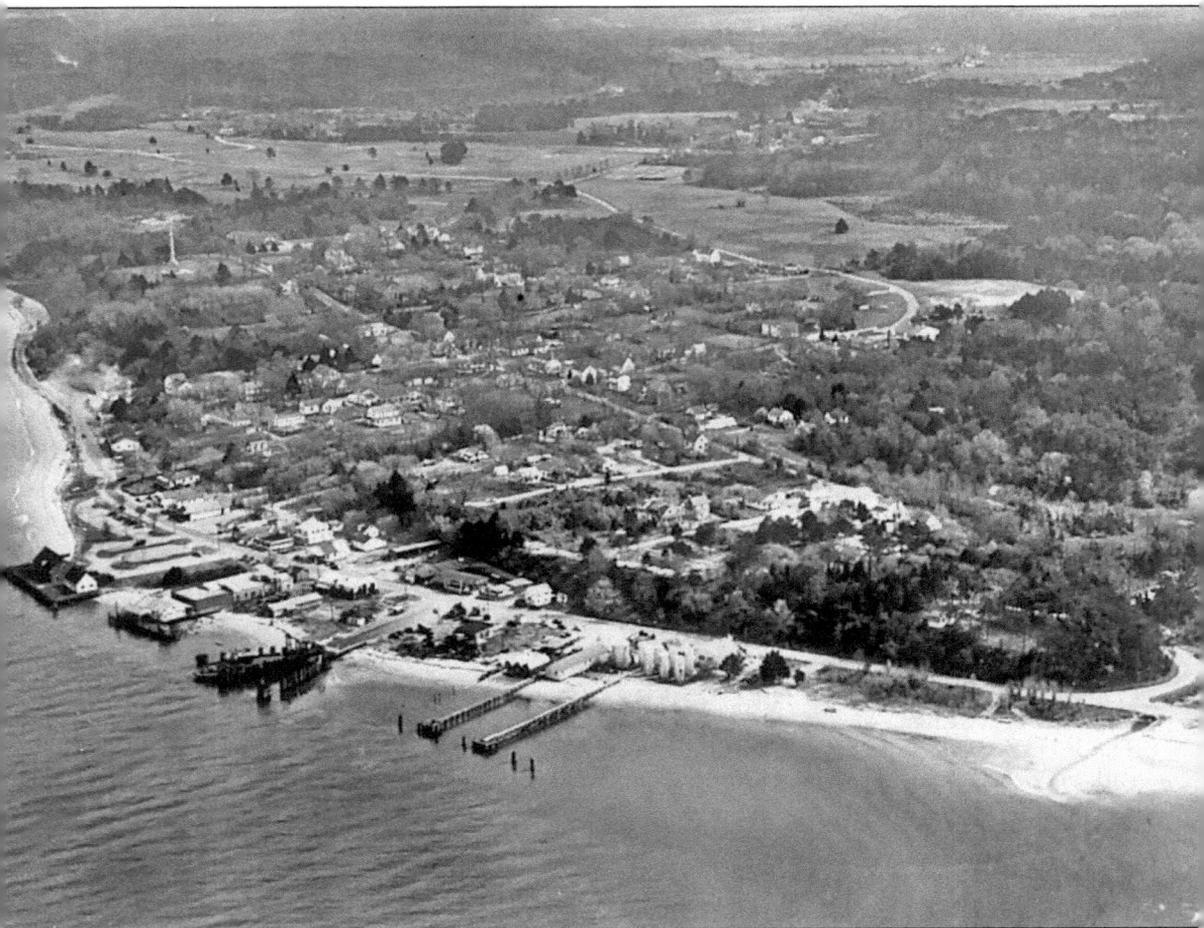

In this pristine shot of Yorktown, nearly every dwelling and place of business can be seen. The wharfs at the riverfront have dwindled in number due to the hurricane of 1933. But, it is with this photograph, before the Coleman Bridge, the reader can see Yorktown in the last phases of being a true hometown. (Courtesy of National Park Service, Colonial National Historical Park Yorktown Collection.)

Six

BEFORE THE BRIDGE

The sesquicentennial celebration and the hurricane of 1933 had passed and life moved on as residents moved into the World War II years. Because there were military bases established in the area, times were changing with the industry of war. The National Park Service was well established in the town and the projects of clearing out and cleaning up came largely to the work camps that were established after President Roosevelt took office. The settlement of the land around the battlefield took more than several years to establish the National Park Service as sole owner. There was much negotiation, but with that done, the work of rebuilding the redoubts and fortifications was underway.

Gone were the days of the 1930s on the waterfront. The hurricane did such extensive damage that many of the owners, without insurance, went permanently out of business. The barbershop, Mercer Hogge's restaurant, White's store, Standard Oil wharf, Topping Oil Company, and Crockett's bathhouse were all wrecked beyond repair. With the help of the CCC camps locally and the Newport News Shipbuilding Company that sent equipment, some of the waterfront businessmen, park service officials, and Naval Mine Depot officers worked together to reorganize the waterfront. A detachment of Marines and local law enforcement helped patrol the affected waterfront. With the rebuilding came a few changes but Yorktown, so noted for its history, looked outward across the river with plans of expansion.

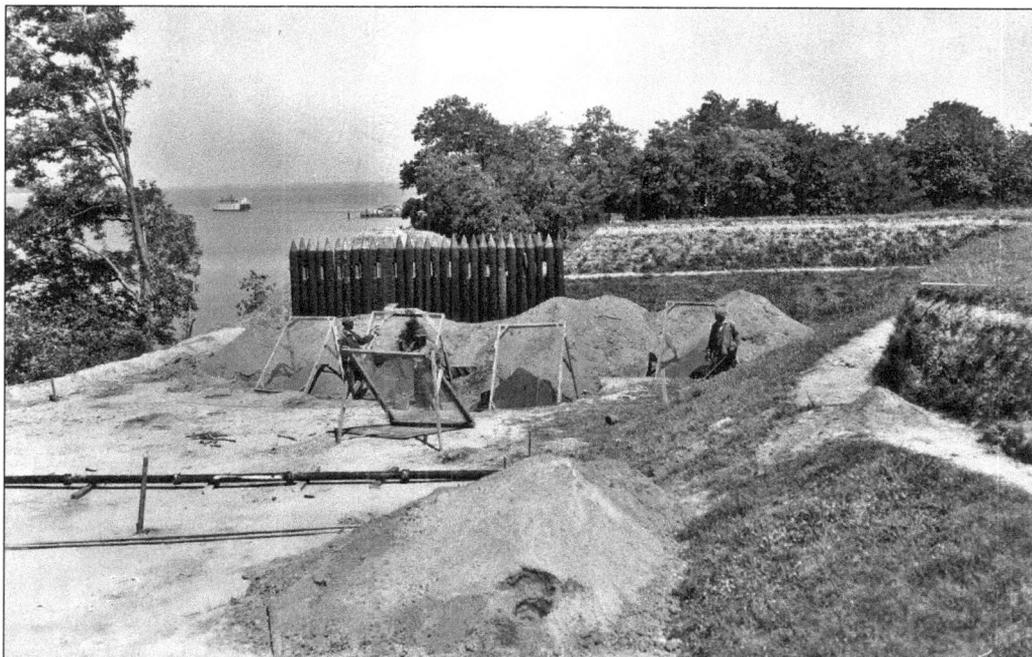

The restoration of the redoubt (across from the Victory Center) shows the work in progress and the Yorktown ferry still crossing to Glouscester Point before the Coleman Bridge. (Courtesy of National Park Service, Colonial National Historical Park Yorktown Collection.)

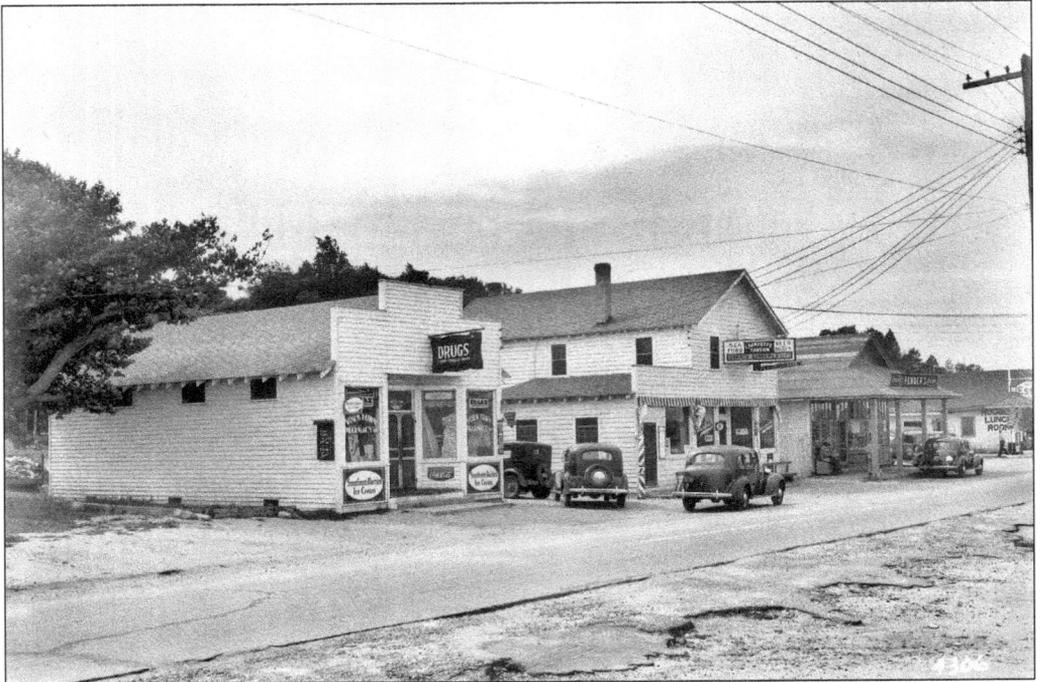

West of Ballard Street, opposite the river, are some of the retail stores on Water Street, *c.* 1940. Penders Grocery is at the end of the row. (Courtesy of National Park Service, Colonial National Historical Park Yorktown Collection.)

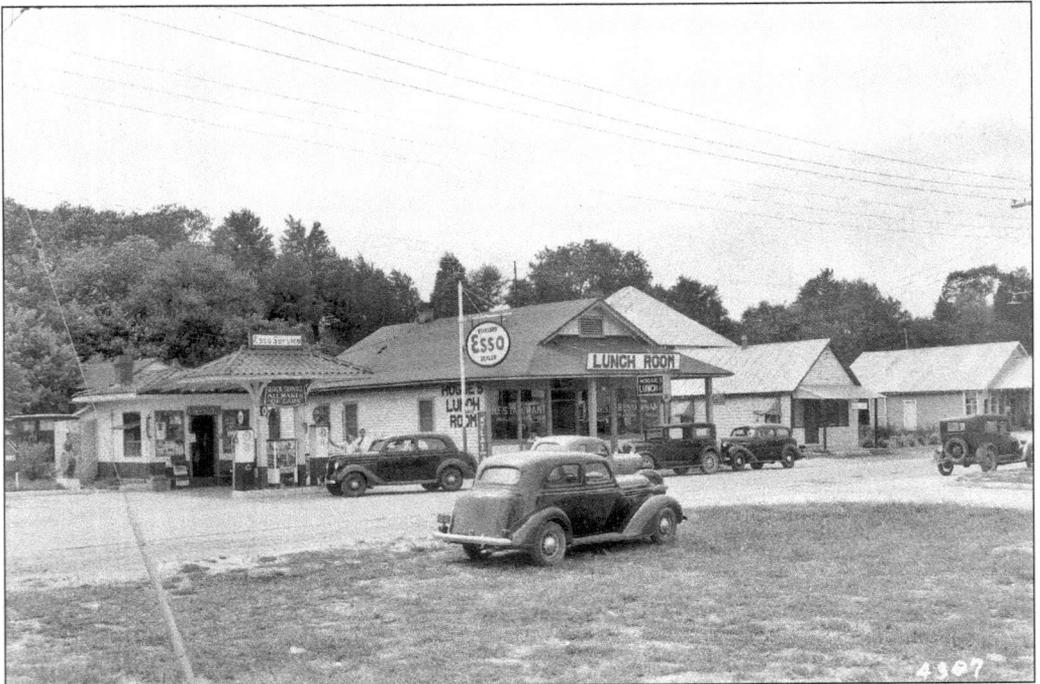

This 1940 view continues west on Water Street, crossing Buckner Street. (Courtesy of National Park Service, Colonial National Historical Park Yorktown Collection.)

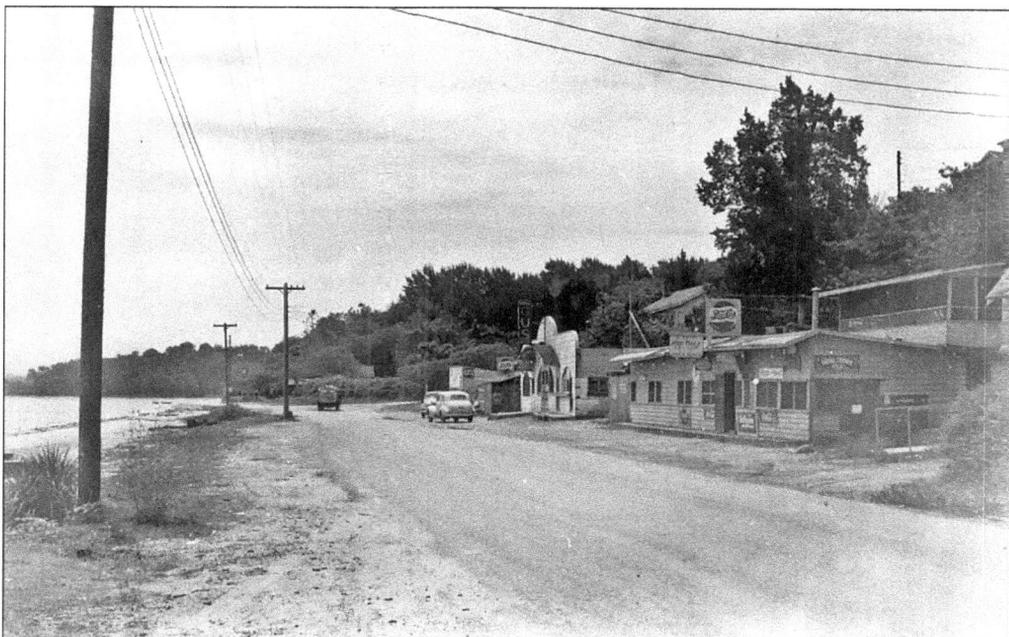

This view is looking east from Ballard Street on Water Street, c. 1940. (Courtesy of National Park Service, Colonial National Historical Park Yorktown Collection.)

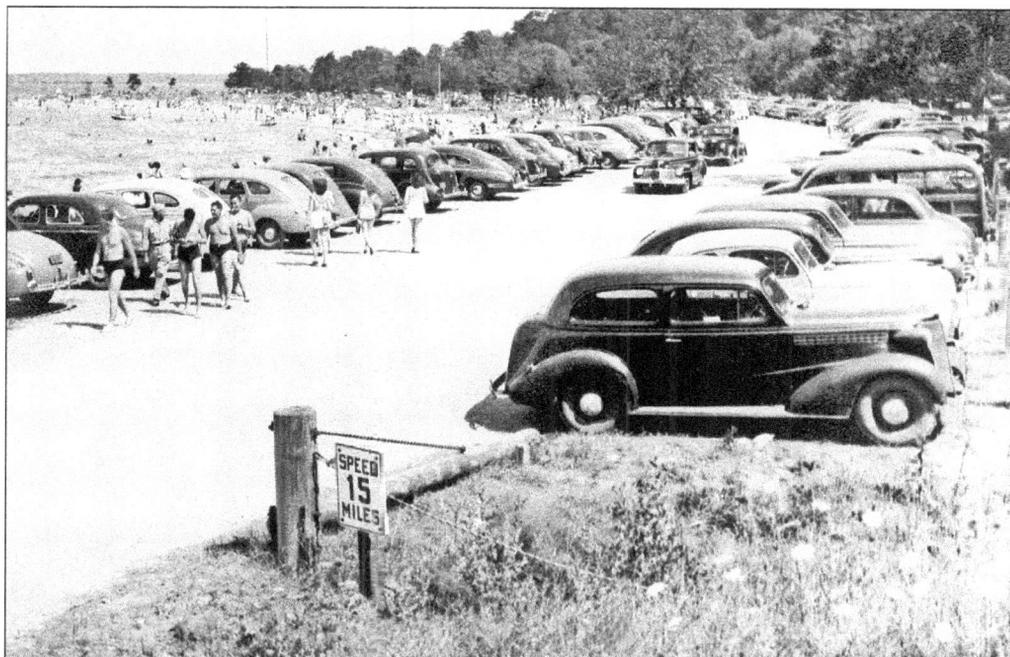

Crowds gather at the Park Beach in July 1944. (Courtesy of National Park Service, Colonial National Historical Park Yorktown Collection.)

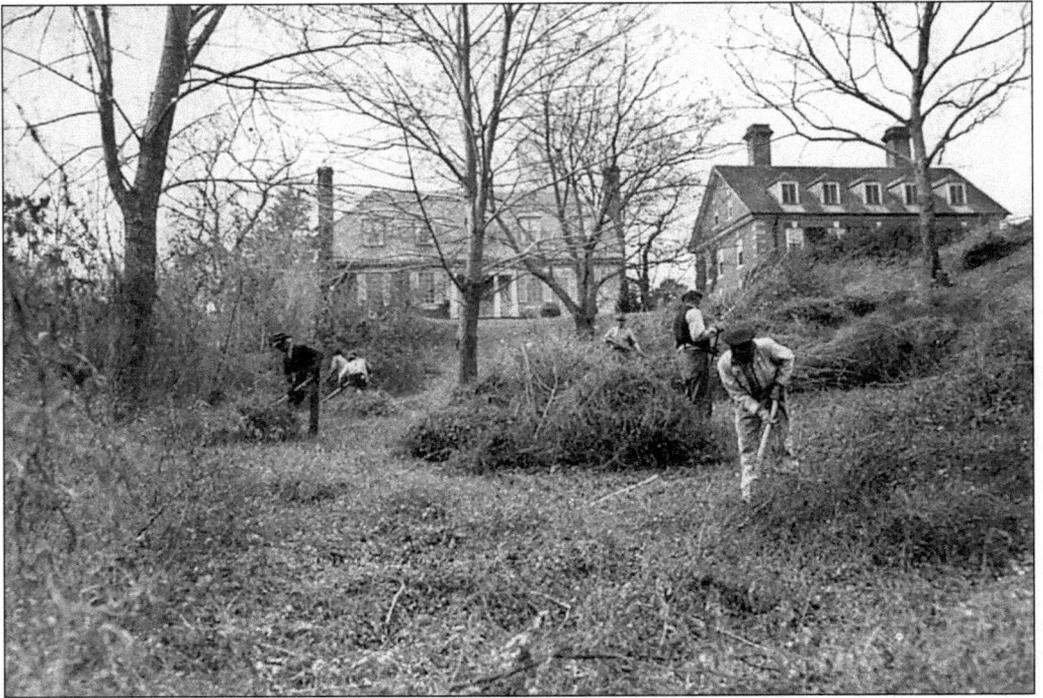

The work of clearing the Great Valley in 1947 is taking place here, with the Sessions and Nelson houses in the background. (Courtesy of National Park Service, Colonial National Historical Park Yorktown Collection.)

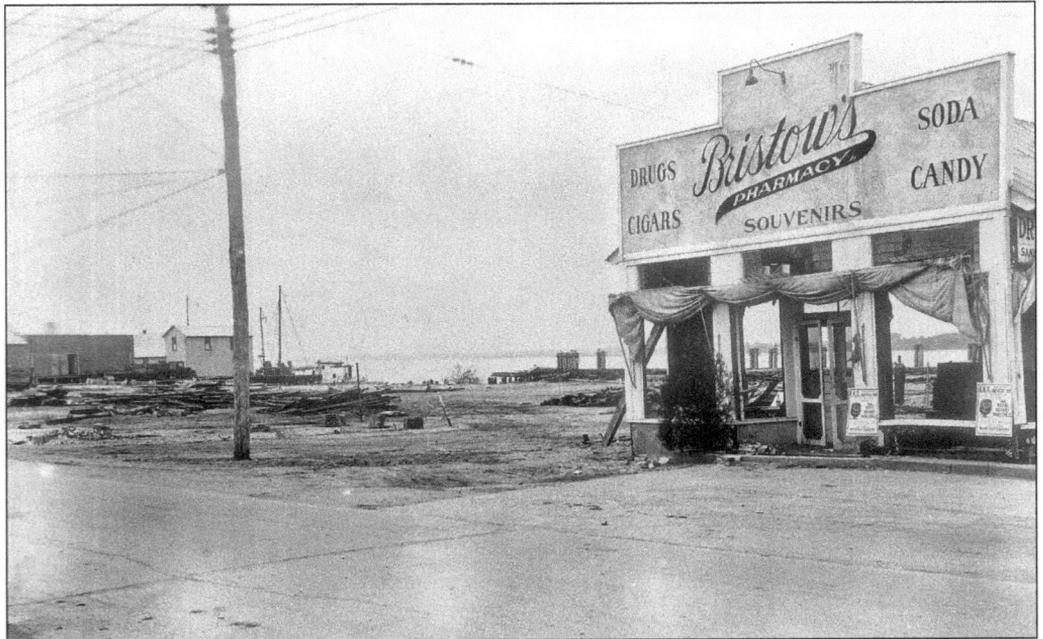

The storefront of Bristow's Pharmacy was ravaged after the 1933 hurricane. Nearly all the businesses on the waterfront were obliterated. (Courtesy of National Park Service, Colonial National Historical Park Yorktown Collection.)

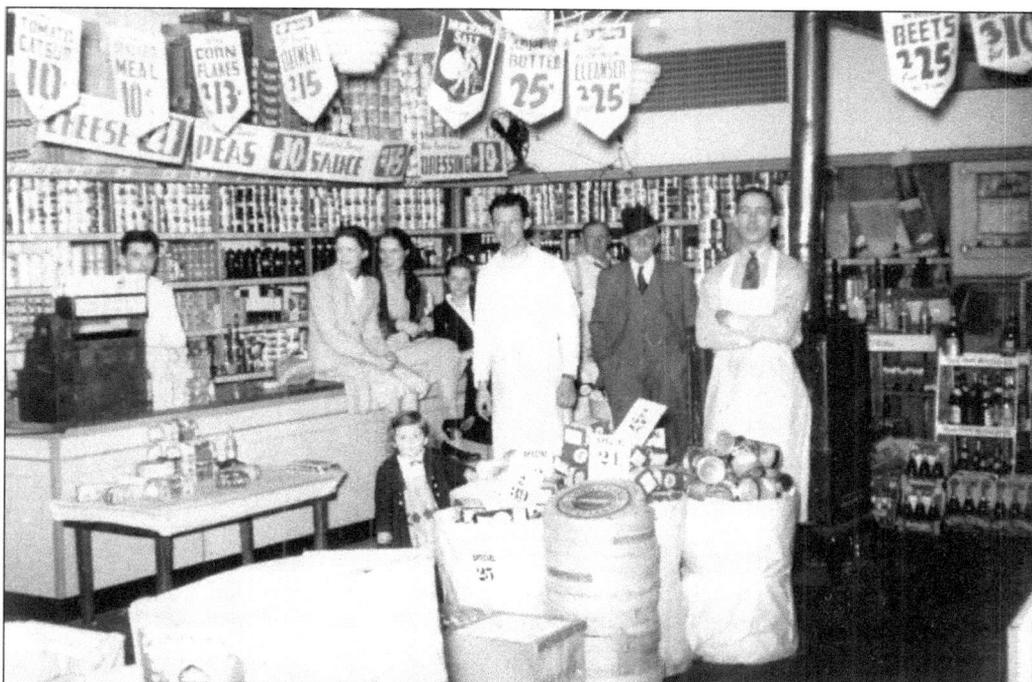

Penders Grocery on Water Street, c. 1940, was the local grocery store. From left to right are Stafford G. Cooke, Mrs. Florence Cooke, Beverly Cooke (the child), sister Edna, and the others are unidentified. (Courtesy of Cooke-Krams Collection.)

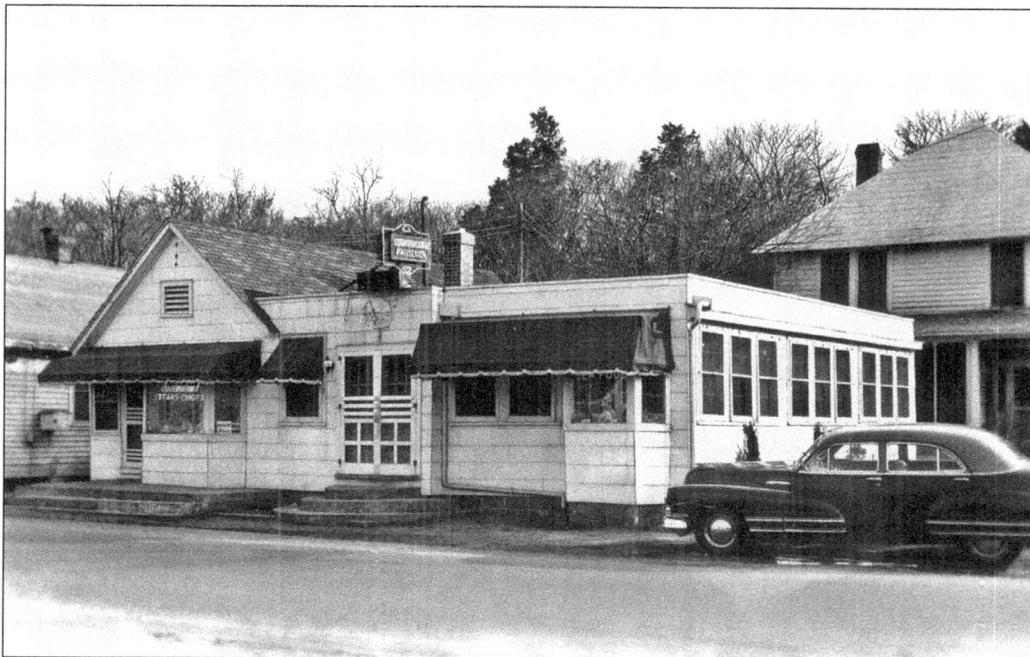

The Seashore Pavilion stood on the site of Nick's Seafood Pavilion, with the White's House in the background. (Courtesy of National Park Service, Colonial National Historical Park Yorktown Collection.)

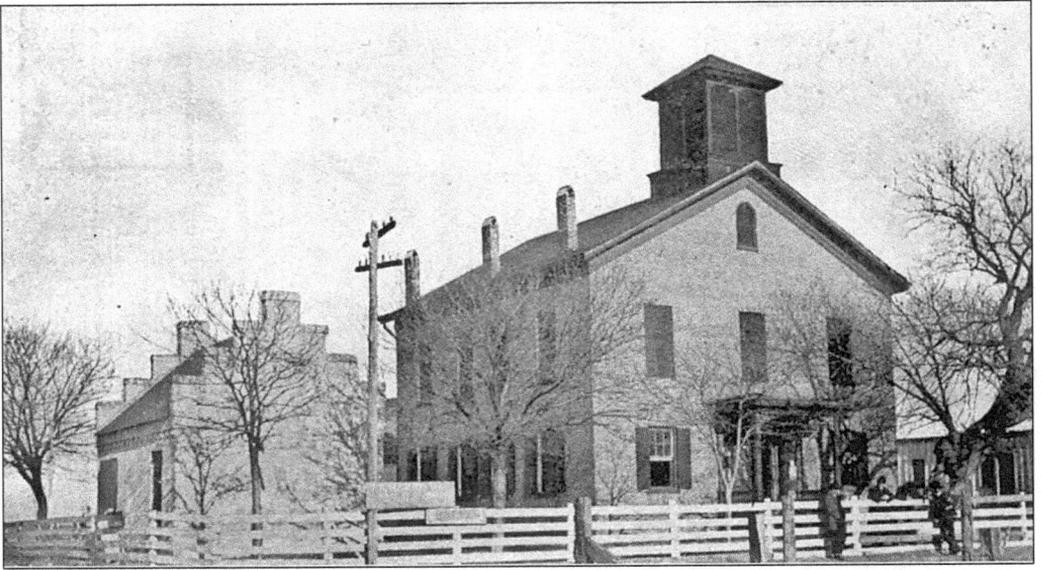

This 1935 postcard shows the fourth courthouse in Yorktown, with the clerk's office next door. (Courtesy of the Collection of John A. Lawson III, Williamsburg, Virginia.)

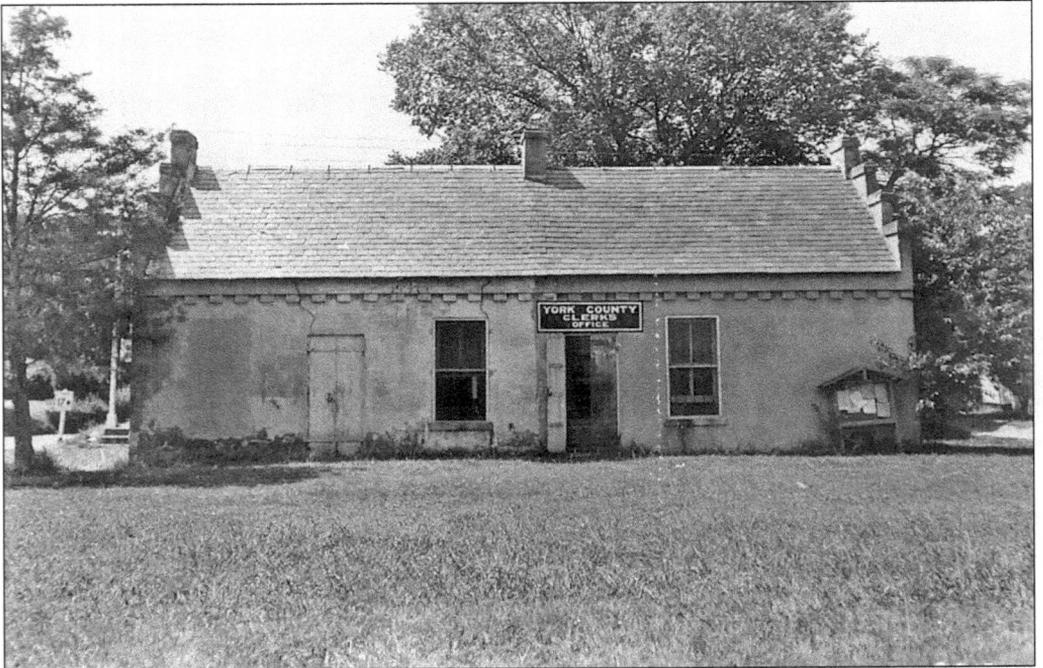

The clerk's office is shown here from Ballard Street. Many important records were stored there, including 60,000 documents important to the restoration of Williamsburg. (Courtesy of National Park Service, Colonial National Historical Park Yorktown Collection.)

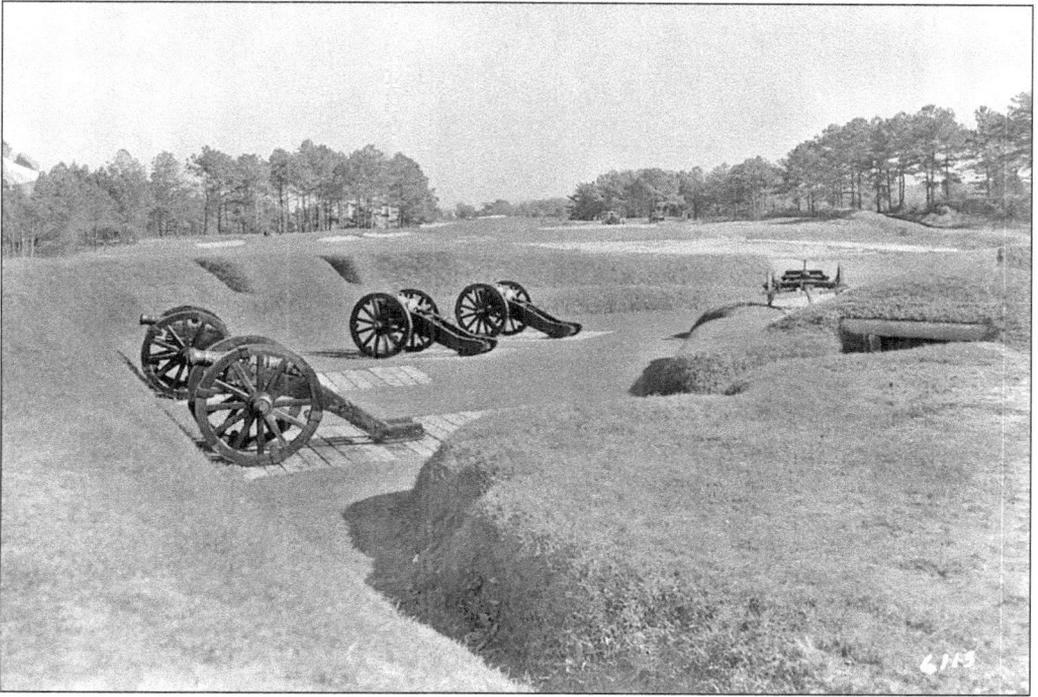

The battlefield fortifications look newly groomed on October 29, 1937. (Courtesy of National Park Service, Colonial National Historical Park Yorktown Collection.)

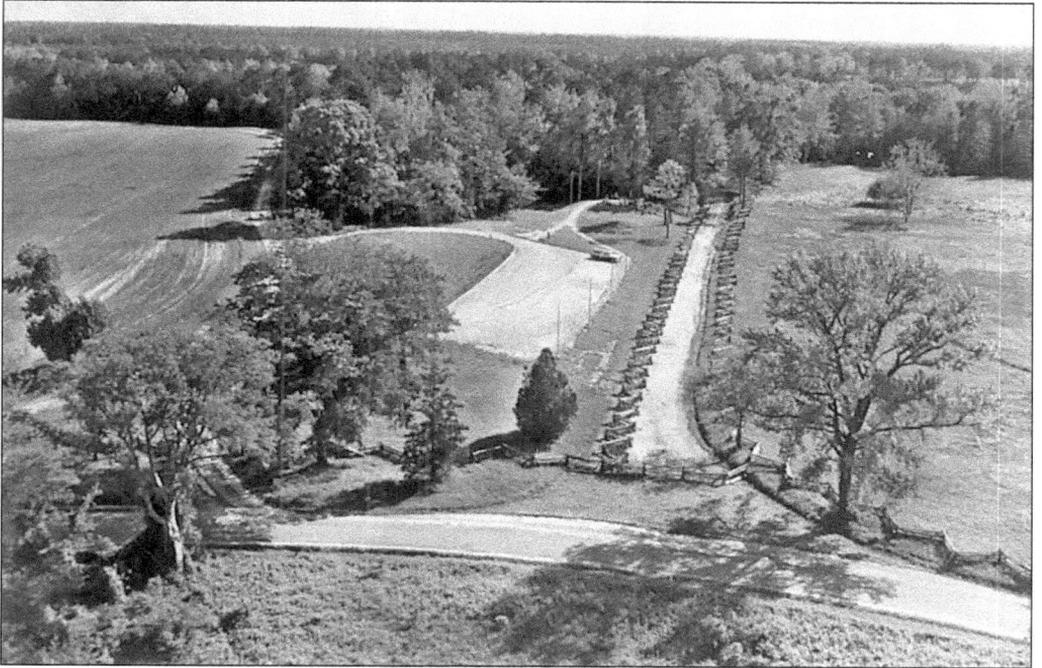

This photograph is of battlefield fortifications on the first parallel Grand French Battery on May 9, 1938. (Courtesy of National Park Service, Colonial National Historical Park Yorktown Collection)

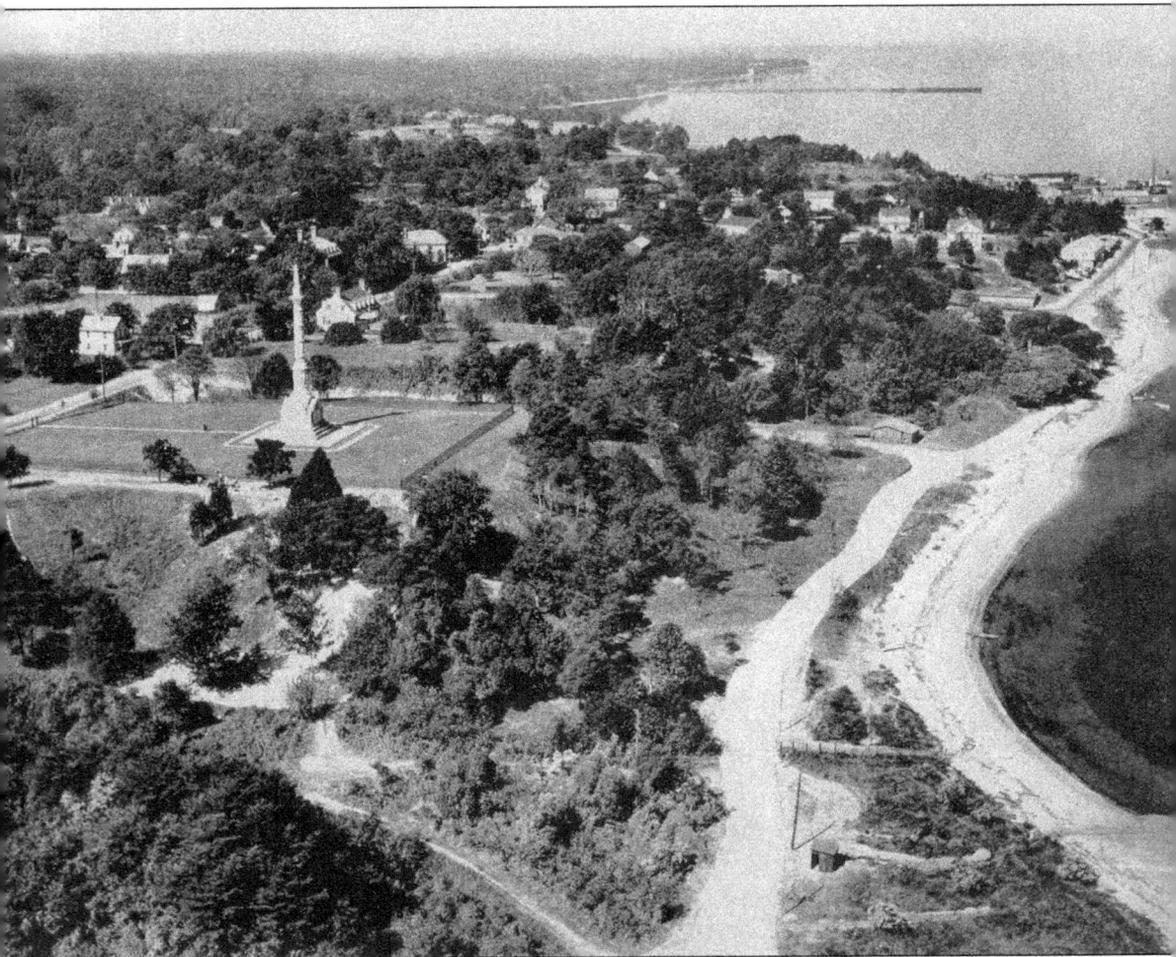

This is a last look at Yorktown in 1931. The beach looks very wide and the piers are intact in the background. (Courtesy of O'Hara Collection.)

Seven

AFTERWARD

The files at the National Park Service are filled with details of the problems of settling the property of the old Manor Hotel, the golf course, and other historic places. Consider the dilemma: razing the old structure of the partially built hotel, dealing with hurricane damage, and creating new developments needed on the waterfront. The work was steady and extensive.

Starting in October 1931, it was established that the asking price of $625,000 would never be affordable to the National Park Service. With plans to keep the golf course open and perhaps finish the hotel, Horace M. Albright, director at the National Park Service, was working for a settlement with J.F. Braun. In 1933 the golf course was still operating, but the hotel pier washed away; by 1934 appraisers were being appointed to assess a price for the property. The appraisal of $789,898.50 was established and the park service began to worry as Braun was advertising the battlefield to be divided into lots for sale; 239 acres lay waiting for the requisition of government money to purchase. Mr. L.R. O'Hara and Mr. W.T. Ashe of Yorktown, and Gloucester Point, representing the Jamestown Corporation, negotiated and purchased the property to turn it over to the government at cost plus expenses and a flat fee.

The Daily Press in Newport News ran a story on September 1, 1936, stating that 218 acres had been settled, purchased for the price of $187,500. The decision to raze the hotel structure was solidified, but the fate of the golf course was undetermined. The park service also stated that the Revolutionary redoubts had to be restored since they were leveled, at that time, to prevent their use by others troops who might advance to the area.

With the demolition and reconstruction underway, Yorktown was becoming the quiet historic national monument.

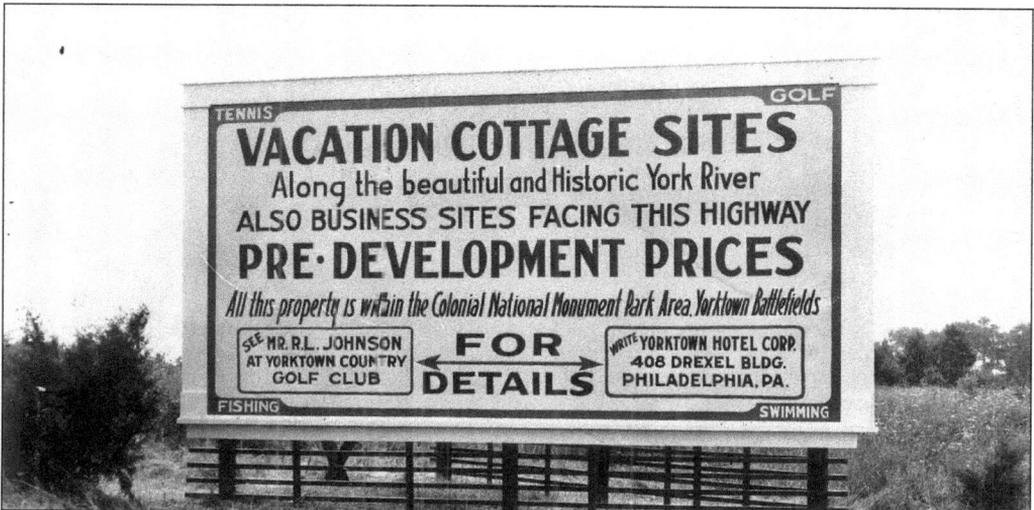

This was the sign that sent letters fluttering back and forth between members of the National Park Service before the land acquisition. (Courtesy of National Park Service, Colonial National Historical Park Yorktown Collection.)

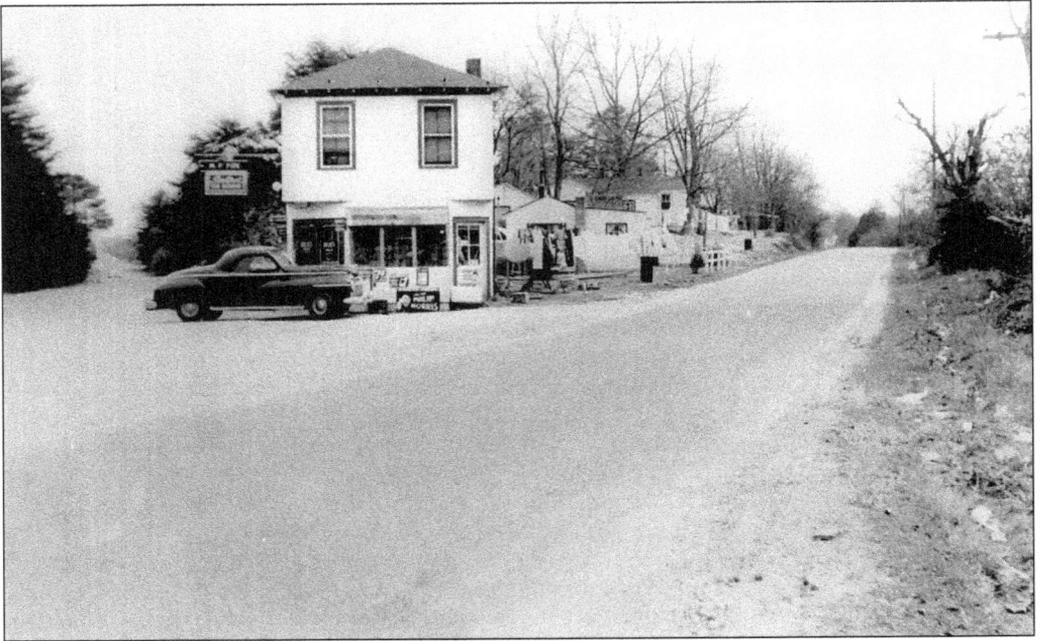

A most bemoaned demolition came to this country store that stood at the intersection of Cooke and Surrender Road. (Courtesy of National Park Service, Colonial National Historical Park Yorktown Collection.)

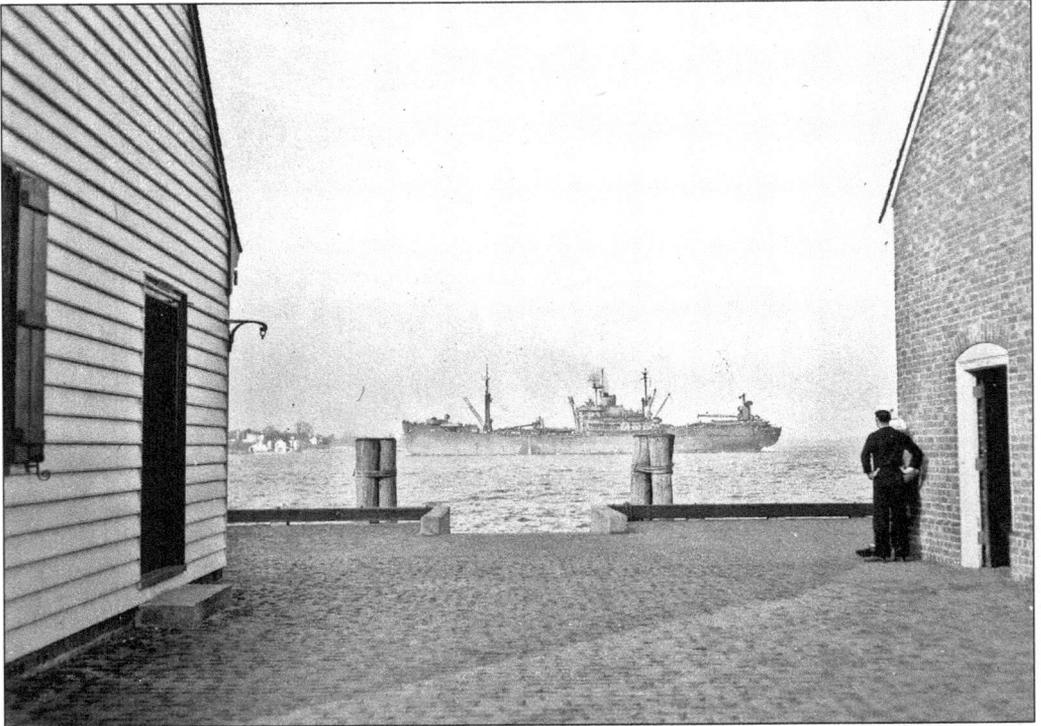

This quiet scene captures a sailor admiring another tourist attraction. (Courtesy of National Park Service, Colonial National Historical Park Yorktown Collection.)

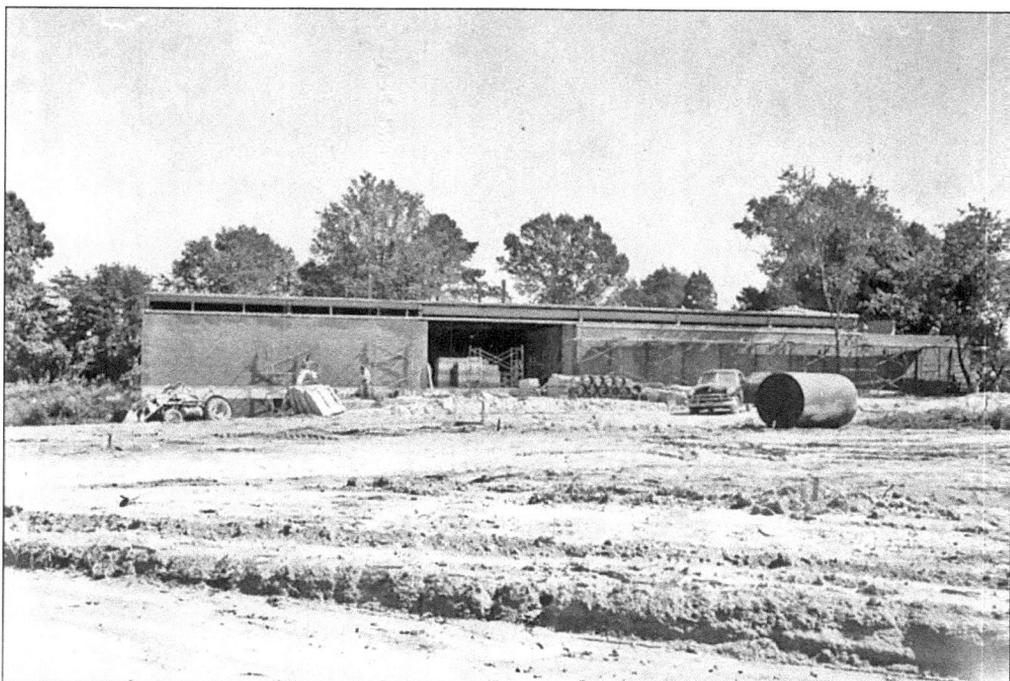

The building of the Visitor Center begins on the site of the Manor Hotel on May 3, 1956. (Courtesy of National Park Service, Colonial National Historical Park Yorktown Collection.)

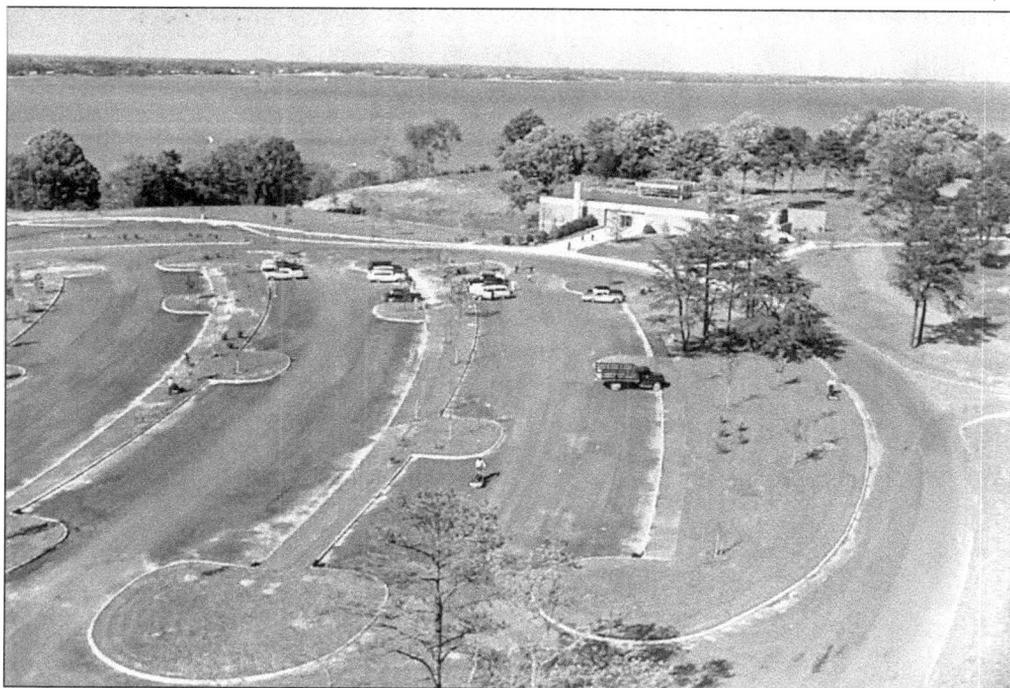

A May 1958 view shows the completed Visitor Center—a place inviting guests to enjoy a piece of American history. (Courtesy of National Park Service, Colonial National Historical Park Yorktown Collection.)

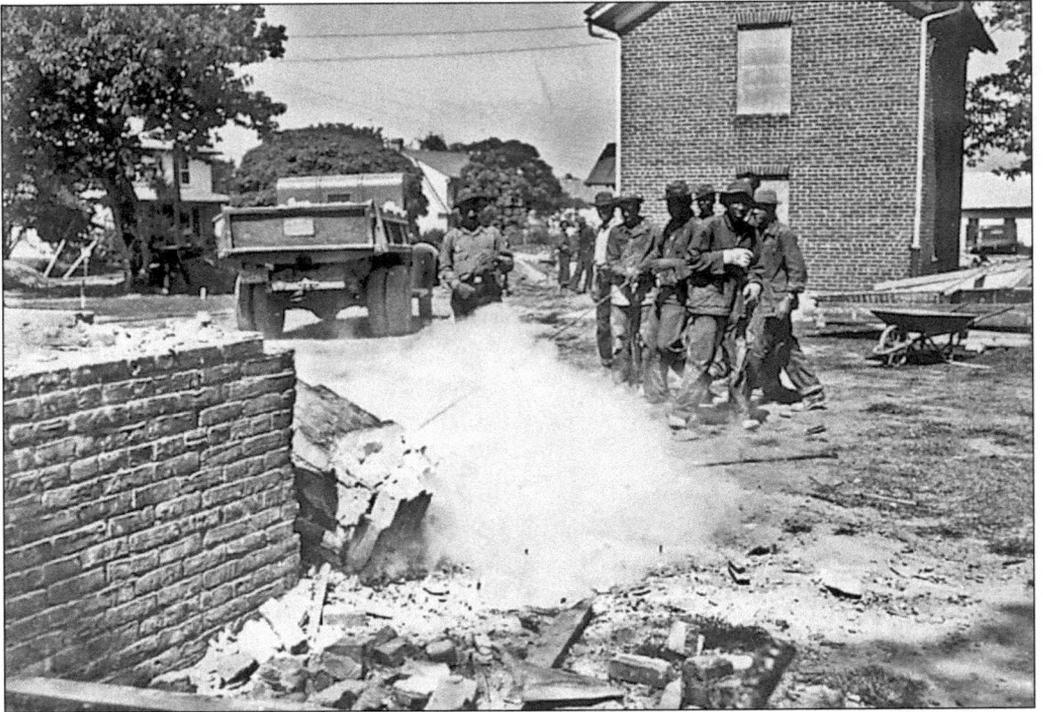

New construction on the fifth courthouse begins at the corner of Ballard and Main Street. (Courtesy of National Park Service, Colonial National Historical Park Yorktown Collection.)

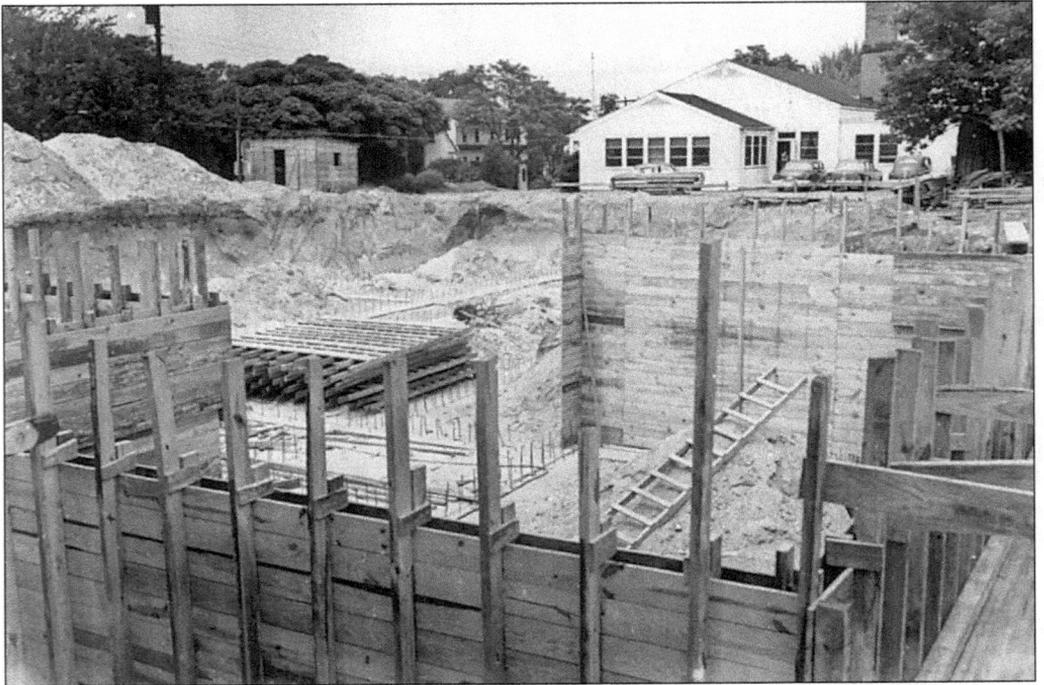

The basement construction is taking shape on the fifth courthouse on June 15, 1954. (Courtesy of National Park Service, Colonial National Historical Park Yorktown Collection.)

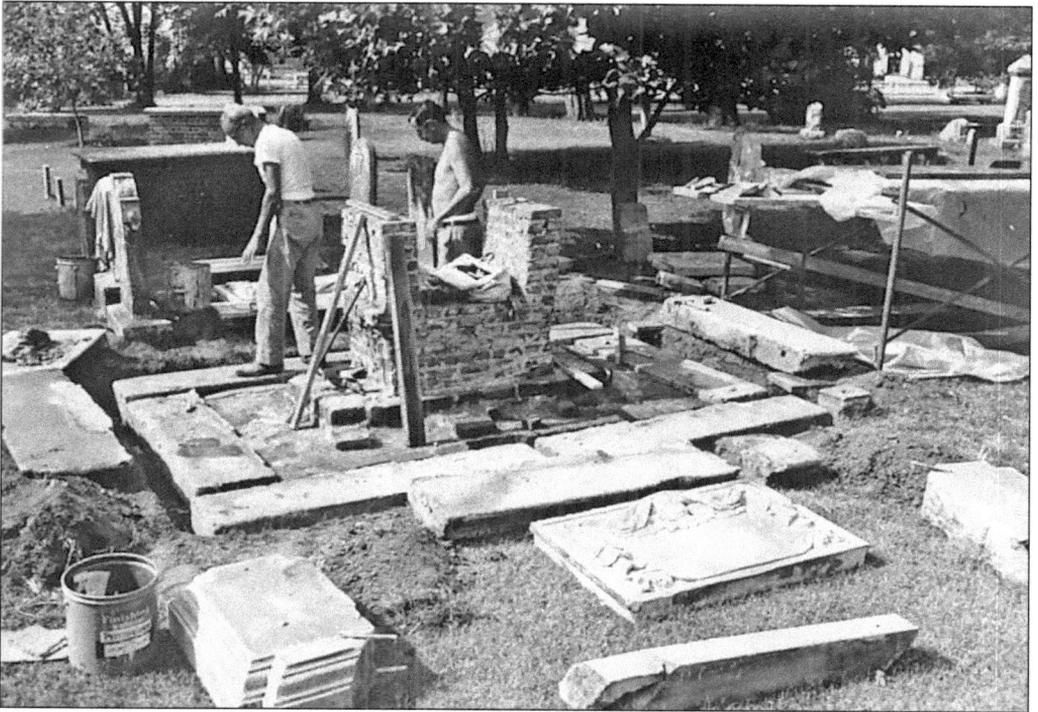

In August of 1963, restoration of the "Scotch Tom" Nelson tomb at Grace Church was already well underway, with reassembly about to begin. (Courtesy of National Park Service, Colonial National Historical Park Yorktown Collection.)

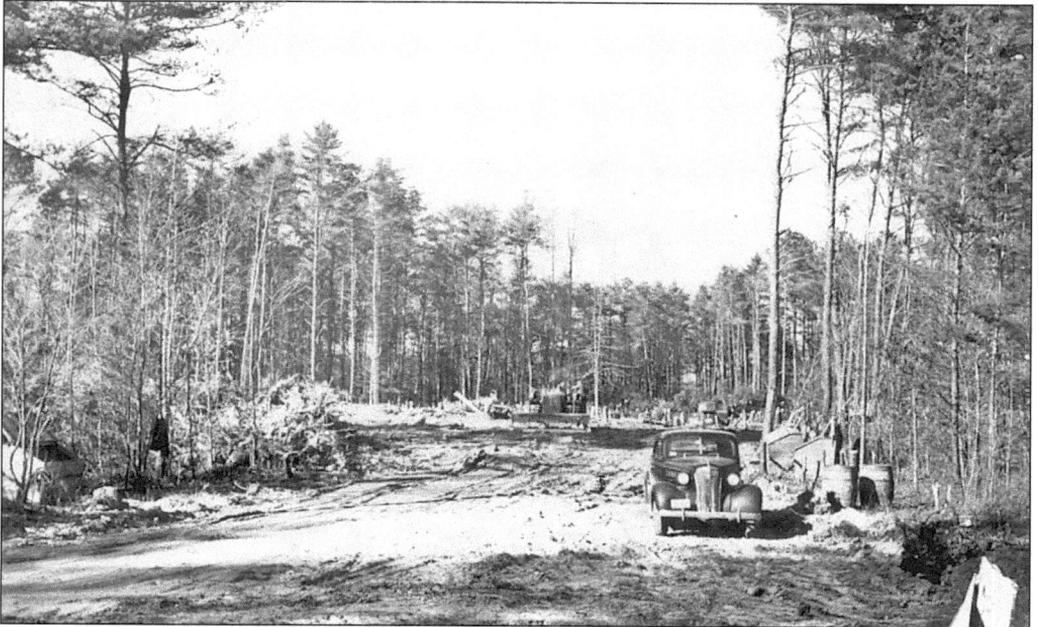

This February 17, 1943 photograph is of the Navy Mine Depot Cook Terrace and Annex when clearing had begun. (Courtesy of National Park Service, Colonial National Historical Park Yorktown Collection.)

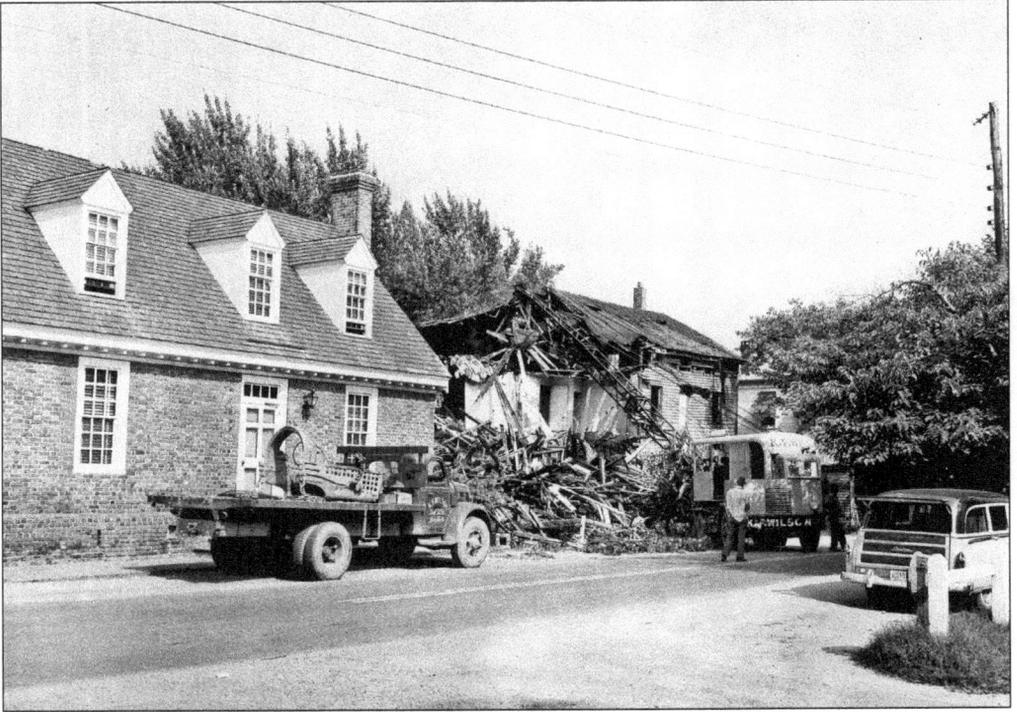

Demolition of De Neufville's store took place on September 3, 1957. (Courtesy of National Park Service, Colonial National Historical Park Yorktown Collection.)

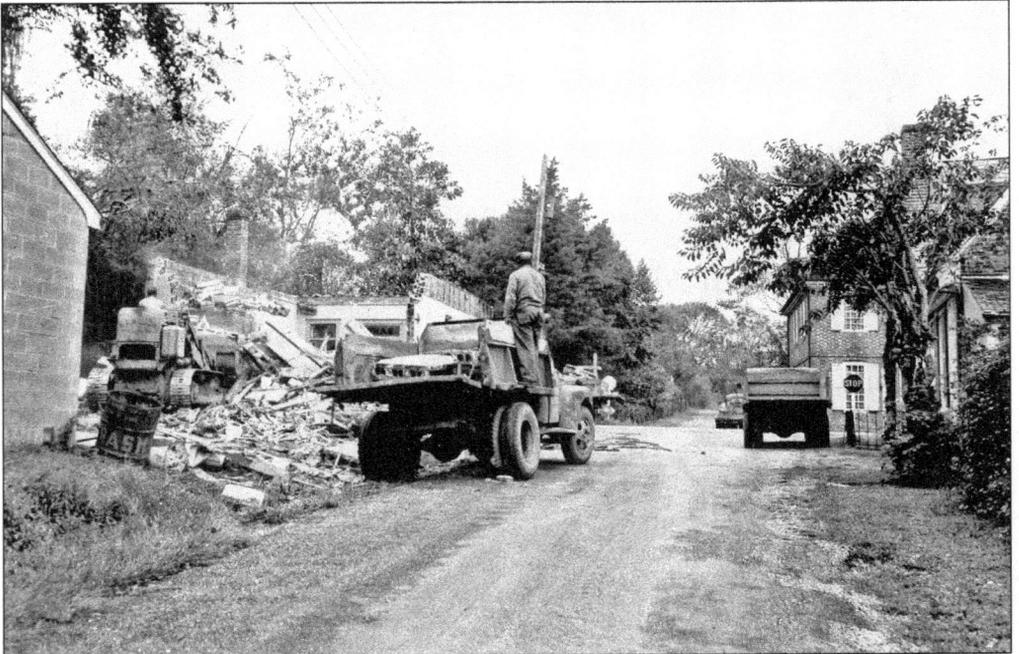

Demolition of the First National Bank building, at the corner of Main and Read Streets, was a milestone event on September 30, 1959. (Courtesy of National Park Service, Colonial National Historical Park Yorktown Collection.)

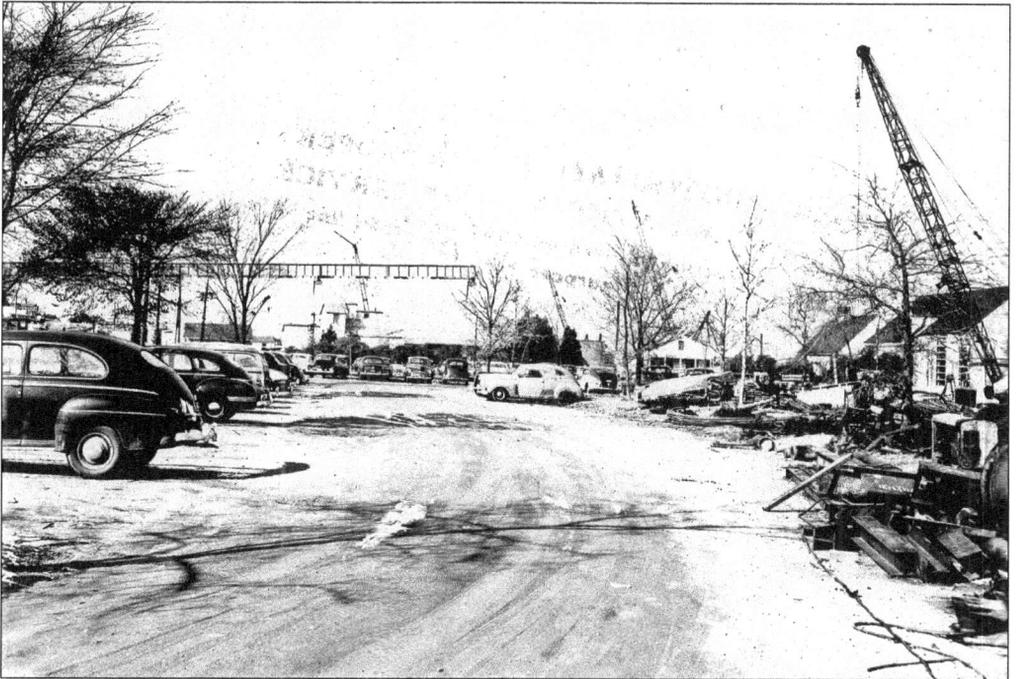

This scene is of initial construction on the Coleman Bridge along Water Street on November 30, 1950. (Courtesy of National Park Service, Colonial National Historical Park Yorktown Collection.)

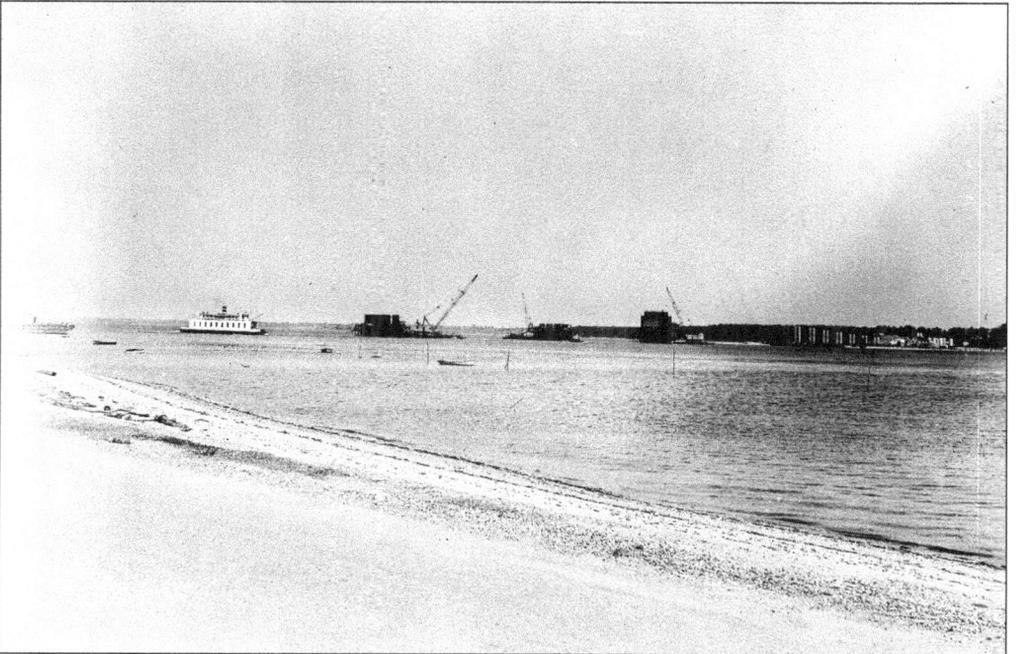

It is the passing of an era as the Yorktown Ferry cruises across the river while the Coleman Bridge construction is underway on August 9, 1950. (Courtesy of National Park Service, Colonial National Historical Park Yorktown Collection.)

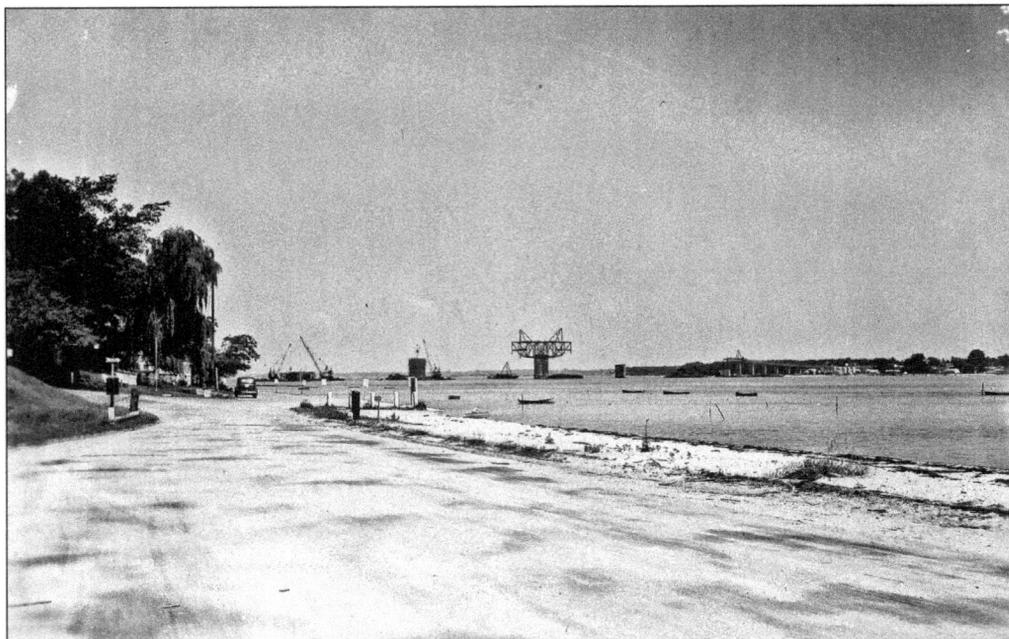

Looking upriver from the Park Beach June 27, 1951, construction of Coleman Bridge exposes a view of the center span. (Courtesy of National Park Service, Colonial National Historical Park Yorktown Collection.)

Here the ramp for loading materials, caissons, and equipment for construction on the George P. Coleman Bridge is shown. (Courtesy of National Park Service, Colonial National Historical Park Yorktown Collection.)

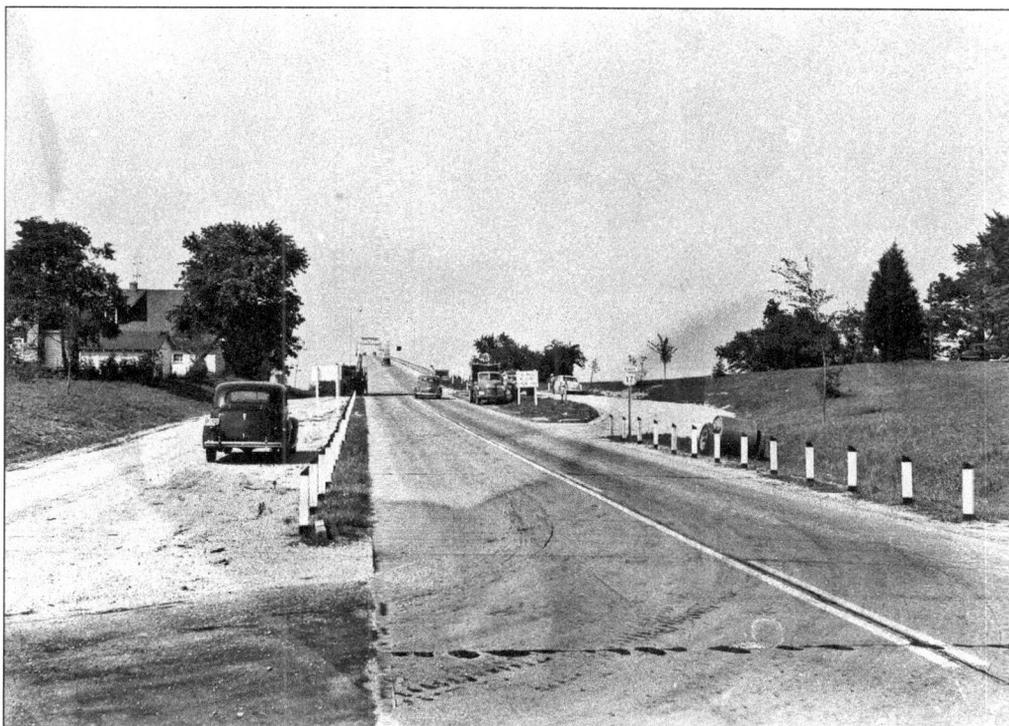

On July 21, 1952, Yorktown provides a proud view of the completed George P. Coleman Bridge. (Courtesy of National Park Service, Colonial National Historical Park Yorktown Collection.)

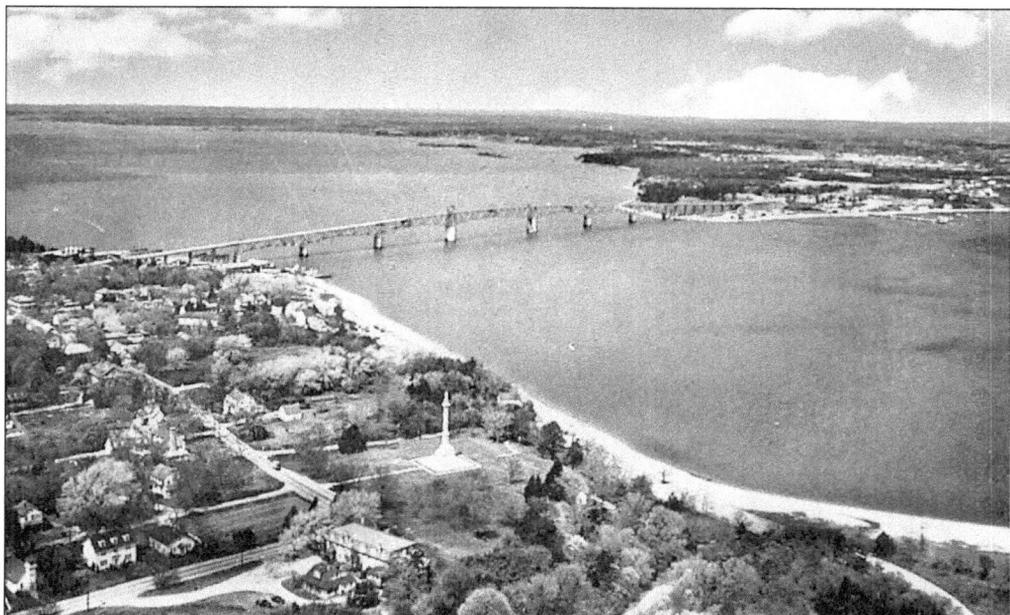

This postcard provides a clear sight line of the completed Coleman Bridge with one of the last looks at the Monument Lodge in the lower portion of the picture. (From the Collection of John A. Lawson III, Williamsburg, Virginia.)

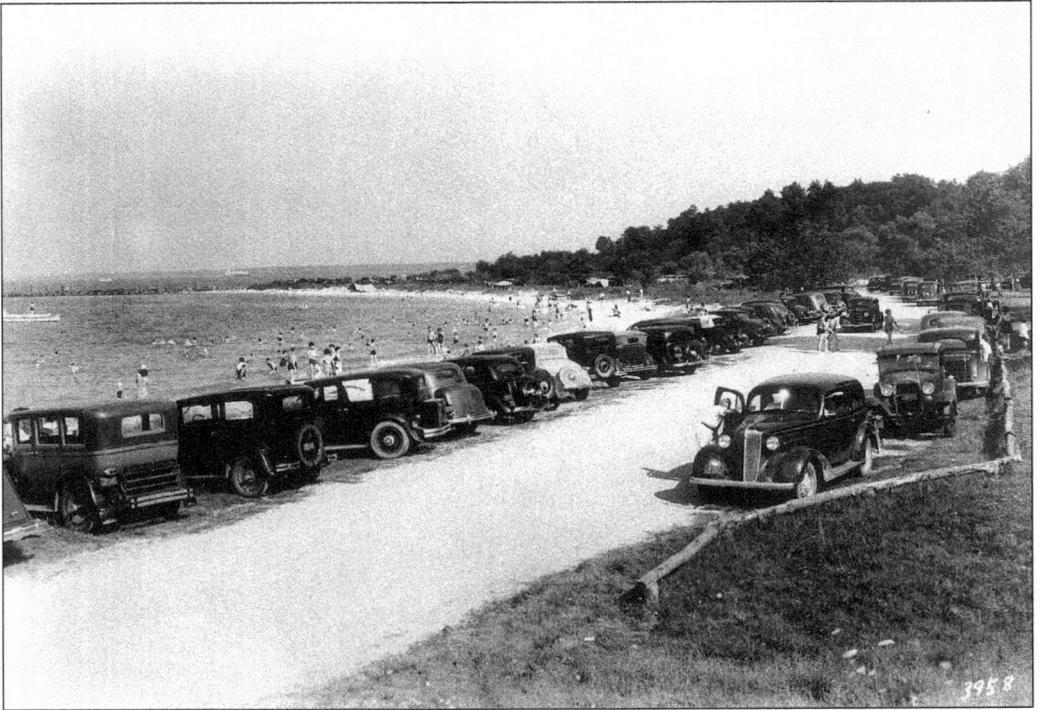

Breezes blow ever better at the beach, *c.* 1940 (Courtesy of National Park Service, Colonial National Historical Park Yorktown Collection.)

Shown in this March 12, 1955 image is the Dumas motor court on the Yorktown waterfront next to Read Street. (Courtesy of National Park Service, Colonial National Historical Park Yorktown Collection.)

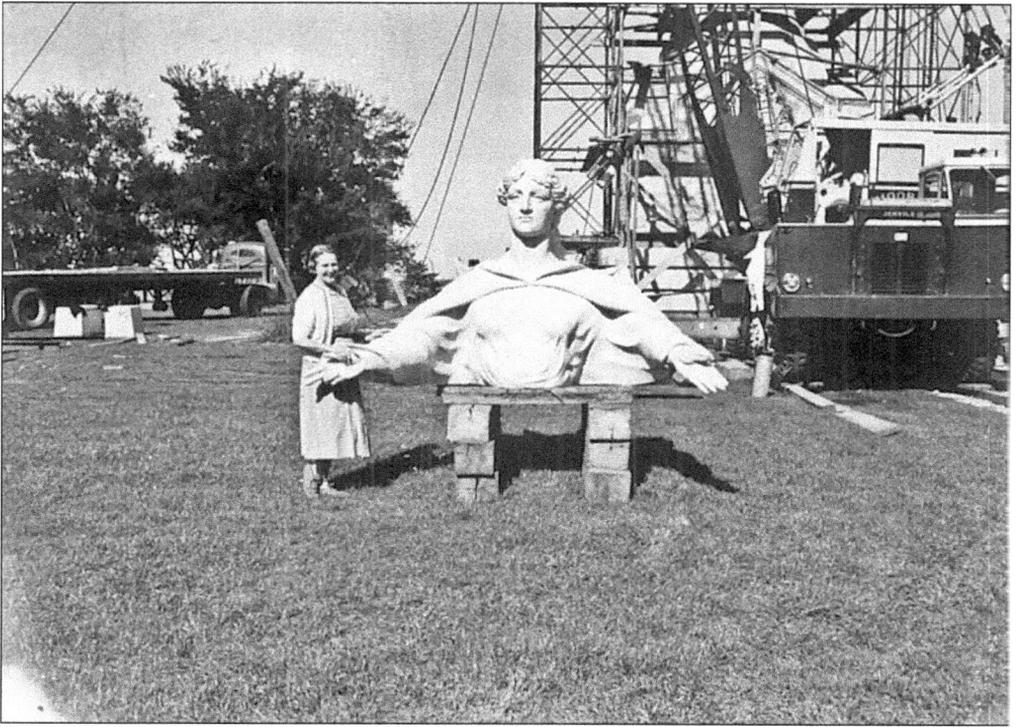

Lady Liberty waits to be taken aloft onto the statue, *c.* 1956 (Courtesy of National Park Service, Colonial National Historical Park Yorktown Collection.)

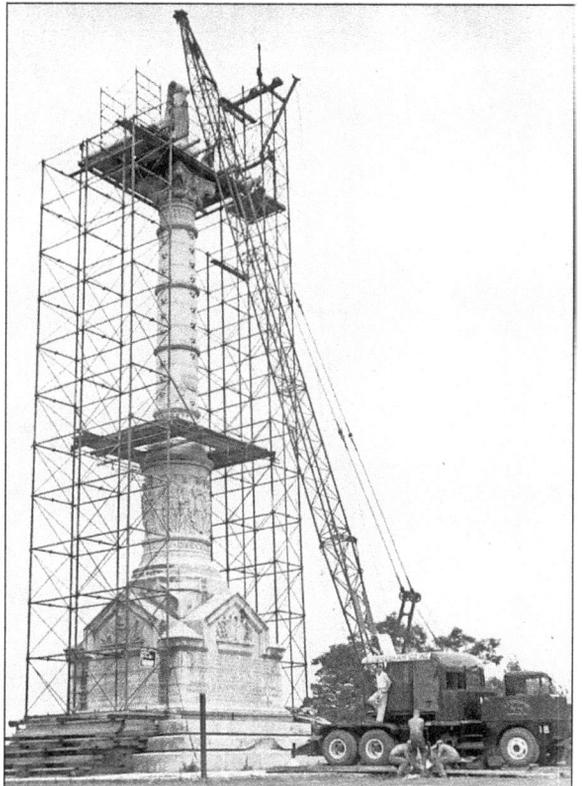

In 1942 the Victory Monument, the statue with outstretched arms, was struck by lightning. Rather than repair it, sculptor Oakar J.W. Hansen prepared a new figure that was mounted on September 10, 1956. A lightening rod now runs down the core of the statue and shaft. The monument was rededicated on October 19, 1957. (Courtesy of National Park Service, Colonial National Historical Park Yorktown Collection.)

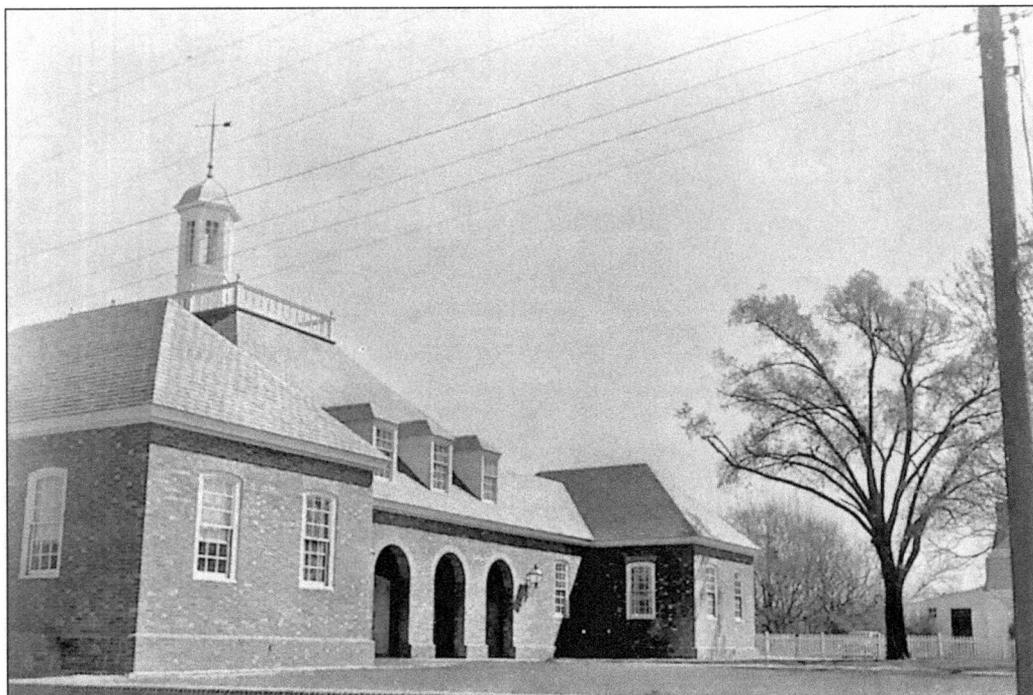

The courthouse, now York Hall, stands on the corner of Main and Ballard Streets. (Courtesy of National Park Service, Colonial National Historical Park Yorktown Collection.)

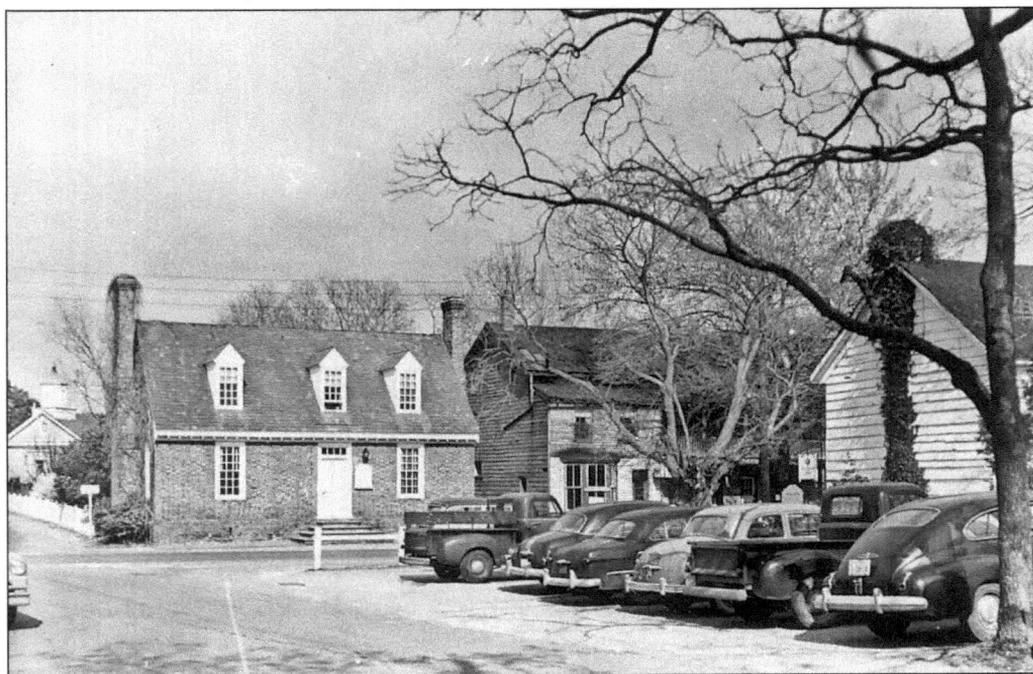

The restored Somerwell House is seen on March 24, 1954, with Grace Church in the background and De Neufville's store to the right (Courtesy of National Park Service, Colonial National Historical Park Yorktown Collection.)

Cars line Water Street in front of Crockett's Bathhouse in June 1953. (Courtesy of National Park Service, Colonial National Historical Park Yorktown Collection.)

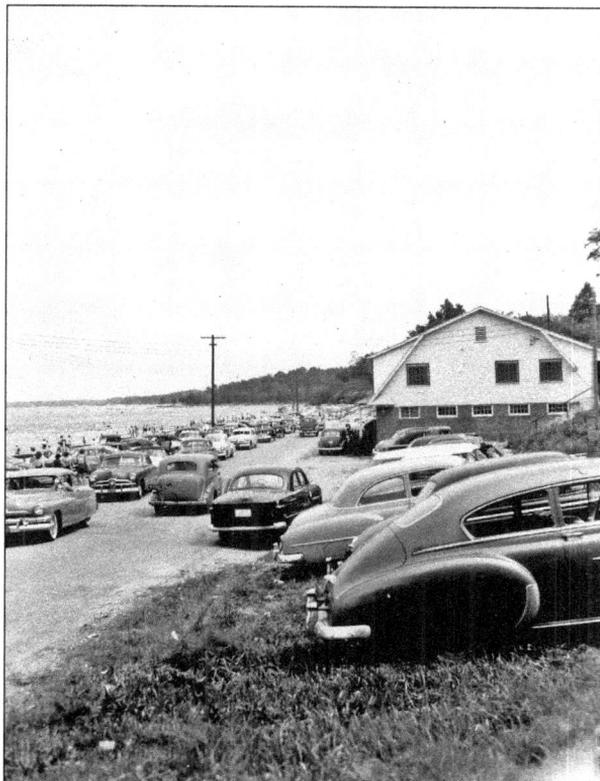

This August 11, 1952 photograph demonstrates why the George P. Coleman Bridge is now an icon of Yorktown. (Courtesy of National Park Service, Colonial National Historical Park Yorktown Collection.)

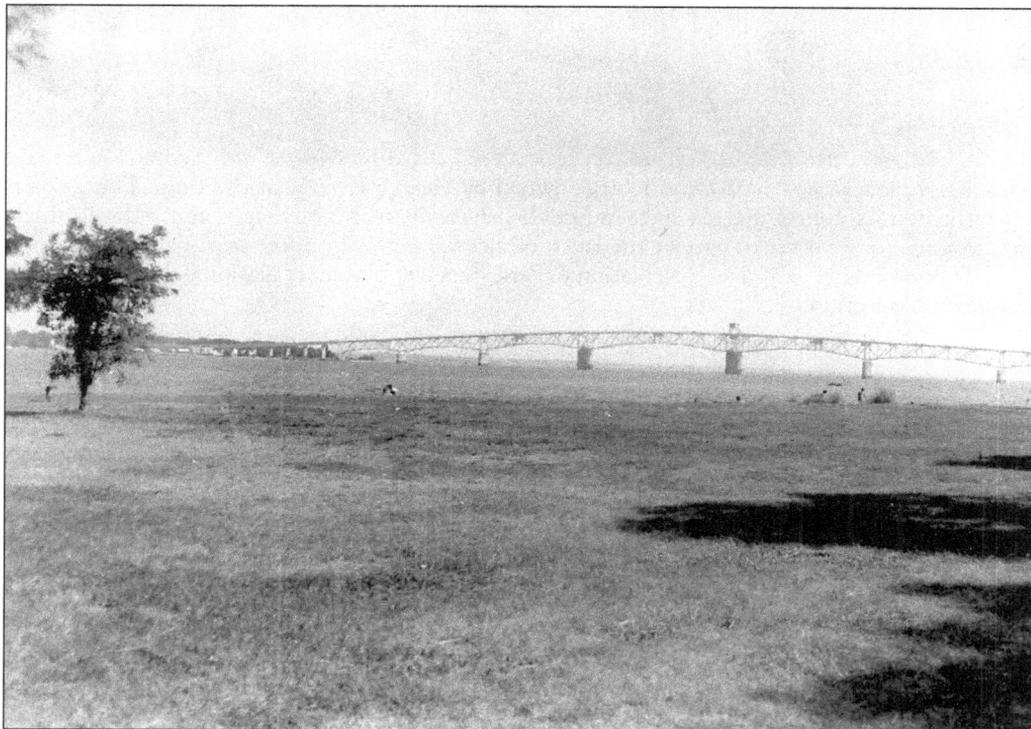

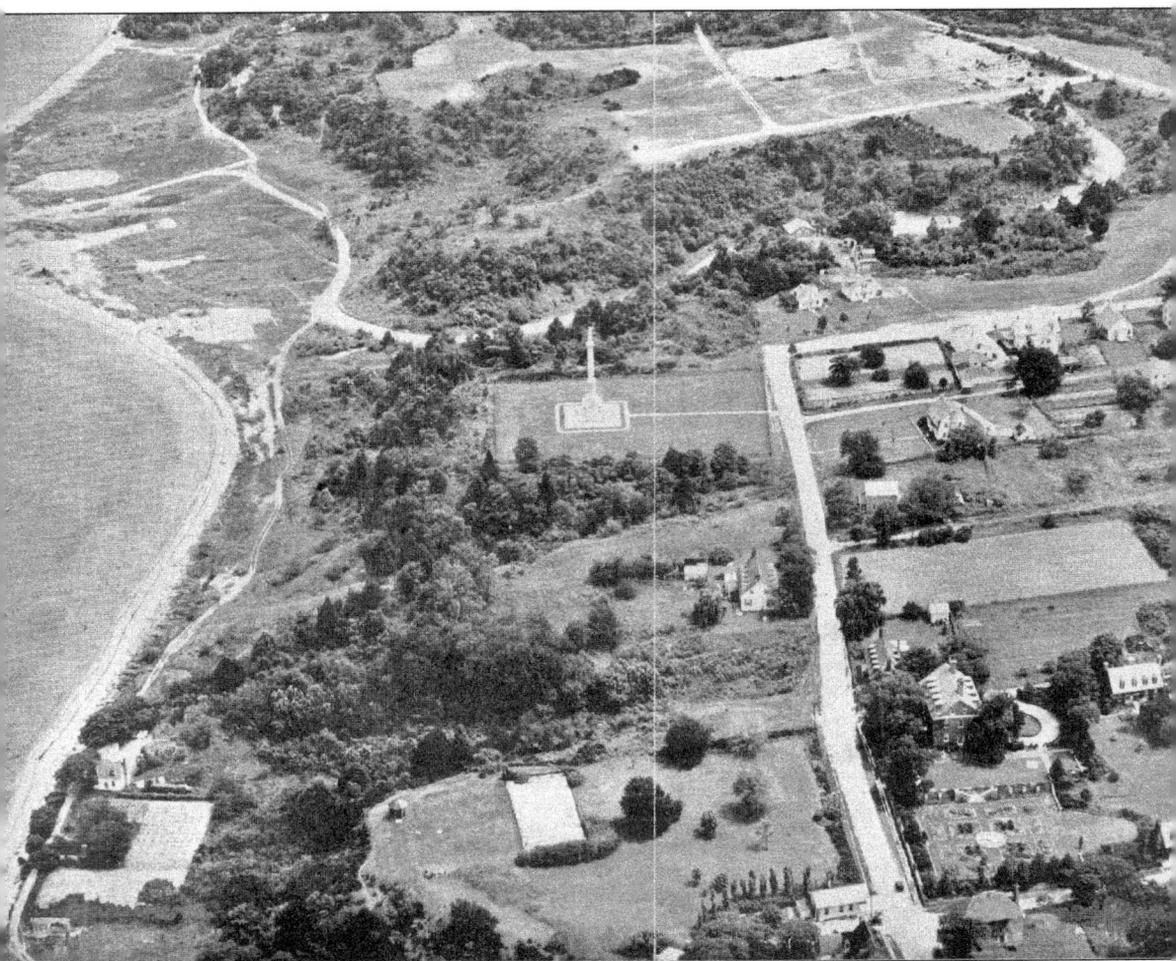

This aerial view shows the Nelson House, owned by George P. Blow at the time. The gardens with the tennis courts are easily seen on the riverside of Main Street and a lovely little gazebo waits for a visitor to gaze at the river. Notice no power lines or street pavement in this c. 1920 photograph. (Courtesy of National Park Service, Colonial National Historical Park Yorktown Collection.)

Eight

"WE THE PEOPLE"

The creation of inanimate objects, such as buildings, matter nothing without the people. When everything else was finished and the town was near collapse from the early storms and the bloody drama of war, the people still remained. Let the images of people always be the last vision here, as it is in Yorktown.

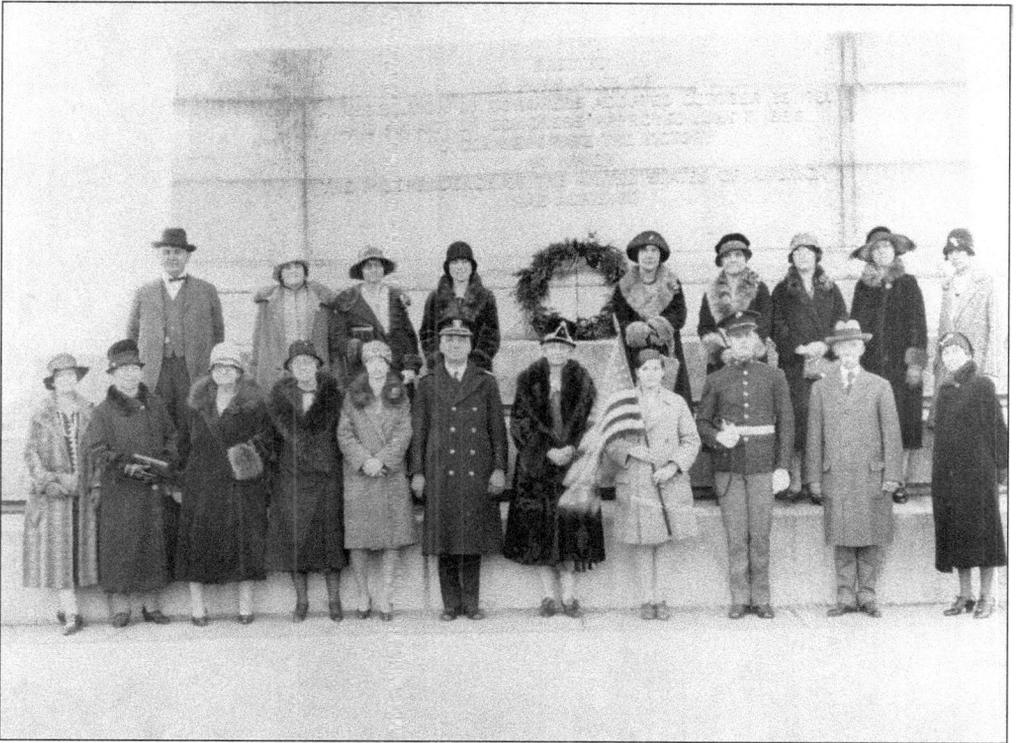

The commemorative wreath, resting in the middle of this 1928 photograph, was laid in honor of Yorktown Day. From left to right are (front row) Frances Curtis, Margaret Williams, Nannie Curtis, Elizabeth Madison, unidentified, Flauntleroy Smith, Mrs. Chenoweth, Anne Cary Renforth (flag bearer), a bugler, Mr. Chenowith, and Mrs. A.J. Renforth; (back row) A.J. Renforth, Elizabeth Curtis, Sally Cooke Shield, Sidney Smith, Mrs. B.P. Smith, Mrs. J.L. Wainwright, and the others are unidentified. (Courtesy of the O'Hara Collection.)

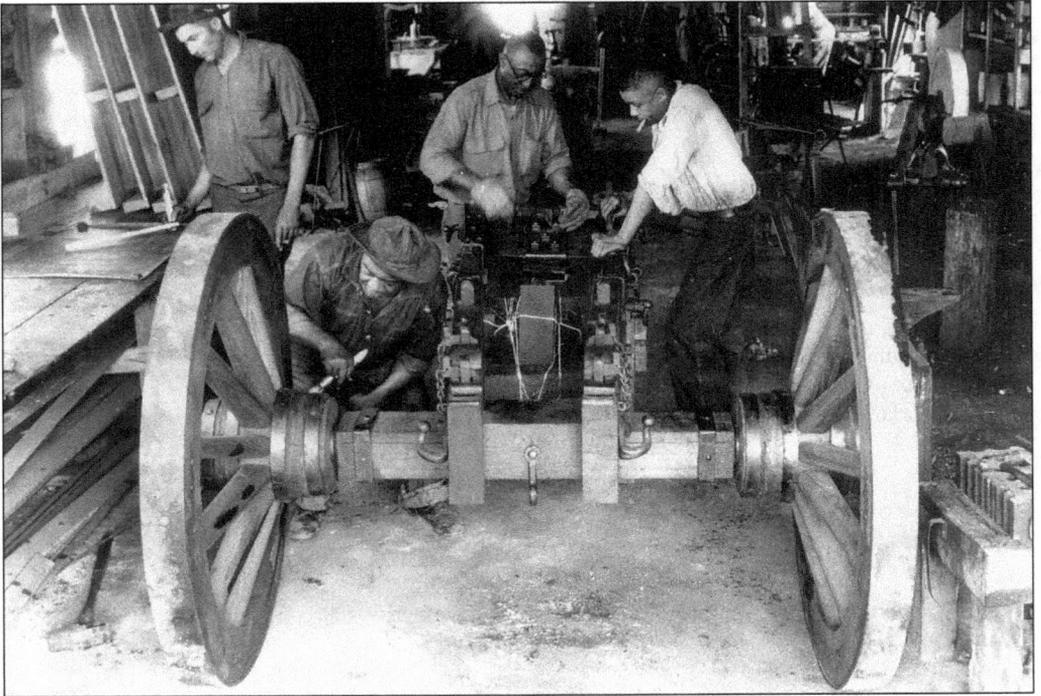

Here a cannon mount is in progress in 1930 with CCC craftsmen finishing the their work. (Courtesy of National Park Service, Colonial National Historical Park Yorktown Collection.)

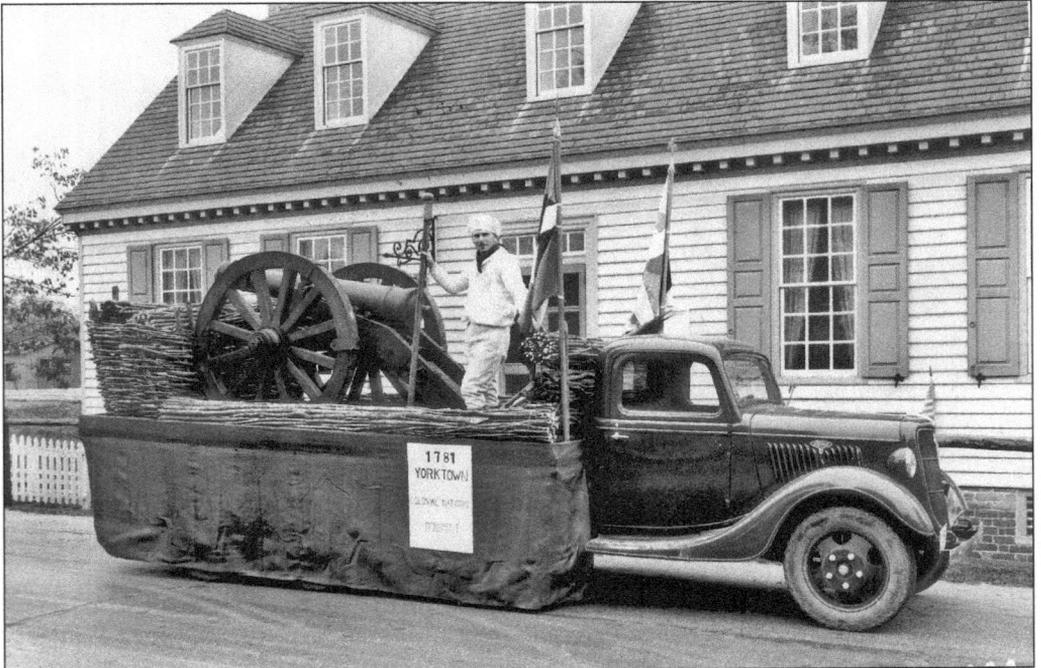

The William and Mary homecoming parade float on November 2, 1935, was prepared by the Division of Historical Service. (Courtesy of National Park Service, Colonial National Historical Park Yorktown Collection.)

Craftsmen briefly pause for the camera in the metal shop of the CCC, c. 1930. (Courtesy of National Park Service, Colonial National Historical Park Yorktown Collection.)

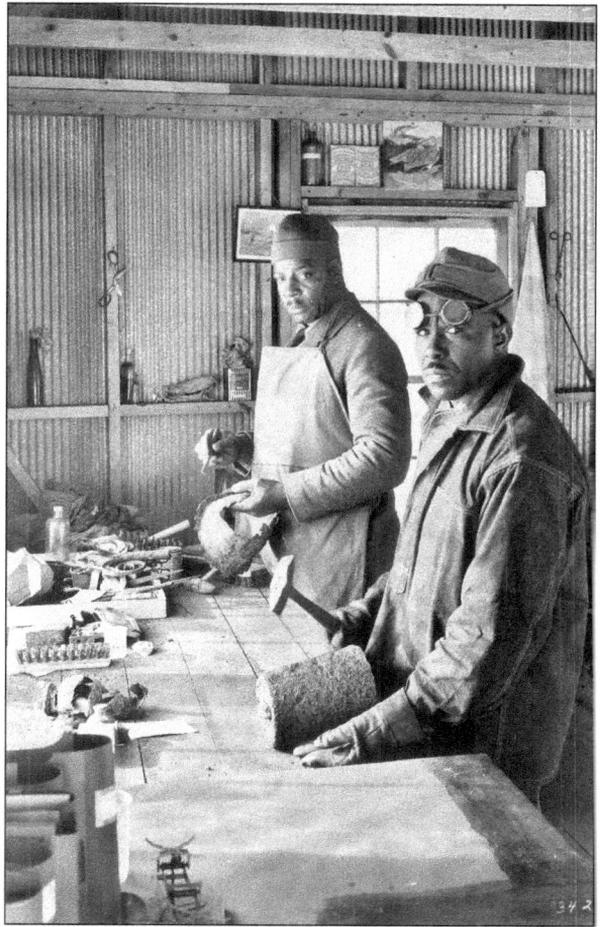

In October 1931, a well-dressed crowd of hats and gloves can be seen as the crowd watches one of the main events at the Sesquicentennial Celebration. (Courtesy of National Park Service, Colonial National Historical Park Yorktown Collection.)

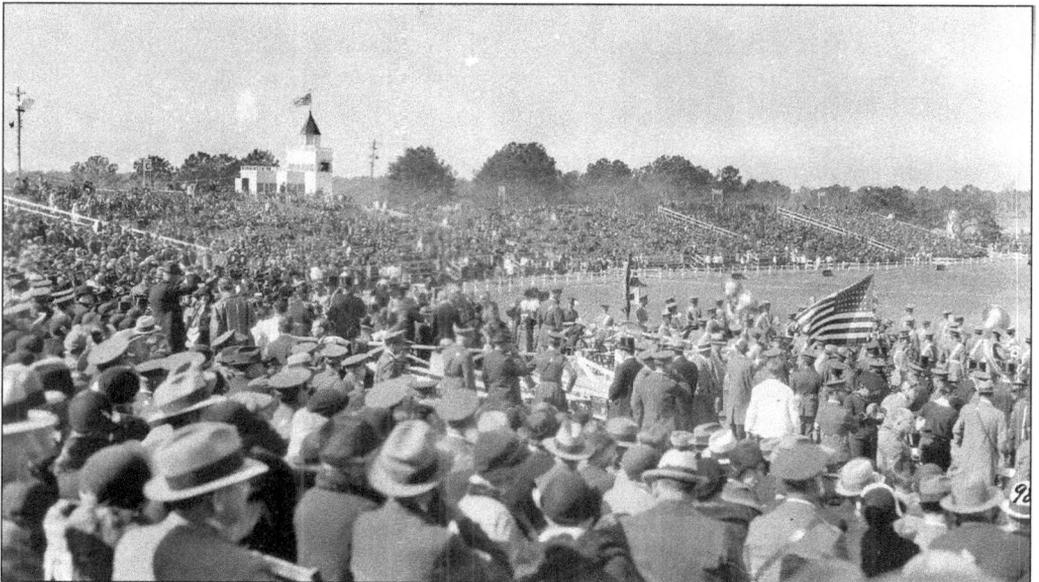

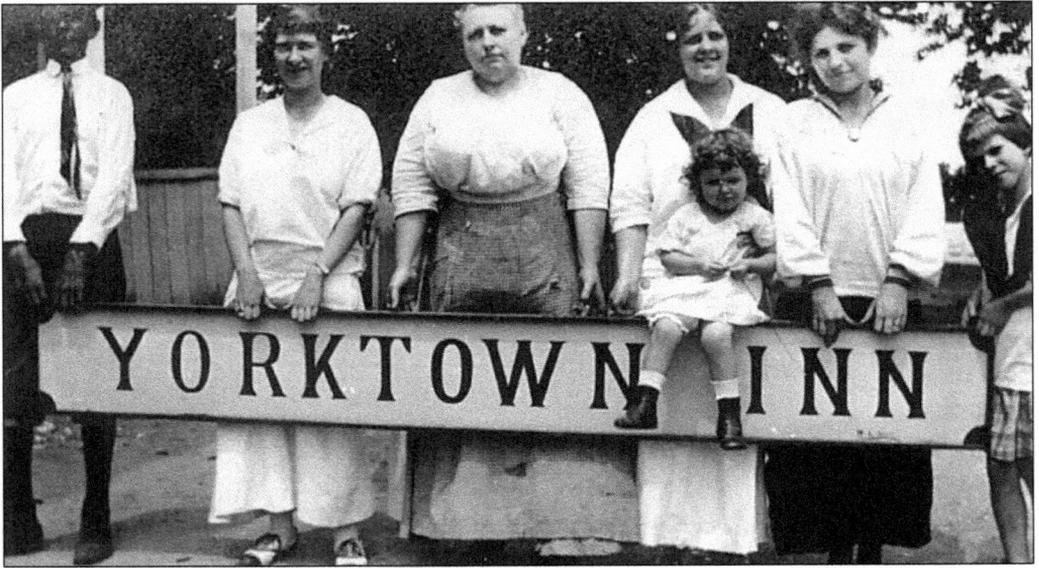

Some of the Cooke family pose here at the Yorktown Inn in 1920. (Courtesy of Cooke-Krams Family Collection.)

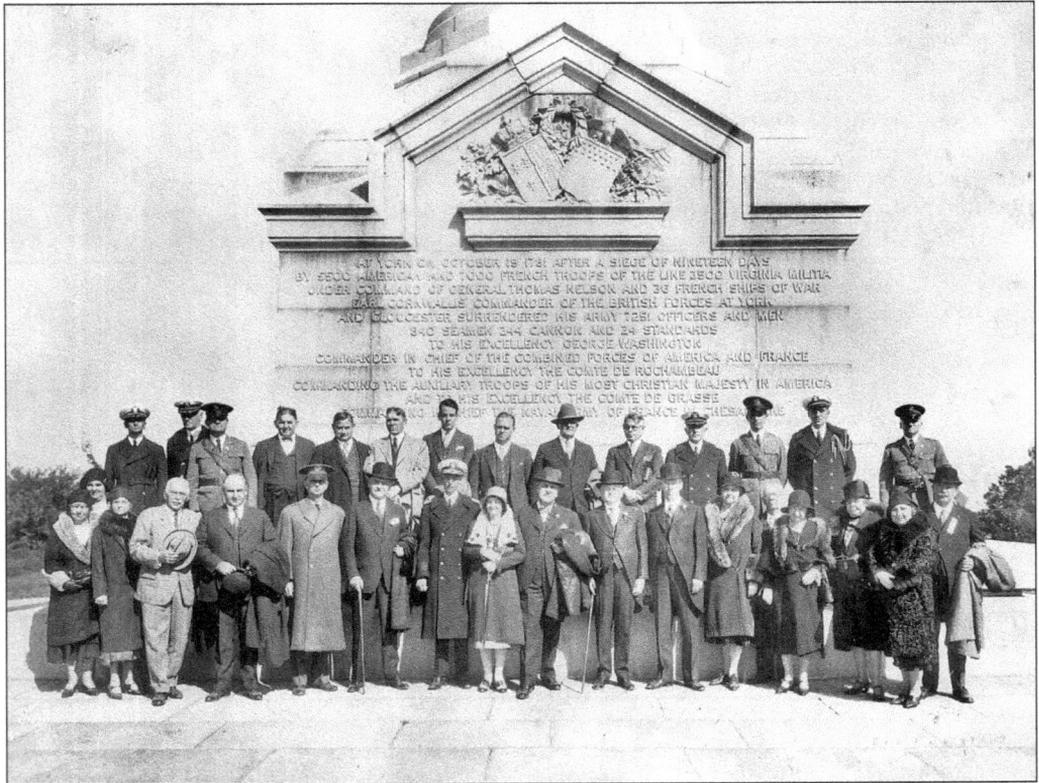

Various dignitaries gather in front of the Victory Monument in 1931. (Courtesy of National Park Service, Colonial National Historical Park Yorktown Collection.)

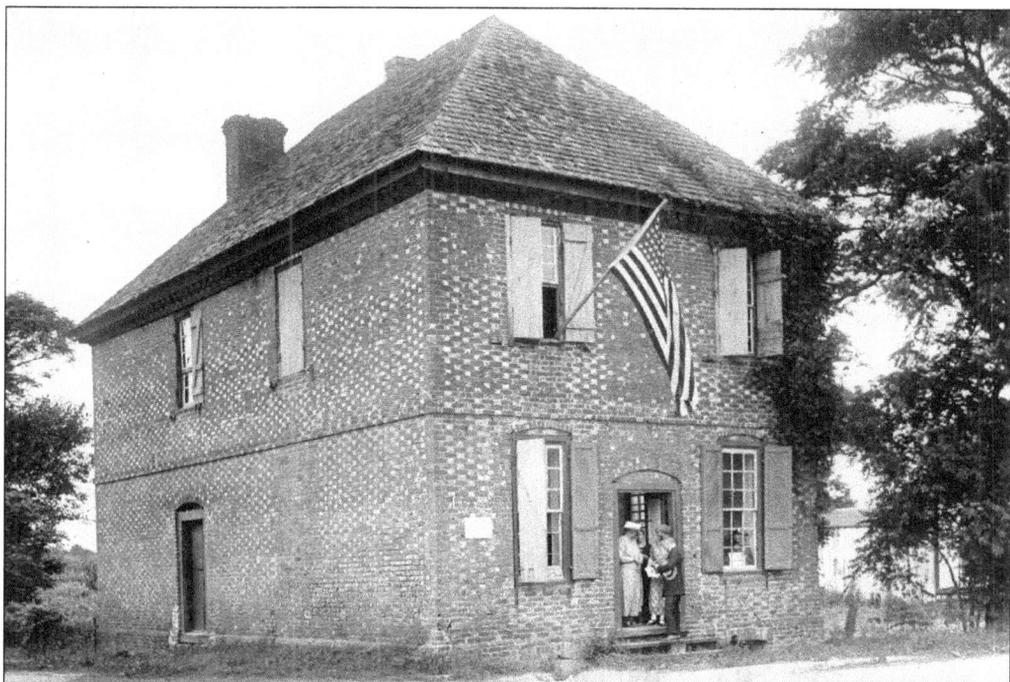

Standing on the battered wooden steps of the newly acquired Customs House in 1926, some ladies of the DAR exchange pleasantries with a messenger who has come to call—notice the onlooker in the window. (Courtesy of O'Hara Collection.)

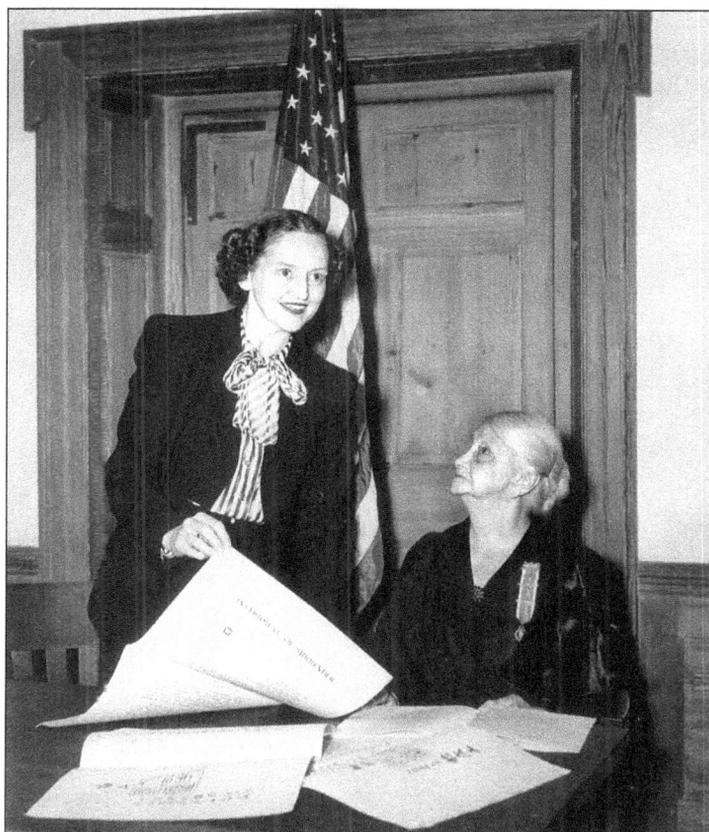

Kay Blow and Emma Chenoweth compare the terms of surrender after World War II with Revolutionary War at the Customs House in 1945. (Courtesy of O'Hara Collection.)

Floyd Flickinger was superintendent of the National Park Service. (Courtesy of National Park Service, Colonial National Historical Park Yorktown Collection.)

People flocking to the beach can be seen through the trees on June 8, 1947. (Courtesy of National Park Service, Colonial National Historical Park Yorktown Collection.)

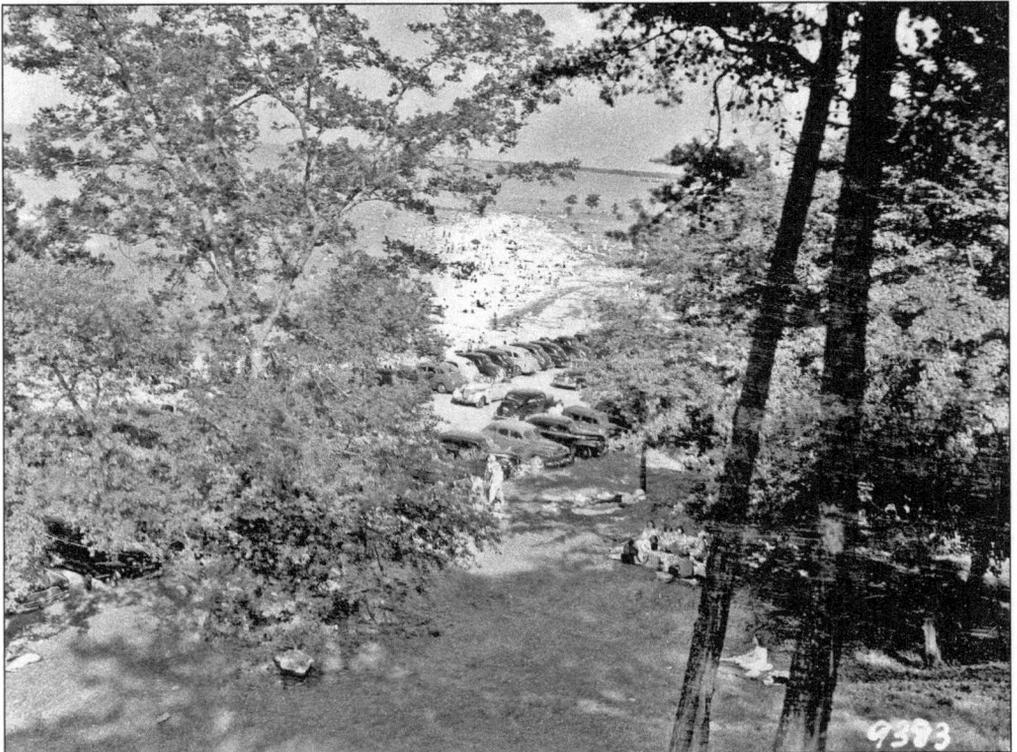

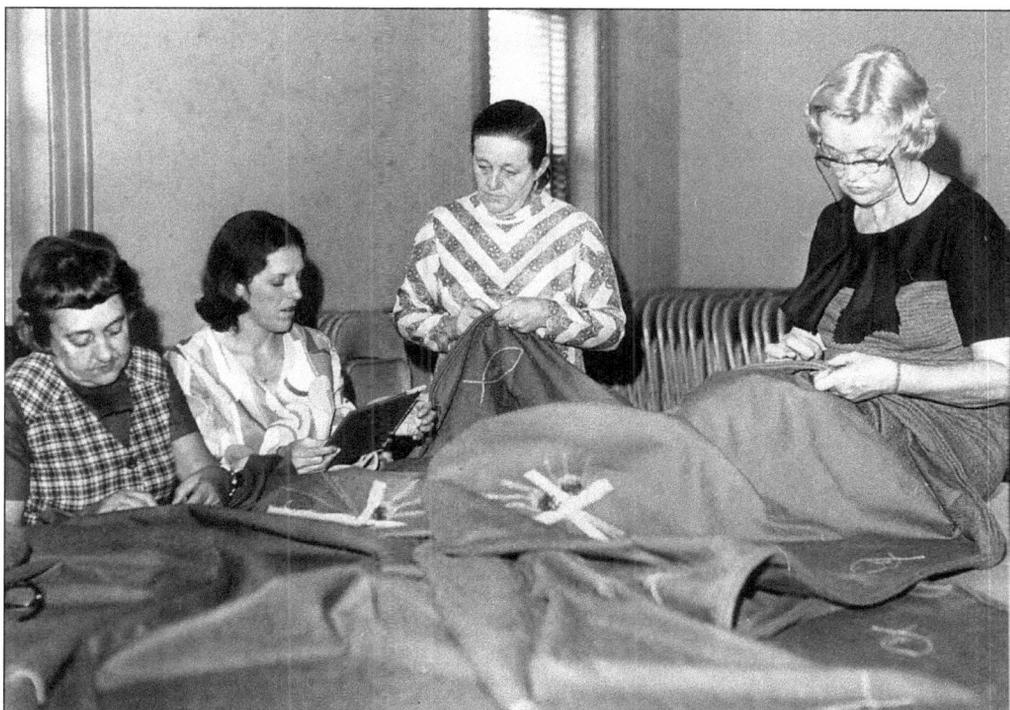

The ladies of Grace Church are sewing a hand made altar cloth that is still in use today. From left to right are Suzie Shield, two unidentified, and Mem Lemay. (Courtesy of Grace Episcopal Church.)

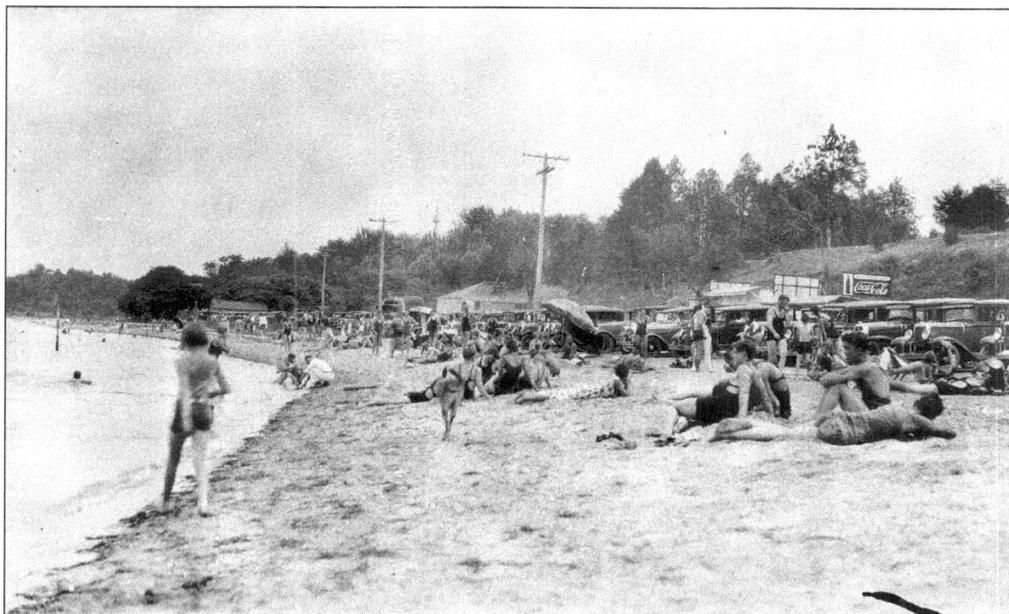

In this beach scene, c. 1920, it is interesting to note the lack of development on the hill in the background. (Courtesy of National Park Service, Colonial National Historical Park Yorktown Collection.)

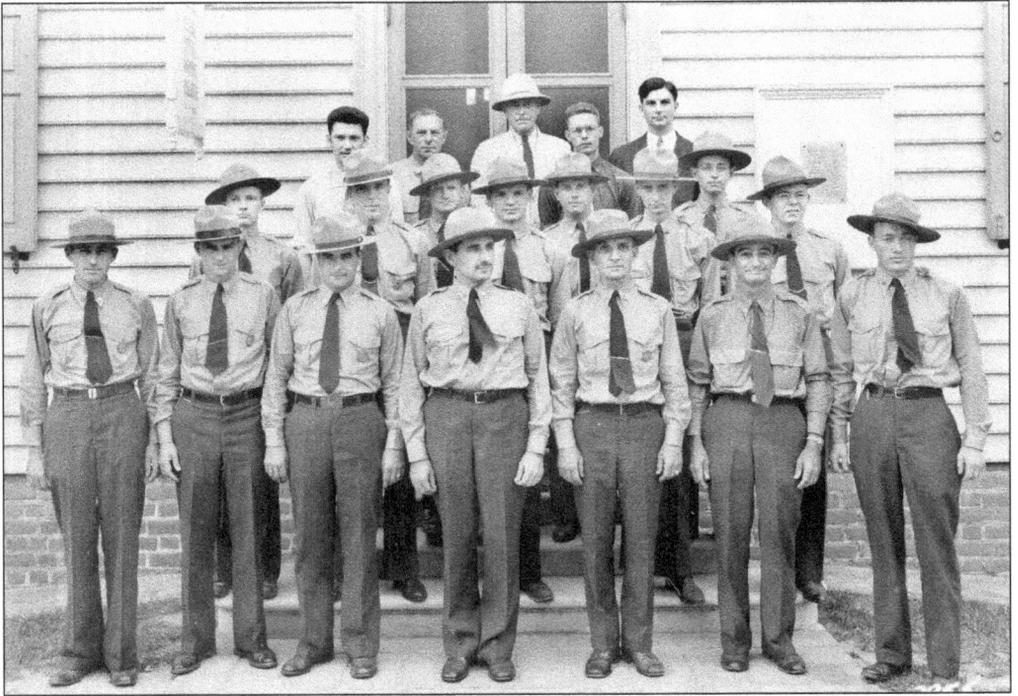

In this *c.* 1930 picture the first park rangers in Yorktown stand on the steps of Swan Tavern with B. Floyd Flickinger in the center, front row. John Gary Fletcher is on the second row, far right. (Courtesy of Fletcher collection.)

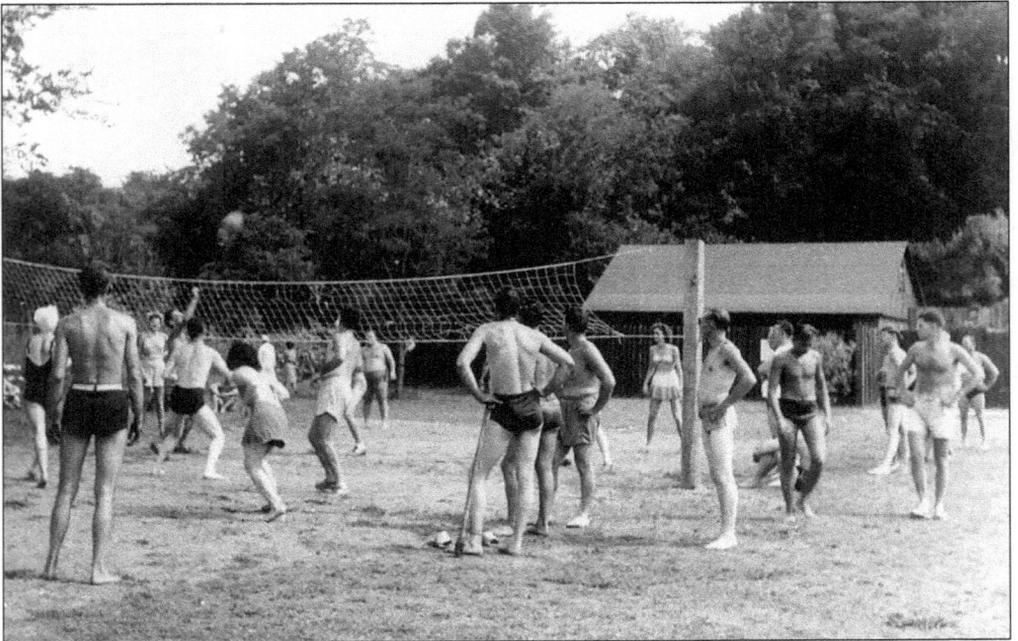

In July of 1944, the men of the armed services are seen playing volley ball on the Park Service beach. (Courtesy of National Park Service, Colonial National Historical Park Yorktown Collection.)

Shirley Temple is pictured at the Moore House, standing between Harry Doust, left, and B. Floyd Flickinger, right. Among the many dignitaries that came to Yorktown, Shirley Temple thrilled the locals with her visit. (Courtesy of National Park Service, Colonial National Historical Park Yorktown Collection.)

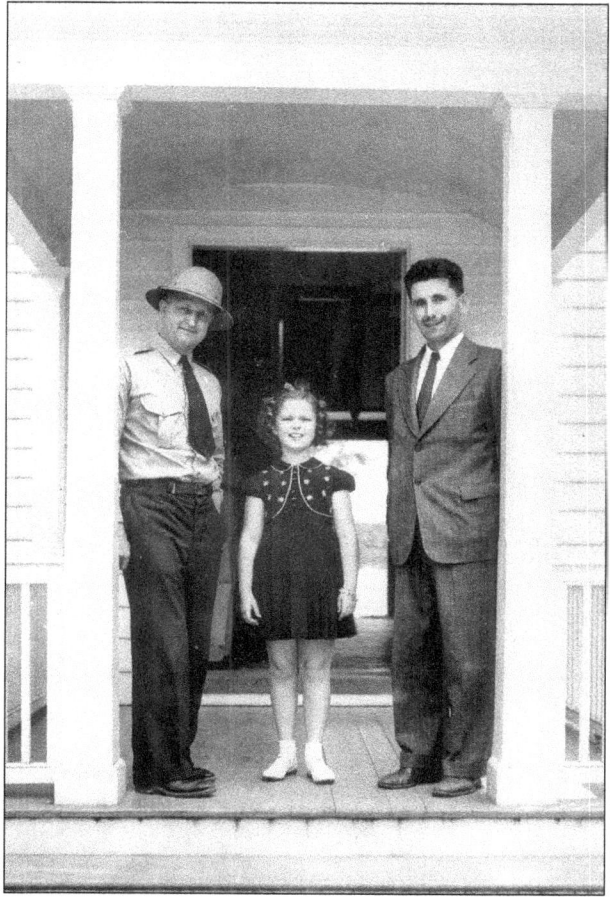

A traveling salesman delivers a Comfort Home Range to Walter P. Cooke. (Courtesy of Cooke-Krams Collection.)

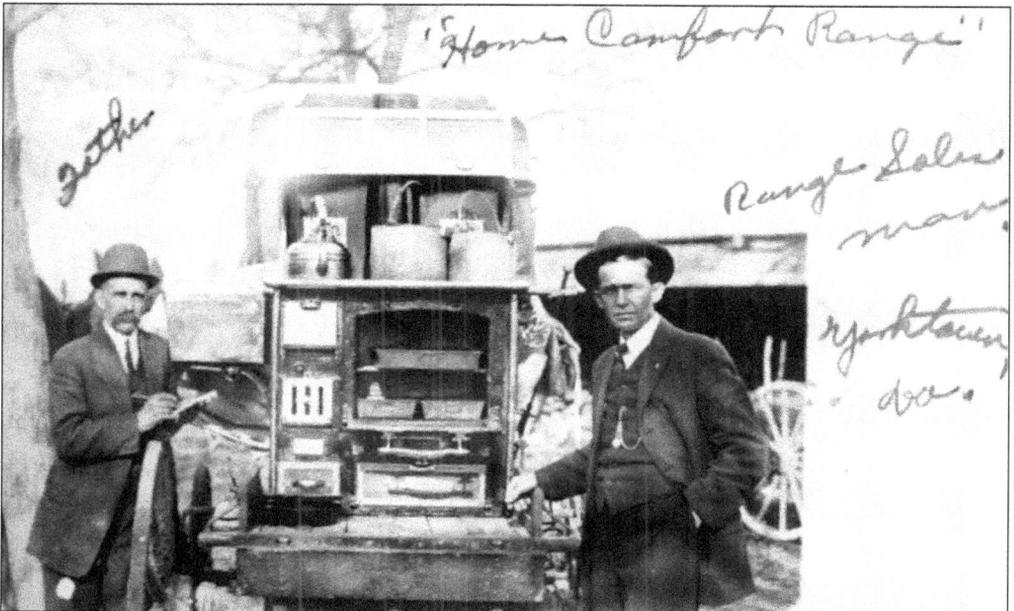

BIBLIOGRAPHY

Bigelow, Bob. *Slabtown, Yorktown Home For Freed Slaves*. York Series #C-6, Feb. 2003

Boyce, Debra, and Jean Kirkham. *In Every Generation*. Yorktown, Virginia: Grace Episcopal Church, 1997.

Campbell, Helen, J. "Residents Will Do Battle to Retain Colonial Atmosphere." Yorktown: *Daily Press*, 1950, June 4.

Colonial National Historical Park Archives.

Deetz, Kelley. *Slabtown: Yorktown's African American Community 1863–1970*. Senior honors thesis, University Archives, Swem Library College of William and Mary, 2002.

Historical Flight. Richmond, Virginia: *Richmond Times Dispatch*, 1925.

Hoak, Micheal. *The Men of Yorktown: Black Men and the Civilian Conservation Corps, 1933–1936*, 1997.

Ivy, Dick. "Postcards From the 1900 Yorktown." *Yorktown Crier*, 1985.

Ivy, Dick. "Recalling a Vanished Yorktown." *Yorktown Crier*, 1985.

Moore, Perry Wornom. *Yorktown:A Guide Book*. Richmond, Virginia: Deitz Press, Inc., 1976

Official Program of the Yorktown Sesquicentennial. Richmond, Virginia: Lewis Printing Co. Inc. 1931.

O'Hara, Leslie. Speech for the Bi-centennial. Yorktown, Virginia: 1981

O'Hara, Lucy Hudgins. *Yorktown As I Remember*. Verona, Virginia: McClure Printing Co., 1981

Wistar, Isaac Jones. *Autobiography of Isaac Jones Wistar*: 1827–1905, Philadelphia, Pennsylvania: The Wistar Institute of Anatomy and Biology, 1937.

Trudell, Clyde F. *Colonial Yorktown*. The Eastern National Park & Monument Association, 1971.

The World Forum. Richmond, Virginia: *Richmond Times Dispatch*, 1925.

The Yorktown Customhouse 1720–1981. Compiled by the Comte De Grasse Chapter, DAR, Moore House Society, CAR.

The Yorktown Book. The Official Chronicle and Tribute Book. Yorktown Sesquicentennial Association, Richmond, Virginia, 1932, Whittet & Shepperson, Richmond, Virginia.

www.ingramcontent.com/pod-product-compliance
Lightning Source LLC
Chambersburg PA
CBHW050613110426
42813CB00008B/2549